Trash or treasure?

Manchester University Press

Inside Popular Film

General editors Mark Jancovich and Eric Schaefer

Inside Popular Film is a forum for writers who are working to develop new ways of analysing popular film. Each book offers a critical introduction to existing debates while also exploring new approaches. In general, the books give historically informed accounts of popular film, which present this area as altogether more complex than is commonly suggested by established film theories.

Developments over the past decade have led to a broader understanding of film, which moves beyond the traditional oppositions between high and low culture, popular and avant-garde. The analysis of film has also moved beyond a concentration on the textual forms of films, to include an analysis of both the social situations within which films are consumed by audiences, and the relationship between film and other popular forms. The series therefore addresses issues such as the complex intertextual systems that link film, literature, art and music, as well as the production and consumption of film through a variety of hybrid media, including video, cable and satellite.

The authors take interdisciplinary approaches, which bring together a variety of theoretical and critical debates that have developed in film, media and cultural studies. They neither embrace nor condemn popular film, but explore specific forms and genres within the contexts of their production and consumption.

Trash or treasure?

Censorship and the changing meanings of the video nasties

Kate Egan

Manchester University Press
Manchester and New York

distributed exclusively in the USA by Palgrave

Published by Manchester University Press
Oxford Road, Manchester M13 9NR, UK
and Room 400, 175 Fifth Avenue, New York, NY 10010, USA
www.manchesteruniversitypress.co.uk

Distributed in the United States exclusively by
Palgrave Macmillan, 175 Fifth Avenue,
New York, NY 10010, USA

Distributed in Canada exclusively by
UBC Press, University of British Columbia, 2029 West Mall,
Vancouver, BC, Canada V6T 1Z2

British Library Cataloguing-in-Publication Data is available

Library of Congress Cataloging-in-Publication Data is available

ISBN 978 0 7190 7233 8 paperback

First published by Manchester University Press in hardback 2007

This paperback edition first published 2012

The publisher has no responsibility for the persistence or accuracy of URLs for any external or third-party internet websites referred to in this book, and does not guarantee that any content on such websites is, or will remain, accurate or appropriate.

Printed by Lightning Source

This book is dedicated to Tim Noble and Sue Ellis

Contents

Figures

Every effort has been made to obtain permission to reproduce copyright images in this book. If any proper acknowledgement has not been made, copyright-holders are invited to contact the publisher.

Abbreviations

BBFC	British Board of Film Censors (before 1984), British Board of Film Classification (1984 and onwards)
DPP	Director of Public Prosecutions
ICA	Institute of Contemporary Arts
NFT	National Film Theatre
OPA	Obscene Publications Act
OPS	Obscene Publications Squad
VPRC	Video Packaging Review Committee
VRA	Video Recordings Act

Acknowledgements

Special thanks to: Paul Binnion for the books I've borrowed from him over the years; Mark Jancovich and Paul Grainge for their advice and support throughout my time as an MA and PhD student at the University of Nottingham; Martin Barker for his advice and encouragement (without which I would have never finished this book); Jamie Sexton for his comments on drafts of the book and for being an extremely valued friend, a constant source of support and a fantastic proof-reader; and Tim Noble and Sue Ellis for always being there, for always believing in me, and for keeping me going.

I must also thank the University of Nottingham for funding my three years of doctoral research. Thanks also to: Owen and Ruth Egan, David Egan, Edward Ellis, Linden and Chris Higgins, Nathan Hunt and Philippa Tibbitts, Jeongmee Kim, Karen McNally, Basil Glynn, Russ Hunter, Kerstin Leder and James Mackley, Ernest Mathijs, Hege Rossa, Damon Miller and Zoe Bliss, Harriet Jarman, Gavin Morgan, Jo Higginson, all at Manchester University Press, Meir Zarchi, the Cube cinema, the Phoenix cinema, Tony Earnshaw at the Bradford Film Festival, and to the collectors whose memories proved to be an important primary resource employed by this book.

Earlier versions of parts of this book have appeared in the following publications: 'The amateur historian and the electronic archive: identity, power and the function of lists, facts and memories on video nasty-themed websites', *Intensities: The Journal of Cult Media*, www.cult-media.com/issue3/Aegan.htm, 3 (2003); 'The celebration of a "proper product": exploring the residual collectible through the video nasty' in Charles Acland (ed.), *Residual Media* (Minnesota: University of Minnesota Press, 2006).

Introduction: the video nasties and the consequences of censorship

In the early 1980s, a group of previously suppressed post-1950s American and European horror films were released on video in Britain, and became the target of a media panic orchestrated, centrally, by a group of moral campaigners and the right-wing British newspaper, the *Daily Mail*. As the panic over the supposed harmful effects of these videos, and their easy access to children, began to mount in the British press, the police began seizing particular titles from video shops in the hope of prosecuting the shops and/or the video distributors under the 1959 Obscene Publications Act (OPA). As a guide for the police, the Director of Public Prosecutions (DPP) (at the Home Office) constructed a list of potentially prosecutable horror videos available, at that time, in British video shops. Employing the term that a *Sunday Times* journalist had coined to describe these videos,[1] this inventory of horror titles became known (by the authorities and the press alike) as the 'video nasties'.

Following police seizures, prosecutions of particular video titles did take place, but, while some court cases were successful, other British courts found the same or other horror video titles not guilty under the auspices of the OPA. With the right-wing press and other moral campaigners continuing to call for more robust and dependable methods to regulate video and remove the nasties from the British cultural landscape, the Thatcher government of the time finally met calls to put a new system of state video censorship into place, and thus in 1984 passed the Video Recordings Act (VRA) – to date, perhaps the most stringent form of regulation imposed on the media in a western country. The act legally required that, from 1984 onwards, all British video distributors should submit poten-

tial video releases to the British Board of Film Classification (BBFC) for approval and certification, and that they should pay for the privilege of having the title considered for certification and release. Under the terms of this act (which had stringent restrictions on the depiction of sex and violence), it was clear to British video distributors that a large number of the video nasty titles would fail to gain BBFC-administered video certificates, and they were therefore removed from the shelves of British video shops and, effectively, became banned.

Looking back more than twenty years later, the events surrounding the formation of the video nasties category are now a distant part of British film censorship history. The VRA is still in place, governing the BBFC's approval or rejection of all videos submitted for certification and release within Britain, but, in the sense that the OPA is now obsolete as a regulative framework for video, the video nasties category and list no longer has a functional legal purpose in Britain. There is no need for the Home Office to employ the term to identify and group together uncertified and potentially prosecutable horror videos for police to search and seize from video shops because (consequent to the establishment of the VRA) there *are no* uncertified and potentially prosecutable horror videos in British video shops anymore. And, while some of the seventy-one horror titles that were at one point on the video nasties list are still legally unavailable in Britain, at least thirty have now been certified and re-released – either in cut versions or, increasingly, in uncut versions.

Yet, despite this and at least at the time of writing, the video nasties, and the events surrounding their initial banning, continue to have a public presence in Britain. Discussions of the events surrounding the video nasties panic and reproductions of the video nasties list proliferate on British horror fan websites and in a range of fan-orientated, limited edition books; the original pre-certificate video versions of the video nasty titles are advertised and sold on *eBay* and other internet auction sites; re-released DVD versions of nasty titles foreground the films' original status as video nasties on video packaging and through the inclusion of extras which document and explore the events of the video nasties panic; and British newspapers and magazines still rarely fail to reference a particular film's association with the now obsolete nasty category in re-release video reviews. Indeed, even the *Daily Mail*, in an extremely

positive review of a 2003 television screening of the nasty title *The Evil Dead*, framed the film not as an early work from the now widely known director Sam Raimi, but, primarily, as 'the film at the heart of the absurd "video nasty" debate in the mid-1980s'.[2] Arguably, then, what these events seem to illustrate is the extent to which a legal category and tabloid term, whose relevance and functionality seemed confined to a previous era in British cultural and legal history, has become a recognisable film genre within Britain.

For some, this statement may appear contentious, for, in terms of conventional academic definitions, the video nasties category and its formation clearly fails to meet the criteria for a recognisable film genre.[3] Firstly, and most obviously, the video nasties is not a universally or internationally recognised filmic term – it is used, primarily in Britain, to refer to a set of British cultural circumstances, and, in the sense that Hollywood studios and film-makers never consciously made video nasties, the category isn't an industrial term that informs (or has ever informed) film production or theatrical marketing strategies. Secondly, the video nasty titles weren't predominantly grouped together because they shared common thematic and formal characteristics. Clearly, the videos were seen (by the British authorities) to all contain extreme depictions of violence and/or sex, but, as a number of commentators on the nasties have noted, many of those who impounded or condemned these titles never watched them and would often single out a particular video on the basis of the film's title or the extremity of its video packaging, rather than considering the film's contextual or formal treatment of sex and violence.[4]

Arguably, then, the corpus of titles that made up the video nasties category were not predominantly grouped together on the basis of shared formal, thematic and/or structural features, but on the basis of historical and political circumstances. Firstly, they were clearly grouped together by pure historical coincidence – specifically, by dint of the fact that they all happened to be released on video during the pre-VRA era in Britain. Secondly, however, and as the British authorities' selection criteria above should illustrate, the titles that were singled out as nasties (from a vast glut of horror videos that were released at this time) were a rather random bunch of films (ranging from horror parodies like *The Evil Dead*, to underground art-house films like *The Driller Killer*, to partly fake, partly genuine mondo-style documentaries like *Faces of*

Death). Indeed, as Kim Newman has argued, many of the nasty titles weren't necessarily the most extreme or explicit examples of violent cinema available on British video shelves at that time,[5] and, as many video nasty commentators have acknowledged, it therefore appeared that this rather random group of horror video titles were there to serve, primarily, as useful emblematic scapegoats, whose suppression would enable the dramatically mushrooming video industry to be regulated and controlled, and the Conservative government of the time to win votes by solidifying and strengthening its law and order image.[6]

However, does this rather anomalous set of circumstances really suggest that the video nasties can't be approached and considered as a film genre? In *Film/Genre*, Rick Altman sets out to challenge the conventional academic definitions of genre discussed above, by approaching film genres not as coherent and fixed textual or industrial categories, but as discursive constructs whose formation and historical perpetuation and circulation could be seen as far more complex and unpredictable than many had previously considered. After a consideration of a range of seemingly anomalous generic categories (including the video nasties, but also such exhibition, reception or consumption-derived categories as festival films, film noir and chick flicks), Altman not only concludes that the location of genres 'may depend at different times on ... differing criteria',[7] but that users of genres may focus, at different times and in different situations, on different aspects and characteristics of the films within that genre. For him, this can mean that 'whatever intrinsic characteristics generic material may have had prior to its recognition as a genre, it is actively modified by those who pronounce the genre's name, describe its traits, exhibit it ... or otherwise make use of its potential', and that 'the perceived nature and purpose of genres' can therefore 'depend directly and heavily on the identity and purpose of those using and evaluating them'.[8]

It is this 'user-orientated approach'[9] to genre that appears particularly useful and productive when considering not only how and why the nasties category was formed, but also how and why it has continued to proliferate, in different locations, from the commencement of the VRA to the present day. It is clearly the case that, since the video nasties was first designated as a legal term, it has been used to refer to a range of different objects, circumstances and ideas. Firstly, in its initial use by the British police and Home

Office, it was used to group together a range of potentially prosecutable horror video titles available, at that time, on British video shop shelves. Then (as the *Daily Mail*'s use of the banner 'Ban the Sadist Videos' should illustrate) the term began to be used by the British press as an emblem of all that was most insidious about the nascent video industry. Indeed, in this context and as I will go on to demonstrate, the specific nasty titles began to take second place to the *idea* of evil horror videos, which was constructed primarily through second-hand descriptions of violent scenes and images of video cover art from a range of horror titles (not only those that the police had impounded), as well as through rhetorical descriptions of the impact of these videos on British families and children.

Then, after the nasties' banning, British fans and collectors of the video nasties used the term not only to refer, once again, to the specific titles, and the specific video versions of these titles on the Home Office's video nasties list, but also to the events that had led to the moral panic *and* the fans' experience of renting uncertified horror videos during this period. Then, as new, but often cut, versions of the nasty titles began to be released on video and DVD, the term was used to refer to the film titles' association with the nasty era, even though these versions of the films were often of differing lengths, had different distributors and were in different formats to the original video versions that were included on the nasties list.

Not only, then, has the video nasties term been used to refer, over time and in different contexts, to a set of film titles, a specific set of video versions, a set of historical events and a personal consumption experience, but clearly, and in line with Altman's arguments, the way in which the term and category has been defined and approached has depended 'heavily on the identity and purpose of those using and evaluating' it. For the British press, the video nasties needed to be presented as an emblem of the worst excesses of horror video, so focus was placed on the films' (and on other non-nasty horror videos') cover art and most violent moments. For nasty fans and collectors, the focus needed to be placed on the exact distributor and cut of each video nasty, so that the exact banned version of that particular video title could be sought out and collected. For re-release distributors, the focus was placed, once again, on the film titles, rather than the exact video nasty version of that title, so that their product could be associated

with a recognisable cultural event and given a familiar commercial identity.

In all these examples, then, the term 'video nasty' remains constant, but what it refers to changes – focus is placed on different aspects of the videos, new objects, ideas and associations become attached or are detached from the category, and the uses, and therefore the meanings, of the term change through time. The aim of this book is therefore to chart and explore the cultural mediations and historical processes that have underpinned the video nasties genre and its changing uses and meanings, and, through this, to contribute to an understanding of how genre users can affect the functions and meanings of a genre or cultural category through time, and in relation to specific contexts and circumstances. For while the video nasties can be considered as a particularly unusual example of genre formation and perpetuation, a study of this category and its historical circulation can help to underscore that, as Altman has argued, all generic categories can fruitfully be conceived and approached as discursive constructs whose functions and meanings can be modified, to varying degrees and for varying reasons, by different users in different contexts through time.

In a similar fashion to James Naremore (who has also approached film noir as a user-determined discourse and idea), this book therefore attempts to delineate the key 'modes of existence' of the video nasties discourse within British society between 1981 and 2001, and, through this, to consider not only 'who can appropriate' the term, but *why* and *how* each user has appropriated it.[10] In order to chart and explore this process systematically, the study that follows draws on the theoretical and methodological framework employed in the field of historical reception studies, particularly as it has been utilised in the work of Robert Kapsis and Barbara Klinger.[11]

In their work, both Kapsis and Klinger have focused centrally on how the functions, uses and meanings of particular films change through time, and have both stressed the need to explore the *historical* circulation of particular films in order to catch hold of the 'vivid array of meanings' films may have and range of 'particular ideological functions' they may adopt during the course of their public existence and circulation.[12] In order to explore this practically and systematically, both have attempted to identify 'key

moments' within the 'historical transit' of a particular group of films,[13] and to then identify the key discursive sites (or 'determinations') that appear to impact most significantly on the meaning of particular films within a particular historical moment.[14] By discursively analysing key historical documents and other materials related to each site, both have been able to explore the 'systems of intelligibility and value' that are employed to define and evaluate films at particular historical moments,[15] and, through this, to illuminate the historical, social, cultural and ideological institutions, contexts and discourses that Kapsis argues 'are crucial in shaping the historical reception of films and other artifacts of culture'.[16]

In order to explore the changing uses and meanings of the video nasty category, a similar methodological framework will be employed in this book. In order to identify the 'key moments' or 'modes of existence' of the nasty category, the book is structured chronologically and divided into three parts, which broadly represent the nasty titles' movement in and out of legitimate circulation in Britain. Part I focuses on the period from the introduction of video in Britain up to the nasties' banning under the VRA; part II then focuses on the discussion and circulation of the nasties, from 1984 onwards, amongst a secondary market of nasty fans and collectors; and part III focuses on the gradual reintroduction, from 1990–2001, of the nasty titles back into the British commercial sphere – both in the form of re-released video versions and screenings in art cinemas, film festivals and on niche British television channels.

In order to explore the key shaping discourses at work in each period of the category's circulation, each chapter will focus on a particular discursive site that appears, at that moment, to have used and appropriated the term or idea of the nasties in a particular way and to have impacted significantly on its meanings at that particular point in time. By conducting a historically and contextually informed discursive analysis of a particular kind of historical material (or materials) closely associated with that site (from film reviews and national press articles to marketing materials and fan websites), the aim will be, firstly, to determine how the nasties (as a term, category and idea) was approached, defined and used by that site; secondly, to explore the key discourses that circulate around and inform such a use and definition; and thirdly, to consider how these discourses are shaped and underpinned both by the general

function and politics of that site and the historical context that the site exists in at a particular moment.

By adopting this framework, the book therefore coheres to Janet Staiger's assertion that 'cultural artefacts [or categories] are not containers with immanent meanings' because 'variations among interpretations have historical bases for their differences, and ... differences and change are not idiosyncratic but due to social, political, and economic conditions'.[17] While the video nasties is evidently a rather unusual and exceptionally multi-faceted object of study, its malleability is constrained by the fact that it is not, like any film or filmic category, an idea or category that can come to represent and refer to anything and everything. Instead, its uses and meanings have clearly been shaped by specific and changing historically, culturally and ideologically specific circumstances. While this book is therefore unable to present itself as a comprehensive study of *all* the meanings and uses (and, indeed, all the possible reasons for uses) that the video nasties may have had, the methodological focus – on key users of the nasties, on the politics and motives of those users in a particular site and at a particular time, and on the changing meanings that result from this – exists, as it has for other historical reception theorists,[18] as the most productive and systematic way in which to approach the question of how a film or a filmic category's many and varied manifestations can be caught hold of, explored and accounted for.

Indeed, in terms of this consideration of the nasties as a thoroughly contextualised category and term, this book not only focuses on the changing meanings of the nasties, but also attempts to track the *relations between* each of these meanings. Broadly, it will do this by looking, in part I, at how initial associations and meanings became attached to this category, and then, in parts II and III, by not only considering how later groups and institutions used the category, but also to what extent they drew on initial and previous associations and meanings in order to appropriate the nasties category in a particular way.

By adopting this approach, the book not only draws on general historical reception studies approaches, but also Kapsis and Charles Maland's more specific focus on the 'biographical legends' or 'reputations' of cultural figures or ideas, and the possible ways in which such reputations can be seen to be built up, in a 'cumulative' manner,[19] over time. As Klinger notes, when discussing

Maland and Kapsis' work, the different discursive determinations that influence and change the meanings of a text or texts can also help to 'constitute "biographical legends"... legends that deeply affect contemporary meanings for past artefacts'.[20] For her, these legends are initiated in the initial historical moment, but, arguably, it is after this initial historical moment and 'through the cumulative effects of time' that 'legends' or 'reputations' can achieve their 'biggest impact on meaning'.[21]

While in the past this approach has generally been applied to the reputations of film stars and directors, a secondary aim of this study is to consider if cultural categories or genres can also accrue a reputation through the distinct accumulation of meanings and associations as a category passes through different discursive sites through time. In order to do this, this book will also engage with, and aim to test, Arjun Appadurai's theory of 'paths and diversions', an anthropological/material culture-derived theory that aims to explore how a cultural object (or, in this case, a category) is formulated and then pushed off down one cultural pathway but then diverted (by other users) down another and then another pathway – a process which allows an object or a category to accumulate 'a life history of associations and meanings' through time.[22] As Appadurai argues, 'diversions are meaningful only in relation to the paths from which they stray. Indeed ... part of the anthropological challenge is to define the relevant and customary paths, so that the logic of diversions can properly, and relationally, be understood'.[23]

While this book is therefore, on one level, concerned with identifying and focusing on different competing users of the nasties in three key eras of its circulation, it is also concerned with defining initial 'relevant and customary pathways' of meaning, so that later cultural uses can be firmly grasped and related to these initial forms of meaning production. In this respect, each competing user of the nasties is never analysed in a vacuum, but is considered through their relations to previous users and meanings, always recognising that each new cultural use can only be fully understood in relation to previous uses of the category.

Further to this, I hope that this focus on the relations and associations between different uses of the video nasties will enable this study to contribute to another area of knowledge and understanding – namely, the processes, mechanisms and consequences of film

censorship. In her groundbreaking book on film censorship, Annette Kuhn argues that, instead of approaching censorship as a reified object or phenomenon that is instigated by one central and dominant institution, the study of censorship should, more productively and fruitfully, 'engage with the various institutional practices surrounding film censorship' in order to 'unravel ... the ensemble of powers, practices and discourses constituting the apparatus within which film censorship is embedded'.[24] By focusing less on the rules and regulations of the VRA and more on the discursive sites where key 'practices and discourses' around censorship emerged, this study posits a commitment to Kuhn's argument that censorship is not just an act or a law but is the result of a range of discourses, groups and ideologies in context which feed into the 'apparatus within which film censorship is embedded'. The central focus in the first section of the book, then, will not be on police seizures, parliamentary debates and acts of law, but on the ways in which the conflicting discourses generated in a range of adjacent discursive sites (film review columns, video distribution companies and newspaper debates) reacted against each other, and helped (whether inadvertently or otherwise) to pave the way for an act of legislation.

However, if this is one way in which the book contributes to an understanding of film censorship, then the other relates to the notion that the nasty category has continued to be used subsequent to the banning of the nasty videos themselves. Clearly, the first section of this book focuses on how the nasty category was slowly solidified and given initial meanings and associations, but the fact that the nasty category continued to be used by others subsequent to the VRA suggests, in many ways and as Kuhn has argued, that censorship can, however inadvertently, also be productive,[25] and, in this particular case, productive in terms of its cultural and commercial consequences. For while, evidently, nasty fans and re-release distributors and exhibitors were reacting against the singling out, naming and banning of a group of videos, they clearly also continued to use the legally-instigated category and idea of the nasties and, in addition to this, were also able to realise the subcultural or commercial potential of the nasties category through the very fact that the nasty videos had been banned.

In terms of fans and collectors, the fact that the nasty videos were banned clearly solidified their status as artefacts that had been

distinguished from legitimate, authorised culture, allowing fans and collectors to slowly build a culture around them, which had the potential to be particularly active (because of the need to identify, hunt down and collect officially unavailable videos), and to be surrounded by materials and knowledge (the nasty list, the history of the films' banning, details of the cuts, distributors and running times of the videos, the video covers). While, in terms of re-release distributors and exhibitors, because the nasty category, by the early 1990s, had a clear cultural history in Britain (through its relations to a past British censorship controversy), it also held the potential to be utilised as a commercial selling point – enabling the films these distributors and exhibitors were marketing to be associated with a category instigated by censorship and, through this, to solidify further the cultural relevance, identity and commercial profile of the video nasties within the contemporary British video, film and television market.

Bearing all this in mind, then, this study aims to consider not only the shifting and cumulative uses and meanings of the nasty category, but, through focusing on relations between these uses and meanings, also to consider the potential cumulative consequences of an act of censorship on a range of relevant contemporary cultural and commercial spheres. Arguably, the video nasties is a particularly useful case study for such an enquiry, not only because of the unprecedented nature of the act of censorship which solidified the initial meanings and associations of the category, but also because of the intricate and varied range of cultural, material and technological changes that have occurred since the category's establishment – the growth of the internet and internet fan cultures, the commencement of DVD and its recognised ability to re-contextualise the history and status of past artefacts, the emergent academic and commercial recognition of video collecting as a fan practice,[26] and the critical and academic rehabilitation of horror as a legitimate and culturally significant film genre. All of these developments have clearly informed the continued circulation and changing uses and meanings of the nasty category (as a discursive consequence of censorship that has continued to circulate in the post-VRA world), and, along with changing historical contexts, the informing impact of these wider circulating contextual factors will also therefore be taken into account in the analysis that follows.

The book begins, then, at the eye of the cultural storm around the video nasties, with part I, entitled 'Producing the nasties', focusing on the period from the explosion of video in Britain to the containment of the nasties, and charting and tracking both the formation of the term and idea of the nasties and the constitution of the key cultural meanings that would most markedly feed into its later cultural life.

The first two chapters in this section therefore look at conflicting discourses and meanings circulating around the horror film and horror video prior to the notorious video nasties press campaign – both in British press reviews of three horror titles that would later be included on the nasty list (*Visiting Hours*, *The Funhouse* and *The Evil Dead*) and through the promotional tactics and video cover iconography employed by distributors to promote a range of horror videos prior to and during the encroachment of the video nasty campaign. In this way, these two chapters aim to consider how two key discursive legacies (the history of British critical reactions to horror films and the international tradition of exploitation and horror film marketing) were drawn on in these contexts in order to manage modern horror films in two conflicting ways, which would later clash to dramatic effect. The final chapter in this section then looks at the immediate cultural response to this clash, by charting responses to these videos, their retailers, distributors and consumers, in the *Daily Mail* and other British right-wing newspapers both before and after legislation to ban the nasties and regulate video was considered.

After the first, and most significant, cultural shift in the history of the nasties (the imposition of the VRA and the centralisation and corporatisation of both the video industry and the BBFC), part II of the book, entitled 'Cults, collectors and cultural memory', then turns to the community of collectors and fans who discussed, and illicitly swapped and collected, the nasties from the commencement of their banning and onwards. By looking at three fan arenas which exist on a sliding scale from the public to the private (British horror fan magazines, fan websites and discussion forums, and a specific video nasty video collection), the section explores the ways in which the video nasties category, and its history of associations and meanings, has been used, interpreted and appreciated by fans and collectors in three related, but discursively distinct, fan sites.

Part III, entitled 'Re-releases and re-evaluations', then explores

how the nasty category has been circulated, used and interpreted in two sites which have distributed or exhibited versions of the nasty titles between 1990 and 2001. Chapter 7 considers how re-release video distributors have employed the nasty association in the marketing of their products (through video cover packaging and the inclusion of DVD extra material), while chapter 8 focuses on the ways in which specialist art-house exhibitors (in the cinema and on television) have framed screenings of nasty titles through associations with the nasties category and censorship. In this way, this section aims to consider how specific distribution and exhibition strategies have harnessed the nasties and its history in order to market particular versions of the nasty titles as old or authentic (through discourses of retro and commercialised nostalgia) or as something different and exclusive (through changing notions of the relationship between art and 'high' culture, and exploitation and 'low' culture).

Finally, the conclusion will return to the issue of cumulative meanings and relations, exploring the extent to which the book has been able to trace discursive relations between the various uses and meanings of the nasties category, while also, briefly, considering the ways in which studies of cross-cultural reception and censorship might contribute to debates around, and understandings of, national cultural identity and national film culture.

I will end this introduction, however, with a brief but extremely important qualification which relates, centrally, to earlier academic work that has been conducted on the video nasties. Around the time of the video nasties panic, two film and media academics, Julian Petley and Martin Barker, conducted a range of analyses of the video nasty phenomenon. Their central aim was to vehemently oppose the reactionary and ill-considered political and cultural logic that had underpinned the video nasties press campaign and the establishment of the VRA, and they achieved this, centrally, by focusing on the hypocrisies and inadequacies of the evidence used to demonise and suppress the nasties (particularly the claims that the nasty videos were harming and influencing children and 'impressionable' adults) and by analysing the nasty films themselves.[27]

As a film academic and lover of films, I am also vehemently opposed to the censorship of films intended for an adult audience, and am a huge supporter of academic work which unpicks and

challenges common-sense assumptions about the effects and influ-
ence of violent films within society, through textual analysis of
relevant films and/or audience research that focuses on viewers'
readings and responses to such films.[28] However, this is not the
kind of enquiry that I'm undertaking in this book. Because my
focus here is on the changing cultural status of the video nasties as
a category, term and idea, this, rather than my (or other viewers')
responses, readings and viewings of the nasty films themselves, has
to remain my central concern.

The kind of enquiry I've chosen to undertake in this book has
therefore shaped my focus, and the limits of this focus, in two key
ways. Firstly, while three chapters in this book draw on empirical
material (fan magazine letters, fan website discussions and inter-
views with a nasty collector), my central concern, when analysing
such material, will be to consider how fans and collectors (as the
primary users and distributors of the nasties at this time) used,
appropriated and managed this category, rather than how they
responded to viewings of the films themselves. This is not to say
that the specific textual features of the individual nasty films *didn't*
impact on the uses of, and meanings given to, the nasties category –
clearly, elements of the texts have been drawn on to judge, discuss
or promote these films, and these will be discussed and considered
at relevant points in this book. However, my primary methodolog-
ical goal is to track the cultural status of the *category* of the nasties
(a category which has continued to proliferate way beyond the
British re-release of some of the nasty films). As a consequence,
then, the central focus of this book will not be on individual nasty
films or viewer responses to these films, but, instead, on the ways in
which different material within the nasty category (including
specific textual elements from the films, as well as marketing mate-
rials, videos and knowledge and information about the video
nasties) were drawn on by different groups, in order to appropriate
and use the nasties term and category in different ways and in
different contexts.

Secondly, in order to assess the ideological, cultural and histori-
cal factors that shape particular appropriations of the nasties
category (and the way in which each appropriation then impacts
on the next), this book approaches each user of the nasties equally
and uses the same method of enquiry throughout. I do not support
the logic that underpinned the video nasties press campaign, and,

equally, there are some who may find the sexual violence against women contained in some of the nasty films, and nasty fans' viewings and focus on such material, troubling. I respect all these viewpoints and their right to exist, but, as Thomas Austin has argued, the fact that certain appropriations and uses of controversial material or ideas may be seen as 'politically conservative is no reason for ignoring ... the processes through which' these uses and appropriations 'come about'.[29]

I respect the anti-censorship stance of the nasty fans and take this stance seriously, and also share many of the practices and tendencies discussed in part II of this study (an interest in collecting, an interest in lists and facts, an interest in horror films). However, my central aim, in this book, is to explore the ways in which *all* uses of the nasties (whether progressive or non-progressive) are mediated by discourses, contexts and prior cultural events. By doing this, I hope this book will serve as an illustration of a different way in which moral panics and censorship can be productively explored within the field of film studies – by focusing, equally, on the ways in which films intersect (through an act of censorship) with social and political spheres, *and* the material, commercial and cultural consequences of this intersection.

Notes

1 For a long time, the exact originator of the term 'video nasty' remained unclear. For Martin Barker, the earliest user appears to have been the moral campaigner Mary Whitehouse at a meeting in 1982. Martin Barker, 'Nasty politics or video nasties?', in Martin Barker (ed.), *The Video Nasties: Freedom and Censorship in the Media* (London: Pluto Press, 1984), p. 8. However, in interview footage included in the *Ban the Sadist Videos* documentary on the 2005 *Box of the Banned* DVD, ex-BBFC director James Ferman claims that the term was originally used in a *Sunday Times* article by Peter Chippendale, in order to describe the product available at a video trade fair in Manchester in late 1981/early 1982. 'Ban the Sadist Videos', *Box of the Banned*, DVD box-set, Anchor Bay Entertainment, 2005.
2 Review of *The Evil Dead*, *Daily Mail: Weekend* (18 October 2003), p. 92.
3 For a summary of traditional academic approaches to film genres and genre study, see Rick Altman, *Film/Genre* (London: British Film

Institute, 1999), pp. 13–29.

4 See, for instance, Kim Newman, 'Journal of the plague years', in Karl French (ed.), *Screen Violence* (London: Bloomsbury, 1996), p. 135, and comments made in interviews with journalist Tom Dewe Matthews, moral campaigner Mary Whitehouse, and British video wholesaler Bob Lewis in *Ban the Sadist Videos*.

5 Newman, 'Journal of the plague years', pp. 135–6.

6 See, in particular, Barker, 'Nasty politics', pp. 7–38; and Nigel Wingrove, 'The nasties: a personal view', in Nigel Wingrove and Marc Morris (eds), *The Art of the Nasty* (London: Salvation Films, 1998), pp. 1–11.

7 Altman, *Film/Genre*, p. 86.

8 *Ibid.*, p. 98.

9 *Ibid.*, p. 99.

10 Michel Foucault, cited in James Naremore, *More Than Night: Film Noir in Its Contexts* (California: California University Press, 1998), p. 11. Naremore is here citing the questions Foucault has applied to the study of the author as a form of textual and discursive classification, in order to consider whether genre can be approached and analysed in a similar way.

11 For examples of other studies that explore the changing meanings of either a film, the filmic output of a director, or a popular fictional hero, by focusing on key moments in the object of study's historical circulation, see Tony Bennett and Janet Woollacott, *Bond and Beyond: The Political Career of a Popular Hero* (London: Macmillan, 1987); Charles J. Maland, *Chaplin and American Culture: The Evolution of a Star Image* (Princeton, New Jersey: Princeton University Press, 1989); Mike Budd, 'The moments of *Caligari*', in Mike Budd (ed.), *The Cabinet of Dr Caligari: Texts, Contexts, Histories* (New Brunswick and London: Rutgers University Press, 1990), pp. 7–119; and Cynthia Erb, *Tracking King Kong: A Hollywood Icon in World Culture* (Michigan: Wayne State University Press, 1998).

12 Barbara Klinger, *Melodrama and Meaning: History, Culture, and the Films of Douglas Sirk* (Bloomington and Indianapolis: Indiana University Press, 1994), pp. xv and xx.

13 *Ibid.*, pp. xx.

14 *Ibid.*, pp. xvii.

15 *Ibid.*, pp. xvii.

16 Robert E. Kapsis, *Hitchcock: The Making of a Reputation* (Chicago: University of Chicago Press, 1992), p. 2.

17 Janet Staiger, cited in Sarah Street, *British Cinema in Documents* (London: Routledge, 2000), p. 3.

18 For further discussions of this issue, see Barbara Klinger, 'Film history
 terminable and interminable: recovering the past in reception studies',
 Screen, 38:2 (1997), 107–28; and Street, *British Cinema*, pp. 1–9.
19 Charles J. Maland, cited in Kapsis, *Hitchcock*, p. 9.
20 Klinger, 'Film history', p. 126.
21 *Ibid.*, p. 126.
22 Celia Lury, *Consumer Culture* (Cambridge: Polity Press, 1996), p. 22.
23 Arjun Appadurai, 'Commodities and the politics of value', in Susan
 M. Pearce (ed.), *Interpreting Objects and Collections* (London:
 Routledge, 1994), p. 89.
24 Annette Kuhn, *Cinema, Censorship and Sexuality: 1909–1925*
 (London: Routledge, 1988), p. 10.
25 *Ibid.*, p. 4.
26 For a discussion of the impact of DVD on the cultural identity of past
 films, and the recognition of video collectors by commercial institu-
 tions, see Barbara Klinger, 'The contemporary cinephile: film
 collecting in the post-video era', in Melvyn Stokes and Richard
 Maltby (eds), *Hollywood Spectatorship: Changing Perceptions of
 Cinema Audiences* (London: British Film Institute, 2001), pp.
 132–51.
27 See Barker, 'Nasty politics', pp. 7–38; Martin Barker, '"Nasties": a
 problem of identification', in Martin Barker (ed.), *The Video Nasties:
 Freedom and Censorship in the Media* (London: Pluto Press, 1984),
 pp. 104–18; Julian Petley, 'A nasty story', *Screen*, 25:2 (1984), 68–74;
 and Julian Petley, 'Two or three things I know about video nasties',
 Monthly Film Bulletin, 51:610 (1984), 350–2.
28 For an extremely influential example of the latter, see Annette Hill,
 Shocking Entertainment: Viewer Response to Violent Movies (Luton:
 University of Luton Press, 1997).
29 Austin is here discussing the importance of exploring seemingly non-
 progressive readings of *Basic Instinct* made by heterosexual male
 viewers. Thomas Austin, *Hollywood, Hype and Audiences: Selling
 and Watching Popular Film in the 1990s* (Manchester: Manchester
 University Press, 2002), p. 92.

Part I

Producing the nasties

1

The British art of policing cultural boundaries: the legacy of British horror film reviewing

In a 2002 essay, published as part of a book collection on British horror cinema, Julian Petley attempts to chart the history of negative critical reactions in Britain to the genre of horror, moving from responses to the gothic novel right through to the critical reception of the horror film and citing important work from Charles Barr on *Straw Dogs* and Peter Hutchings on Hammer horror along the way. Petley's overall purpose is to demonstrate how dominant British attitudes to horror in both literature and film have been honed and shaped over time, but also to attempt to determine the long-term consequences for the horror film as a result of this, in Petley's words, 'vociferous and insistent critical clamour'.[1] For Petley, the most serious consequence is that such insistent and deeply embedded critical attitudes have resulted in critics becoming makeshift censors, with their unchanging and relentless 'clamour' often resulting in particular horror films being removed from the British cultural landscape.

It is of no surprise, then, that Petley cites the video nasties press campaign of the early 1980s as particular evidence of this. As he argues:

> most seriously of all, critical disdain for the horror film meant that when the 'video nasty' bomb dropped in the early 1980s, not one mainstream critic saw fit to defend in print any of the films in question, nor to take issue with the distorted and ludicrous nonsense that was appearing on the news pages and in the editorial columns of the papers for which they wrote.[2]

As Petley goes on to acknowledge, certain film critics, from the more cine-literate broadsheet end of the film review spectrum, *did*

begin to protest against the video nasty panic and its implications as the Video Recordings Act (VRA) loomed into view and its implementation by the Conservative government began to become a reality. In particular, such heavyweight critics as Alexander Walker of the *Evening Standard* and Derek Malcolm of the *Guardian* were at the forefront of such protests, with Walker penning the first anti-legislation article to appear in the popular press in August 1982, and Malcolm famously defending the nasty title *Nightmares in a Damaged Brain* at a 1984 court hearing at the Old Bailey, where the title was being considered for prosecution under section two of the 1959 Obscene Publications Act (OPA). However, while oppositions to video censorship in general were openly voiced by such critics from the advent of Walker's article and onwards, a direct defence of the nasty titles themselves was comparatively rare in the period leading up to the implementation of the VRA, and when they were discussed this was often conducted in 'a barely helpful manner'.[3]

There is no doubt that the legacy of set critical attitudes towards the horror film that Petley charts in his essay clearly underpinned this uneasiness about directly defending the content or the artistic validity of the films concerned. Indeed, what is clearly conveyed by both Petley and Hutchings is how naturalised the critics' positions on horror had become during the course of the history of newspaper film criticism within Britain. Arguably, a key factor has, historically, perpetuated this logic among the 'mason-like'[4] circle of British newspaper film reviewers, whether they write for broadsheet or tabloid or right-wing or left-wing orientated newspapers – the 'negative consensus' among film reviewers towards popular and, more explicitly, American culture.[5] Petley and Hutchings both acknowledge that the legacy of intellectual and critical arguments about the threat of 'Americanization', conducted throughout the twentieth century by a variety of British critics of both left- and right-wing political persuasions, could underpin and inform the parallel British critical consensus towards the horror film. However, they do so only briefly, with Petley raising this explicitly only at the end of his essay and Hutchings referring to this idea only in an endnote at the close of his chapter on press reviews of Hammer horror.[6]

In light of this, one of the key aims of this chapter is to argue that this parallel critical legacy of 'Americanization' arguments

also had a key determining influence on why both right-wing
tabloid critics and the more cine-literate critics of the quality press
were united in their unwillingness or inability to openly defend
the nasties. In order to chart this consensus, and how it could be
seen to operate across the spectrum of film review columns in the
immediate time period before the video nasty panic, this chapter
will look at theatrical press reviews, from the 'Fleet Street nexus'[7]
of British daily newspapers, of three films that would subsequent-
ly be labelled as video nasties – Tobe Hooper's *The Funhouse*,
Jean-Claude Lord's *Visiting Hours* and Sam Raimi's *The Evil
Dead*. As stated, while the first section of the chapter will trace
similarities with historically dominant British critical responses to
horror, the second will look at how an inherent anti-Americanism
could also be seen to underpin evaluations of these films in review
columns.

However, if this is one way in which this chapter serves as an
addition to Petley's arguments on British critics and the nasties,
then the other is its aim to consider how the immediate cultural
context of the early 1980s inflected critics' responses to these films,
and also served as a key reason why the nasty titles themselves
remained culturally ghettoised and unable to be defended. Indeed,
while Petley's essay charts, in great detail, critical responses to
Hammer horror films, Michael Powell's *Peeping Tom* and Sam
Peckinpah's *Straw Dogs*, he then makes a direct leap, based on
these findings, to the ultimate consequence of these responses – the
video nasty press campaign, a campaign which occurred around
ten years later. Admittedly, Petley's approach is broad and general,
in the sense that he is dealing with the long-running legacy of criti-
cal views towards horror over a period of a couple of centuries.
However, this leap over a significant period of British cultural
history and American/European horror history (the move from
exploitation or independent horror in the early 1970s to the early
1980s low-budget slasher film) suggests that there is a missing
historical link in his writing, albeit a link that is of minor impor-
tance to Petley's overall argument but of major importance to my
aim to chart the rise of the nasties.

With this in mind, an analysis of theatrical reviews of these three
pre-nasties can be seen as a means of homing in on this missing
historical link, and exploring how set critical approaches to the
horror film were inflected by contemporary cultural debates and

concerns. By looking at responses to these films in this way, a number of factors will be considered.

Firstly, in the sense that the film critic can be seen to operate as a 'public tastemaker' or the 'cultural "gatekeepers"' of conceptions of film culture and film art',[8] attention will be paid to how critics maintain the boundary between set national notions of 'art' and 'entertainment' and thus determine what enters the realms of film culture and what is defined against it or, in some cases, ejected and expelled from it. While, as Colin McArthur and Dominic Strinati both argue, such a conception of the role of the critic crosses the entire 'political spectrum' of the mainstream popular press,[9] it can be seen to exist within its most concentrated form among the quality critics of the broadsheet press. Indeed, in the sense that Malcolm, Walker and other broadsheet critics can be seen to have maintained a substantial influence on powerful national and metropolitan institutions associated with culture and film,[10] it could be argued that it is *these* critics that had the greatest interest in defining what constituted 'legitimate' and 'illegitimate' culture in Britain.[11]

As a result, while the chapter traces initial theatrical responses to these films across the whole spectrum of British newspaper reviews, it will focus, in particular, on responses from the quality left-wing end of the film reviewer spectrum. Indeed, as later discussions will demonstrate, within the realm of British film review discourse, it was often in the columns of these supposedly more liberal critics that attacks on the horror film were at their most ferocious, where the need to dismiss, marginalise or, in some cases, to eject the 'illegitimate' was at its most marked, and where discussions of censorship most prominently emerged.

Secondly, while the chapter will therefore trace 'the cultural hierarchies of aesthetic value' that operated within film review columns during this time,[12] and in particular the power of the broadsheet columns to maintain and defend them, it will also attempt to map out the class assumptions and political motivations that underpin these distinctions and hierarchies. By digging beneath the cultural to the political in this way, the chapter will suggest why such deep-seated and inherently conservative approaches towards the horror film were mobilised by critics of all political persuasions, and thus will attempt to shed further light on why later opportunities to defend the individual nasty titles as artistically legitimate were so

resolutely avoided by Walker, Malcolm and other anti-censorship critics.

Pitching into a 'welter' of horror: the critics' use of dismissals, contradictions and distinctions

Perhaps the most striking characteristic of the majority of the British press reviews of *The Funhouse*, *Visiting Hours* and *The Evil Dead* is the level to which these films were dismissed by the critics. Firstly, and perhaps most obviously, this dismissal is conveyed through the position and length of the discussion of these films in each film review column. As McArthur notes, in a comment which demonstrates the true consensus between popular press film critics, reviews in, for instance, the *Sunday Times* and the *Observer* would often be 'uncannily similar, to the point of giving over their major space to the same two films'.[13] When searching for pre-nasty reviews between the years of 1980 and 1984, this became particularly noticeable with, for instance, Bob Rafelson's *The Postman Always Rings Twice* always being reviewed first and at length in all review columns for 8 May 1981, and Tobe Hooper's *The Funhouse* invariably bringing up the rear with a mere paragraph being devoted to it. In particular, the majority of press responses to *The Evil Dead* (a film that, ironically, would be held up by later commentators as one of the most important and culturally significant of all the nasties) tended to comprise a mere couple of sentences.

In addition to this, the fact that 'the week's horror film' had been pushed down to the margins of the column would often not be enough of an indication of its lower cultural position, and, in many cases, the reviewer was inclined to draw further attention to a particular film's lesser cultural status. Thus, for instance, the *Times* begins its discussion of *Visiting Hours* by stating 'last and least is *Visiting Hours*, a Canadian shocker', while *The Financial Times*, in a more overt indication of contempt, notes that 'last and egregiously least, [is] the week's horror film, *Visiting Hours*'.[14]

What emerges is an idea of 'the week's horror film' being regularly and consistently put in its place by the critic, and culturally tamed by being made subservient to the overall design, tone and order of the weekly column. In addition, this use of an immediate generic identification at the beginning of a review not only allows a

film's lesser cultural status to be highlighted, but also justifies the small amount of space that is given over to these films in each review column. As Peter Hutchings has argued in his discussion of British critical responses to Hammer horror, such an approach acts as a useful form of 'shorthand' for the film critic, with the term horror or other horror-related generic labels being constituted as 'reductive, descriptive' categories.[15] As a result, the use of such labels as 'horror', 'shocker' or 'blood bath movie' can all be seen to operate in this descriptive way,[16] allowing such critics to make brief, and predominantly negative, judgements without the need for lengthy discussion or debate of any kind.

However, while a restricted amount of space therefore tended to be devoted to a discussion of these films, the space that *is* given over is often used to mock the films concerned, and in particular to mock their formulaic nature as parts of commercial cycles of films seen to be solely made for money. This second kind of dismissal can clearly be seen in a *Daily Express* review of *Visiting Hours*, where the critic notes (in a parodic reference to the film's hospital setting) that 'having given it a thorough examination I diagnose imaginative failure complicated by severe cliché infection,' or in the *Financial Times* review of *The Evil Dead*, which concludes its particularly brief discussion of the film by deeming it 'a very old bag of sideshow tricks'.[17]

The fact that this tone suggests that the films cannot be reviewed seriously (as they are formulaic and thus culturally worthless products) is indicated further by the same *Daily Express* critic's comment that *Visiting Hours* 'should be in an intensive care unit instead of out and about at the Classic Oxford Street'.[18] What is implied in all of these comments, and which provides further justification for the limited space given over to these films, is that the critics did not want to review these films, but, if they had to, then in many cases they would not even attempt to take them seriously, to the point where they would indicate, under the veil of parody, that they shouldn't even be considered 'films' (fit for showing in cinemas) at all.

However, when attempts *are* made to discuss the films in a vaguely serious manner, they are not considered in relation to the idea that they are commercial ventures with plots based around spectacle and fantasy, but are measured against a realist norm, where the logic and plausibility of narrative and characterisation

always takes priority over the visual and spectacular. Thus for Philip French in the *Observer*, again on *Visiting Hours*, 'the implausible plot and foolish case-history could be used as a text-book definition of "factitious"';[19] while for Clive James, in a video review of *The Evil Dead* which could be seen as a 'textbook definition' of British responses to the horror film:

> when the zombie erupts from the prop-leaf mold and comes lurching through the dry ice fumes ... we decline to be alarmed because we are too busy wondering why the silly cow agreed to stay the night, the surrounding territory being so obviously crammed with recumbent zombies. She stayed in order to be haunted. She has no motivation, only a function, which is to get torn apart. The screenplay is all effects and no story. In other words, the people who made the movie care about nothing except movies.[20]

What such a comment reveals is the tendency, in the majority of British film reviews, to consider any elements of overt spectacle in a film as a distinct anomaly, and to view any deviation from the notion that a narrative should be convincing, logical and realistic as evidence of a 'bad' film. For McArthur, as well as for Petley and Barbara Klinger, this general approach to cinema, in the majority of film reviews, is clear evidence of 'the predominantly literary formation of its practitioners'.[21] However, as Petley argues, while this consensus among reviewers as to what a 'good' film should be has clear implications for the critical reception of horror in general, it also has implications for the *modern* horror film in particular, considering that, as a number of critics have argued, a large number of slasher or splatter films are largely constructed around spectacular set pieces and reworkings of previous genre formulas at the expense of narrative plausibility or cohesion.[22] As a result, and as Petley argues, the frequent consequence of such films being judged in relation to a set British valorisation of realism is that they 'are judged by wholly inappropriate standards and roundly condemned for not being what they never set out to be in the first place'.[23]

This is all clearly conveyed by the James quote above. For him, despite the fact that he acknowledges that the character's only function 'is to get torn apart', that the screenplay is 'all effects and no story' and that the film's only referent is other movies (all factors which should indicate to him that the film is not intending

to be realist in *any* sense), he still claims that this is a 'bad' film by measuring it against a realist norm (the narrative is implausible, the character has no motivation, the film references movies instead of any sort of reality). The result is a highly contradictory logic, where the critics' dismissal of these films oscillates between categorising them as formulaic entertainment and thus not giving them a serious review, and negating this categorisation entirely by imposing an inappropriate critical framework on each film in order to judge it and to magnify its supposed narrative weaknesses. Both approaches aim to dismiss the film and to not take it seriously, but show a barely concealed shifting about, on the critics' part, between dominant British critical definitions of film 'entertainment' and film 'art', grabbing bits from both in order to further their argument.

However, if this is one means by which these films are judged by 'wholly inappropriate standards', then the James quote hints, very clearly, at another in his statement that 'we decline to be alarmed'. While, on the one hand, this is expressed through James' argument that a lack of plausibility or 'realism' means that we can't be horrified by particular horror films, he also clearly indicates that, as far as he's concerned, horror films cannot be horrific if they are overly physical or revel in excessive gore or violence. For Petley, this is a common response to horror, which dates back to British literary critics' responses to the gothic novel where a preference was frequently exerted for the tale of terror (a tale of 'psychic dread') over the tale of horror (the more excessive and physical).[24] James uses this distinction between 'terror' and 'horror' to criticise *The Evil Dead* and to present it as physically repulsive, but, because this repulsiveness is not what he considers 'proper horror', this distinction is also used to present the film as fundamentally harmless and thus (like the approach of parody adopted by other critics) to ultimately dismiss it.

Further to this, James compounds this distinction between 'terror' and 'horror' by then going on to provide examples of past, more subtle horrors, including *Psycho* and *The Beast With Five Fingers*, that have managed to scare him. Indeed, this distinction between old and new horror is a common approach across broadsheet reviews, with Derek Malcolm, for instance, noting that while *The Funhouse* 'acknowledge[s] Tod Browning's *Freaks* and other classics of an older genre', it then succeeds in 'pitching itself into a welter of the usual contemporary Grand Guignol'.[25] What such

statements arguably do is, in Klinger's words, to assist 'in reland-scaping the past', and creating a tradition of old horror classics which appear to be 'better and more authentic than the "New"'.[26] By creating an old authentic cultural map of 'classic' horror in this way, James, Malcolm and others not only allow for quick judgements to be posited, but also allow such films to be severed from any remotely respectable cultural or generic tradition and to be, in Malcolm's words, pitched 'into a welter' of the fundamentally unoriginal and unsubtle and, most crucially, the fundamentally new.

What all such critical weapons ultimately do, then, is, as Peter Hutchings argues, to allow critics to keep these films at a firm, safe 'distance'[27] so that further discussion is rendered redundant and they are effectively tamed within the realms of the film review column. However, if such strategies allow critics, in most instances, to dismiss these films and put them back in their culturally designated place, two other characteristics of the films concerned are quite frequently identified and cause a sudden change of tone in the reviews. The first is the acknowledgement that these films are not only new, but new and fashionable. Thus for the *Sunday Telegraph*, *Visiting Hours* is 'fashionably cynical' and for *The Times*, *The Evil Dead* is 'a prize exhibit of the current craze for joky, excessive horror films'.[28]

The second is the acknowledgement that, despite the critics' dismissal of them, these films are both commercial and popular. While this is often expressed subtly (as in the *Guardian* and *Observer*'s appraisal of *Visiting Hours* as, respectively, 'mindless' and 'slick', the *Sunday Telegraph*'s claim that *The Evil Dead* is 'manipulative', and *The Financial Times*' portrayal of *The Funhouse* as a prime example of 'take-your-money-and-run horror'),[29] the most telling assertion of the threat that the popular poses to the critics' self-designated power to put cultural products in their place comes from Geoff Brown's short but striking review of *The Evil Dead*. As he notes, 'during its journeys around the country, this has already become Britain's second provincial box-office winner, after *ET*. A few sharp words might therefore be in order: the film is tedious, repellent and deeply depressing'.[30]

What this quote ably demonstrates is the critics' suspicion of the popular, and if the above distinction between *ET* and *The Evil Dead* is taken into account, the *popular horror film* in particular.

For Petley, what such responses to the horror film suggest is the critics' 'barely concealed dislike of popular culture in general and popular cinema in particular'.[31] To take this further, they reveal a barely concealed dislike of American culture, and the supposed effect this culture has on young audiences (horror cinema's supposed core audience).

In the next section of this chapter, the tendencies that have been identified in the initial British reception of these films will be taken further, to interrogate the politics of taste that the critics construct around themselves and the condemnations of American culture, and horror's audiences, that result from this.

The film review as a 'display of taste' and its relationship with constructed audiences

Colin McArthur begins his article on British film reviewing by attempting to consider what the actual function of the British film reviewer is (a mean feat, considering that this function is scarcely revealed by the reviewers themselves, as this 'is not the kind of thing the British go in for').[32] In an approach which aligns McArthur with Barbara Klinger's views on film reviewing, he identifies the primary function of film review columns as not being 'the construction and transmission of knowledge' or even being 'informed guides to what is worthwhile in the week's releases', but as, fundamentally, a 'display of taste' by the individual film reviewer.[33] While this function may suggest that such reviews are merely assertions of taste with no real or tenable social power or impact, it is arguably the case that the clear distinctions made in the name of such taste lie at the heart of the film reviewer's power to set the agenda (in McArthur and Klinger's terms)[34] on each reviewed film, and to slot it neatly into its socially prescribed place.

As noted in the last section, two of the characteristics of these films that were seen as particularly abhorrent, and perhaps made it more difficult for the critics to slot them into their socially prescribed place as 'low' and meaningless cultural products, were their status as popular and fashionable versions of the already greatly maligned horror film. For Duncan Webster and Richard Maltby, what fundamentally lies behind this fear or distrust of the popular is a deep-seated and long-running contempt for American popular culture in general. As Webster argues, citing Christopher

Bigsby in his discussion of the history of 'Americanization' arguments:

> 'Americanization' is a term belonging to a world 'for whom the modern experience is coeval with the American experience'. The emergence of a popular culture based on mass reproduction, and the experiences of urbanization, industrialization, and consumerism, are confused with the country with which they are most identified.
> [... Thus] America is mobilized as the paradigm of the traditionless, the land of the material not the cultural.[35]

While, as stated in the last section, this mobilisation of America is frequently hidden in reviews through the use of such shorthand adjectives as 'mindless' or 'slick', an attack on specifically American, as opposed to just commercial, culture does become explicit on certain occasions. Thus, for instance, Geoff Brown, in his previously cited review of *The Evil Dead*, can't help but disparagingly remark that the director of the film is 'a *young American* with a ferocious taste for dismemberment and gore' (my emphasis).[36]

However, perhaps the most striking example of the critics' direct mobilisation of America comes from the most vocal of all popular press critics on the subject of censorship – Alexander Walker of the *Evening Standard*. As he ominously remarks, 'last week in America I learned a new, ugly but useful name for the sort of film represented by this week's other release, *Visiting Hours*. The word is "slashers"'.[37] What Walker seems to do in this brief statement is to present an idea of horror coming over from America to invade British shores and, in particular, to identify a new and extremely insidious strain of horror, which he names 'slashers'. As a result, while, as in the earlier cited examples, the word 'slashers' is used as a quick 'useful' descriptive label to identify the product concerned, it is, in this example, even more effectively identified and contained by being appended to an idea of 'America'.

Such an approach, in Dick Hebdige's terms, can be conceived as a 'fixing of a chain of associations',[38] where a new strain of horror is identified as fashionable and commercial and thus, regardless of its actual national origins, is perceived by critics as emerging from America (the 'paradigm' of consumerism and the traditionless). As many critics have argued, horror is actually 'a truly international phenomenon',[39] a cross-fertilised genre whose origins exist in

French theatre and British Gothic literature and whose history is characterised by the exchange of influences across Europe, America and other parts of the world. However, in order to deflect the idea that horror had or has an established cultural significance in Britain, critics such as Walker are able to suppress such international influences and to disregard Britain's own indigenous horror tradition, through a simple mobilisation of the term 'America' – a term that, as Webster argues, 'could "contaminate" whatever it was placed next to'.[40]

However, if modern horror is frequently perceived in this way in reviews (as a newly evolved strain of commercial and thus American culture, whose British popularity is reworked into evidence of a cultural invasion), then, inevitably, this meant that the critics needed to construct a victim for this new strain of American cultural invasion in order to tame and dismiss it within the realms of the film review column. Invariably, these invoked victims were the audience sectors that the critics felt these films were aimed at – victims who, as in the 1950s 'Americanization' debates, are implicitly constructed as working-class teenagers.[41] Indeed, as Klinger argues in relation to Anglo-American review discourse more generally, 'critical canons of good taste could be ventured and sustained ... only by constituting a heathen underclass of tasteless consumers to serve as a radical, aesthetic Other'.[42]

On a large number of occasions in review columns, this 'heathen underclass' is appended to a discussion of the films themselves, to demonstrate the critics' true distance from these films and all they stood for. Thus, for the Evening Standard, Visiting Hours has 'only the barest motive and even less characterisation in the repulsive incidents that are staged with a disregard for plausibility that demonstrates aptly enough the makers' contempt for the very audiences to whom they are pandering'. While, for the Glasgow Herald (Scotland being where the film was first released), The Evil Dead 'takes no interest whatsoever in psychology, except maybe in the psychology of people who will give up their own money to watch other people rot to bits in front of their very eyes'.[43]

Here, while a variety of approaches to the horror film are mobilised (dismissal of a film because of its lack of plausibility and characterisation, as well as an attack on a film's visceral and physical approach to the staging of horror scenes), these become more charged by turning an identification of the film's characteristics

into a judgement on the film's supposed target audience. Thus, in both incidences, an attack on a film is also, by default, an attack on audiences – audiences who have, in the *Glasgow Herald*'s terms, a troubling 'psychology' (and who are thus as sick as the films themselves), but who are also seen as the weak victims, passive and willing to be duped, of a culture which is aggressively commercial at the expense of all else. For, in comments such as these, such audiences are identified as the people who are treated with 'contempt' by 'manipulative' filmmakers, but who still, like good little consumers but unlike the critics themselves, 'give up their own money'.[44]

For Hutchings, what underpins this approach is the critics' need to maintain a 'division between "them" and "us", the bad and the good audience'.[45] In these examples, the 'good' or 'us' is represented by the critics and their readers (who, if they stumble into a screening of *Visiting Hours*, 'may be among those wishing [... they] had chosen another cinema'),[46] and the 'bad' is represented by the critics' constructed audiences, who display an addled 'psychology' by allowing themselves to be made passive by filmmakers who have a barely concealed 'contempt' for them (a 'contempt' that the critics and the 'good' audience can see, but the 'bad' audience never can).

What should be apparent from these examples, and this is something that Petley clearly recognises, is the implicit 'class dislike' behind such statements,[47] with constructed audiences being pushed away and distanced from the critics (in the sense that they are different and are not one of 'us') in order for the critics to, as Klinger puts it, insulate 'themselves from the "commoners" who allegedly identify with the spectacles offered by popular representations'.[48] However, crucially, in these examples, it is when American culture is directly cited that this 'class dislike' becomes most explicit. Hence, while Derek Malcolm in the *Guardian* does concede that *The Evil Dead* has 'a kind of manic energy on show that's praiseworthy', he concludes his review with the ultimate dismissal: 'but the general tone of *The Evil Dead* is ludicrously bananas, like a *Friday the 13th* for even more backward teenagers, choking on I Love Elvis lollipops'.[49]

What is suggested by Malcolm's comments is that, while *The Evil Dead* does display some flair, it's still ultimately not a film for 'us' but for 'them' – backward teenagers, obsessed with American-

style consumption (as the term 'choking on I Love Elvis lollipops' suggests) to the point where they have become not just 'common-ers' but 'temporary American citizens'.[50] What the critics' construction of such audiences thus clearly attempts to suggest is that there are certain types of audience in Britain who are beyond help and who are too blind, 'backward' and Americanised to even be concerned with. But, crucially, they are never 'us' but 'them' – a vague, malleable entity which needs to exist, so that the critics are able to make these distinctions and maintain their insulation, and thus their superiority, from them.

What lies behind this logic is, as Petley acknowledges, a 'barely concealed dislike for popular culture in general', and, in line with Webster, Strinati and Maltby, a contempt for the effects of a post-war democratisation of cultural forms and consumerism on the young, who are seen as threatening in their capacity to gain cultur-al agency through their conspicuous consumption of popular commercial products. The critics thus have to tame these audiences in the same way that they tame the films themselves – by construct-ing and defining their tastes and characteristics, in order to distance themselves from them and put them back in their cultural-ly specified place.

In this respect, then, the critics' true motivation for adopting this approach could be seen to derive from the long-held feeling amongst both left-wing and right-wing British critics and intellec-tuals that a consumer-driven society was 'levelling down' established 'hierarchies of discrimination, taste and class'.[51] However, in line with some of Webster's observations on the posi-tions of British left-wing intellectuals and politicians in the early 1980s, such an approach could also be linked to a more specific, contemporary left-wing aversion to the implications of 'populism'. As Webster argues, populism, at this time, was becoming 'a key term in British politics', as a 'part of analyses of the ideological appeal of Thatcherism',[52] and part of this populist appeal was often characterised by notions of the free market and, crucially, of the working-class right to consume. At this particular point in time, then, such notions of populism and market and money-led culture were commonly perceived to be the terrain of the Conservatives, and thus, inevitably, were also perceived as a threat to the power of left-wing critics and cultural commentators to control and maintain cultural hierarchies and distinctions of

the kind that have been identified thus far.[53]

When perceived in this light, attempts to construct, class and then Americanise such phantom audiences can be seen to be driven by the threat of a reconstituted, right-wing-orientated consumer society, and the need to block and externalise the populism around which such a threat could be seen to have emerged. As a result, condemnations of such films as threateningly popular could be seen as a form of 'displacement of terms and anxieties from the political sphere to the cultural',[54] where political notions of populism, and its key links to American political policies, were conflated with cultural notions of 'the popular' and, thus, of American culture. This renewed political emphasis on consumer power in society at large could, therefore, be seen as something that was threatening to such critics, and threatening, in particular, to their power to set the cultural agenda and to distinguish and categorise cultural forms within the review column and within dominant British cultural institutions and networks more widely.

However, while such a threat may have lurked behind the critics' condemnation of these films, this is never revealed by the critics themselves. Instead, boundaries are consistently redrawn around 'good' and 'bad' audiences and 'good' and 'bad' films, with critics clinging to the notion that a film may be threateningly popular, but 'a few sharp words' was all that was needed to put everything back in its socially prescribed place. However, while a fear or lack of understanding about contemporary popular culture and its consumers could, in some cases, be countered through a fixing of a series of negative 'associations' around horror and American culture, the last section of the chapter will explore how, on a number of occasions, a further need to tame the modern horror film often led, by default, to discussions of censorship.

'Policing the boundaries' between an 'art of excess' and an 'entertainment of excess'

Earlier in the chapter, I acknowledged that the strategy of either dismissing these films outright or measuring their worth based on highly inappropriate criteria demonstrated the British critics' muddled and ever-shifting perceptions of the function of 'art' and 'entertainment' (with conceptions changing, depending on how a critic wanted to further their argument). However, while this

suggests a subtle blurring of the boundaries, there are a number of occasions where the need to distinguish between 'good' and 'bad' audiences and 'good' and 'bad' films encouraged the critic to construct a sharp distinction between what they considered as 'art' and as 'entertainment', and what the function of each should be.

For Richard Maltby, this theorised divide or distinction between 'art' and 'entertainment' is 'typically constructed as a binary opposition', and is maintained and perpetuated in the following way: 'the boundaries of national culture are reinforced by criteria of taste and quality, and cultural frontiers are policed by the institutions of censorship and criticism. Regimes of censorship ensure that entertainment conforms adequately to its socially prescribed role; regimes of criticism define entertainment as trivial, and maintain the distinction'.[55]

In terms of the reinforcement of boundaries through 'criteria of taste and quality', the critics' maintenance of this 'binary opposition' in these reviews emerges in a number of ways. On a number of occasions, critics will acknowledge an underlying social theme or a 'praiseworthy' quality in these films, but will choose to negate this by reminding themselves that this is 'entertainment' and should thus always be seen as trivial. Derek Malcolm's response to *The Evil Dead* cited in the last section is one example of this, and another is David Robinson's appraisal of *The Funhouse*. Here, in a surprisingly generically-focused review, Robinson attempts to engage with the film's fascination with the theme of the family, and he discusses this at length. However, despite the length and depth of this discussion, he still cannot help but perpetuate the notion that 'entertainment' is always 'trivial' by noting that while this theme is interesting, it is also 'admittedly quite unprofitable'[56] – a phrase which immediately denies any real cultural value in the film and puts it back on the 'right side' of Maltby's binary opposition.

However, if, on most occasions, an allegiance to this binary opposition can effectively and economically categorise a film in this way, then, if some of the responses to *Visiting Hours* are taken into consideration, some features of the modern horror film appear to hinder such straightforward categorisations. There are, perhaps, two key ways in which *Visiting Hours* is seen to achieve this. Firstly, the film is often seen as too self-conscious and clever, particularly in the sense that it uses contemporary feminist debates around the slasher film within its narrative, meaning that, as Philip

French notes, it's 'a movie that shows a slick awareness of the debate this very genre engenders'.[57] Secondly, while, in other examples, overly physical horror is seen as an indicator of a film's lack of ability to truly frighten or alarm, *Visiting Hours*' use of excessive or graphic violence is sometimes seen as threatening to critics, suggesting a lack of restraint and thus a lack of distance between violence and the director or between violence and the audience.[58]

What such responses effectively convey is the sense that 'unlike art, entertainment is not supposed to be socially disruptive',[59] and that, as a result, problems emerge when films that are supposed to be fantastic and harmless appear too clever, excessive or complex. What is therefore being expressed by critics, on perceiving such anomalous horror films, is a concern over the potential collapsing of set critical categories. And, as Richard Maltby argues, such an approach is often based around the critics' notion that while 'an art of excess was a form of social criticism, an entertainment of excess was a form of cultural debasement'.[60]

However, if these examples suggest that critical mobilisations of the cultural distinction between 'art' and 'entertainment' can sometimes fail to tame such films within the film review column, then, in line with the previously cited Maltby quote, the critics can always upgrade their role – moving from the reinforcement of 'cultural boundaries' to the policing of 'cultural frontiers'. As my opening discussion of Petley's work should suggest, if the wielding of distinctions in the name of taste is a 'hidden power' of the critic,[61] then their influence on regimes of censorship also gives them the potential to wield these distinctions on the terrain of the legal. As Petley argues, a letter attacking *Straw Dogs* (a film which, as Maltby and Charles Barr demonstrate, was also attacked for its self-referentiality and its supposed excessiveness and lack of restraint) was sent to *The Times* in December 1971 and was signed by thirteen film critics from British daily newspapers, including the aforementioned Malcolm and Walker. Furthermore, it was this letter that, as Petley and others argue, had a decided effect on the fact that the film was removed from circulation by the British Board of Film Censors (BBFC), and remained unavailable in Britain in an uncut form for over thirty years.[62]

Bearing this in mind, the fact that the following statement on *Visiting Hours* comes from Derek Malcolm should come as little

surprise. As he argues, 'no doubt the censor has trimmed the film a little here and there, but one has the right to ask what he is doing passing it all and at the same time arguing about giving a certificate to a Canadian film about the way pornography affects its women participants, which Contemporary Films wishes to show at the Paris Pullman for perfectly valid reasons'.[63]

Here, as in the previous examples, a mobilisation of the critics' binary opposition ('art' has a serious social function, 'entertainment' does not and should stay in its designated place) is still in position. However, what is particularly significant about Malcolm's redrawing of the boundaries is that it has the added cultural charge of invoking censorship and making direct appeals to the censor, and thus not just policing the boundaries between 'art' and 'entertainment', but policing the censor's decisions on what is showable in cinemas (because it's 'serious' and social) and not showable (because it negates its function to be harmless 'entertainment') in Britain.[64] Indeed, this approach is also identifiable in the *Daily Express'* earlier cited assertion that *Visiting Hours* is only fit for an 'intensive care unit', and the *Daily Mirror*'s claim that the film should not carry an 'X' certificate but a 'health warning'.[65]

What such examples indicate is that a direct criticism of the inadequacy of current censorship policies and ratings is a further 'hidden power' of the British critic, a power that is mirrored, historically, in previous critical calls for such new categories as '"D" for disgusting' (in a *Sunday Times* review of *No Orchids For Miss Blandish*) and '"SO" ... for Sadists Only' (in a *Daily Telegraph* review of *The Curse of Frankenstein*).[66] For, on occasions like these, when the divide between 'art' and 'entertainment' requires urgent clarification, the critic can be seen to upgrade his role by policing not just the theorised boundary between 'art' and 'entertainment', but also the censor's conception of this boundary – a tendency which ably illustrates Julian Petley's assertion that 'censorship often acts as the "armed wing" of [British] criticism'.[67]

What this helps to reveal is the nature of the relationship that, historically, has existed between the British censors and critics, where critics are able to wield their established ability to exert pressure on the censors and attempt to bring the censors' distinctions in line with their own. However, the central idea around which such forms of distinction operated was also indebted to a prior form of cultural liberalisation, established in the 1960s in Britain. As Leon

Hunt notes, such a liberalisation, initiated in a number of ways by the chief censor at that time, John Trevelyan, was largely 'a middle-class, arts-related, metropolitan phenomenon'[68] and solidified itself around the 1959 OPA. For Hunt, this act had marked 'the beginning of a distinction between a "high" and "low" permissiveness' which had 'introduced the defence of "public good" – artistic, scientific or some other kind of merit which distinguished the meritorious from the exploitative'.[69]

This distinction between 'high' and 'low' (between the meritorious and exploitative) was one, which as Maltby clearly points out, was thus legally enforceable. What this suggests is that while the critical practice of the separating out of 'art' and 'entertainment' was vague and based on issues of taste, it could, at certain moments, be enforced by the invoking of the broadsheet critics' established influence over censorship, embodied in such prior left-wing-orientated legal distinctions as the OPA. And, in the process, this allowed critics to enforce and perpetuate their definitions of 'art' and 'entertainment' and thus display their ability to slot films not just into their cultural place, but also into their legal place.

However, if such approaches seemed assured, it could be argued that they were shadowed, once again, by an inherent contemporary insecurity. As Hunt also acknowledges, if a general climate of liberalisation in the 1960s had ensured a constitution and protection of 'high permissiveness', then the commencement of the Thatcher era and a determined swing back to the right was clearly characterised by the beginnings of a 'reversal of post-war permissiveness' and a return to more middlebrow notions of law and order[70] – notions that could potentially mobilise against, and show little distinction between, 'high' and 'low permissiveness'. Within this climate, this desire to police horror films that, as far as the broadsheet critics were concerned, were not only 'low' but 'low' *and* culturally ambiguous could be seen as particularly necessary, if they were to maintain their categories and their power to defend the 'high' but permissive cultural terrain that they valorised.

In light of this, Malcolm's approach of identifying these films, in their pre-nasty existence, as unacceptable entertainment, and the critics' general separation of these films from those that were defensible as 'art', would have dire consequences for these films when they emerged on video. In addition, the occasional appeals to the censor to enforce this separation demonstrates the depth of the

broadsheet critics' power to police and enforce the boundaries between what was considered culturally acceptable and unacceptable, despite (as the above examples demonstrate) the arbitrary, and frequently contradictory, nature of their definitions of 'art', 'entertainment' and the horror genre, and the specific motives that I've argued lay behind their positions on culture.

Conclusion: thinking about the calm before the storm

Through this conception of modern horror (as a frivolity to be dismissed or as a threat to be culturally policed), the mobilisation of film review discourse to tame, categorise or culturally ghettoise these kinds of films can be seen as successful. Indeed, when some of the broadsheet critics were later forced to defend the nasty titles in anti-censorship articles, all the approaches identified above were systematically utilised. In particular, in articles from Malcolm, *Financial Times* critic Nigel Andrews and *Sunday Times* commentator John Mortimer, nasty titles were either dismissed as harmless and implausible or treated as crude, excessive and thus deserving of suppression, with debate then often moving on to a discussion of the need to protect 'authentic' works by 'authentic' artists and an attack on the 'populist, unthought out' nature of the impending VRA.[71]

In line with Petley, then, what this seems to demonstrate is the power of the set critical logic towards horror films and the need for broadsheet critics to enforce it, even when they were trying to construct anti-censorship arguments that explicitly involved a discussion of horror films. However, there is a further and final 'hidden power' of the film critic that also needs to be considered. *The Funhouse*, *Visiting Hours* and *The Evil Dead* were reviewed by British newspaper critics in 1981, 1982 and 1983 respectively and, in this sense, the responses discussed here provide a useful survey of the general British critical position on modern horror films in the three years prior to the implementation of the VRA in 1984.

However, despite searching extensively, the fact that I could only find popular press reviews of these three particular pre-nasties is itself suggestive of a number of things. In particular, considering the fact that around twenty-three of the seventy-one films that were at one time or another tagged as 'nasty' were released in a theatri-

cal form in Britain before they emerged on video,[72] it suggests the power of the mainstream film critic to not just categorise or attempt to eject, but to systematically block exposure to certain types of films and, in particular, films that could potentially even more violently negate the established critical frameworks and categories discussed in this chapter.

What, in retrospect, was achieved by the perpetuation of these deep-seated discourses was to allow the majority of these horror films, whether previously released in Britain or not, to emerge *en masse*, as new and unknown, when they were released on video. This new form of distribution, which was based around a new and legally and critically unregulated medium, was able to bypass the ties of power that had been established between the film column and film censor in Britain, and thus also bypass the rigid tone, order and cultural categorising of the film reviewer. As many commentators have acknowledged, video became a new and accessible alternative form of distribution for horror and exploitation films previously screened in metropolitan midnight movie venues in Britain,[73] and this was exactly the type of film and exhibition venue that the film columns had chosen to ignore in the past.

Thus, what also emerges is an idea of the contemporary British film reviewer 'hermetically sealed'[74] in their column, happily blocking access to these films and their production and exhibition traditions until, through cracks and fissures prized open by video, they emerged in a torrent elsewhere. For, with critical, artistic and legal boundaries established and with many modern horrors dismissed or blocked and cast out into the critical wilderness, the horror video was ready and able to emerge and breach such established boundaries. And emerge it did – trammelled, as the next chapter will outline, between the two key popularist tenets of Thatcherism.

Notes

1 Julian Petley, '"A crude sort of entertainment for a crude sort of audience": the British critics and horror cinema', in Steve Chibnall and Julian Petley (eds), *British Horror Cinema* (London: Routledge, 2002), p. 38.
2 *Ibid.*, p. 39.

3 *Ibid.*, p. 39.

4 This useful term, which effectively conveys the closed-off and conspiratorial nature of the mainstream film critics, is borrowed from Dina Rabinovitch, 'Can I have some of that?', *Empire* (November 1992), p. 67.

5 Dick Hebdige, cited in Duncan Webster, *Looka Yonder! The Imaginary America of Populist Culture* (London: Routledge, 1988), p. 182. This comment was made specifically about the classic 'Americanization' arguments of the 1930s to the 1960s, where 'a "negative consensus" of cultural "if not political conservatism"' linked together cultural commentators and intellectuals from both the right and the left.

6 Petley, 'A crude sort of entertainment', p. 38; and Peter Hutchings, *Hammer and Beyond: The British Horror Film* (Manchester: Manchester University Press, 1993), p. 22.

7 This classificatory term is used by Colin McArthur, 'British film reviewing: a complaint', *Screen*, 26:1 (1985), 79.

8 See Barbara Klinger, *Melodrama and Meaning: History, Culture, and the Films of Douglas Sirk* (Bloomington and Indianapolis: Indiana University Press, 1994), p. 70; and Dominic Strinati, 'The taste of America: Americanization and popular culture in Britain', in Dominic Strinati and Stephen Wagg (eds), *Come on Down? Popular Media Culture in Post-war Britain* (London: Routledge, 1992), p. 72.

9 Strinati, 'The taste of America', p. 72; and McArthur, 'British film', p. 80–1.

10 A number of the broadsheet critics have served as film critics and producers on BBC television and radio and have had key influences on the policies of the British Film Institute, the National Film Archive and the London Film Festival. For further background, see, in particular, Rabinovitch, 'Can I have some of that?', pp. 66–8.

11 As Klinger notes, 'among other things, the critic distinguishes legitimate from illegitimate art and proper from improper modes of aesthetic appropriation'. Klinger, *Melodrama*, p. 70.

12 *Ibid.*, p. 70.

13 McArthur, 'British film', p. 80.

14 Geoff Brown, Review of *Visiting Hours*, *The Times* (16 April 1982), *Visiting Hours* microfiche clippings file: British Film Institute; and Nigel Andrews, Review of *Visiting Hours*, the *Financial Times* (16 April 1982), *Visiting Hours* microfiche clippings file: British Film Institute.

15 Hutchings, *Hammer*, p. 5. Hutchings makes this observation specifically in relation to the critics' use of the word 'Hammer' as a 'reductive, descriptive category' in press reviews of Hammer films.

However, this descriptive approach can be seen to apply to critics' responses to horror in general, at least based on the evidence of this chapter's sample of pre-nasty reviews.

16 Arthur Thirkell, 'Horror carve-up is over the top', *Daily Mirror* (16 April 1982), *Visiting Hours* microfiche clippings file: British Film Institute.

17 Ian Christie, 'An incurable case ... switch off the life support', *Daily Express* (16 April 1982), *Visiting Hours* microfiche clippings file: British Film Institute; and John Pym, Review of *The Evil Dead*, the *Financial Times* (4 March 1983), p. 17.

18 Christie, 'An incurable case'.

19 Philip French, Review of *Visiting Hours*, *Observer* (18 April 1982), *Visiting Hours* microfiche clippings file: British Film Institute.

20 Clive James, 'Duds and spoofs', *Observer* (23 December 1984), p. 25. While James' piece is a video review rather than a film review (and does, in fact, explicitly refer to the fact that *The Evil Dead* had begun to be targeted by the Director of Public Prosecutions), it is included as an example here because of the way in which it utilises a large number of the key critical strategies adopted by critics across the whole sample of reviews of the pre-nasties.

21 McArthur, 'British film', 81.

22 See, for instance, John McCarty, *Splatter Movies: Breaking the Last Taboo of the Screen* (New York: St. Martin's Press, 1984), p. 1; and Vera Dika, 'The stalker film, 1978–81', in Gregory A. Waller (ed.), *American Horrors: Essays on the Modern American Horror Film* (Urbana and Chicago: University of Illinois Press, 1987), pp. 70 and 87.

23 Petley, 'A crude sort of entertainment', p. 34.

24 The term 'psychic dread' comes from D. P. Varma, and is cited in *Ibid.*, p. 28.

25 Derek Malcolm, Review of *The Funhouse*, *Guardian* (7 May 1981), p. 13.

26 Klinger, *Melodrama*, pp. 84 and 86.

27 Hutchings, *Hammer*, p. 9.

28 David Castell, Review of *Visiting Hours*, *Sunday Telegraph* (18 April 1982), *Visiting Hours* microfiche clippings file: British Film Institute; David Robinson, Review of *The Funhouse*, *The Times* (8 May 1981), p. 14; and Geoff Brown, Review of *The Evil Dead*, *The Times* (25 February 1983), p. 15.

29 Derek Malcolm, Review of *Visiting Hours*, *Guardian* (15 April 1982), *Visiting Hours* microfiche clippings file: British Film Institute; French, Review of *Visiting Hours*; David Castell, Review of *The Evil Dead*, *Sunday Telegraph* (27 February 1983), p. 16; and Andrews, Review of *The Funhouse*, p. 17.

30 Brown, Review of *The Evil Dead*, p. 15.

31 Petley, 'A crude sort of entertainment', p. 37.

32 McArthur, 'British film', 79.

33 *Ibid.*, pp. 79 and 81.

34 See *Ibid.*, p. 79; and Klinger, *Melodrama*, p. 70.

35 Webster, *Looka Yonder!*, pp. 179–80.

36 Thirkell, Review of *Visiting Hours*; and Brown, Review of *The Evil Dead*, p. 15.

37 Alexander Walker, 'Something nasty in the cutting room', *Evening Standard* (15 April 1982), *Visiting Hours* microfiche clippings file: British Film Institute.

38 Dick Hebidge, cited in Webster, *Looka Yonder!*, p. 184.

39 McCarty, *Splatter Movies*, p. 119.

40 Webster, *Looka Yonder!*, p. 184.

41 See, for instance, Webster, who notes that 'the other new consumer who featured in the 1950s debates was the teenager, a specific example of working-class hedonism and Americanized youth'. *Ibid.*, p. 184.

42 Klinger, *Melodrama*, p. 84.

43 Walker, Review of *Visiting Hours*; and Lindsay Mackie, Review of *The Evil Dead*, *Glasgow Herald* (17 January 1983), p. 8.

44 As Dina Rabinovitch notes, critics such as Walker are 'never required to hand over [their] ... hard-earned British quids to check out the latest releases, instead seeing them at cosy little screening theatres with attentive fellow hacks, and with a free sarnie and glass of vino.' Rabinovitch, 'Can I have some of that?', p. 66.

45 Hutchings, *Hammer*, p. 9.

46 Andrews, Review of *Visiting Hours*.

47 Petley, 'A crude sort of entertainment', p. 37.

48 Klinger, *Melodrama*, p. 83. While, in this respect, audiences are implicitly delineated as working class in such reviews, there are also occasional discussions of the gender of such audiences. Walker, for instance, notes that films such as *Visiting Hours* 'exist to provide patrons, usually male, with opportunities of seeing knives being stuck into women'. However, conversely, the *Daily Mirror* not only notes that *The Funhouse* is 'a film for teenagers', but also, implicitly, a film for women, ending its review with the comment 'take lots of mascara, girls, and see it with a close friend'. Walker, Review of *Visiting Hours*; and Arthur Thirkell, 'Freak out on funfair fear', *Daily Mirror* (8 May 1981), p. 21. What such approaches, arguably, suggest is that critics use such contradictions for their own rhetorical ends, invoking a male audience when they want to portray a film as excessively violent and thus threatening, and a female audience when they want to highlight the 'emasculating' influence of such films on audiences. For further

discussion of this notion of the 'emasculating' influence of American or popular culture, see Webster, *Looka Yonder!*, p. 187; and Klinger, *Melodrama*, pp. 77–80.

49 Malcolm, Review of *The Evil Dead*, p. 15.

50 This term ('temporary American citizens') is borrowed from a 1937 *Daily Express* editorial on American cinema and British (and, again, explicitly female) audiences, which is cited in Richard Maltby, '"D" for disgusting: American culture and English criticism', in Geoffrey Nowell-Smith and Steven Ricci (eds), *Hollywood and Europe: Economics, Culture, National Identity: 1945–95* (London: British Film Institute, 1998), p. 104.

51 *Ibid.*, p. 106.

52 Webster, *Looka Yonder!*, p. 175.

53 See *Ibid.*, pp. 174–9 and pp. 204–8.

54 *Ibid.*, p. 180. This comment is specifically made by Webster in relation to the use of 'Americanization' arguments in an article by Edmund Gosse, written in the 1880s. This conflation of the political and the cultural in left-wing critiques of American culture has also been seen to have underpinned the 1950s Horror Comics campaign, as detailed in Martin Barker, *A Haunt of Fears: The Strange History of the British Horror Comics Campaign* (London: Pluto Press, 1984).

55 Maltby, '"D" for disgusting', p. 106.

56 Robinson, Review of *The Funhouse*, p. 14.

57 French, Review of *Visiting Hours*.

58 An approach which is adopted, for instance, in Arthur Thirkell's review in the *Daily Mirror*, where he notes that 'there can be only one motive in *Visiting Hours* to make the audience recoil in horror. [...] Little is left to the imagination ... The camera moves in close to show the victims' terror as the knife-wielding sadist approaches'. Thirkell, Review of *Visiting Hours*.

59 Maltby, '"D" for disgusting', p. 106.

60 *Ibid.*, p. 111.

61 This term is borrowed from McArthur, 'British film', 80.

62 Petley, 'A crude sort of entertainment', p. 39. See also Maltby, '"D" for disgusting', pp. 110–12; and Charles Barr, '*Straw Dogs, A Clockwork Orange* and the critics', *Screen*, 13:2 (1972), 17–31. *Straw Dogs* was passed for DVD release by the BBFC with no cuts in July 2002.

63 Malcolm, Review of *Visiting Hours*.

64 Walker employs a similar argument in his review of *Visiting Hours*, where he attacks the censor for allowing *Visiting Hours* to be shown at cinemas while continuing to refuse a certificate to the art/porn film *The Story of O* (ending with a direct appeal to the chief censor, James Ferman, where he asks 'better a dead female than a deviant one – eh,

Mr Ferman?').

65 Thirkell, Review of *Visiting Hours*.

66 See Hutchings, *Hammer*, p. 6; and Maltby, '"D" for disgusting', p. 109.

67 The term 'armed wing' comes from Chris Baldick and is cited in Petley, 'A crude sort of entertainment', p. 24.

68 Murray Healy, cited in Leon Hunt, *British Low Culture: From Safari Suits to Sexploitation* (London: Routledge, 1998), p. 21.

69 *Ibid.*, p. 21. As Hunt further acknowledges, the solidification of this binary opposition between 'high' and 'low permissiveness' could account for the fact that the BBFC tended, in the 1960s and early 1970s, to 'overcompensate' for letting controversial but more culturally respectable films through, by 'cutting heavily into less respectable films'. *Ibid.*, p. 22.

70 *Ibid.*, p. 17. Hunt specifically makes this comment in relation to Thatcher's Clause 28 initiative, which prohibited 'the "promotion" of homosexuality' and symbolised the beginning of an extension of 'legalised containment ... to a "moral" domain'.

71 Nigel Andrews, 'Nightmares and nasties', in Martin Barker (ed.), *The Video Nasties: Freedom and Censorship in the Media* (London: Pluto Press, 1984), pp. 45 and 47; and John Mortimer, 'Censors: the real video nasties', *The Sunday Times* (4 March 1984), p. 54. See also Derek Malcolm, 'Pop, crackle and snaps', *Guardian* (9 February 1984), p. 21; and Derek Malcolm, 'Stand up to the new censorship', *Guardian* (15 March 1984), p. 21.

72 This figure is based on information provided in Francis Brewster, Harvey Fenton, and Marc Morris (eds.), *Shock! Horror! Astounding Artwork from the Video Nasty Era* (Surrey: FAB Press, 2005), cross-referenced with information from the British film journal *Monthly Film Bulletin*, which *did* review a large number of these films.

73 See, for instance, Steve Chibnall, 'Double exposures: observations on *The Flesh and Blood Show*', in Deborah Cartmell, I. Q. Hunter, Heidi Kaye and Imelda Whelehan (eds), *Trash Aesthetics: Popular Culture and its Audience* (London: Pluto Press, 1997), pp. 86 and 88.

74 McArthur, 'British film', 83.

Reconsidering 'the plague years': the marketing of the video nasties

In his account of the early years of video in Britain, Kim Newman coins the term 'the plague years' to describe 'a golden age ... [which] offered brief and unprecedented access to material which was hitherto almost legendary in its unavailability'.[1] In many ways, it is comments such as this that attempt to present the pre-certification era of 1981–83 as a 'golden' time, an 'anarchic heyday'[2] where a previously marginalised culture of exploitation and horror films became widely available in the local corner shop to the delight of horror fans throughout Britain. However, in accounts of this kind, the construction of this 'golden age' is often mirrored by a construction of the 'bad guys' who destroyed it – the unprovoked, witch-hunting right-wing press, who pounced on these films as evidence of the prevailing permissiveness of modern society, and were then solely blamed for the suppression of a 'golden' culture of 'international horror classics'[3] that they just couldn't understand or appreciate.[4]

Although this now familiar retelling of the nasty 'plague years' has its origin in fact, it is this almost black and white portrayal of a small, innocent video culture swallowed whole, and destroyed by the evil machinations of a censorious establishment, that needs to be complexified. For while the importance of the collision between a suppressed culture of drive-in and exploitation horror and a newly censorious right-wing British establishment cannot be underestimated, it was a collision that was largely informed and mediated by the activities of the forty-six video distributors who released these films onto the British market in the early 1980s, backed by a series of excessive, and now highly infamous, marketing campaigns. Indeed, while the right-wing British press may have

coined the term 'video nasty', it can be argued that the *image* and *idea* of the nasties was created, as Nigel Wingrove acknowledges, through 'the packaging and presentation of [these] films on video'.[5] With this notion in mind, this chapter aims to explore the ways in which distributors (through video covers and other marketing tactics) gave these films a public face in the British video market, a face that, potentially, would not only determine how these films were perceived by potential video renters, but would also have a key influence on the ways in which they would subsequently be perceived by the press and moral campaigners.

However, if this is the primary aim of the chapter, then its secondary aim is to consider how such tactics were informed by the immediate social and cultural context of early 1980s Britain. As the above Wingrove quote should suggest, it *is* the case that later, more fan-orientated work on the nasties has attempted to bring a discussion of video distributors and their marketing tactics into the frame. However, while the importance of video covers to the nasties' subsequent image is frequently acknowledged by such commentators, the video nasty marketing campaigns themselves are often portrayed as being ill-conceived, with distributors misunderstanding or disregarding the social, political and cultural context into which they were releasing their products. As Wingrove argues, 'it was unfortunate for the video nasty that it shocked too hard, too much, in the wrong place, at the wrong time'.[6]

Certainly, at first glance, Wingrove's assertion appears well-founded. For, as the last chapter outlined, while the early Thatcher era was characterised by a drive towards enterprise and profit-making, where small companies were encouraged to be free and independent (a climate in which such distributors could potentially thrive), it was also, at the same time, equally characterised by a renewed emphasis on the importance of law and order and a concurrent allegiance to notions of control and restriction of workers' rights, of immigration, of crime, but also, increasingly, of supposedly permissive cultural products.[7] Indeed, for John Corner and Sylvia Harvey, these two ideological tenets constituted the key 'tension' or 'contradiction'[8] of the Thatcher era, a cultural climate where 'the free market, released, unbound, deregulated' could exist in conflict with the idea of 'a heavily centralized and frequently authoritarian state'.[9]

However, while this climate of increased social and cultural

legislation could be seen as the 'wrong place' and the 'wrong time' for distributors to have released a group of exploitation titles on to an unsuspecting British marketplace, it could also be argued that this key Thatcherite contradiction between deregulation and restriction had the potential to act as a cultural enabler for such distributors. As D. William Davis argues, 'a distribution strategy that does not come to terms with the historical and political specifics of its market will always fall flat'.[10] As later arguments will demonstrate, these video marketing campaigns *did* eventually fall flat, in the sense that a number of distributors were ultimately prosecuted and their product confiscated. In line with Davis' argument, however, what this chapter also aims to assess is the extent to which marketing tactics employed by these distributors may have connected up, however fleetingly, with 'the historical and political specifics' of their contemporary cultural context and played-off (or at least benefited) from the tension between a free 'unbound' marketplace and a renewed concern with law, order and containment.

However, it should be noted at the outset that a large number of the tactics which will be examined and discussed here are not fundamentally new in themselves. Indeed, not only were some of these British video covers exactly the same as those that had been used to promote such titles in their original distribution and exhibition contexts,[11] but many other tactics employed by distributors could be seen as merely a perpetuation of approaches utilised during the era of 'classic' American exploitation from the 1920s to the late 1950s, and the post-1960s era of drive-in exploitation in both the US and elsewhere.[12] However, while a large number of the distribution tactics adopted can therefore hardly be seen as unique, this chapter aims to consider how the use of such techniques was re-inscribed within, or reframed by, the specific context of 1980s Britain.

Indeed, for a number of reasons, the ethos of classic exploitation marketing can be seen to lend itself particularly effectively to a cultural climate saturated with the values of entrepreneurship and profit-making. Firstly, the group of video entrepreneurs who oversaw the release of these films onto the British video market can almost be seen as modern versions of classic exploitation ballyhoo merchants, buying rights to films and frequently modifying both the films and their advertising as they saw fit,[13] enabled largely by

the benefits of 'free play' in the early 1980s Thatcherite market-place.[14] Secondly, both classic exploiteers and 1980s video distributors, from Go to Vipco, also fit with the key Thatcherite idea of 'self-starters' – who 'make their own luck ... are vigorous individualists ... [and] thrive on the excitement of competition and the stimulus of commerce'[15] where making money is always the bottom line.

By considering how prior exploitation techniques were borrowed, modified and utilised in a British context, this chapter will explore how such distributors made 'their own luck' in a polit-ically-charged and contradictory cultural environment, and, in turn, how such approaches relate to the discourses employed in the subsequent British press campaign against the nasties. In order to assess the key characteristics of the marketing strategies employed, a number of different sources will be examined. Firstly, the original British video covers for the nasty titles (reproduced in Wingrove and Morris' book),[16] secondly, factual information from various sources about other marketing and distribution techniques that were employed, and thirdly, articles and advertisements from *Video Trade Weekly* (a prominent British video trade publication of the time).

'Terror beyond belief':[17] promoting the alien through titles, images and taglines

In his earlier cited 'plague years' essay, Kim Newman fondly refers to some of the Italian nasty titles as being like 'alien artefacts' in their British video incarnations.[18] While Newman is referring here to some of the specific textual features of the films concerned, it can be argued that particular distribution circumstances and marketing approaches also contributed to these films' status as 'alien artefacts' in the early 1980s British video market.

Firstly, in the sense that a large number of these films had never been available in Britain prior to their video release, had previous-ly been rejected by the British Board of Film Censors (BBFC) or submitted to the BBFC under alternative titles,[19] they could be seen to appear as not only new but also highly unfamiliar. Indeed, when surveying the full range of previously suppressed horror and exploitation titles that were released on video between 1981 and 1983, what emerges is the sense that their British distribution on

video had initiated a wholesale collapsing of horror and exploita-
tion production history. Not only do the previously unseen titles
released at this time span nearly twenty years of exploitation and
horror production (stretching from the 1963 film *Blood Feast* to
1982's *The Evil Dead*), but also a long lineage of historically
contextualised subgenres and nationally contextualised horror
traditions, all previously suppressed in Britain, can be seen to have
been inadvertently collapsed into each other. This allowed, for
instance, Mario Bava's Italian horror *Blood Bath*, made in 1971, to
jostle for space on British video shelves with a host of other Italian
titles which were largely influenced by Bava's work and were made
around ten years later, and *Love Camp 7*, made in 1968, to emerge
at the same time as a host of later Italian Nazi exploitation imita-
tors, including the infamous *SS Experiment Camp*.[20]

What thus emerges is a situation where a mish-mash of films
with different production contexts, and released chronologically
in their native countries, are all released, at once, in a historical
vacuum on the British video market. And because both old
precursors and new imitators were not framed, in Britain, within
any known production, distribution or exhibition tradition (with,
as the last chapter acknowledged, the prior British distribution of
a few of the titles being largely confined to specialist cinemas on
the edges of London), their emergence in a homogenised flood on
video allowed such films, whether made a year ago or twenty
years ago, to all be presented as not only major new video
releases, but also as examples of new, extreme and unsurpassed
horror.

Thus, a 1983 *Video Trade Weekly* article is able to promote
Blood Rites, an old cheaply made exploitation title from the late
1960s, as 'one of the most talked about horror movies of the
year'.[21] While the cover for Astra's release of *Blood Feast*, a film
that not only inspired the content but also the marketing tactics of
a large number of later horror and exploitation titles,[22] retains the
tagline '*nothing so appalling* in the annals of horror!' (my empha-
sis). While this tagline had not been devised by Astra but had been
cooked-up for the film's promotion on the drive-in circuit in the
1960s, *Blood Feast*'s appearance as an unknown quantity in the
1980s British video market could arguably mean that it appeared,
to a large majority of the British public, as a new pinnacle of
'appalling' extreme horror, despite the fact that the film was almost

twenty years old and a familiar exploitation classic within a US exhibition context.

In many respects, then, the promotion of these titles as alien, major, unsurpassed and new was largely reliant on their previous lack of distribution and exposure within a British context. However, the correlative result of this promotion was to enable moral campaigners to not distinguish between old and new horror films, to delineate a historical rag-bag of horror titles as the 'worst' examples of modern horror,[23] and to enable the authorities to present such films as, in the words of the head of the Obscene Publications Squad (OPS), 'a new problem'.[24]

However, if this inadvertent collapsing of horror history was one way in which these titles could be imbued with a sense of the new and alien, then the images on the video covers were also hugely important factors in promoting this sense that such videos were unfamiliar and were pushing the boundaries of contemporary acceptability too far. As Eric Schaefer argues, 'classical exploitation films centered on some form of forbidden spectacle that served as their organizing sensibility – at the expense of others'.[25] When looking at a range of video covers (many of which were used to promote the first brace of video horror releases in 1981 and 1982), this sense of how 'forbidden spectacle' serves as an 'organizing sensibility' on video covers is consistent and clearly conveyed. The majority of video cover images either focus on moments of violence just before they occur (for instance, both the Goldstar and Market releases of *Mardi Gras Massacre*), when they are occurring (*The Driller Killer, The Burning*) or just after they have occurred (*Death Trap, Don't Go in the House* or *I Spit on Your Grave*). But, in each case, they focus on a frozen moment of violent spectacle, either through the use of a single still from the film or an illustrated cover image.

The function of such covers is therefore a clear foregrounding of particular ideas or themes, at, as Mikita Brottman puts it, 'the expense of [conveying] narrative coherence'.[26] What is also frequently clear is how the title of the film, the image on the cover and the accompanying cover tagline all work together to achieve this highlighting and foregrounding of a particular idea and theme, with the image and the tagline visually and textually literalising the film's title.

Vipco's infamous cover for Abel Ferrara's *The Driller Killer* demonstrates the effectiveness of this approach (see figure 1). Here,

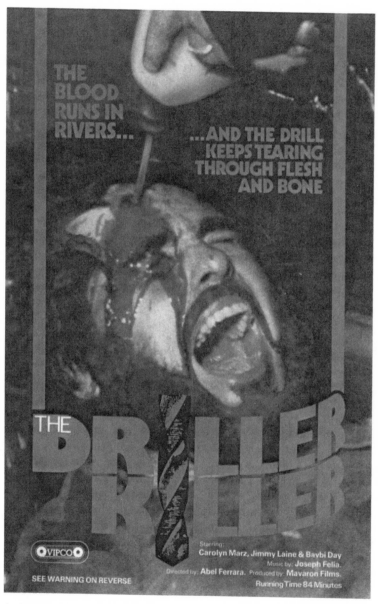

THE
BLOOD
RUNS IN
RIVERS...

...AND THE DRILL
KEEPS TEARING
THROUGH FLESH
AND BONE

THE DRILLER KILLER

VIPCO

SEE WARNING ON REVERSE

Starring:
Carolyn Marz, Jimmy Laine & Baybi Day
Music by: Joseph Felia.
Directed by: Abel Ferrara. Produced by: Mavaron Films.
Running Time 84 Minutes

1 Conjuring up a violent 'narrative image': the 1982 Vipco British video cover for *The Driller Killer*

the image of a tramp looking upwards and screaming as a drill penetrates the centre of his forehead, covering the left side of his face in blood, freezes and centralises an exact moment of violent spectacle from the film, a moment of violent penetration and human pain. Below this image is the legend 'The Driller Killer' in large red lettering with an illustrated drill bit slicing through the middle of the title, and above the image, on either side of the drill, is the red-lettered tagline 'the blood runs in rivers ... and the drill keeps tearing through flesh and bone'.

What is clear is how all these three elements work together to foreground, in John Ellis' terms, the supposed 'narrative image' of the film.[27] Here, the tagline, instead of contextualising this moment within the frame of the film's *overall narrative*, merely narrates the image ('the blood runs in rivers'), the image literalises the film's title (by showing a drill penetrating a human head) and the blood from the human head at the centre of the image then almost appears to drip into the film's title below. The blood in the image, the literal, descriptive red-lettered tagline and the red-lettered title therefore all seem to connect up with each other and frame the cover image spectacle. And, in turn, all three elements seem to link together to foreground blood, a drill, violence and pain (i.e. key elements of violent spectacle) as the true essence of the film, despite the fact that the film itself has relatively few gore moments and is, fundamentally, a psychological art-house film.

While Vipco's *The Driller Killer* image is perhaps the cover that uses these tendencies in the most concentrated way, a range of other early British video covers also utilise various versions of this approach. Thus, Arcade's cover for *Don't Go in the House* uses a descriptive tagline ('in a steel room, built for revenge they die burning ... in chains') above a still of a burnt figure hanging from the ceiling, Thorn EMI's cover for *The Burning* foregrounds a literalised still of a figure bursting into flames, and the technique of merging blood from a human victim into the cover title is enacted across a whole range of video covers (including the illustrated covers for *Blood Feast*, *Don't Go in the Woods ... Alone!* and Vipco's release of *Death Trap*).

In addition, while, on the whole, a use of an illustrated image rather than a still could give *carte blanche* to distributors to foreground images of spectacle that didn't exist in the film itself,[28] a number of other covers actually create a contrived sense of specta-

cle by using stills but modifying their meanings by juxtaposing them with other elements. Thus, on the *Bloody Moon* cover, a still of a woman screaming is placed next to an illustrated blade splashed with fake blood (to create an effect of violent incision), and on the *Nightmares in a Damaged Brain* cover, a still of an anguished man's face appears to be sporting fake illustrated blood, which drips from his eyes (see figures 2 and 3).

Further, a number of distributors also clearly employed another key element of 'the enterprise paradigm', of 'taking the initiative',[29] and extended a key spectacular theme or idea into an effective extra-textual marketing gimmick. This technique allowed, for instance, World of Video 2000 to launch *Nightmares in a Damaged Brain* at a Manchester video fair, and later, outside a London hospital, by holding a 'guess the weight of the brain' in a jar competition (an aspect of their campaign which they were then able to incorporate into the film's video cover), and Palace Pictures to announce a 'consumer competition' to win 'one year's supply of red meat!' in a 1983 trade advertisement for *The Evil Dead*.[30]

To return to Schaefer and Brottman's arguments, what such tendencies all seem to achieve, whether through freezing or constructing an image of spectacle on a video cover or extending an abstract theme into a marketing stunt, is a clear foregrounding of 'forbidden spectacle' at 'the expense of [conveying a film's] narrative coherence'. Indeed, video covers rarely contextualise such images within the frame of a cause-and-effect narrative or any sense of characterisation. The covers of *I Spit on Your Grave* and *SS Experiment Camp*, for instance, centralise and abstract anonymous females, and taglines rarely mention character names, with, for instance, *I Spit on Your Grave*'s tagline referring to the protagonist featured in the image as 'this woman' (see figure 4). In addition, taglines frequently frame such films by noting that they depict some of the 'horrifying experiments ... in pursuit of the master race'[31] (*SS Experiment Camp*) or 'the slaughter and mutilation of nubile young girls – in a weird and horrendous ancient rite!' (*Blood Feast*), suggesting that the films are not structured around cause-and-effect plots but are, instead, a string of successive, spectacular experiments, slaughters and mutilations.

While, as the last chapter acknowledged, some of these films *were* largely structured around violent spectacle, this heightened foregrounding of violent and excessive incidents and themes over

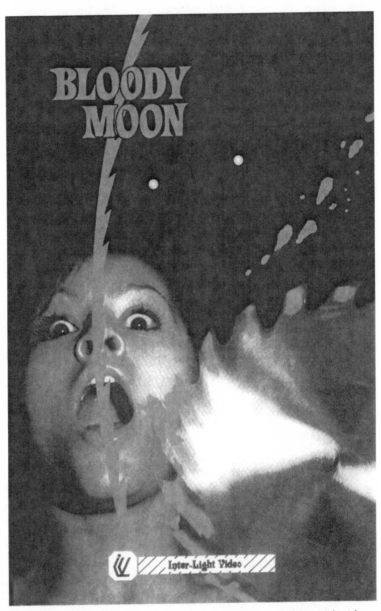

2 Juxtaposing separate visual elements: the 1981 Interlight British video cover for *Bloody Moon*

narrative context or any notions of artistic or esoteric quality could be seen as a marked form of provocation in a British cultural climate where entertainment was supposed to stay in its culturally designated place and not indulge in the excessive, the forbidden or the unfamiliar. Indeed, in a comment that articulates the true *effect* of this heightened spectacle approach, Eric Schaefer has noted how such forms of marketing ballyhoo can be conceptualised as 'a hyperbolic excess of words and images that *spark . . . the imagination*'(my emphasis).[32] Perhaps inevitably, then, such out-of-context words and images were all moral campaigners needed to spark *their* imagination and to see, as Duncan Webster puts it, 'only what they wanted to see'.[33] For what these words and images fundamentally created and bred was a slew of out-of-context reactions and responses, allowing the press to dot their campaign articles with a range of spectacular video cover images rather than stills from the films themselves,[34] and to churn out a descriptive list of violent events which seem uncannily similar to the taglines from the films' video covers.

Such cover images and taglines therefore enabled press campaigners to utilise them as a tool, an out-of-context sign or description which could have an immediate sensational and shocking effect and aid the rhetoric of their argument. This approach allowed, for instance, a 1982 *Daily Express* article to depict the content of *I Spit on Your Grave* as 'rape and "an orgy of stabbing, hacking and chopping"', and to discuss the insidiousness of *SS Experiment Camp* almost solely through a description of its video cover.[35] Furthermore, what such a correlative effect seems to fundamentally illuminate is the extent to which both the video distributors *and* their detractors simultaneously operated within the realms of a Thatcherite-induced consumer culture which, as Don Slater puts it, not only wallowed in a wealth of 'signs and meanings' but was also 'proudly superficial, profoundly about appearances'.[36]

However, while this suggests that the distributors' use of 'superficial', spectacular images had the potential to backfire on them, with such images frequently being used as fodder for a law and order campaign, they could also be seen to act as an enabler for distributors, both in a commercial and legal sense. Firstly, and most obviously, the coverage of both the films and their video covers in the press, at least initially, could act as useful further

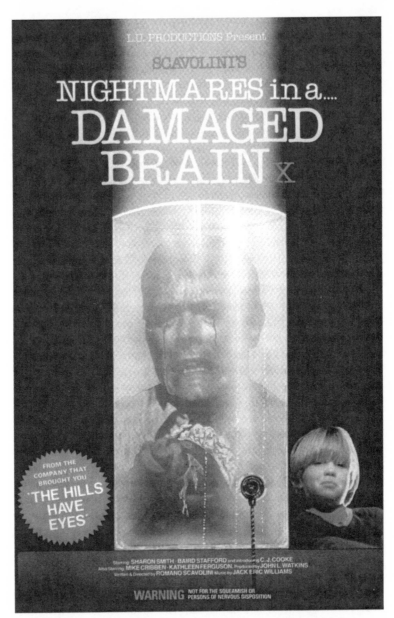

3 Creating an image of contrived violence: the 1982 World of Video 2000 British video cover for *Nightmares in a Damaged Brain*

publicity and exposure, particularly when press articles highlighted the possible seizure or prosecution of particular titles. Indeed, nothing demonstrates this more clearly than the case of Astra's 1982 release of *I Spit on Your Grave*, which, according to Wingrove and Morris, 'topped the UK rental charts when rumours of its imminent banning were publicised'.[37]

Secondly, and as a number of fan-orientated nasty critics have pointed out, many of the actual films, packaged up in their excessive video covers, had actually been heavily pre-cut for their original British video releases. In some cases, such cutting had occurred accidentally, but, in others, it appears to have been intentional, whether, as Kerekes and Slater posit, due to 'the video company wanting to save cash on magnetic tape' (in the case of *Faces of Death*)[38] or whether they had been censored of moments of gore by uncharacteristically cautious distributors aware of potential legislation against the actual content of the videos concerned. Thus, for instance, while World of Video 2000's cover for *Nightmares in a Damaged Brain* is replete with constructed, bloody images of gore, a whole ten minutes of violence had been shed from the film itself; and while Go's illustrated gore-guzzling cannibal did its imaginative work on the *Cannibal Holocaust* video box, six minutes and twenty-four seconds had apparently been pre-cut from the actual video inside.[39]

What such cutting seems to highlight is the fact that, in exploitation films old and new, there is often 'a long swim between what the lobby promised and what the screen delivers'.[40] However, this approach, of blunting the excessiveness of the actual content of a video while maximising the excessiveness of a video's cover art, could also be seen as an effective commercial strategy within this cultural climate. For if video distributors wanted to remain within the realms of acceptability, and thus on the edge of legal, they could censor their product, but, through a utilisation of advertising on which no restriction had been threatened, could still imply that their product was of 'undiminished strength'.[41]

Furthermore, the release of different versions of a title onto the video market by the same distributor, with some being cut and others being uncut, also enabled distributors to *blur* the boundary between the culturally acceptable and unacceptable. Medusa, for instance, is known to have released cut and uncut versions of *Madhouse* onto the market at exactly the same time, while *Zombie*

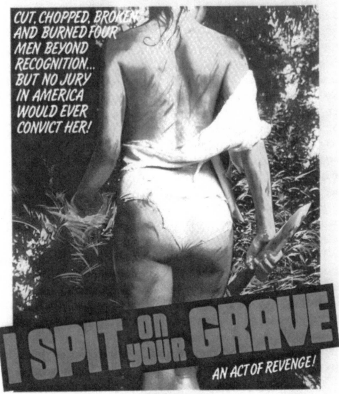

THIS WOMAN HAS JUST...

CUT, CHOPPED, BROKEN AND BURNED FOUR MEN BEYOND RECOGNITION... BUT NO JURY IN AMERICA WOULD EVER CONVICT HER!

I SPIT on your GRAVE

AN ACT OF REVENGE!

Starring CAMILLE KEATON ERON TABOR RICHARD PACE ANTHONY NICHOLS
produced by JOSEPH ZBEDA
written and directed by MEIR ZARCHI
RUNNING TIME 98 MIN

ASTRA VIDEO

4 Foregrounding the anonymous woman: the 1982 Astra British video
cover for *I Spit on Your Grave*

Flesh Eaters was released by Vipco in a cut and then an uncut version.[42] In addition, two different versions of the video cover for *Death Trap* were also allegedly released onto the video rental market by Vipco at around the same time. While one version of the video cover appears to use the standard warning symbol utilised on such Vipco video covers as *The Driller Killer* and *Shogun Assassin*, the other version also boasts a large red sticker claiming that this is the 'strong uncut version!!' of this particular film.[43]

As Kerekes and Slater see it, there is 'no discernible difference' between the content of the cut and uncut versions of *Death Trap*, with them putting the confusion surrounding these supposedly different but actually identical versions of the same film down to a 'packaging error'.[44] Alternatively, it could be argued that such techniques – of cutting a product while maximising the spectacular effect of its cover art or of simultaneously promoting the same product as both cut and uncut – constituted a key strategy for video distributors aiming to carve out a tentative commercial path for themselves, in a cultural climate riddled with ideological contradictions. By remaining true to the ethos of commerce, while balancing this with at least a nod to an idea of restriction and responsibility, distributors were, at least for a short time, able to walk a fine line between the legitimate and the transgressive – managing to make money and achieve profit through sensation, but, at the same time, attempting to avoid prosecution and the destruction of their business.

However, if this was one way in which distributors thrived in a consumer climate of 'superficial' signs and 'appearances', then another can be seen to crystallise around an alternative classic exploitation approach – the use of borrowed ratings and warning symbols. A marketing tactic which, as the next section of the chapter will argue, could also potentially interact with the wider British political and ideological tension between moral restriction and economic liberation.

Slowly going 'beyond X': a mobilisation of the mock-legal and the mock-illegal

In his historical survey of classic exploitation era marketing techniques, Eric Schaefer highlights the usefulness of 'adults-only' labels to exploitation distributors and exhibitors, both as a useful

indicator of legality and responsibility and a highly effective form of publicity. As he notes, 'adults-only' labels not only 'gave the appearance of responsibility to the community by indicating the willingness of exploiteers to protect children from material they might not be mature enough to understand', but also, crucially, 'acted as powerful beacons, promising audiences sights that were not found in the average Hollywood film'.[45] Arguably, a use of a range of mock-legal symbols on early 1980s British horror video covers can be seen as a comparative marketing approach to this classical use of the 'adults-only' label, and there are perhaps two key tactics which appear to balance this indication of responsibility and maximisation of commercial distinctiveness in the most marked and effective way.

The first is the consistent use of borrowed certification logos on the front of a range of video covers, an approach which was largely dependent on the fact that a dedicated British certification system for video was yet to be established. The source for such borrowed ratings varies from example to example, but, in some cases, seems reliant on whether the film in question had been theatrically released in Britain and therefore had previously been awarded a certificate by the BBFC. However, this borrowing of BBFC ratings is not as straightforward or legitimate as it might appear, for while a number of videos with covers proudly sporting an 'X' were exactly the same as their certified and cut theatrical versions (with *The Evil Dead* perhaps being the most prominent example), a number of others with 'X' logos *had* been awarded BBFC certificates in the past, but had then been released on video in uncut and therefore strictly uncertified versions.[46]

Alternatively, in cases where a film hadn't received a prior theatrical release in Britain, a range of imposed ratings appear to have been utilised. On the whole, these ratings appear to have been borrowed from American exhibition contexts, but while some covers (including *Deep River Savages* and *Absurd*) use 'X' ratings, a wide range of others (including *Don't Go in the Woods … Alone!*, *Contamination* and *Axe*) employ boxes with 'R – Restricted' certification logos inside them. What this tendency therefore seems to highlight is how far a notion of 'free play' could be extended in a liberated, deregulated video marketplace – allowing distributors to not only pass off imported 'X' certificates as legitimate British ones, but also to employ entirely foreign regula-

tory symbols (such as the American-style 'R' rating) in order to imbue their product with an 'appearance of responsibility'.

However, this distribution tactic of harnessing foreign or alien tropes of legality is frequently extended on a number of video covers through a second type of mock-legal marketing tool – the self-imposed warning tag. Like the majority of borrowed certification logos, these tags tend to be tucked away at the bottom of video covers, often seeming visually subordinate to the graphic images that were discussed in the last section of the chapter. However, their mock-official text is still both illuminating and telling, noting, for instance, that this film 'contains scenes of graphic violence' (*Don't Go in the Woods . . . Alone!*) or that it 'contains scenes of extreme and explicit violence' (IFS' covers for *Night of the Bloody Apes* and *Night of the Demon*).

In one sense, and largely due to the fact that they are preceded by the word 'warning', the inference in such statements is, as in Schaefer's examples, that distributors are protecting 'children [and others] from material they might not be mature enough to understand'.[47] However, in another, the suggestion that the video '*contains*' violence, combined with the frequent use of adjectives like 'graphic' and 'extreme', seems to turn such tags into official guarantees of the film's explicitness, allowing a tag to function as a 'powerful' commercial 'beacon' rather than as a responsible warning to sensitive souls. Indeed, this notion of the warning tag as a commercial 'beacon' is also compounded by the fact that IFS' warning tags, while placed spatially at the bottom of the video cover, are hued a distinctive blood red, marking them out visually and allowing attention to be drawn to them (see figure 5).

While the use of such mock-legal tropes therefore allowed distributors to utilise and extend the commercial effectiveness of prior exploitation practices, they could also be seen to have allowed distributors to, once again, operate within the contradictory tenets of Thatcherism and continue to maintain a balance between commercial and restrictive imperatives. Both the borrowed rating and the self-imposed warning symbol clearly allowed distributors to maintain an 'appearance of responsibility', with both tropes acting as a means of assuring the public that the video version of a particular film was certified and had been approved by a classificatory body when, in general, this wasn't the case. But, secondly and conversely, it also served as an additional

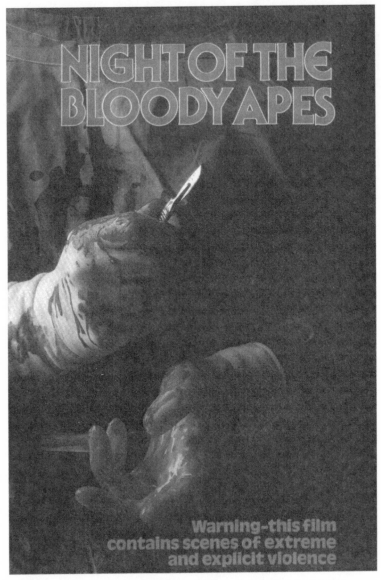

NIGHT OF THE
BLOODY APES

Warning-this film
contains scenes of extreme
and explicit violence

5 The warning symbol as 'commercial beacon': the 1983 IFS British
video cover for *Night of the Bloody Apes*

means of promoting a film as explicit and contentious, and high-lighting the extremity and the adult, X-rated nature of its content for all to see.

In this respect, this approach rather mirrors the distributors' previously described tactic of cutting and thus blunting the exces-siveness of the film itself, while maximising the excessiveness of the image displayed on the video cover. Both tactics, although different in their approach, assist in allowing distributors to remain on the edge of legal – remaining true to a Thatcherite drive for profit-making, but balancing this with an awareness of law and order concerns. In the first instance, distributors can censor a film of a contentious scene in order to curtail prosecution or banning, but still allow images of contention to assist in selling the film. In the second instance, a demonstration of a film's explicit content is incorporated into the official motif of the rating or warning symbol, which enables distributors to maximise the key selling point that the film possesses while still appearing to be responsibly warning sensitive viewers of a film's disturbing content.

Such duplicitous approaches, then, enabled the distributor to advertise their product as dangerous, while also attempting to contain this danger and transgression through a concession to notions of the legal or, at the very least, the restrictive and respon-sible. However, while the combining of a lurid image with a mock-official rating or warning symbol is the primary way in which distributors appeared to walk this cumbersome tightrope, the distribution company Replay can be seen to have adopted an alternative approach.

In Julian Petley's article on the post-Video Recordings Act (VRA) video industry, a contemporary independent horror video distributor, from the distribution company Colourbox, is quoted as complaining that 'as an independent you do have to rely on strong images to create an impact with your packaging. The majors have all the well-known titles and stars – they could put out a big title in a white sleeve and still do well'.[48] Despite the validity of this gripe, on the basis of the evidence provided by the video covers for *Cannibal Ferox* and *The Last House on the Left*, this was exactly what Replay attempted to do, by packaging both films in plain black covers. Both covers do, of course, display some additional text, including the film's title, plus, in the case of *Cannibal Ferox*, a brief list of credits and, in the case of *The Last House on the Left*, a

citation of producer Sean Cunningham's credentials as director of *Friday the 13th*, and the employment of the key tagline 'to avoid fainting keep repeating, it's only a movie ... only a movie' (a tactic that was originally devised by the film's American theatrical distributors, Hallmark and AIP).[49] However, among this additional text, and placed in a central position on both covers, are red-lettered warning tags which note, in the case of *The Last House on the Left*, that 'due to the specific nature of the horrific and violent scenes in this film the front cover is not illustrated to avoid offence' (see figure 6) and, in the case of *Cannibal Ferox*, that 'due to the specific and horrific nature of this film this area is not graphically illustrated to avoid offence'.

This alternative tactic can, on the one hand, be seen to adhere even more markedly to law and order concerns than the previously cited examples, in the sense that the lurid cover image has been completely jettisoned in favour of a sombre and inoffensive warning symbol. Indeed, the fact that both films were released by Replay after the initial seizure of *SS Experiment Camp* by the OPS, and, in *Cannibal Ferox*'s case, after a number of other video distributors had been prosecuted under the Obscene Publications Act (OPA), suggests that a need to imbue a video cover with a sense of legality and responsibility would have been particularly charged at this time. However, while these covers, in one sense, appear to more fervently endorse a censorious and responsible approach to marketing, it can also be argued that a central use of such a symbol also allows distributors like Replay to even more effectively draw attention to a film's explicitness.

Firstly, the fact that both covers note that 'this area' hasn't 'been graphically illustrated to avoid offence' immediately emphasises the fact that they haven't illustrated this central area on the cover *and* the fact that they haven't *graphically* illustrated it. In other words, the inferred implication is that it would be impossible to illustrate the cover in *any* way, as any form of visual representation of the film (whether through the use of illustrations or stills) would be liable to offend.[50] Secondly, and perhaps more implicitly, the use of a black cover and warning label also draws attention to *why* it's there – namely that, because of 'the specific nature of the horrific and violent scenes' contained within the film, the video is liable to be seized and prosecuted if such scenes were displayed on the cover. Thus, this tactic not only highlights the extremity of the

6 The power of the plain black cover and warning symbol: the 1982
Replay British video cover for *The Last House on the Left*

film's content, but also the video's potential status as forbidden fruit, which could, at any moment, be seized and deemed illegal. Finally, and crucially, the use of such vague phrases as 'specific nature' and 'specific and horrific' may appear to be a means of putting-off consumers with sensitive dispositions, but can also be seen as an attempt to stir curiosity, in both the consumer and the moral campaigner, as to what the 'specific and horrific nature' of the film might be.

In this sense, the employment of a plain cover and centralised warning symbol can effectively promote the excessiveness and potential illegality of a product equally as, if not more effectively than, the more prevalent lurid video cover image. Indeed, Sarah Thornton has highlighted a comparative model to this particular marketing approach, which involves the use of 'parental advisory' warning labels on the front of record sleeves as a key means of both provoking media attention and promoting the idea that a product is explicit and thus intriguing.[51]

Further to this, the general use of warning labels on video covers not only highlights the supposed explicitness of the film inside the video box, but also seems to imbue such products with a drug-like aura, giving the sense that while these products may be legal, they could also be highly dangerous and, potentially, bad for your health.[52] Indeed, if, as the last chapter demonstrated, the 'X' certificate had been constituted by British critics and censors as the boundary line of acceptability that couldn't be crossed, then the use of a warning label (rather than an 'X' certificate) could also convey the idea that such products were so explicit and drug-like that they were unable to be classified and contained within the realm of current British legal ratings.

In this sense, if critics and censors had established the boundary line of acceptability as being marked by the 'X' certificate, then transgression and illegality could be seen to be determined by the extent to which such films went beyond this line. And while the use of the warning label could be seen as a means of placing these videos right on the edge of this line, then, in a number of cases, it also allowed distributors to promote such films as going far beyond it, presenting their product not as classified, cut or restricted but, instead, proclaiming proudly, on the Abbey and Market release covers for Love Camp 7, that 'this is the film that goes beyond X' or, in the trade advertisement for The Last House on the Left, that

this film goes 'too far'.[53]

However, if this is one way in which distributors could promote such films as moving beyond the boundaries of the acceptable, a further, and far more direct, video marketing approach involved cutting out the mediating tactics of video covers and the tropes of legality and illegality completely, and directly tipping-off moral campaigners about the unacceptable nature of their product. Nowhere is this more apparent than in a key tactic employed by Go, the British video distributor of *Cannibal Holocaust*, which is outlined in John Martin's book *The Seduction of the Gullible*. As this particular distributor sees it, 'nobody had heard of *Cannibal Holocaust* ... till I wrote to Mary Whitehouse complaining about it. Once she got in on the act I couldn't run off enough copies to meet the demand'.[54]

If any marketing tactic directly invited the consumer to see a product as potentially transgressive, it was this approach of engineering a complaint, which then led to public protest and media panic and which then assisted in further promoting and advertising a product. In addition, and as was more inadvertently achieved with the earlier cited case of *I Spit on Your Grave*, by promoting and exploiting this media panic, Go could highlight the implied threat to the long-term availability of their product and incite video renters to, basically, get it while they could.

The use of this tactic can therefore be perceived as a successful attempt to break away completely from a model of balancing profit-making with an allegiance to law and order concerns. Instead, this break can be seen to have allowed Go to exploit one concern for the benefit of the other – explicitly provoking instead of appeasing their potential detractors, harnessing their reactions and then offering them up as grist for the mill of commerce and publicity. Indeed, such an approach can be conceptualised, in Thornton's terms, as a direct use of 'moral panic' as cultural 'hype', where controversy is deliberately fuelled and ignited in order to frame and give a marketable identity to a product which, at least as far as Go was concerned, had previously been commercially under-exposed.[55]

However, by moving out of a model of balancing provocation with responsibility, such tactics can be seen as the point where the British early video marketing campaigns *literally* went 'too far'. For, as Thornton notes, while 'negative newspaper and broadcast news

coverage' can most effectively 'baptize transgression', it can also 'imbue [a product] . . . with a "real-life" gravity that moves it beyond lightweight entertainment'.[56] This '"real-life" gravity' is something which, arguably, not only moves such tactics from commercial strategies into public issues, but also equally moves such films, even more effectively than the use of warning tags, from the realm of 'lightweight entertainment' into the realm of the drug-like (via marketing tactics which engage directly with the public sphere). In this respect, while Go were able to achieve fleeting success by utilising contemporary law and order concerns for the benefit of publicity, they were perhaps not fully aware of the potential for the commercial to equally be offered up as grist for the mill of law and order concerns. For while the key tenets of Thatcherism could be exploited for the sake of commercial imperatives, they could, as Duncan Webster points out, also work together to 'police . . . popular culture, stigmatizing individual artists or even whole genres and placing them outside the arena of approved pleasures'.[57]

By exploiting the key political tenets that had fed a 'golden age' of British video anarchy, then, this direct 'moral panic' approach could be seen to have sealed the fate of both these video titles and those that had distributed them. For such approaches not only allowed moral campaigners to place such films 'outside the arena' of the culturally acceptable, but, ultimately, enabled the right-wing press to turn a technological innovation into an invasion of insidiousness, to turn video distributors from Thatcherite 'princes of industry'[58] into 'merchants of menace', and, ultimately, to turn video into the video nasty.

Conclusion: the nasty as commercial stigma

For these early British video distributors, an attempt to remain true to the Thatcherite drive for enterprise (while also balancing this with an 'appearance of responsibility') did, at least in some cases, reap initial commercial benefits. What this suggests is that while, ultimately, these marketing strategies are prime examples of failed marketing campaigns, the complexities of approach and distinct linking-up to contemporary concerns demonstrates a cultural and social awareness on the part of these distributors that many accounts of the nasties phenomenon rarely give them credit for. In addition, and more generally, such campaigns provide a compara-

tive model to early marketing practices in the US film industry, with, as in the early Production Code era, commercial innovation exceeding regulation and campaigns being able to exploit regulatory anomalies and public sphere debates in an unfettered and thus incredibly interesting way.[59]

However, as the climate changed and the threat of state video legislation became a reality, many British independent distribution companies did appear to recognise that to be associated with the ensuing public debates around the nasties was a stigma rather than a positive selling point for their products. If one charts the nature of publicity pieces in *Video Trade Weekly*, this becomes all too clear. In May 1982, the publication announced Arcade's release of *Don't Go in the House* by proudly proclaiming that a 'new "nasty" from Arcade Video' would soon be available.[60] However, at the time of the release of *The Evil Dead* in January 1983, clear attempts were being made by the trade press and the distributor, Palace Pictures, to present the film as imbued with quality and technical innovation, and to overtly sever the film from any association with the video nasty debates.[61] Other such attempts at promoting the changing face and renewed responsibility of the independent distributor included Go Video's declaration of support in the trade press for the implementation of a voluntary, rather than state-administered, video classification system, and Scorpio Video's announcement of its reversible video cover for the 1983 release of *Blood Rites*, allowing retail outlets to promote the film tastefully or with maximum gore.[62]

But while such strategies suggest that distributors were attempting to emerge from the ensuing public controversy and continue to trade, it became clear that, by binding themselves so publicly to the emergent idea of the video nasties, they were destined to be associated with it indefinitely. Most prominently, the revelation that Astra (distributors of *I Spit on Your Grave* and, allegedly, *Snuff*) was branching out into children's films was not held up as a sign that distributors were adapting to outside concerns and diversifying their product, but instead was used by the British press as a stick to beat the company into submission. Hence, subsequent to the *Daily Mail*'s revelation of the horrifying 'moral conflict' around Astra's decision to market children's films where profits went to charity, they could gleefully reveal, one month later, that Astra had gone into receivership and that bankruptcy was imminent.[63]

By so firmly and effectively creating the idea of the video nasties (offering such films up as a new threat to society and imbuing them with a sense of the drug-like), distributors had given moral campaigners and the press all the rhetorical materials they needed to construct and power the rhetoric of their law and order campaign. And if distributors had breached the boundary between the culturally acceptable and unacceptable, then this would inspire boundaries to once again be redrawn, within the more charged public realm of the home and the high street but also, as the next chapter will outline, in relation to the activities of another untrustworthy figure – the child.

Notes

1 Kim Newman, 'Journal of the plague years', in Karl French (ed.), *Screen Violence*, (London: Bloomsbury, 1996), p. 132.
2 Mark Kermode, 'Horror: on the edge of taste', in Ruth Petrie (ed.), *Film and Censorship: The Index Reader* (London: Cassell, 1997), p. 157.
3 Kermode, 'Horror', p. 157.
4 For other accounts, which discuss the video nasty panic years in similar terms, see Julian Petley, 'Two or three things I know about video nasties', *Monthly Film Bulletin*, 51:610 (1984), 350–2; and Mark Kermode, 'The British censors and horror cinema', in Steve Chibnall and Julian Petley (eds), *British Horror Cinema* (London: Routledge, 2002), pp. 17–19.
5 Nigel Wingrove, 'The nasties: a personal view', in Nigel Wingrove and Marc Morris (eds), *The Art of the Nasty* (London: Salvation Films, 1998), p. 5.
6 *Ibid.*, p. 2. See also John Martin, *The Seduction of the Gullible: The Curious History of the British 'Video Nasty' Phenomenon* (Nottingham: Procrustes Press, 1993), pp. 53, 139 and 153.
7 See Leon Hunt, *British Low Culture: From Safari Suits to Sexploitation* (London: Routledge, 1998), pp. 16–33, for a detailed discussion of the various forms of social and cultural legislation introduced by Edward Heath in the early 1970s and Thatcher in the early 1980s.
8 John Corner and Sylvia Harvey, 'Great Britain Limited', in John Corner and Sylvia Harvey (eds), *Enterprise and Heritage: Crosscurrents of National Culture* (London: Routledge, 1991), p. 10 and 12.
9 *Ibid.*, p. 12.

10 D. William Davis, 'A tale of two movies: Charlie Chaplin, United Artists, and the red scare', *Cinema Journal*, 27:1 (1987), 60.

11 Astra, for instance, appears to have used the same taglines and images for their *I Spit on Your Grave* and *Blood Feast* video covers, as were used for the films' original exhibition in the US.

12 For further information on the history of classic American exploitation, see Eric Schaefer, *'Bold! Daring! Shocking! True!' A History of Exploitation Films, 1919–1959* (Durham and London: Duke University Press, 1999); and for a discussion of both the production history and key marketing tactics of post-1960s exploitation cinema, see Mikita Brottman, *Offensive Films: Toward an Anthropology of Cinema Vomitif* (Westport: Greenwood Press, 1997), pp. 9–10; John McCarty, *Splatter Movies: Breaking the Last Taboo of the Screen* (New York: St. Martin's Press, 1984), pp. 116–29; and David A. Szulkin, *Wes Craven's Last House on the Left: The Making of a Cult Classic* (Surrey: FAB Press, 2nd edn, 2000), pp. 127–59.

13 See, for instance, Eric Schaefer on the states' rights system, one of a number of classic exploitation distribution practices where the frequent localised modification of advertisements by distributors was the norm. Schaefer, *'Bold! Daring! Shocking! True!'*, pp. 98–9.

14 Duncan Webster, *Looka Yonder! The Imaginary America of Populist Culture* (London: Routledge, 1988), p. 175.

15 Corner and Harvey, 'Great Britain', p. 7. As Corner and Harvey note, this conception of the 'self starter' was originally laid down by Thatcher in a 1982 interview with the *Daily Express*.

16 Except where indicated in subsequent notes, all covers discussed in this chapter are reproduced in Nigel Wingrove and Marc Morris (eds), *The Art of the Nasty* (London: Salvation Films, 1998), pp. 15–42.

17 Tagline for the 1983 Videomedia/Vampix original British video cover for *Tenebrae*.

18 Newman, 'Journal of the plague years', p. 140.

19 *Island of Death*, for instance, had originally been passed with an 'X' by the BBFC in 1976, under the title *A Craving for Lust*. See Wingrove and Morris (eds), *The Art*, p. 23.

20 Wingrove and Morris note that *Love Camp 7* was 'the very first in the wave of sleazy "Nasty Nazi" movies'. See *Ibid.*, p. 24. For a discussion of Mario Bava's influence on not only Lucio Fulci and Dario Argento, but also Roger Corman's *Bloody Mama* and the slasher films of the 1980s, see David Kerekes and David Slater, *See No Evil: Banned Films and Video Controversy* (Manchester: Headpress, 2000), p. 87; and Kim Newman, 'Thirty years in another town: the history of Italian exploitation', *Monthly Film Bulletin* (January 1986), 23–4.

21 '"*Blood Rites*" unleashed', *Video Trade Weekly* (3 March 1983), p. 1.

22 For a discussion of *Blood Feast*'s status as 'perhaps the most influential exploitation film ever made', see Brottman, *Offensive Films*, p. 10; and McCarty, *Splatter Movies*, pp. 46–56 and p. 116.

23 See, for instance, Tim Miles, 'The £100, 000 fall of video nasties "king"', *Daily Mail* (12 August 1983), p. 13, which describes *I Spit on Your Grave* and *Snuff* as 'two of the worst American-produced sadism cassettes'.

24 Superintendent Peter Kruger, cited in Tony Dawe, 'This poison being peddled as home "entertainment"', *Daily Express* (28 May 1982), p. 7.

25 Schaefer, '*Bold! Daring! Shocking! True!*', p. 5.

26 Brottman, *Offensive Films*, p. 9.

27 John Ellis, cited in Steve Neale, 'Questions of genre', *Screen*, 31:1 (1990), 48.

28 Indeed, many of the covers that appear to have been produced exclusively for the British market were illustrated, including Go's *Cannibal Holocaust* cover, Vipco's *Zombie Flesh Eaters* image and Palace's cover for *The Evil Dead*.

29 Corner and Harvey, 'Great Britain', p. 7.

30 See '"Damaged brain" taken to Manchester', *Video Trade Weekly* (20 May 1982), p. 32; 'Guess the brain weight', *Video Trade Weekly* (30 June 1982), p. 6; and advertisement for *The Evil Dead*, *Video Trade Weekly* (10 February 1983), p. 67.

31 See the trade advertisement for *SS Experiment Camp*, reproduced in Kerekes and Slater, *See No Evil*, p. 42.

32 Schaefer, '*Bold! Daring! Shocking! True!*', p. 103.

33 Webster, *Looka Yonder!*, p. 198.

34 Indeed, having surveyed a wide range of British national press articles from the video nasty campaign era, I've been unable to find any articles that employ film stills rather than video covers.

35 Video magazine, *Video Today*, cited in Dawe, 'This poison', p. 7.

36 Don Slater, *Consumer Culture and Modernity* (Oxford: Polity Press, 1997), p. 11.

37 Wingrove and Morris (eds), *The Art*, p. 23.

38 Kerekes and Slater, *See No Evil*, p. 155. According to Kerekes and Slater, *The Driller Killer* was another example of a title that had been trimmed for financial reasons. However, Kim Newman claims that scenes had been left out of the British video version due to Vipco 'botching a reel change'. See Newman, 'Journal of the plague years', p. 139.

39 Wingrove and Morris (eds), *The Art*, p. 18 and 26.

40 1929 *Variety* review, cited in Schaefer, '*Bold! Daring! Shocking! True!*', p. 103.

41 Norman Abbott, Director General of the British Videogram Association, cited in Julian Petley, 'The video image', *Sight and Sound*, 59:1 (1989), 25. Abbott is here referring to the potential for such anomalies to occur in the post-Video Recordings Act industry, prior to the establishment of the Video Packaging Review Committee in 1987. However, as the above examples demonstrate, anomalies between content and advertising were also rife in the unregulated, pre-VRA marketplace.

42 See Wingrove and Morris (eds), *The Art*, p. 24 and 27.

43 See the stickered cover, reproduced in Martin, *The Seduction*, p. 62.

44 Kerekes and Slater, *See No Evil*, p. 126. This is a point of contention, however, as Wingrove and Morris claim that all the Vipco covers for *Death Trap* featured this label. See Wingrove and Morris (eds), *The Art*, p. 32.

45 Schaefer, '*Bold! Daring! Shocking! True!*', p. 124.

46 The most prominent example of this is the cover for *Island of Death*, which is discussed in Wingrove and Morris (eds), *The Art*, p. 23.

47 Schaefer, '*Bold! Daring! Shocking! True!*', p. 124.

48 Petley, 'The video image', 27.

49 For a detailed discussion of Hallmark's original drive-in marketing campaign for *The Last House on the Left*, see Szulkin, *Wes Craven's Last*, pp. 127–59.

50 The sense that this approach was both tactical and disingenuous is compounded by the fact that Replay included graphic stills from *Cannibal Ferox* on the back of its video cover, and stills from some of the goriest scenes from *The Last House on the Left* in the title's trade advertisement. See Kerekes and Slater, *See No Evil*, p. 109; and advertisement for *The Last House on the Left*, *Video Trade Weekly* (20 May 1982), p. 47.

51 Sarah Thornton, *Club Cultures: Music, Media and Subcultural Capital* (Oxford: Blackwell, 1995), p. 136.

52 Indeed, this idea clearly links up with the views of the *Daily Express* critic discussed in the last chapter, who argued that *Visiting Hours* shouldn't be classified with an 'X' but with a 'health warning'.

53 Advertisement for *Last House*, p. 47. The exact tagline used in this advertisement is 'Revenge … that went *too far*', an apparent reworking of 'Can a movie go *too far*?' – the title of a disclaimer used as part of *The Last House on the Left*'s original US advertising campaign. Replay's rephrasing of this tagline appears to have altered its meaning entirely, as the original disclaimer, which both highlighted the public outrage surrounding the film in the US and defended it against such outrage, was meant to function in the same way as Replay's warning labels – appeasing moral protestors while also 'playing up the "controversy"' and utilising it as 'added publicity for the movie'. See

Szulkin, *Wes Craven's Last*, pp. 135–7.

54 Martin, *The Seduction*, p. 53.

55 Thornton, *Club Cultures*, p. 136.

56 *Ibid.*, p. 129 and 136.

57 Webster, *Looka Yonder!*, pp. 206–7. Indeed, as Webster argues (quoting Richard Sparks), the key Thatcherite contradiction between law and order and enterprise could be perceived less as 'a sign of logical weakness' and more as an ideological use of 'multiple strategies', allowing 'the deregulation of the cultural markets [to] stimulate … the very sense of disorder which simultaneously guarantee[d] … the law and order vote'. *Ibid.*, p. 197.

58 The term 'princes of industry' was also used by Thatcher in the earlier cited 1982 interview in the *Daily Express*. As Corner and Harvey note, this use of 'princes' rather than 'captains of industry' can be seen as 'a rather unsatisfactory attempt by the New Right to accommodate traditional conservatism' within the realm of an enterprise paradigm. See Corner and Harvey, 'Great Britain', pp. 7–8. For more on these debates, see chapter 3.

59 For instance, see Mary Beth Haralovich on the lack of enforcement of the Motion Picture Producers and Distributors Association advertising code, as opposed to the Production Code, in the early 1930s. As she notes, 'anyone who has seen films from the early Thirties and compared them to their advertising usually finds a marked discrepancy between the two'. Mary Beth Haralovich, 'Mandates of good taste: the self-regulation of film advertising in the thirties', *Wide Angle*, 6:2 (1984), 53.

60 'New "nasty" from Arcade Video', *Video Trade Weekly* (6 May 1982), p. 11.

61 As a 1983 *Video Trade Weekly* article noted, 'unlike the more recent rash of video nasties, *The Evil Dead* … is most definitely a fantasy film of the highest quality'. See 'Putting the "H" back into Horror', *Video Trade Weekly* (20 January 1983), p. 7. As indicated earlier in the chapter, Palace Pictures (the British distributor of *The Evil Dead*) *did* adopt particular marketing strategies that were as excessive as those used by other distributors. However, if this particular article is taken into account, it did appear that Palace wanted to distance itself from the stigma of the nasties, an approach which seems to correlate strongly with the company's dominant image as a distributor of arthouse and cult titles.

62 See 'Go video supports certification scheme for video cassettes', *Video Trade Weekly* (17 June 1982), p. 8; '"Blood Rites"', p. 1 and 56; and 'Exclusive "Rites" is a dealers delight', *Video Trade Weekly* (10 March 1983), p. 12. Interestingly, this latter article presents Scorpio's reversible cover as not only a form of industry regulation, but also as

a 'unique' commercial gimmick – something which suggests that strik-
ing a balance between commercial and legal imperatives was still a
high priority for such distributors.

63 See Tim Miles, 'Charity shock from "king" of the nasties', *Daily Mail*
(16 July 1983), p. 8; and Miles, 'The £100,000 fall', p. 13.

3

A 'real horror show': the video nasty press campaign

This chapter focuses on what is, without question, the most widely known and written-about aspect of the video nasties phenomenon – the British press campaign which, between the years of 1982 and 1984, was mounted in response to the increasing availability of unregulated horror videos throughout Britain. In line with this, it also brings this book right to the heart of a history of debates around the functions of moral panics within British society and their link to conceptions of national culture and particular scape-goats which are invariably conceived as 'shapeless'[1] and external threats to a British 'way of life'. In 1984, as the Video Recordings Act (VRA) was making its way onto the British statute books, Martin Barker published two pieces of academic work which not only attempted to consider how such press-fuelled moral panics were devised and structured, but also focused on campaigns where horror served as the official embodiment of this 'shapeless' threat – *A Haunt of Fears*, which focused on the history of the 1950s British EC Horror Comics campaign, and 'Nasty politics or video nasties?', which (along with Julian Petley's 'A nasty story') was the first academic attempt to unpick the campaign rhetoric which had fuelled the VRA and sounded the death-knell for unregulated horror videos in Britain.[2]

In both accounts, Barker examines how politically-motivated campaigns (whether left-wing or right-wing) were made persuasive and objective by being channelled through notions of 'ordinari-ness' – of ordinary 'family values', of conceptions of a shared 'British heritage', but, perhaps most markedly, through the 'emotional selling-point' of the threatened child.[3] By eliminating themselves and their true aims and targets from scrutiny and

instead focusing on a black and white 'depoliticised'[4] view of
society where 'all values of life' were 'stored up in children' but
were 'threatened by sadists and molesters, profiteers and
perverts',[5] such campaigns allowed the issue at stake to move
beyond the restriction of cultural products and to focus instead on
the protection of the child. For Barker, it was this key shift in focus
that not only enabled specific political motives to be disguised as
universal, moral and human ones, but also, in the process, allowed
potential supporters to be bound together under a 'broadbased'
and publicly acceptable campaign banner.[6]

Within the specific context of the 1980s, Barker sees this black
and white conception of the threat and the threatened as being
particularly beneficial to those who he perceives as the true motiva-
tors of the video nasty press campaign – the Thatcher government.
For, as he argues, in a climate where social unrest and civil riots
were rife, the connection made between the violent content of the
nasties and the enacting of violence in society (embodied in the
above conflation between 'sadists and molesters, profiteers and
perverts') allowed Margaret Thatcher to deflect attention away
from other causes of crime and allow the curbing of the video
nasties to act as a highly public illustration that violence in society
was being effectively suppressed. In this respect, Barker argues that
the specific ideology and rhetoric of the video nasties campaign
was a clear embodiment of Thatcher's attempt 'to launder the . . .
law and order image' of the Conservative government of the time,[7]
demonstrating not only that the potential 'corruption' of children
into a life of crime, rape and violence was being stymied, but also,
in the process, allowing their firm commitment to a moral
'Victorian' view of family values and the protection of children to
be strengthened – a move which, for Barker, largely secured the
Conservatives' subsequent landslide victory at the 1983 British
General Election.

While there is no doubting the validity of Barker's connection
between Thatcherite motives and the usefulness of the rhetoric of
the nasty campaign, this connection is still made on the basis of a
crucial assumption – that the motives of the Daily Mail (who, as
Barker clearly acknowledges, were the central public instigators
and disseminators of video nasty campaign rhetoric)[8] were entirely
aligned with those of the Thatcher government. For while Barker
perceives the Mail and other British right-wing newspapers to have

operated merely as 'associated propaganda' for a 'political campaign' masterminded entirely by Thatcher,[9] there are a number of factors which suggest that the *Mail* may have had independent motives of its own invested within the rhetoric of the nasty campaign.

Existing at the heart of this is the sense that the *Mail*'s initial investment was not primarily linked to the need to strengthen the Thatcher government's perceived political role in society, but instead to maintain and perpetuate the commercial niche and function that *they* had honed for themselves within the context of the British media. For, as Jeremy Tunstall has argued, while the *Mail* had begun its life as a consensual 'midmarket' newspaper, it had moved, since its decline in sales in the 1970s, not only towards a status as a distinct right-wing skewed publication, but also towards a focus on 'lengthy human interest features', 'largely giv[ing] ... up foreign reporting to become the voice of affluent middle-class, middle-aged middle (or Southern) England'.[10] In this respect, its stake in a new 'insularity in British, and particularly English, culture'[11] (inherent in the model of 'family values' and the child that Barker outlines) could be seen as particularly marked, when considering that this 'insular' and nationally-orientated area of Thatcherite politics had already come to form the basis of the *Mail*'s commercial and political niche within British newspaper culture. Crucially, then, it was this niche of 'human interest', and a concurrent exclusive focus on issues affecting the national (rather than the international), which the *Mail* would therefore have a clear interest in maintaining and perpetuating.

However, while this appears to yet further strengthen Barker's assumption that the *Mail* and Thatcher's motives were aligned and entirely consistent, this is to disregard both the exact historical trajectory of the video nasty campaign and the contradictions inherent in Thatcherite policies of the period – contradictions which were brought to the fore in a key early campaign article from the *Mail* entitled 'We must protect our children NOW'.[12] The article, published on 25 February 1983, has been termed a crucial one by Julian Petley, not only because it was the point at which he marks the true beginning of the *Mail*'s 'Ban the sadist videos' campaign, but also because it represented the *Mail*'s first clear attempt to directly connect itself to legislators and politicians in the Houses of Parliament.[13] How this connection is made is crucial,

however, for, instead of aligning itself with the views of the
Thatcher government, the article is quite clearly constituted as an
attack on government policies harnessed and propelled by, from
the *Mail*'s perspective, the most unlikely of political figures –
Gareth Wardell, a young Welsh Labour MP.

The primary reason for this unlikely counter-alliance can be
gleaned from looking at the immediate political debates circulating
around the video nasties at this time. For, at this point, Thatcher's
views on the issue of unregulated videos were as far removed from
the 'insular' model promulgated by the *Mail* as it was possible to
imagine. Not only, as Barker acknowledges, had Thatcher repeat-
edly stated, up to this point in time, that the issue of regulation
should be dealt with by the video industry itself, but, seven days
prior to the publishing of the *Mail*'s 25 February article, Wardell's
bill to prohibit the rental of videos of an adult category to children
had been unceremoniously dropped by the government.[14]

The key to Thatcher's actions on this issue was undoubtedly her
commitment to the 'restructuring' of British society along the lines
of enterprise, commerce and 'the free play of the market'[15] – a
commitment which, potentially, posed a distinct threat to the
authoritarian and state-orientated axis of power that had been
honed between Thatcher, the *Mail* and other law and order-
focused right-wing campaigners in Britain. In this respect, and
from the *Mail*'s perspective, the dropping of the Wardell bill and
the government's initial entrusting of the video issue to the realm of
the voluntary could be seen to represent a distinct undermining of
the political power of a moral and family-orientated view of society
and all those who promulgated it. Instead, Thatcher was clearly
demonstrating a firm commitment to the remapping of British
society through a free-market-driven model: where businesses had
the autonomy to self-regulate, and where issues that had tradition-
ally been the preserve of conservative moralists were slowly being
snatched away and brought under the jurisdiction of businessmen
representing alternative, commercial concerns to those that charac-
terised the state-focused model so fervently coveted by the *Mail*
and its supporters.

It was therefore at an exact point in time when relations between
Thatcher and the *Mail* were strained, and when their views on the
video nasties issue appeared entirely polarised, that the *Mail* chose
to instigate and lay the groundwork for the video nasty campaign –

a campaign which, while later utilised by the government, was thus largely conceived along the lines of the *Mail*'s, rather than Thatcher's, political and social imperatives. Indeed, what the above discussions and events highlight is that the management of the British video industry could, initially, have gone either way, and that it was thus largely the *Mail* (through its counter-alliance with figures like Wardell and consistent highlighting of the government's drift from traditional conservatism and 'family values') that operated as the primary instigator of Thatcher's famous decision, on 30 June 1983, to allow the state to intervene on the video nasties issue.

To take this a stage further, if the *Mail* was therefore the primary investor in, and rhetoric-creator of, the video nasty campaign, it could also be argued that the *Mail* may have had its own specific targets and 'enemies within' coded into the 'shapeless' threat that the video nasties represented[16] – namely, the new Thatcherite-endorsed video entrepreneurs that posed such a challenge to the moralists' right to be the designated British expert on cultural issues. In order to try to test the strength of such a premise, the chapter that follows will examine the formation and construction of the video nasty campaign from a different perspective to that of Barker's Thatcher-focused model. Firstly, through an exploration of issues and concepts introduced in the key 25 February article, the chapter will consider the extent to which the *Mail*'s allegiance to the rhetoric of 'family values' can not only be perceived as an attempt to keep British society 'insular' and morally-focused but also, more implicitly, to put the potential commercial 'restructuring' of Britain back out on to the margins of society. In order to explore this systematically, the chapter will not look at the *Mail*'s portrayal of the direct effects of horror videos on children and its links to crime, but, instead, will attempt to chart its discussions of the network of commercial activities which were perceived to propel the video nasties from the margins of Britain into the 'insular' domestic world of the threatened child. Crucially, and as I will argue, this commercial network not only implicates a series of bad entrepreneurs and sellers within society, but also a series of nightmare child figures within whom threatening commercial values, rather than the precious 'values of life', are seen to be stored.

By charting the trajectory of this exclusively *Mail*-inspired rheto-

ric from the crucial 25 February article and onwards, the chapter
will, primarily, attempt to assess the *Mail*'s potential role as a
public platform for implicitly anti-enterprise (and thus anti-
Thatcherite) views. However, by exploring how such deeply
embedded campaign elements were later taken up by Conservative
MPs and other sectors of the right-wing press, it will also assess the
extent to which the *Mail*, rather than Thatcher, can be seen as the
prime mover and shaper of a powerful rhetoric which would, ulti-
mately, lead to the implementation of British state video
censorship.

From the centre to the margins and back again: constructing the 'spectre' of enterprise

In the 25 February 1983 *Mail* article, one phrase in particular
seems to neatly encapsulate the nightmare image that the *Mail*
wished to invoke – 'kids filling the parlour up with flickering
filth'.[17] The *Mail* uses this phrase as a means of describing the
content of the letters that Gareth Wardell had received from
distraught parents who had 'stumbled' on their children watching
particular videos in the home, and while it should be noted that this
phrase is not given any particular prominence in the article, it
seems, for me, to have significance and resonance for a number of
reasons. Centrally, what this phrase conveys, through spatial
imagery, is the paper and its implied readers' shared fears about a
potential contemporary Britain in disarray, but also, at the same
time and more implicitly, it establishes what is central and valued
and what should be expelled and externalised from a state-focused
British society.

Firstly, and most obviously, the phrase sets up a shared and
familiar space of certainty (the parlour) which, through its status as
a space occupied by children, is clearly being constructed as a
family space, governed by each of the *Mail*'s interpellated reader-
parents. For David Morley and Kevin Robins, this kind of image is
an established means for the British media to engage with a 'cultur-
al tradition of the Southern upper class', to link together the
concepts of culture, community, nationality and identity, and 'to
articulate' the link between 'the private and public spheres' by
connecting together 'the family and the nation'.[18] The family home
is therefore clearly being constituted here as the key sphere in

which the identity of each British citizen is determined, and the key component that makes up Britain as a nation. And, in this respect, the family space of the home is clearly being presented as a fundamentally public space, where all domestic acts have highly public and national consequences because it is a space which, fundamentally, connects all Britons and which all Britons occupy.

Secondly, and conversely, the phrase also establishes the idea that the family space that binds and connects all Britons should not be 'filled up' with anything and should remain empty, pristine and untouched, like an exhibition in a museum. In many respects, then, the parlour is being presented here as a space that shouldn't be affected by social or political change but should remain in a pure vacuum, cut-off and separated from activities in the modern world. For David Grant McCracken, such attempts to present spaces, ideas or values as pure and separate clearly connects with the need to preserve and protect 'hopes and ideals', which are given meaning by being transposed to another place which exists separately from the everyday and the social. As he argues, 'confronted with the recognition that reality is impervious to cultural ideals, a community may displace these ideals. It will remove them from daily life and transport them to another cultural universe, there to be kept within reach but out of danger. The displaced meaning strategy allows a culture to remove its ideals from harm's way'.[19]

In turn, if one considers that the 'parlour' is a distinctly Victorian term and idea, then this conception of the shared family space can be seen to not only be removed from 'daily life' and the social, but also removed, along the axis of time, from the contemporary world into the 'golden age' of the past. However, if this is the image and model of basic national certainty that the *Mail* is constructing, then what does the imposition of this model suggest and achieve?

Firstly, in the sense that 'reality is impervious to cultural ideals', the rhetoric clearly separates out an ordinary and certain domestic world from the complexities of modern life and, by pushing it into the past, makes it appear long-running and established. While, on the one hand, this allows the *Mail* to compare a proper use of the home to particular examples of its modern misuse, it also, arguably, allows them to invoke a past moral terrain (of the Victorian) where previous conservative alliances were formed, and to portray this terrain as the only certainty and construct that holds, and has always held, all Britons together as national citizens.

By highlighting the established and consistent centrality of this moral focus on the family (the issue and one of 'the impertinent questions' that, for the *Mail*, 'ought to plague us all'),[20] the *Mail* can therefore highlight the drift of the Thatcher government from this past conservative world of strong moral alliances, and portray them as a failed 'law-and-order Government' that 'will not act'.[21]

Secondly, by turning each home into a component of a national and public whole that is structured and determined along primarily public lines, this rhetoric can also directly oppose the Thatcherite discourse of privacy and individual autonomy within the British home. For Don Slater, 'consumer choice is private in the ... negative sense that it is restricted to the household, mundane domesticity, the world of private relationships', meaning that 'any particular act of consumption is private in the sense of having no public significance'.[22] In many senses, this view of consumption as a private act, which has no link or relation to the state and the public sphere, was a key component of Thatcher's aim to present consumption as an autonomous activity, which was unrestricted by determinants of class or national identity.[23] However, by reinstating the idea of the home as a public and state entity, the *Mail* could deny the centrality and influence of this discourse of private autonomy within the home and British society in general and, instead, present it as external, irrelevant and nationally and officially unsanctioned. In turn, by denying the established free flow of other influences in the home, and portraying this space as one where only abstract moral and human values circulate, such rhetoric also allows the *Mail* to reclaim guardianship of domestic activities (including consumption) and thus deny the credibility of all other viewpoints (whether political, intellectual *or* commercial) in relation to this sphere because, as Wardell argues, the 'degredation [sic] of children' and the home is not 'a great political' (and thus complex) 'issue on which we [can] ... argue pros and cons' and there is therefore no 'case for the other side we must consider'.[24]

However, to return to the phrase itself, while the parlour therefore represents what is central, certain and officially sanctioned within British culture, the nightmare image conveyed is of consumption forcibly gaining entry to the parlour. In this respect, while the forces of free and autonomous consumption are portrayed, in an ideal conception, as being irrelevant to the domes-

tic sphere, they are still presented, in a contemporary nightmare image of disarray and breakdown, as threatening the precious space of the publicly-owned home. In one sense, this conception of consumption as extraneous to the home, as something that shouldn't be there, can be seen to have been achieved by separating the idea of the home from the realities and complexities of the modern world via McCracken's 'cultural ideals' process – something which allows commercially and morally-orientated perceptions of the home to seem distinct, rather than parallel and intermingling, discourses in society. However, the use of the word 'filth' to oppose, rather than just separate, the pure space of the moral home and the activities of individual and private consumption hints at something else – something which can even more effectively extricate commercial activities from the inner recesses of society.

The key to this is the *Mail*'s description of the extent and source of the public problem that has initiated this distribution of filth-like videos into the home. For, after outlining the nightmare image of the parlour, they note that 'the problem is now described by some child psychiatrists as "epidemic". In America, where the wave of horror has reached out to envelope such nasties as the purported "live" video of the postmortem of Elvis Presley, parents are buying locks for video machines'.[25] Here, then (and in similar fashion to the Alexander Walker quote discussed in chapter 1), is a key identification of the source of the problem as being America – the place where 'the wave of horror' or, to quote two further examples from another *Mail* article, the 'sea' or 'tide of degenerate filth' is perceived to have most forcibly taken hold.[26]

Perhaps what this invoking of America most clearly indicates is how frequently what Dick Hebdige calls the *'spectre of Americanisation'*[27] lurks behind moral, insular and family-orientated models of the 'ideology of Englishness',[28] regardless of whether, as was the case with the majority of listed video nasties, the scapegoated products themselves derived from a diverse range of origins and traditions. (Indeed, the nasty titles' heterogeneous origins, combined with Barker's focus on a Thatcherite rather than a traditional conservative construction of campaign rhetoric, may explain why he identifies 'Americanization' discourse as being at work in the Horror Comics campaign but not in the video nasties campaign).

Additionally, this focus on ideas of America also illustrates how

frequently political counter-alliances crystallise around anti-American discourse. As Duncan Webster argues, quoting Antonio Gramsci's work on 'Americanism', 'in Europe, it is the passive residues that resist Americanism ... because they have the instinctive feeling that the new forms of production and work would sweep them away implacably'.[29] In this sense, Wardell and the *Mail*, who, as noted earlier, could be perceived to be under threat from a renewed focus on commerce and enterprise in society and its potential to 'sweep' away their political power, seem to be using 'Americanization' discourse here as both a refuge from and a 'revenge' against such rising power and structural change and the Thatcher government that promoted it.[30] Indeed, it is, arguably, this implicit invoking of notions of America that not only allowed the free flow of the market (or 'the wave of horror') to seem external in source but also, through the use of a classic 'Americanization' '"invasion" or "infection" model',[31] to portray the growth of British video retail outlets as an 'epidemic' and video entrepreneurs and retailers as 'filth merchants' and 'peddlers' of not cultural products or forms of entertainment but of disease and contamination.[32]

While these associations remain implicit in the 25 February article (with, aside from the reference to the American 'wave of horror', Wardell overtly presenting video retailers as 'gangster gangs' and 'mafia types'), they are more explicitly developed and consolidated in a later *Mail* article, where, in a special investigation, Tim Miles 'exposes' the culture of horror film production in the US. Focusing on three horror producers (only one of whom is a director of a nasty title), the article presents them as 'ambitious' entrepreneurs who 'wear ... the trappings of success like a well cut suit' and who produce products that when 'neatly packaged into a video cassette' 'will find an appreciative audience in Britain', which 'has provided a fresh outlet' for their product.[33] By focusing on this system of foreign production and dissemination, what this article therefore seems to do is to pull back, even more overtly than the 25 February article, from the growth of British video distribution outlets and instead to fix attention on particular horror films' American production rather than the shifting meaning and significance of their British distribution on video. The overriding aim, therefore, is to implicitly present British horror video distributors and retailers as puppets of American commerce, rather than as

being informed and grounded within a British political context of entrepreneurship and denationalisation.

In turn, the focus on Britain as a 'fresh outlet' allows the phenomenon of video horror, once again, to be portrayed as a disease-like invasion which is contained in, and carried via, a 'neatly packaged' video cassette, an association which is also clearly invoked in an earlier *Daily Express* article (entitled 'This poison being peddled as home "entertainment"'). Here it is noted that 'most of the films come from abroad' and that while 'Customs and police keep an eye out for the worst material at ports and airports ... it is fairly easy for someone to enter the country with a single master video, which can then be copied'[34] – a comment which neatly conveys an idea of a 'master video' from abroad (a foreign source of poison or disease) entering Britain, being copied and distributed internally, and thus spreading and transmitting disease further into British society.

Crucially, this equation of commerce with disease, and of distribution and selling with the dissemination of disease, also has another key strategic use within campaign rhetoric. For by judging a product in relation to the system that disseminates it (a system of 'back-street filth merchants' and 'the video-pusher'),[35] such films can be neatly sectioned-off not as narrative entertainment or, to quote another *Mail* article, as part of the familiar '"normal" run of films',[36] but as drug-like products 'of diseased minds'[37] which, by being connected to the sellers that peddle them and the spaces that disseminate them, can be seen to have one homogenous intention and one potential homogenous effect (to drug, infect or contaminate). In addition, this yet further allows the issue of video horror to be presented not as a commercial issue or an issue of cultural restriction but of social and public health, with horror videos being turned, via such rhetoric, into drug-like or diseased oral or biological objects rather than visual and entertainment-based commodities.

However, while such associations are constructed by connecting products to the, supposedly unlawful, edges of society (to ports, airports and marginal back-street establishments), later campaign rhetoric highlights the subsequent growth of this public health invasion by providing nightmare scenarios of horror videos' existence not in the back-streets but in the high streets and corner shops of British communities. This heightened emotive

tactic was utilised, in its most marked form, during the course of the second reading of the Video Recordings Bill (once Thatcher had initiated the process of state legislation) and was primarily conveyed through abstract descriptions of horror videos being sold in outlets that were purveyors of food and other familiar household goods.

Thus, in a *Guardian* report outlining the progress of the second reading of the bill, Gareth Wardell notes that it was 'quite horrifying for me to find that local greengrocers' shops were quite active in the trade of renting to very young children pornographic and horror video cassettes'; while the key fear for the bill's Conservative instigator, Graham Bright, was that 'we have no way of ensuring that material like this is not sold in the high street like something as innocuous as cornflakes and toothpaste'.[38] By portraying the unacceptable invasion of the high street or corner shop in this way, what such imagery seems to emphasise is the extent to which 'the free flow of market forces'[39] had already begun to infiltrate society, not only overtaking specialist video entrepreneurs but also respectable and established commercial sectors of British society. By existing on the corner rather than the back-street of the campaign's insular, domestic-orientated world, these sectors could be perceived as nearer to the home and family, and thus, within the logic of such rhetoric, should therefore be those who manage the line between a traditional domestic world of consumption (of cornflakes, toothpaste, fruit and vegetables) and a new foreign and marginal one.

Indeed, as an earlier July 1983 *Mail* editorial had noted, it was now becoming 'too easy just to blame the back-street filth merchants', for 'reputable citizens' and 'respectable ... backers' (from corner shop owners to 'fund managers' to British conglomerates with video subsidiaries) were all falling under the spell of diversification,[40] letting diseased commerce into the realm of 'respectable' sectors and communities and thus allowing foreign objects to mix with the everyday oral and biological products of family and childhood consumption. However, if, within the campaign rhetoric, the 'spectre' of Americanised enterprise could travel this far into the recesses of British society (via a series of disseminators whose national values had been overtaken by market-led commercial ones), it could therefore also hold the potential to determine and affect the figure who, as Barker

acknowledges, existed at the heart of this insular view of Britain and its community of families – the child.

Commerce in and out of the playground: the child as sinister consumer and trader

Beyond the scenario of the invaded parlour, another nightmare image is also brought to the fore in the 25 February article (an image which, notably, is seen to incense Wardell more than any other) – the supposed 'freedom of the gangsters who operate hard-porn video shops to go on hiring out cassettes of stark filth to any child with 50p to spare'.[41] While this idea's potency still clearly connects up with a focus on how far the 'free market in such filth' has 'penetrated our society',[42] it can also be seen to hinge, crucially, around the idea that video shops are primarily addressing the child not as a particular and specific kind of vulnerable citizen (a child who is distinct from an adult) but as one among a homogenous many who, by having money in their pockets, are *just* consumers. If, as Barker argues, the child is seen to be owned by, and thus is a construct of, the family and the nation, the 'freedom' of shops to address children in this way can therefore be perceived, by campaigners like Wardell, as a freedom which threatens to eradicate society's carefully constructed '*conception* of childhood'[43] and allows children to 'grow ... up too fast'[44] into adult-style consumers.

However, if this commercial address to the child is therefore seen to potentially erode and re-determine the identity of *individual* children, it can also, for Wardell and the *Mail*, have a key effect on how *communities* of children operate in society. As the *Mail* ominously notes, 'it is three years since teachers first sounded the warning that groups of kids were pooling their pocket money and playing hookey to watch appalling sex-and-sadism videos they had rented'.[45] Like the 'gangster gangs' and '50p' scenario, this image clearly operates around the abhorrent notion of children becoming consumers, but it also has the added rhetorical power of being embedded, once again, in the key conceptual opposition of the campaign. For not only are such children organising themselves into groups based around consumption activities ('pooling their pocket money' to give themselves increased spending power in society) but, in the sense that they are 'playing hookey' from

school, they are also seen to be indulging in such activities away from the national institution of the school (a domain in which they are fervently sectioned off from the rest of society as 'children'). By forfeiting education in this way (and thus cutting-off the power of state authorities to control such activities) such children are there-fore able, within the scope of the rhetoric, to abandon their child-like status and, within the context of a group of the same age, become self-serving, individualist members of consumer consor-tiums – 'little stunted' adults who pool their pocket money to gain equal status with real adults at the video shop and in a restructured consumer society as a whole.[46]

If this is the key fear around which Wardell and the *Mail*'s argu-ment hinges, the obvious solution for campaigners, as Barker notes, was to 'return' such 'stunted' adults 'to childhood' via the influence and action of state authorities.[47] Indeed, if one key 'cultural ideal' mobilised by the campaign was the image of the pure established parlour, then another, built-up and consolidated in campaign articles throughout all sectors of the right-wing press, was the ideal image of the school within a state-orientated society. It is this image that, crucially, appears to be largely based around the use of stories within society as a means of indoctrinating chil-dren into shared national and cultural values, and imbuing them with a sense of themselves as, primarily, moral and cultural beings.

Indeed, this focus on the school's 'ideal' function emerged in, perhaps, its clearest form in an infamous *Sunday Times* article by David Holbrook, published one month before the *Mail*'s 25 February piece. Arguing for the importance of stories to the upbringing and schooling of the child, Holbrook notes that:

> we may observe this provision in any good primary school. Teachers and parents recognise that there is a huge tradition upon which chil-dren may draw, from nursery rhymes to *The Secret Garden* and *Alice*, to develop their sense of what it is to be human and what reality is like … Traditionally, the good family has also protected children against the corruption of the imagination. One of the strangest features of our time is that this important preservation of the tender consciousness of the child has broken down.[48]

Here, then, is a clear model of the importance of stories to a state-orientated society – a source which, rather than restricting or indoctrinating, *preserves* the child's status as a national citizen within the safe confines of the school and (ideally) the home,

through the use of cultural and 'human', rather than commercially-produced, materials. However, just like the rhetorical image of the Victorian parlour, this notion of traditional storytelling can also operate as a conceptual base which can be built upon, enabling it to play a number of other key strategic roles within the campaign. For, while Holbrook delineates *The Secret Garden* and *Alice in Wonderland* as the key essential and natural stories that can circulate freely in a nationally-constituted child's world, other campaign articles overtly extend this tradition, factoring a mind-bogglingly diverse range of modern cultural texts into the realm of familiar children's activities and stories (ranging from Enid Blyton, *Grimm's Fairy Tales* and Edgar Allan Poe to Roy Rogers, Hammer Horror, Walt Disney, *Men Only* and *Swap Shop*).[49]

Firstly, and most obviously, what such a conflation of texts allows campaigners to do is to white-wash the recent past – lining up a historically and culturally diverse litany of reference points and then naturalising them by assimilating them into a commerce-free, culturally active and human tradition of nationally-sanctioned stories. Secondly, it then also allows them to remould and reshape Holbrook's child-orientated cultural model, to create not only an established tradition of cultural stories but also a tradition that is constant, linear and still live and credible within modern British society. Indeed, in the sense that references to Roy Rogers, Enid Blyton and Hammer Horror are factored in, it also demonstrates, at least in the case of the *Mail* and *Express*, how campaigners address their middle-aged audiences, speaking, just as within the realms of the horror comics campaign, with the confidence that their readers 'will instantly recognise their shared upbringing'[50] and their shared childhood experiences and activities.

However, perhaps these newspapers' key tactical use of this carefully constructed British tradition of scary stories and 'childish curiosity'[51] was not just to address and draw their readers into a shared idyllic past culture of childhood, but also, ultimately, to select and amalgamate reference points that were the most rhetorically useful when constructing their nightmare view of the immediate contemporary world. For, as Holbrook's comments should demonstrate, by highlighting a constant, certain and long-running world of familiar story-swapping and scary stories that ran right up to the present day, campaigners were then able to

over-emphasise and amplify the sudden fall from moral and cultur-
al certainty that the activities and 'stories' of today's children
exemplified.

Indeed, while in Wardell's earlier scenario, children were only
perceived to be able to engage in individualist consumption activi-
ties away from the protected and confined sphere of the school,
later articles, using the infamous government-endorsed *Video
Violence and Children* report as key rhetorical evidence, provide
powerful examples of consumption activities *entering* the school
via the hijacking and corrupting of these same established state
networks and traditions of childhood story-swapping. Thus, as the
Daily Star notes, teachers, cited within the report, had highlighted
the existence of a '"horror grapevine" which has schoolfriends
swapping stories of video violence in the playground', and that
'even children from "protected" homes – whose parents take them
and collect them from school – cannot escape the tales of horror
and violence traded in the playground'.[52]

This scenario, which was similarly utilised in a *Daily Telegraph*
article published on the same day,[53] seems, through the selective
use of governmental report evidence, to powerfully visualise and
realise the warning sounded in Holbrook's article. The idea sets up
a nightmare image of an externally-induced 'horror grapevine'
(which cannot be escaped) invading the precious realm of the play-
ground, corrupting the school's story networks, and thus breaking
down the barriers of provision and preservation which had been
erected around protected (and clearly middle class) home-orientat-
ed children.[54] By amplifying the external source of these bad stories
in this way and contrasting them, implicitly, with a natural and
internal culture of traditional stories, the idea conveyed is of a
homogenous disease invading and circulating in the playground of
the school, uniformly taking over each child and eradicating class
and familial determinants in the process.

However, while this therefore seems to invoke a similar concep-
tion of the passive, vulnerable child to the one identified and
discussed in Barker's work, this is to disregard the fact that this
scenario is also dependent on the creation of an inverse nightmare
figure – the child trader, who brings such consumption tales into
the realms of the playground and distributes them amongst his
friends and peers. By doing this, not only are they seen to transmit
disease (in a manner that suggests head-lice or measles) but also to

indoctrinate other children into a world of commerce, where classic state-orientated stories are replaced by traded 'tales' of consumption experiences and activities.

What this demonstrates, within the campaign rhetoric, is just how deeply the nasties, powered by a 'free market in such filth', had 'penetrated our society', moving from an external 'wave of horror' into a reconfigured child's story-swapping network and, in the process, transforming children not only into deviant consumer-adults but also (just like the legitimate businessmen previously described) into internal distributors and disseminators of foreign and diseased culture. In turn, and considering the fact that these bad, consumption-based 'tales' are second-hand stories about these videos that have been gleaned from viewing experiences and then used as a 'status-symbol' by the child,[55] this scenario also powerfully lays out the true horror of commercial, and implicitly Americanised, products being able to 'acclimatise themselves in England' rather than remaining at the level of 'merely a half-understood' and thus marginal 'import' from abroad.[56]

The battle that is therefore clearly being set up is a storytelling battle, where traditional, healthy stories of the state and the insular nation are pitted, within the crucial child-shaping realm of the school, against a wave of new, diseased and commercial ones. And, considering that the ultimate prize of such a battle is control of the child's upbringing, it therefore almost seems to be constituted as a battle for the parentage of modern children, which will ultimately determine the values, priorities and experiences that they will inherit from their childhood and carry into the future. Indeed, as Barker acknowledges, this focus on the potential future of Britain's contemporary children was heavily employed throughout the campaign, stretching from Wardell's claim that 'these evil video gangsters can corrupt a whole generation ... [of] seven-year-olds' to the *Mail*'s warning that 'unless the tide of filth is stemmed, the next generation could be overwhelmed by a diet of sexual horror and brutality peddled by unscrupulous dealers'.[57]

However, when stepping back from such logic, what this battle seems to mirror and truly represent is not the battle for the birthright and future of the child, but for the future of British society as a whole, brought down to the level of children. For these two cipher-like child figures (constructs, respectively, of campaign-

ers' shared values and worst fears) also neatly reflect the wider
struggle between a new commercially restructured view of British
society, and a threatened, potentially undermined, moral, classed
and state-orientated one. In this respect, and as Walter Benjamin
argued in relation to earlier 'Americanization' critics, the *Mail*, the
Express and other traditional conservative institutions 'were right
to perceive that what was at stake was a future – their future'[58] to
police and control cultural domains.

Further, what the analysis above suggests is that the most impor-
tant horror text in the campaign was perhaps not one or more of
the scapegoated video nasties, but the horrific rhetoric of the inva-
sion of home, nation and, ultimately, humanity and identity that
the *Mail* and its allies so carefully constructed in order to counter-
act and marginalise their opponents and enemies. Indeed, as Ken
Gelder argues, in a comment which demonstrates the close align-
ment of 'the rhetoric of Americanization'[59] and the narrative
structure of horror:

> the rhetorics of horror ... provide ways of defining, for example,
> what is evil (and what is good) in societies, what is monstrous (and
> what is 'normal'), what should be seen (and what should remain
> hidden), and so on. These rhetorics are put to use routinely not just in
> horror texts themselves, but in the very same socio-political system
> that can find itself worrying about their proliferation ... Braver souls
> might even suggest that the socio-political system *needs* these
> rhetorics, narratives and so on – that is, it needs horror itself – in
> order to be what it is and do what it does.[60]

By channelling their insecurities into a similarly constructed and
utilised horror narrative – turning what threatened them into a
monstrous 'spectre' of enterprise, investing their own proclivities in
a normal and good construction of society and consequently creat-
ing a nightmare world threatened by an 'Invasion of the
heritage-snatchers'[61] – such moralists were able to shape the video
nasties campaign into their own personal horror film. For this was
a tactic that enabled their social and political ideals and fears to be
powerfully visualised, and thus channel and power a campaign
which would, ultimately, propel Britain to an unprecedented level
of state censorship.

Conclusion: the legacy of bad stories

It is important, at this point, to return to the nightmare image of kids swapping second-hand stories about the nasties in the playground and the claim, made in the *Daily Star*, that this had become a special kind of 'status-symbol' for children in 1980s Britain. If, while it was utilised strategically by the right-wing press, this *was* an activity that was occurring in Britain at that time (and, as I will subsequently show, there is evidence to suggest that it was, at least for some, a very real and meaningful activity that took place within the early 1980s school environment), then what does its perceived social function as a 'status-symbol' amongst British children suggest and indicate?

Certainly, in a way that mirrors Keith Roe's argument on the nasties, it could be argued that by de-officialising horror video commerce and consumption within the pages of their newspapers (and by highlighting teachers' condemnations of such activities), the campaign itself assisted in amplifying the appealing and liberating status of such videos and story-swapping activities and thus, in the process, encouraged 'some pupils to adopt the very values those same teachers ... decry'.[62] Indeed, if, as the *Star* notes, watching 'the most violent and gory sequences' of each nasty title had acquired a heightened currency as a 'status-symbol' among children,[63] then an argument could be made that the public status of such sequence-inspired stories had been generated not just, or even primarily, within the confines of the home, video shop and schoolyard, but also via the discussion of their subversive status within the official public sphere in which the *Mail* and its ilk operated. Further to this, if the press's frequent representation of the nasty titles as a litany of isolated scenes is anything to go by (with, for instance, Wardell delineating the nasties experience as being solely made up of 'hangings, castrations, disembowelling, severings of hands, arms and legs, drillings of the chest, back and forehead'),[64] then it could even be argued that such press-generated discourse helped to shape and determine the dynamic and character of the stories themselves, as well as their perceived currency among Britain's children.

Whether this is the case or otherwise, there is no doubting the fact that the campaigners and their associates had set the subversive seal on the video nasty titles, on the consumption experiences

that surrounded them, and on the spaces of the video shop and the schoolyard where stories of such experiences were perceived to circulate. And it was, as I will subsequently argue, this seal that would not only have framed the meanings of these videos' status, social use and public dissemination within contemporary communities of children, but would also have an impact on the meaning and significance that groups would give to the nasties, and to the memories of such communities, in the future.

For if the British press had made the experiences of this generation into a highly public and notorious issue, then this public discourse (saturated with associations of commercial independence, subversion and abominable adulthood) would continue to have a legacy and significance beyond the passing of the Video Recordings Act (VRA) and the consequent public removal of the nasty videos in 1984. With this in mind, the extent to which this public discourse shaped the childhood video consumption memories of the *Mail*'s theorised commercial, free-market-influenced generation will be explored in the next section, and explored, ironically, through an activity that has traditionally been conceived as an acceptable way for children to learn about and understand the world around them – collecting.[65]

Notes

1 Martin Barker, cited in Duncan Webster, *Looka Yonder! The Imaginary America of Populist Culture* (London: Routledge, 1988), p. 196.

2 Martin Barker, *A Haunt of Fears: The Strange History of the British Horror Comics Campaign* (London: Pluto Press, 1984); Martin Barker, 'Nasty politics or video nasties?', in Martin Barker (ed.), *The Video Nasties: Freedom and Censorship in the Media* (London: Pluto Press, 1984), pp. 7–38; and Julian Petley, 'A nasty story', *Screen*, 25:2 (1984), 68–74.

3 Webster, discussing Barker's work, *Looka Yonder!*, p. 195; Barker, 'Nasty politics', p. 27; Barker, cited in Webster, *Looka Yonder!*, p. 196; and Barker, 'Nasty politics', p. 38.

4 Barker, cited in Webster, *Looka Yonder!*, p. 193.

5 Barker, 'Nasty politics', p. 38.

6 Webster, discussing and citing Barker's work, *Looka Yonder!*, pp. 193–4.

7 Barker, 'Nasty politics', p. 12.

8 Barker, 'Nasty politics', p. 27.
9 Martin Barker, 'Introduction', in Martin Barker (ed.), *The Video Nasties: Freedom and Censorship in the Media* (London: Pluto Press, 1984), p. 2.
10 Jeremy Tunstall, *Newspaper Power: The New National Press in Britain* (Oxford: Oxford University Press, 1996), p. 15.
11 Leon Hunt, *British Low Culture: From Safari Suits to Sexploitation* (London: Routledge, 1998), p. 18. Hunt uses this phrase, specifically, to describe the English cultural response to the rise in Welsh, Scottish and Irish nationalism during the course of the 1970s and early 1980s.
12 Brian James, 'We must protect our children NOW', *Daily Mail* (25 February 1983), p. 6.
13 Petley, 'A nasty story', p. 71.
14 Barker, 'Nasty politics', pp. 8–9; and Petley, 'A nasty story', p. 71.
15 John Corner and Sylvia Harvey, 'Great Britain Limited', in John Corner and Sylvia Harvey (eds), *Enterprise and Heritage: Crosscurrents of National Culture* (London: Routledge, 1991), p. 4; and Webster, *Looka Yonder!*, p. 175.
16 As a number of commentators have noted, the notion of 'enemies within' was a key Thatcherite term and concept of the period. See, for instance, *Ibid.*, p. 203.
17 James, 'We must protect our children NOW', p. 6.
18 Mulgan and Worpole, cited in David Morley and Kevin Robins, *Spaces of Identity: Global Media, Electronic Landscapes, and Cultural Boundaries* (London: Routledge, 1995), p. 53; and *Ibid.*, discussing Cardiff and Scannell's work, p. 66. While the focus of discussion here is the role of British broadcasting and the BBC, it is arguable that comparative claims could be made about Britain's 'midmarket' newspapers. (See Tunstall, *Newspaper Power*, p. 10, for a discussion of the commercial role played by the 'midmarket' newspapers, the *Mail* and the *Daily Express*, since the 1950s and onwards).
19 David Grant McCracken, *Culture and Consumption: New Approaches to the Symbolic Character of Consumer Goods and Activities* (Bloomington and Indianapolis: Indiana University Press, 1988), p. 106.
20 James, 'We must protect our children NOW', p. 6.
21 *Ibid.*, p. 6.
22 Don Slater, *Consumer Culture and Modernity* (Oxford: Polity Press, 1997), p. 28.
23 As Webster argues, Thatcher's ideological promotion of consumer rights can be seen to have been characterised by 'the identification of pleasure with *private* rather than *social* experience, and consumption with property (precisely the right to buy)'. Webster, *Looka Yonder!*, p. 204.

24 Gareth Wardell, cited in James, 'We must protect our children NOW',
 p. 6. For a discussion of how such child and home-focused examples of
 'closed rhetoric' also blocked out the right of intellectuals to voice their
 views on the nasties issue, see Barker, 'Nasty politics', pp. 19–22.
25 James, 'We must protect our children NOW', p. 6.
26 'Rape of our children's minds', *Daily Mail* (30 June 1983), p. 6.
27 Dick Hebdige, cited in Webster, *Looka Yonder!*, p. 182.
28 Ibid., p. 195.
29 Antonio Gramsci, cited in *Ibid.*, pp. 184–5.
30 This notion of a morally-orientated 'revenge' has clear links to Pierre
 Bourdieu's arguments on the cultural battles enacted by different
 sectors of the *petite bourgeoisie* in 1970s France. As he argues, when
 faced with a situation where 'their values, and even their conception
 of their job [are] threatened by the arrival of new ... generations
 bearing a new ethos', socially declining class factions 'only have to
 place themselves on their favourite terrain, that of morality' in order
 'to have their revenge'. Pierre Bourdieu, *Distinction: A Social Critique
 of the Judgement of Taste*, trans. Richard Nice (London: Routledge,
 1984), p. 353.
31 Webster, *Looka Yonder!*, p. 191.
32 Among numerous examples of the campaign's use of the phrases 'filth
 merchants' and 'peddlers', see 'Outlawing the sadism-pushers', *Daily
 Mail* (1 July 1983), p. 6; and Lord Coggan, cited in Tim Miles,
 'Sadism for six year olds', *Daily Mail* (24 November 1983), p. 2.
33 Tim Miles, 'The men who grow rich on bloodlust', *Daily Mail* (4
 August 1983), p. 18.
34 Tony Dawe, 'This poison being peddled as home "entertainment"',
 Daily Express (28 May 1982), p. 7.
35 'Video sadists and respectable dupes', *Daily Mail* (4 July 1983), p. 6;
 and 'Rape of our children's minds', p. 6.
36 Richard Neighbour, 'Hooking of the video junkies', *Daily Mail* (13
 August 1983), p. 8.
37 Lord Coggan, cited in Miles, 'Sadism for', p. 2.
38 Wardell and Graham Bright, cited in 'MP demands gaol terms for
 video nasty sellers', *Guardian* (12 November 1983), p. 3.
39 Labour MP Dennis Skinner, cited in Petley, 'A nasty story', p. 73.
40 'Video sadists', p. 6. See also Tim Miles, 'Buying into the sex and
 horror business', *Daily Mail* (1 July 1983), p. 2; and Stewart Payne
 and Bryan Carter, 'Video share deal shock', *Daily Mail* (4 July 1983),
 pp. 1–2.
41 James, 'We must protect our children NOW', p. 6.
42 'Advertisement for evil', *Daily Mail* (27 February 1985), p. 6; and
 'We must stamp out this evil', *Daily Star* (24 November 1983), p. 8.
43 Barker, 'Nasty politics', p. 26.

44 *Ibid.*, p. 33.
45 James, 'We must stamp out this evil', p. 6.
46 Matthew Davenport Hill, cited in Barker, 'Nasty politics', p. 32. Barker uses Hill's comments, which were part of his contribution to a 'Select Committee inquiry into the causes of juvenile crime' in 1855, to demonstrate how working-class children are frequently implicated in British moral panics (a point in his argument where he *does* begin to identify a parallel nightmare child figure at work within the nasties campaign, albeit in order to make a Thatcherite-orientated link between 'street violence' and the working classes). While my aim here is to map how a consumer-orientated, rather than a crime-orientated, child is implicated in the campaign, the ability for both consumer-children and juvenile children to be seen as abhorrent 'stunted' adult figures does indicate that a connection between consumption and the working classes is clearly at work in newspaper-generated nasty campaign rhetoric. Indeed, this connection with the working classes, as chapter 1 indicated, was a key element in left-wing critiques of Thatcher's 'free market' political model (see Webster, *Look a Yonder!*, p. 204) and was thus, arguably, a tactical approach which could be utilised by all those 'passive residues' who wished to oppose such a model (both left-wing *and* traditional conservative).
47 Barker, 'Nasty politics', p. 33.
48 David Holbrook, 'The seduction of the innocent', *Sunday Times* (2 January 1983), p. 14.
49 Lynda Lee-Potter, 'Switch off the nasties', *Daily Mail* (29 June 1983), p. 7; John Mortimer, 'Censors: the real video nasties', *Sunday Times* (4 March 1984), p. 54; 'Rape of our children's minds', p. 6; Dawe, 'This poison', p. 7; Gareth Renowden, 'The secret video show', *Daily Mail* (12 May 1982), p. 12; and James, 'We must stamp out this evil', p. 6.
50 Barker, discussing the rhetorical approach of horror comics campaigner George Pumphrey, cited in Webster, *Look a Yonder!*, p. 195.
51 James, 'We must stamp out this evil', p. 6.
52 Catherine Evans, 'Video nightmare', *Daily Star* (24 November 1983), p. 4.
53 Robin Stringer, 'Video nasties watched by five-year-olds', *Daily Telegraph* (24 November 1983), p. 3. It is, admittedly, the case that the utilisation of 'playground' evidence from the *Video Violence and Children* report was confined to the *Star* and the *Telegraph*, with the same day's *Mail* and *Express* choosing, instead, to focus on evidence (from the same report) of birthday parties where video nasties had allegedly 'replaced the conjuror and children's games'. See Miles, 'Sadism for', p. 1; and Don Coolican, 'Four children in ten watch

video nasties', *Daily Express* (24 November 1983), pp. 1–2. However, it is still the case that the concept of abhorrent consumer-children 'pooling their pocket money', on which such images of playground disarray clearly depend, was an idea conceived and pioneered exclusively by the *Mail*. Indeed, the 'pooling the pocket money' phrase and concept would prove to be a highly influential one, reappearing not only in later *Mail* articles and editorials but also in comments made to the press by Graham Bright at the time of the second reading of the Video Recordings Bill (see, for instance, 'MP demands', p. 3).

54 Again, the notions of 'protected' and 'unprotected' children clearly suggest that there is a class dimension embedded in such comments (with working-class children being implicated as the key spreaders of diseased commercial values throughout Britain). Julian Petley has also focused on the significance of such comments, and has argued that the use of this playground evidence, in the original *Video Violence and Children* report, was a clear attempt to scapegoat working-class (or 'underclass') children. See Julian Petley, 'Us and them', in Martin Barker and Julian Petley (eds), *Ill Effects: The Media/Violence Debate* (London: Routledge, 2nd edn, 2001), pp. 177–8. What this therefore, once again, demonstrates is how the demonisation of the working classes could reap rhetorical benefits for both traditional right-wing newspaper campaigners (through associations with the market and consumerism) and the Thatcher government (through associations between the working classes and crime).

55 Evans, 'Video nightmare', p. 4.
56 Terms borrowed from George Orwell's classic anti-American critique of James Hadley Chase's *No Orchids for Miss Blandish*, cited in Webster, *Looka Yonder!*, p. 189.
57 James, 'We must stamp out this evil', p. 6; and Christopher Rowlands, 'Scarred for life', *Daily Mail* (17 October 1985), p. 2.
58 Walter Benjamin, cited in Webster, *Looka Yonder!*, p. 185.
59 *Ibid.*, p. 191.
60 Ken Gelder, 'The field of horror', in Ken Gelder (ed.), *The Horror Reader* (London: Routledge, 2000), p. 1.
61 Webster, *Looka Yonder!*, p. 199.
62 Keith Roe, cited in Barker, 'Nasty politics', p. 35.
63 Evans, 'Video nightmare', p. 4.
64 Gareth Wardell, cited in Gordon Greig, 'Video victory!', *Daily Mail* (12 November 1983), p. 2.
65 See, for instance, Susan Stewart's discussion of Montiesor's book on children and collecting, in Susan Stewart, *On Longing: Narratives of the Miniature, the Gigantic, the Souvenir, the Collection* (Baltimore: Johns Hopkins University Press, 1984), p. 162.

Cults, collectors and cultural memory

Mapping out the territory of a fan culture: video nasties and the British horror magazine

In her ground-breaking study of the politics of music subcultures, Sarah Thornton is quick to identify the importance of what she calls the 'subcultural consumer press', not only through their role as subcultural commentators, but also subcultural mediators, leaders and originators. As she argues, 'consumer magazines operate in *subcultures*. They categorize social groups ... give definition to vague cultural formations, pull together and reify the disparate materials which become subcultural homologies. The music and style press are crucial to our conceptions of British youth; they do not just cover subcultures, they help construct them'.[1]

As Kerekes and Slater note in their account of the growth of a video nasty collecting culture in Britain, old ex-rental copies of video nasty titles – sold off by video shops and dealers before the Video Recordings Act (VRA) came into force – began to re-emerge and proliferate, throughout the late 1980s and early 1990s, in car boot sales and market stalls throughout Britain.[2] As this newly formed secondary video market began to take shape, a mediating publication of the kind described by Thornton could therefore be perceived to be necessary, if 'definition' was to be given to the video nasties' subcultural potential and interested parties were to come together to form a new second-hand collecting community. During this time, two British horror magazines, arguably, began to fulfil that role: *Fear* (which began in the late 1980s and folded in the mid-1990s) and *The Dark Side* (*Fear*'s clear successor, which emerged in the early 1990s and is still published up to the present day).

However, it is here worth asking: what exactly made these publi-

cations so central to this emerging fan community? By considering some observations from Thornton's work, this chapter will attempt to explore exactly how the boundaries of this burgeoning subculture were set up and maintained by such publications and, in turn, how they therefore assisted in constructing a new existence for the video nasties as collectible and subcultural objects. While the chapter will explore the influence of both magazines on the construction of key subcultural rules and hierarchies in the video nasty fan community, the primary focus of discussion will be around the more influential and longer-running publication *The Dark Side*, with my research findings being drawn from a sample of thirteen randomly-selected issues of *Fear*, from July 1988 to November 1990, and thirteen issues of *The Dark Side*, stretching from March 1992 to September 2002.

Keeping the faith and banning the corporate: the setting up of a reader/editor collective

Firstly, it is worth considering exactly how such publications gained the patronage of interested parties and would-be nasty collectors in the first place. Arguably, what is most apparent, when surveying issues of *The Dark Side*, is that it is frequently, and overtly, concerned with constructing its identity in opposition to rival horror magazines, and to thus indicate to readers not only what it stands for but also what its readers should stand for. It is true that *The Dark Side*, with its glossy, tasteful cover art and reasonably high production values, could not, technically, be labelled a fanzine (which, arguably, would be seen as more authentically subcultural, through its status as an amateur, fan-produced publication). However, by the same token, *The Dark Side* could not easily be labelled as a prozine or, at the very least, it struggles very hard to present itself as opposed to the values of a prozine. For David Sanjek, the horror prozine is exemplified by the American publication *Fangoria*, and differs from the fanzine in its emphasis on the make-up artist or special effects supervisor and its tendency for 'articles [to] resemble press kits, replete with interviews of cast and crew and premature praise of the unfinished product'.[3] *Fangoria* was first published in 1979 and, by the time *The Dark Side* appeared in the early 1990s, was an internationally known product, recognised on both sides of the Atlantic as a central organ of the horror scene.

Thus, in order for *The Dark Side* to carve out a unique commercial identity and compete against such a well-established product, *Fangoria* had to become the 'other' of all that *The Dark Side* stood for – an emblem of the subculturally inauthentic, and the exemplar of the supposedly corporate-influenced prozine that they wished to define themselves against. For, while *Fangoria* is discussed both positively and negatively in *Fear* (at one point the word is used as a swear-word, 'F*******', by one letter-writer),[4] *The Dark Side* appears to take this one stage further by directly contrasting their own serious and transgressive values to those of *Fangoria*. Thus, when one letter-writer accuses *The Dark Side* of pandering to 'brown-nosing pubescents', *The Dark Side* is quick to retort that 'we very rarely touch upon the Jason/Freddy films and steer clear of lengthy set reports from new horror movies, preferring to concentrate on interesting obscurities'.[5] Although *Fangoria* is not directly cited here, it is quite apparent to whom *The Dark Side*'s editor is referring – it is a form of cultural shorthand that all regular *Dark Side* readers would be quick to pick up on and interpret as a call to oppose *Fangoria* (and its connotations of the new and vacuous) and embrace the obscure, old and authentic films that *The Dark Side* champions and discusses.[6] Thus, while *Fangoria* is presented as a commercially-orientated publication, existing in the pockets of Hollywood producers and mainstream horror films and attracting teenage readers looking for the newest horror movies, *The Dark Side* clearly presents itself as encouraging the patronage of readers with deep-rooted knowledge of bizarre and marginal films, and the seriousness required to engage with the task of hunting down 'interesting obscurities', of the kind exemplified, at this time, by the defunct video nasties.

As in Thornton's discussions of rave culture, what *The Dark Side* therefore appears to be encouraging is the setting up of distinctions between different kinds of horror fans – between the teenage horror crowd who are frivolous, clueless and mainstream horror-focused, and the serious enthusiasts who are prepared to work hard for their interest, live on the edge and 'keep ... the faith' (to coin a 2001 *Dark Side* editorial).[7] In turn, these distinctions appear to have been established not only to promote the uniqueness of *The Dark Side*, but also to give some indication to readers (and would-be collectors) as to what they should oppose and what they should value. What this therefore allows for is the emergence of an 'identi-

ty project', where the values of the magazine and the potential reader are carved out in tandem, with the magazine and its editor being constituted as the key subcultural prime mover – leading the way and establishing the ground rules.

The niche that *The Dark Side* therefore carves out for itself is not fanzine or prozine, but glossy subcultural consumer guide. It not only rejects the commercial values that *Fangoria* supposedly stands for, but also embraces horror fanzine culture, providing a regular 'Fanzine focus' report, which reviews and recommends fanzine issues to readers and provides regular advice columns on how to start up a fanzine and how to become involved in fanzine publishing collectives. By carving out this identity, and by placing itself so self-consciously in relation to publications that exist either side of it, *The Dark Side* thus also advertises itself as a horror fan community mediator. Neither mainstream nor amateur and inaccessible, it presents itself as a true consumer guide: devoid of gimmicks and serious about its commitment to both its readers and the culture of horror video collecting through which the editor/reader relationship frequently operates.[8]

However, if this closeness between reader and publication is partially conveyed through its alliances and oppositions with other relevant magazines and fanzines, it is more markedly consolidated via two sections which operate as 'gateways' to the British horror fan community[9] and are promoted as features that break down barriers between reader and publication – the listings section and the letters page, which runs to six pages in most issues. Two factors assist in promoting the idea that these sections are 'gateways' into the magazine, and into a subculture. Firstly, both *Fear* and *The Dark Side* openly promote these sections' gateway function by regarding them as 'ways in' to connecting with horror fans and collectors in Britain and throughout the world. Thus, *The Dark Side* promotes its classified section as the 'most cost effective way to reach 60,000 horror fans!!',[10] and letter-writers further respond to this by asking *The Dark Side* to 'print my address so that like-minded headcases can contact me'.[11]

This approach further indicates the importance of *The Dark Side*'s role as a mediator figure, allowing fans over large geographical distances to hook-up with each other. However, it is also important to note that *The Dark Side* doesn't just mediate (and thus not directly engage with) this dialogue, but frequently

becomes part of it, through the personalised role of *The Dark Side*'s editor, Allan Bryce. For Thornton, this dual editorial role, where the magazine editor exists as both advisor/leader and fellow fan, is a common subcultural phenomenon and can contribute greatly to the relevance and appeal of any subcultural consumer publication. As she notes:

> *aficionados* who become the writers, editors and photographers of the subcultural consumer press have at one time or another been participants in subcultures and still espouse versions and variations of underground ideology. There is a fraternity of interest between the staff *and* readers of these magazines, not only because they are of the same sex, but because they share subcultural capital investments.[12]

This 'fraternity of interest' between staff and readers of *The Dark Side* is primarily promoted through the figure of Bryce, as editor and, in many ways, friend to the horror fan and collector. His image and input is stamped all over the magazine (every issue including an introduction, signed by and accompanied by a photograph of the man himself), and his personality and opinions pervade the six pages of the letters section of every issue of the magazine. In turn, letters sent to *The Dark Side* clearly engage with this imputed fraternal bond between Bryce and his readers, with readers often addressing letters to Bryce rather than the magazine itself, and the voicing of opinions by fans and collectors often being followed by asides ('sorry Allan' or 'you were wrong, Allan') if views have clashed with those put forward by the editor in previous issues.

What emerges, through this heightening of the editor's personality and authenticity as fellow collector and fan, is a relationship between reader and publication where autonomy swings both ways. On the one hand, the autonomy of the editor as subcultural leader is promoted, firstly, through Bryce's relationship with and insider knowledge of specialist horror video and DVD companies (for whom he provides quotes for video covers and source material, such as imported laserdiscs, for new re-releases) and, secondly, through his mediating role as guide through the magazine, leading readers who want to get involved in the collecting scene to the classified section, or readers who want to know about the nasty titles to previous articles and features that have been published on the topic.

However, on the other hand, Bryce will often concede his lack of knowledge about a certain title or video version and then open up debate to readers, asking them to respond to a fan who requires particular information. Thus the dynamic of the relationship is such that Bryce will offer up advice and knowledge based on his particular collecting experiences, but will also acknowledge that other fans will have equally valid experiences. Consequently, many letters written to the 'Post mortem' section will not just ask questions, but provide answers to questions – imparting experiences of car boot sale acquisitions, the merits of one video version of a title over another, or, as is frequently the case, suggesting features that could and should be published in future issues of *The Dark Side*.

What is apparent is that, within the confines of the letters page section, while Bryce is, fundamentally, the leader and shaper of any discussion or act of information-swapping (and mediator between each fan and commercial companies and organisations), he is not always the primary knowledge-holder – only able to offer advice based on his own collection and collecting experiences, and often seeking input from others to paper over the cracks. What emerges, when surveying 'Post mortem' discussions over a number of issues, is that this pooling of knowledge promotes the idea that reader and editor are almost interchangeable, and that the autonomy of the fan, as Bryce's fellow collector and knowledge-holder, is both highlighted and encouraged.

It is therefore this collapsing of hierarchies between reader and editor that most markedly promotes this sense of closeness, fraternity and solidarity, and it is this closeness and fraternity, over geographical distance, which is often identified as being central to fan cultures.[13] In addition, this idea of an advisory collective between 'real', 'true' and 'serious' collectors (whether editors or readers) yet again conveys the idea that the magazine is promoting an authentic, grassroots culture where all are welcome, as long as their interests are never commercial.

However, to take this a stage further, it is also worth noting that there is not just a collapsing of hierarchies between reader and editor that occurs over the course of letters pages and classifieds, but also the breaking down of the barriers between the roles of producer, distributor and consumer of the products concerned. In this sense, if the magazine's 'Fanzine focus' section provides reports and information about horror fanzines but also encourages

readers to get involved themselves (and form publishing collectives), the same grassroots approach is also promoted in the letters pages and, most markedly, in classified sections.[14] Thus *Fear* not only promotes and encourages involvement in classifieds by warning readers not to 'miss your chance to reach the horror/SF/fantasy world', but also excludes any sinister or unwelcome commercial interests by noting that the service 'is not open to trade or commercial advertisers',[15] aside, of course, from fanzines. Here trade is only encouraged on a small-scale, grassroots level and readers are urged not only to obtain original nasties and other horror videos, but also to swap them or sell them (for cash) via advertisements. Thus, once again, it is clear that the autonomy of the fan over the videos concerned (whereby they don't just consume them, but own and distribute them, and archive them in their collection) is actively being encouraged and, overall, the impression given is that these videos, rejected and prohibited by society at large, have now become exclusively the collecting community's property – to own, to discuss and to trade.

Perhaps nothing so clearly demonstrates this subcultural goal of providing readers with a feeling of complete autonomy over, and ownership of, these videos than the appeal from video company Taste of Fear, which appeared in a 1995 issue of *The Dark Side*. Here the director of the company put a direct 'S.O.S.' out to readers[16] asking them to provide relevant publicity material, stills and artwork for old horror titles that they were planning to re-release on video, and, as promised, classified advertisements were later placed by the company whenever the need to plunder fans' archives arose. What this example demonstrates is that, over and over again, readers are portrayed as the experts: the parties who not only contribute to subcultural debate, but can also construct and play a role in distribution networks (through classifieds and letters of advice) and assist commercial companies in commercially reproducing the videos themselves. Not only by giving new meanings to these videos by placing them in their collections, but also by affecting the artwork or (in Bryce's case) the print of a particular video or DVD re-release.

However, if such discourses help to construct a harmonious image of a subcultural world, where everyone is welcome to participate and enter a community of individual autonomy and collective solidarity, it is worth remembering that this autonomy and solidar-

ity is still based on the fundamental exclusion of the 'other' – the corporate, the commercial, the inauthentic. Thus, if any interested parties want to benefit from the nasty collecting community's experience, they still have to be filtered through, and vetted by, *The Dark Side* itself in order to gain access to the knowledge and rare videos around which the magazine draws its boundaries. For, if one form of exclusion enacted by the magazine is the negating of the overtly corporate and commercial, a further inner boundary is also clearly drawn around the fans and collectors themselves. It is through this inner boundary that potential members of the collecting community are filtered, and its policing by the magazine is consistent and clearly conveyed, as the next section of the chapter will illustrate.

Withholding information and drawing a line between the knowledgeable and the inauthentic horror fan

The previous section attempted to explore the dual role that Bryce and *The Dark Side* occupy in relation to the nasties subculture, playing, at different moments, the role of colleague and friend, and mediator, leader and information-provider, to the collector. However, although this is the framework through which *The Dark Side* demonstrates its function to British horror video collectors, it is worth considering whether the publication is as democratic as it might first appear. Although, on many occasions, Bryce will answer a reader's query in a straightforward fashion – giving a long and detailed answer, which provides advice and information based on Bryce's collecting experience – there are other occasions where answers and responses become shorter, more elliptical and more ambiguous. In most cases, the type of reply received will depend on the kind of question the reader asks and, in some cases, it may be 'the wrong question' that elicits an elliptical and ambiguous response.

One particular example of this occurs in a *Dark Side* issue from 1998, where a collector notes his recent acquisition of an imported Dario Argento laserdisc and suggests a trade (for other Argento films) via Bryce himself. In response, Bryce provides an answer which is short and abrupt, albeit rather jokey, noting that 'swapping uncertificated laserdiscs is a bit of a dodgy area that we can't, unfortunately, get involved in. Carefully worded classifieds seem

the best bet, not that we'd encourage such a thing of course'.[17]

Although it should be noted that Bryce's tone is still friendly here, and that information is passed on to the reader (via a kindly redirection to the classified section of the magazine), the abruptness of his response does seem to suggest that the reader has been given short shrift for going about subcultural matters in the wrong way. By asking Bryce to become directly involved in the exchange of uncertificated goods, the reader is, unintentionally, exposing Bryce's unspoken role as mediator and constructor of an illicit distribution network, and using the incorrect facility (a letter, rather than a classified) in order to become part of this network. Thus, the reader has made the double *faux pas* of making hidden relationships (between reader and editor) too explicit and apparent, and thus also exposing his lack of knowledge of subcultural rules. In response, all Bryce is able to do is to carefully correct the reader's mistake, but, at the same time, distance himself, and the more advisory sections of the magazine, from any direct association with the network that exists in another part of the publication.

What this all suggests is that, although the flow of collecting information between reader and editor is a central function of *The Dark Side*, the withholding of information, in certain contexts, is also essential if illicit networks are to be policed and the boundary between 'us' (the fans/collectors) and 'them' (the subcultural layman or 'inauthentic' horror fan) is to be maintained. However, if this particularly telling dialogue occurred on the letters page, it is, more generally, the classified section of the magazine where such information is withheld or made vague. As Thornton notes (albeit discussing listing magazines rather than classifieds), 'listing magazines are available from any newsagent, so they manage the flow of information with degrees of cryptic shorthand, innuendo and careful omission. Their gatekeeping can often establish the boundaries of the esoteric, protect the feel of the underground and mitigate overexposure'.[18]

What is clearly apparent when surveying classified sections in both *Fear* and *The Dark Side* is how carefully this shorthand is employed and maintained by British horror fans and collectors, in order to pass information to the 'right kind' of people while denying access to the 'wrong kind'. Thus while, once again, both publications hide the fact that they are involving themselves in the trade of video nasties or other uncertified, and thus illegal, video

versions (*Fear* by using the vague, non-committal disclaimer 'it is illegal to trade in uncertificated films', and *The Dark Side* by employing the more blatant and jokey moniker 'no dead horses or video "nasties" please'),[19] a variety of codes of varying degrees of subtlety are frequently used to pass on the information that a nasty (or other, uncertificated version) is required or available without actually mentioning the word 'nasty' in the advertisement copy.

Although it would take too long to list all types of codes employed, there a number of key tactics which are frequently used:

1. A list of key directors of nasty titles is given, rather than naming any specific films (e.g. Argento, Fulci, Bava, D'Amato).
2. A list of pre-VRA distribution companies is given, rather than naming any specific films (e.g. Go, Vampix).
3. Reference is made to the fact that the videos are old and original pre-recorded rental tapes (e.g. 'pre-1984 originals', 'originally boxed films' or 'pre-certificated originals').[20]
4. Reference is made to the scarcity of the videos concerned (e.g. ultra rare horror films no longer readily available).
5. Reference is made to the fact that the videos are import versions from abroad, or alternatively the placer of the advertisement has a foreign address (e.g. small Dutch or Swedish video companies).

It could be argued that the use of such codes is a necessity rather than a self-conscious subcultural strategy, when considering that the trade of such videos is illegal and that editors and readers therefore have no choice but to hide the overt identity of the video versions concerned. However, it could equally be argued that this is what makes nasty collecting so ripe for subcultural redefinition in the first place, and so open to the use of implicit and exclusive codes and shorthand.

However, if such advertisements, primarily, demonstrate how the videos themselves were coded and disguised, they also give indications of the collector etiquette that is employed within the confines of this uncertified video distribution network. Firstly, the majority of advertisements (either asking for films, selling films or swapping films) indicate quite clearly that they deal in quality product only (i.e. that all videos are originals and not copies, with original boxes and original covers). While, on the one hand, this

provides an intriguing example of how original pre-recorded nasty videos, boxes and covers were beginning to be perceived as authentic and collectible, it also indicates that, in order to trade in this way, swappers, sellers and buyers had to maintain a respect for others in their makeshift distribution network and not attempt to, bluntly put, 'rip them off'.

Secondly, and in marked contrast to the previously cited letter-writer who explicitly attempted to involve Bryce in the trade of uncertified videos, such advertisements clearly indicate that communication between collectors should occur in gradual stages. Thus, advertisements frequently provide particular hints about the sort of videos available and then suggest that any interested parties should either phone for a more specific list, send a list of 'wants' to the advertiser's address, or that the advertiser and the interested party should swap lists. What this suggests is that communication, via the magazine/mediator, should be brief and that there should only be a hint of the more personal one-to-one communication that might follow later (where, presumably, specific titles and versions will be named, away from the confines of the magazine, in lists or phone calls).[21]

Overall, what the use of such codes and rules suggests (and the short shrift that is given if such rules are misused or disrespected) is that the magazine may mediate and provide essential information, but it does not do all the work for the reader. Instead, it appears to be an unspoken rule that knowledge of the magazine's codes, and of the nasty titles themselves, must be gained before any direct communication between collectors is made.

However, the question remains: how is this knowledge conveyed to collectors in the first place? For a number of readers, knowledge of the titles themselves may already have been gained via direct experience of renting, talking and reading about the nasties in their pre-1984 existence. Indeed, such readers are clearly given a position of privilege and receive a special level of interpellation within the confines of the magazine, an issue I will return to later in the chapter. However, for newer and younger fans concessions are occasionally made, with information being intermittently doled out in the form of special issues on the nasties (two nasty issues were published in *The Dark Side* in 1992 and 1996, with the second issue being produced due to reader demand and the fact that the original issue had sold out).[22] For Bryce, such special issues

are a means of welcoming new collectors into the fold and, as he puts it, 'to help less knowledgeable readers compile their shopping lists'.[23] Perhaps, more cynically, it could be suggested that such issues are a means of gaining more readers when circulation is low, but even if this is the case the publication of such issues and their popularity amongst readers clearly demonstrates two key factors. Firstly, the fact that the currency and relevance of information on the nasties was consistently acknowledged by readers and, secondly, the central role *The Dark Side* played in terms of highlighting the continued currency of this information and thus reviving and perpetuating the subculture when interest, intermittently, flagged.

However, while this, once again, suggests that the magazine is a welcoming organ that allows the unregulated flow of such information, this is to disregard the fact that such concessions to newcomers are fundamentally intermittent occurrences. Thus, on a number of other occasions, requests for specific information from readers are categorically refused by the editors of both magazines. For on a more day-to-day basis, particular queries, which either involve the magazines producing copious amounts or lists of information or spelling out hidden and implicit facts about the distribution network, are frequently greeted with bewilderment by their respective editors.

Thus, regular reader requests for lists of running times and cuts to particular video versions are frequently refused in both publications, and the implicit impression given is that such readers are time-wasters or curious 'tourists', who have not taken the time to accumulate this knowledge gradually, or who display a distinct lack of personal investment in the nasties phenomenon, or who indicate an unwillingness to take risks and involve themselves in illicit practices. As Will Straw notes, of collector logic in general (and its relation to ideas of 'hipness'), 'hipness almost always requires a knowledge which is more or less cultivated, but must repress any evidence that this knowledge is easily acquired in the mastery of lists or bookish sources. In this respect, as Andrew Ross suggests, hipness is one point in an economy which threatens to flounder on the opposed alternatives of being over- or under-informed'.[24]

Two particularly illuminating examples, which display this tendency to 'flounder' when excessive amounts or inappropriate kinds of information are required, both occur in the pages of 'Post mortem', in two separate issues.

The first query is from a clearly more experienced collector who, firstly, requests a list of 'sell-through tapes' with details of which 'are fully uncut, and on which label', and then asks Bryce if he can 'get the BBFC to release the Vipco [video company] titles fully uncut' because he is 'sick of paying £25 per tape from Holland'.[25] In response, Bryce appears bemused, beginning his reply with the comment 'you don't want much, do you?' and then failing to act on either request.[26] Here, the letter-writer has made subcultural errors on three counts: 1) by requesting too much information that he should have already attempted to gain access to; 2) by revealing his lack of knowledge of British censorship practices; and 3) by complaining about the fact that he has to work hard to obtain information and engage in illegal practices in order to collect uncut or defunct horror videos. By revealing his lack of subcultural mettle in these ways, this reader appears to be dismissed by Bryce and denied access, at least on this occasion, to further help or advice from the magazine.

An even more marked example of this kind of response occurred one year earlier, in a 1998 issue, where another letter-writer not only admits to having just started to read *The Dark Side*, but also confesses to the fact that he is 'rather uneducated in the ways of the horror film' (surely an approach which marks his card as an 'outsider' from the outset). The letter then provides a long list of queries, but the most revealing one relates to the classified section of the magazine. As the writer notes, 'after seeing European companies offering the films of Fulci, Hooper etc. for sale, I take it these are advertisements for films legally unavailable in Britain. What is the legal status regarding such companies? I am only trying to avoid a criminal record'.[27]

While, in many senses, this is a perfectly reasonable question to ask, this reader sets himself up for a fall in this context by exposing his lack of knowledge of British censorship practices and the magazine's rules and codes. However, even more than the previous letter-writer (who appeared unwilling to exert any more effort into hunting out illegal video versions, but at least demonstrated that he had done so in the past), this query gives the impression that the letter-writer is not prepared to 'work hard' to become a horror video collector. Instead of reading back issues, obtaining knowledge of the magazine's rules and cracking the necessary classified codes, the impression given is that this reader wants the magazine

to spell out 'the rules' for him, and to make his initiation into the distribution network a smooth and effortless process, but also a blatant and exposed one. If this is not, from the magazine's perspective, taboo-breaching enough in itself, the reader also requests a list of nasty titles (which, at this stage, had been published on two previous occasions in *The Dark Side*), and in response Bryce remains silent, providing no reply whatsoever and moving on to the next letter.

It is important here to stress the fact that the printing of this letter in the magazine clearly indicates that it hasn't been completely disregarded by Bryce (although the fact that the reader also asks for his address to be printed, so that other readers can contact him, is perhaps the most obvious explanation for the letter being printed, despite the reader's other requests being ignored). However, the fact that every other letter I read in *The Dark Side* (in issues stretching from the early to the late 1990s) received some form of response from Bryce still appears to indicate the short shrift such requests will receive if the contract between reader and editor is so explicitly breached. For what seems apparent is that, if readers are not prepared to respect the two-way relationship between reader and editor (by coding all of their correspondence and taking it as read that they should already be, to an extent, 'in the know'), then, to coin Maitland McDonagh, they are 'in the woods without a map',[28] lost and denied access to information that would let them into the inner recesses of the magazine's distribution network.

'I'm home': the centrality and autonomy of the nostalgic reader

If such readers exist on the margins of *The Dark Side*'s community of collectors, then at its core are another clearly distinguishable group of readers – the 'veteran' video nasty collectors. This group is frequently and directly addressed by the magazine and, as a consequence, not only appear closer to the editor than any other type of reader, but are the exemplar of the magazine's ideal reader/collector. The resource this group possesses is nostalgia, and because of their shared pre-VRA experience with the editor of the magazine, they appear to operate, in the magazine, as the embodiment of the casually knowledgeable and authentic nasty collector.

In this respect, if *The Dark Side*'s nasty issues were, on the one

hand, allowing a new set of readers into the collecting community, they were also, at the same time, clearly addressing their core readership of veteran fans and collectors. This dual concern is perhaps most apparent in an advertisement, published in a 1998 issue, for a *Dark Side* book written by Bryce, which reprinted all original nasty covers and, like the previous special nasty issues of the magazine, listed all key information relating to each nasty title.

Firstly, although the advertisement mentions the fact that the book includes running times, credits, reviews and distribution and censorship details for each nasty video (thus providing a further glut of concessionary information to relative newcomers), it is also a limited edition publication that is 'not available in the shops' (thus restricting its circulation to regular readers). However, most prominently, its advertisement copy does not highlight the appeal of the book to new collectors, but to old ones, by noting that 'it was the best of times, it was the worst of times ... For all too short a time, movies like *Driller Killer*, *The Last House on the Left*, *Zombie Flesh Eaters* and *Cannibal Holocaust* were legally available in an uncut form, and we grabbed our viewing chances while we could'.[29]

What this suggests is that *The Dark Side* is primarily basing the book's promotion around the shared pre-VRA experience of veteran readers/collectors and *The Dark Side* itself (the 'we' that the above quote clearly refers to) and is thus, once again, highlighting pre-VRA acquired knowledge and experience as the key currency within this community. However, the question remains: what are the benefits of nostalgia to both the magazine and its veteran readers, and how exactly is it utilised? At this point, it is worth considering Stuart Tannock's arguments on the concept of nostalgia and how, for him, it can be seen as a form of identity-building, where nostalgia acts as a bridge, allowing experiences from the past to be re-inscribed in the present. As he argues:

> this return to the past to read a historical continuity of struggle, identity, and community, this determination to comb the past for every sense of possibility and destiny it might contain – digging around central structures to find the breathing-spaces of the margins, spinning up old sources into tales of gargantuan epic – is a resource and strategy central to the struggles of all subaltern cultural and social groups. Nostalgia here works to retrieve the past for support in building the future.[30]

This is, therefore, one way in which nostalgia's function to 'subaltern' groups can be conceptualised (where previous experiences are highlighted in order to create a sense of historical consistency with, and give a sense of personal meaning to, their current practices).

In a 1998 issue of *The Dark Side* a particularly illuminating letter was published, which displays these kinds of tendencies through its heavy use of nostalgia. The letter, from a reader called Dave Green, begins by thanking *The Dark Side* for its recent coverage of uncut laserdiscs, and indicates how such coverage has assisted in allowing him access to nasty and other banned titles that he thought he would never be able to view again.

The Dark Side then allows the reader 'a slight diversion' (as he puts it) into the past and, notably, he begins with the question 'do you remember that brief but glorious period in the early 80s when uncertificated videos ruled?' (an approach which, in contrast to the previously cited letter, enables this reader to immediately address, and align himself with, the concerns of veteran readers and the publication's editor). The reader then continues along these nostalgic lines, in order to: provide a lengthy account of his days at the video shop as a child, seeking out and renting video nasties (an account which is full of evocative descriptions of dusty old video shops and hidden video gems); and to mourn the loss of these days by noting that 'for all its sleaze, The House of Video was my spiritual home, and I miss it badly sometimes. It's another era now, and perversely there was more freedom when I was a kid than now when I'm an adult'. In conclusion, the reader then returns to his initial topic (the acquisition of his uncut laserdiscs), and attempts to tie this up to his nostalgic diversion into the old days. Contemplating his attitude to his uncut discs, he asks himself 'how do I feel? I feel like I felt when I was a little kid, about to be scared and thrilled, disturbed and exhilarated. I feel like I'm home'.[31]

What is particularly noteworthy about this letter is not just its length (with the magazine allowing the reader to outline his memories over the course of five columns of the letters page), but also its uses of nostalgia, and the importance of these uses to the meanings the reader gives to his videos. What the letter seems to suggest is that, while the original rental nasties exist in the past (in 'another era'), the information provided by *The Dark Side* has allowed the reader to retrieve these titles (albeit in a laserdisc form) and to give

them meaning in the present, in relation to his own life history. In this respect, what the magazine has helped the reader to achieve is a positive act of nostalgic retrieval. However, at the same time, the reader indicates that what was so wonderful about this marginal space of the past was that it was a period that he experienced as a child, and that, through the bridge of *The Dark Side*, he has been able to return to his past, and his past home of the video shop, and to feel like he did when he 'was a little kid'. Thus, at the same time, the magazine has not only allowed the reader to actively retrieve a resource, but to also allow this resource to take him back into the past world of his childhood.

From a theoretical standpoint,[32] Will Straw has noted how, for male collectors (who, like this reader, are reaching their early thirties), a continued embracing of subcultural artefacts can enable a collector to remain transgressive and/or anti-censorship-focused, while allowing them at the same time to remove themselves from a less free adult world. As Straw argues, for these kinds of collectors 'the only real choice is between entry into a world of adult ... responsibility and remaining within the ... homosocial world ... where obscurantist tastes continue to appear political'.[33]

What this suggests, and indeed what Green's letter seems to convey, is that for many collectors of defunct, rare or transgressive artefacts there appears to be a crucial link between collecting and nostalgia, and that often this link can enable collectors to maintain an area of their life that continues to exist outside of the adult world of conformity. In this sense, it may not be too extreme to argue that *The Dark Side*, by acting as a patron to the veteran reader, is a primary protector of this nostalgic world.

It should be noted that this tendency, where readers use the magazine and the nasties to return to the past and to re-experience childhood pleasures, was most clearly evident in this letter, plus another, very similar, nostalgic letter from a reader in his thirties published in the same issue of the magazine.[34] However, more implicit, and tentative, indications of this approach to the nasties were also in evidence in other issues of the magazine, most prominently in a number of classified advertisements placed during this time period (a time when many original VRA-era nasty fans would have been reaching their late twenties and early thirties).

Here, advertisements appear frequently to tell tales of collectors who have succumbed and abandoned their collections for the

demands of adult life. For not only are frequent advertisements placed by collectors 'selling up' their entire banned and nasty video collections, but, in one instance, it is also noted that, regrettably, a reader's 'wife forces sale!' of a collection of rare video nasties.[35] What such advertisements seem to suggest is that, according to subcultural rules and the uses and meanings of second-hand video collecting, readers are not, ultimately, able to exist in both worlds at once. Instead, they can either let adult responsibility eclipse the obscure world of video nasty collecting or, through *The Dark Side*, remain within this world and its challenging and potentially nostalgic pleasures.

However, if this is one apparent function of nostalgia to the veteran reader of *The Dark Side*, the question remains as to why the magazine allows concessions to veteran (and frequently nostalgic) readers to be made on such a regular basis. On a basic level, such concessions clearly allow *The Dark Side* to maintain allegiances with faithful readers, but, in addition, the perpetuation of video nasty-inspired nostalgia can be seen to create a sense of 'historical continuity' which can also act as a key commercial authenticator for such magazines. For, in line with Tannock's ideas, what such a focus on nostalgic experiences enables is the gradual and retrospective construction of a subcultural tradition of nasty collecting, which stretches, in a linear and continuous fashion, from childhood activities enacted in the pre-1984 era right up to forms of nasty appreciation and consumption conducted in the present day. Thus while, in reality, it is the magazine itself that has assisted in constructing and defining this subcultural tradition, the impression further given is that this is an organic, authentic, historically continuous subculture, all-pervading in its past (pre-VRA) and continued (post-VRA) relevance.

Conclusion: reconfiguring the nasty

As Thornton notes, 'one basis for predicting the formation, longevity and even the revival of any British subculture is ... the nature of its association with distinct layers of media'.[36] Throughout *The Dark Side*'s history, it has maintained a direct relationship with a key subculture through which it has formed itself and its activities, and, in an effort to maintain its readership and subcultural vitality, it has continued to reinforce the codes and

rules and, in turn, to manage the changing subcultural relevance of the nasties.

What this suggests is that while the video nasties had moved away from the public sphere and been deactivated as legitimate commodities, their cultural life was by no means at an end. A number of small video distributors, in the early 1980s, had sealed the nasties' subcultural fate by promoting their products' transgression and potential illegality in the name of profit. While this was clearly central to the nasties' subsequent cultural status, their continued subcultural relevance and re-definition as valuable objects was centrally achieved via the discourses of such publications as *The Dark Side*. While, on the one hand, the magazine demonstrated its closeness to the videos concerned and its subcultural investment in them (and thus helped to validate the subcultural pleasures and investments of veteran collectors), it was also, arguably, perpetuating the relevance of the nasties in the name of profit and the maintenance of a readership. Thus, if video distributors had constructed and managed one stage of the nasties' life, the cultural baton had now been taken up by another 'layer of media' with equally commercial concerns.

However, if, as Thornton argues, profit and success was always the bottom line (even for niche or subcultural publications), *The Dark Side* is still a valuable historical resource and biographer of the twists and turns of the nasties' changing and multiple relationships with those who collect them. In its dual role as subcultural constructor/perpetuator and subcultural information-provider, publications like *The Dark Side* helped to give shape and 'definition' to the video nasties in their post-banning (and thus post-commodity) existence. While the nasties had been rejected from society at large, and the commodity sphere in general, *The Dark Side* helped, through its economies of value, to give them renewed status and identity as subcultural, historical, personal and (at least in terms of the context within which memories were placed) as, ironically, very British artefacts. Furthermore, through its hierarchies of collecting knowledge and information, *The Dark Side* could also been seen to have given itself, and its readers, a sense of distinct and clear autonomy, authenticity and exclusivity, which, as the next chapter will explore, would also continue to characterise other fan arenas associated with the nasties.[37]

Notes

1 Sarah Thornton, *Club Cultures: Music, Media and Subcultural Capital* (Oxford: Blackwell, 1995), p. 151. Thornton is here specifically referring to British music weekly and monthly magazines (such as *NME*, *Melody Maker*, *Select* and *Mixmag*) and monthly style magazines (such as *The Face* and *i-D*). These publications, in the sense that they are generally available from British newsagents, can be seen as more widely accessible than the horror magazines discussed in this chapter (which, on the whole, appear to circulate via more specialist British film or science-fiction stores, such as *The Cinema Store* and *Forbidden Planet*). Nevertheless, as this chapter seeks to argue, the subcultural logics and frameworks that Thornton perceives to be at work in such music and style publications can also be seen to be applicable to the British horror magazines discussed here.

2 David Kerekes and David Slater, *See No Evil: Banned Films and Video Controversy* (Manchester: Headpress, 2000), p. 289.

3 David Sanjek, 'Fans' notes: the horror film fanzine', *Literature/Film Quarterly*, 18:3 (1990), rpt. in Ken Gelder (ed.), *The Horror Reader* (London: Routledge, 2000), p. 316. Put simply, 'fanzines' are publications produced by amateur writers, who produce and write fan magazines in their own time, and 'prozines' are commercial mainstream magazines, written by professional journalists. See *ibid.*, p. 316.

4 David Silver, letter, *Fear* (May 1990), p. 82.

5 Allan Bryce, reply to letter, *The Dark Side: The Magazine of the Macabre and Fantastic* (September 1995), pp. 36–7.

6 For an even more explicit example of *The Dark Side*'s 'othering' of *Fangoria*, see the page devoted to the history of *The Dark Side* on the magazine's promotional website. Here, Allan Bryce notes that, 'unlike our American counterpart *Fangoria*, we don't spend whole issues talking about the latest installment in the *Hellraiser* series or the flavour-of-the-month big budget Hollywood scare epic that turns out to be rubbish when finally released. Though you'll find up-to-date video and DVD reviews, the rest of the mag tends to look back rather than forward'. Allan Bryce, 'History', *The Dark Side Online*, www.ebony.co.uk/darkside/history.htm (20 October 2000). However, what is noteworthy here is that *Fangoria* appear to see things rather differently. For instance, in David Schow's article on British censorship, *Fear* and *The Dark Side* are dismissed as 'lavishly-produced' and thus unworthy of discussion. David J. Schow, 'The British chainsaw massacre and other cuts', *Fangoria* (October 1992), p. 20. What this, in many ways, demonstrates is the importance of the 'counter-distinction' that occurs in horror or trash fan publications,

where the distinctiveness and authenticity of one publication is always
expressed through an opposition to a publication operating in the
same subcultural sphere. For a comparative model, see Jeffrey
Sconce's discussion of the 'counter-distinction' games played by *Film
Threat* and *Psychotronic Video* in Jeffrey Sconce, '"Trashing" the
academy: taste, excess, and an emerging politics of cinematic style',
Screen, 36:4 (1995), 375.

7 The exact use of this term occurs in a 2001 *Darkside* introduction,
where Allan Bryce acknowledges the hard work that has gone in to a
particular fan's nasty website, and commends the fan by sending
'good wishes to Adam for his ongoing efforts at keeping the faith!'
Allan Bryce, 'Introduction', *The Dark Side: The Magazine of the
Macabre and Fantastic* (June–July 2001), p. 3.

8 In this respect, it is interesting how often the American publication
Video Watchdog is referenced in the pages of *The Dark Side*. What
this suggests is that *The Dark Side* wants to present itself as a counter-
part to *Video Watchdog* and submerge debates from this publication
into its subcultural world while refusing entry to comment and analy-
sis from other organs.

9 As Kerekes and Slater note, 'Not everyone who had a videocassette to
trade was interested in becoming part of a fan community, but the
classifieds provided a gateway for those who did'. Kerekes and Slater,
See No Evil, p. 290–1.

10 Advertisement for *The Dark Side* Classified, *The Dark Side: The
Magazine of the Macabre and Fantastic* (May 1992), p. 66.

11 Tristan Bishop, letter, *The Dark Side: The Magazine of the Macabre
and Fantastic* (February–March 1998), p. 11.

12 Thornton, *Club Cultures*, p. 153.

13 For instance, see Henry Jenkins' discussions of the merits of science-
fiction conventions in bringing together a widely distributed group of
enthusiasts and fans with shared experiences and interests. Henry
Jenkins, '"Strangers no more, we sing": Filking and the social
construction of the science fiction fan community', in Lisa A. Lewis
(ed.), *The Adoring Audience: Fan Culture and Popular Media*
(London: Routledge, 1992), pp. 208–36.

14 This idea of fans creating a sense of autonomy for themselves, by
becoming producer, distributor or exhibitor as well as consumer is, of
course, a prevalent idea in Henry Jenkins' work (in his discussion of
the fan production and distribution of new texts – songs, artwork,
and fanzines – based on the original texts that the fans' consume). See
Henry Jenkins, *Textual Poachers: Television Fans and Participatory
Culture* (London: Routledge, 1992). However, in the more specific
realm of video swapping and collecting, Goran Bolin has identified a
similar tendency where Swedish film swappers have also produced

their own films, film festivals and fanzines. See Goran Bolin, 'Film swapping in the public sphere: youth audiences and alternative cultural publicities', *Javnost: The Public*, 7:2 (2000), 57–74.

15 'Fear Classified', *Fear* (May 1990), p. 66.

16 Mike Lang, cited in Martin Coxhead, 'A taste of fear', *The Dark Side: The Magazine of the Macabre and Fantastic* (July 1995), p. 14.

17 Allan Bryce, reply to letter, *The Dark Side: The Magazine of the Macabre and Fantastic* (June–July 1998), p. 12.

18 Thornton, *Club Cultures*, p. 146.

19 'Fear Classified', *Fear* (October 1990), p. 80; and 'Little shop of horrors', *The Dark Side: The Magazine of the Macabre and Fantastic* (February–March 1998), p. 35.

20 For examples of the use of such terms in classified advertisements, see 'Fear Classified', *Fear* (May 1990), p. 66; 'The Dark Side Classified', *The Dark Side: The Magazine of the Macabre and Fantastic* (May 1992), p. 66; and 'Little shop of horrors', *The Dark Side: The Magazine of the Macabre and Fantastic* (July 1995), p. 61.

21 This tendency was also raised and discussed in a 2001 interview conducted with John, a nasty collector whose collecting dispositions will be focused on at length in chapter 6. When explaining the process of obtaining a nasty or other banned video title, John outlined how advertisements would lead to phone calls, where, if the right titles were mentioned, a full list of available videos would then be sent through the post. (A key example of how using the right terms and asking the right questions can assist in giving access to the suitably knowledgeable individual). Nasty collector, personal interview, 14 June 2001.

22 Bryce conveys this information in his introduction to the second nasty issue, published in 1996. Allan Bryce, 'Introduction', *The Dark Side: The Magazine of the Macabre and Fantastic* (July 1996), p. 4.

23 This argument was employed by Bryce as a defence against the earlier cited letter-writer, who complained that the magazine was pandering to 'brown-nosing pubescents' and was obsessed with discussion of the nasties. Allan Bryce, reply to letter, *The Dark Side: The Magazine of the Macabre and Fantastic* (September 1995), p. 37.

24 Will Straw, 'Sizing up record collections: gender and connoisseurship in rock music culture', in Sheila Whiteley (ed.), *Sexing the Groove: Popular Music and Gender* (London and New York: Routledge, 1997), p. 9. Elements of this contempt among hipper collectors for those who require large amounts of facts, in a way that reveals their lack of mastery over information, can be found in two particular letters, published respectively in *The Dark Side* and *Fear*. The first is the previously cited letter (who attacks 'brown-nosing pubescents', those readers who ask 'the same old inane questions about owning

video nasties') and the second is a *Fear* letter-writer who, when attacking those who are obsessed with cuts to videos, notes that 'I can already envisage beads of sweat appearing on the pimply brows of your adolescent readers'. Buck Ridgerider, letter, *The Dark Side: The Magazine of the Macabre and Fantastic* (September 1995), p. 35 and C. D. Ward, 'Flogged to death?', *Fear* (October 1990), p. 82.

25 Matthew, letter, *The Dark Side: The Magazine of the Macabre and Fantastic* (February–March 1999), p. 20.

26 Allan Bryce, reply to letter, *The Dark Side: The Magazine of the Macabre and Fantastic* (February–March 1999), p. 21.

27 Bishop, letter, p. 11.

28 Maitland McDonagh, 'The house by the cemetery', *Film Comment*, 27:4 (1991), 43.

29 Advertisement for *Video Nasties*, *The Dark Side: The Magazine of the Macabre and Fantastic* (June–July 1998), pp. 48–9.

30 Stuart Tannock, 'Nostalgia critique', *Cultural Studies*, 9:3 (1995), 458–9.

31 Dave Green, letter, *The Dark Side: The Magazine of the Macabre and Fantastic* (February–March 1998), pp. 11–12.

32 It should be noted here that Straw's theories are based, primarily, on fictional accounts of record collectors given in novels such as Nick Hornby's *High Fidelity* rather than through empirical work with actual collectors.

33 Straw, 'Sizing up', p. 11.

34 Here, once again, the letter-writer reminisces about a lost era where nasties were viewed and rented, and the age of the writer ('a 30-year-ancient-adult') is also identified. Phil Goddard, letter, *The Dark Side: The Magazine of the Macabre and Fantastic* (February–March 1998), pp. 10–11.

35 'Little shop of horrors', *The Dark Side: The Magazine of the Macabre and Fantastic* (February–March 1998), p. 35.

36 Thornton, *Club Cultures*, p. 161.

37 Indeed, as Igor Kopytoff notes about the significance of the life of objects and their intersections with the biography of individuals, 'in the homogenized world of commodities, an eventful biography of a thing becomes the story of the various … classifications and reclassifications in an uncertain world of categories whose importance shifts with every minor change in context. As with persons, the drama here lies in the uncertainties of valuation and of identity'. Igor Kopytoff, 'The cultural biography of things: commoditization as process', in Arjun Appadurai (ed.), *The Social Life of Things: Commodities in Cultural Perspective* (Cambridge: Cambridge University Press, 1986), p. 90.

5

Facts, lists and memories: 'masculine' identities and video nasty websites

In an article devoted to the gender dynamics of internet chat-rooms, Lori Kendall concurs with the now established academic argument that the internet is a particularly useful platform for the performance of identities. As she argues, 'because taken-for-granted visual cues are unavailable in online text-based communication, people must make choices about what to reveal about themselves, [and] how to describe themselves ... The limitations and special factors of online interaction can thus make participants more conscious of both their own identity performances and their evaluation of others' identity performances'.[1]

My research into video nasty websites was an attempt to test this hypothesis – to consider the nature of the relationship between fans of the nasties and the nasties themselves, and to explore the potential power relations and identity performances that might exist behind this relationship when it is enacted, discussed and explored online. Although my study was on a much smaller scale to Kendall's (in total I polled twenty fan-produced nasty sites and followed nasty debate and discussion on four horror or cult-orientated message-boards for two months during 2001), some interesting themes and trends, which relate to this idea of performed online identities, clearly emerged.[2]

While sites differed in their origins (with some, such as *Video Carnage* and *I Fell in Love With a Video Nastie* being small operations, devoted solely to a discussion of previously banned video titles, and others, such as the nasty pages in *Dark Angel's Realm of Horror*, *Hysteria/Slasher/Nasties*, *The Horrorscope* and *Keith's Flesheaters* existing as off-shoots of British fan sites devoted to horror films or exploitation cinema), all adopted a similar

approach, in terms of the content and presentation of their infor-
mation on the nasties. Firstly, such sites showed an almost
obsessional interest in lists, facts and numbers (usually based
around censorship information relating to the nasties) as well as
frequently including sections devoted to memories and nostalgia;
and, secondly, site creators, on the whole, appeared to want to
allow the presentation and display of this information to fore-
ground their ability to teach others about the nasties, and thus
allow this to strengthen the unique identity of the site and the site's
creator.

However, what also seems to mesh with these tendencies on
nasty sites is the fact that, as far as it's possible to determine and
bearing in mind that, as a number of critics have identified, the
internet is a form of media where gendered identities are frequent-
ly masked and indeterminate,[3] such sites appeared to have been
largely constructed by *male* fans and collectors of the nasties.[4]
While this may seem a large theoretical 'leap' to make (in terms of
linking such tendencies to the site creators' gender), it is a link that
has been identified as potentially telling and significant, in the
work of other researchers of cult or horror audiences.

Firstly, this tendency to present and relay information and facts
in a pedagogic manner is something that Julian Hoxter also identi-
fies in his study of fan sites devoted to *The Exorcist* (the majority of
which were also constructed by male British horror fans).[5] As he
argues:

> in terms of content, the typical fan website is helpful and friendly in
> its tone, but it is helpful in the way of a 'sage advisor'. There is a peda-
> gogic quality to the presentation of information. The site provides a
> service that has to do with pleasure certainly, but that service is
> offered on certain terms ... and with the understanding that the
> visitor is there to be informed: to learn something. There is, in this
> way a kind of double play with the notion of fandom. All fans are
> equal and welcome, but this is *my* site, *my* contents (even if, as is
> often the case, every other site has many of the same entries) and I'm
> teaching you *my* way.[6]

Thus, if Hoxter's findings and my own findings are to be
believed, such British-orientated horror fan sites appear: 1) to want
to function, or present themselves as functioning, as educational
forums, where the website creator has control through the wielding
of information and, through this wielding of information, is given

the right not only to speak but to teach; and 2) to present the site as unique because it is their site, and therefore these facts belong to them. What Hoxter's observations suggest is that while these British-based horror websites appear to be spaces that welcome others into the fold (and, indeed, at least in terms of the nasty sites that I visited, frequent encouragement is made to visitors to supply the site creator with further information), such sites, on the whole, only welcome such visitors in on certain terms – namely that they should, fundamentally, appreciate and respect the autonomy of the website creator as primary teacher and guide.

Such an approach, where the collecting together of facts and figures allows the nasty website creator to construct and maintain a distinctly powerful identity as a subcultural historian of the nasties, has key correlations to Joanne Hollows' work on the inherent masculinity of cult (or subcultural) audience consumption patterns. Hollows, employing the theoretical approaches adopted by Sarah Thornton in her book *Club Cultures*, critiques the supposed democracy of certain types of cult or subcultural practices by suggesting that they hinge on ideas of distinction and exclusion, where the authentic practices of those who indulge in the obscure, banned or forbidden are always masculinised, in opposition to a supposedly feminine and commercial mainstream. For Hollows, such authentic and implicitly masculinised practices depend on a series of oppositions which can be labelled as positively masculine versus negatively feminine – a serious and 'intense . . . involvement' in important cultural objects as opposed to a 'random, directionless' disinterest in mere entertainment;[7] an appreciation of the public arenas of the grubby seedy video outlet or grindhouse cinema versus the more private feminised space of the home; and, perhaps most notably, a conception of the fan as an authentic collector of objects and information as opposed to a mere consumer of goods.

Arguably, the collecting together of facts and figures about the nasties can be seen as a smaller-scale part of the nasty fan's primary status as a collector of previously banned, imported or uncertified horror videos, with the primacy of this idea of the nasty fan as collector being clear on all websites I visited, in message-board discussion (where fans' video collections were frequently discussed at length) and, as the last chapter demonstrated, from fan discourse (letters, editorials, classifieds and so on) in such magazines as *The*

Dark Side. Indeed, it should be noted here that the approaches of *The Dark Side* appear to provide a key framework for the layout norms and kinds of information presented on nasty websites. Firstly, as websites often concede,[8] the frequent source of some of the facts and information presented on such sites are niche British horror magazines like *The Dark Side* (who, as the last chapter outlined, often feature lists of nasty titles accompanied by facts and figures relating to their censorship and distribution histories). Secondly, however, what this reveals is that the use of such lists (as well as *The Dark Side*'s frequent use of memory and nostalgia in their discussions of the nasty era)[9] have become the staple means of discussing and consuming the nasties, for nasty collectors who, on the basis of this evidence, are also readers of such magazines. Bearing this in mind, and if Brigid Cherry's work on British female horror audiences is taken into consideration, this link between such sites and *The Dark Side* also appears to point to a potential gender skew amongst nasty site creators, for, as her research demonstrated, many female British horror fans tend to avoid magazines like *The Dark Side* because of their frequent misogynism and focus on gore and, crucially, because of their obsession with trivia and facts.[10]

While it cannot be assumed that all nasty fans are male (and this is not what I'm attempting to do here), what this *does* seem to suggest is that certain networks of nasty appreciation and fandom, utilised on the whole by male fans, have distinct norms (focused around facts, censorship information and memories) which seem to correlate with the authentic and 'masculine' forms of cult consumption and appreciation that Hollows identifies. And, in turn, this argument is compounded by the fact that such forms of appreciation appear to be largely influenced by discourses employed by magazines like *The Dark Side*, a publication which, at least according to Cherry's research, has a predominantly male readership. Arguably, then, it is such forms of traditionally male-orientated cult consumption and appreciation that can be seen to be at work on a significant number of nasty sites, where trivia, lists, facts and memories are gathered and then utilised in order to construct the nasty website creator's status as a powerful subcultural teacher and historian.

However, crucially, while this approach of collecting together facts and figures as a means of strengthening a nasty fan's status

can be seen (in Hollows' terms) as a powerfully masculine act, it can equally be perceived (from outside the arena of fandom) as a *problematically* masculine one, in the sense that knowledge, facts and collecting have been seen as having ambiguous meanings in relation to traditional notions of masculinity. As Will Straw acknowledges, in his study of the gender dynamics of record collecting:

> [there is an] uncertainty ... rooted in competing images of the collection as cultural monument and private haven. Record collections are seen as both public displays of power/knowledge and private refuges from the ... social world; as either structures of control or the by-products of irrational and fetishistic obsession; as material evidence of the homosocial information-mongering which is one underpinning of male power and compensatory undertakings by those unable to wield that power.[11]

With this in mind, it is worth considering how such (in Hollows' terms) implicitly masculine subcultural activities as the collecting of facts, figures and materials surrounding illicit or obscure videos may not be as straightforwardly authentic, dominant and powerful as they may at first appear. For, as Straw outlines, while such activities may appear to connote publicly endorsed masculine authority (achieved through 'information-mongering' and 'public display'), they can also suggest an obsession with cultural artefacts conducted in a private, exclusive and potentially anti-social world. Indeed, as should be apparent, what is clear here is that if the links between collecting, knowledge and masculinity are underpinned by an 'uncertainty' in terms of competing images of masculine identity, they are also underpinned, as the above Straw quote recognises, by a pull between notions of public history and private collections (something which complicates Hollows' notion that the private is always a feminised space and the public a distinctly masculine space).

What I aim to do in the analysis that follows, then, is to home in on these networks of nasty appreciation and consumption and look in more detail at the nature of these potential pulls, between the private and the public and autonomy and insecurity, within the realms of nasty website discourse. My aim, firstly and in line with Hoxter, will be to explore the ways in which male website creators present their sites as educational forums, or, to employ Jim Collins' term, as 'archives',[12] where facts and memories about the nasties

are used to solidify the creator's status as a subcultural teacher and historian. Secondly, however, my analysis will also attempt to explore the complicated meshing of the public and the historical and the private and the personal within such websites, something which not only potentially reveals how forms of exclusivity and combativeness emerge in contemporary British horror cultures, but also allows for further exploration of how the video nasties were rearticulated, by veteran nasty fans, as both a publicly and personally meaningful historical phenomenon.

Checklists and other animals: the gathering of facts, numbers and lists

At the top of the home page of the *Video Carnage* website is a mission statement, which articulates the function and purpose of the site to its visitors. It notes that 'this web-site is aimed primarily at building an archive of the many weird and wonderful films (horror, sleaze, exploitation, etc. ...) available on tape in the UK, before BBFC video certification came into force [...] I created *Video Carnage*. My own humble effort to try and preserve some of the memorable and not-so-memorable video releases of yesteryear'.[13]

What such a statement immediately conveys is not so much the idea that the site will operate as a forum for discussion about the nasties and other pre-certification horror videos, and the relative merits or lack of merits of the films concerned, but that the site's primary function is to operate as an online archive of lost and forgotten videos, where materials and information will be preserved and offered up to those who visit the site. What this therefore immediately suggests is that this site is being presented as a museum exhibit, put together and displayed by a sole curator, who collates and archives video-related material for the cultural and historical benefit of others.

As Hoxter recognises, such an approach (where websites promote the unique and personal service of their site) appears counter to the fact that the majority of such sites often present similar content in similar formats. Indeed, the same staple information does tend to appear on the majority of nasty sites, with sections devoted to scanned video covers and stills of video covers, lists of different running times and distributor details for different

versions of each video, lists of cuts imposed on each version of these videos, lists of alternative titles for each video, and a lengthy synopsis of the censorship background behind, and the press campaign against, the nasties.

However, if the kinds of information presented on these sites often appears identical and standardised (in line with the fact that site formats and layouts have often been influenced by magazines or other published sources), it is notable that the specific information presented is still often imperfect, inconsistent and does vary slightly from site to site. Thus, while entries for certain nasty titles will include an original British pre-certificate video cover (scanned on both sides) and a lengthy review, other entries provide very little information, with maybe only a still of a video cover, or a scanned cover of an imported video version or a DVD re-release (rather than a pre-certificate original). These inconsistencies are quite obviously based on the fact that some of the information provided has been culled from the creators' own video collections (which, considering the illicit nature of some of the methods involved in video nasty collecting, will therefore inevitably include a piecemeal mixture of videos obtained from a variety of sources and with a variety of origins). Indeed, it is admitted by certain websites that their information is rather general in places as they 'haven't had the pleasure of viewing all of [the nasties] ... yet'.[14]

Nevertheless, it is, in some ways, this mish-mash of different pieces of information being collated together, and of significant gaps existing in this information, that gives each site its 'human' dimension and the sense that it is engaging in an ongoing, unique and original act of retrieving lost and forgotten cultural facts and materials. Such a dimension, therefore, assists in presenting each site creator as an amateur historian or, to use Jim Collins' terminology, a 'popular archivist'[15] committed to the activity of hunting down and placing items and pieces of information in their collection of online artefacts. However, if this suggests, as the *Video Carnage* creator does, that this role of amateur historian is a 'humble' activity, it also appears, in some ways, as a heroic one, in the sense that such website constructors are putting together these archives for the benefit of others and their subcultural education. While the *Carnage* creator's collection of videos, materials and facts could have been kept as a private pleasure, they have been turned into a 'public display', which, through the site's function as

an archive, gives the website constructor a sense of contributing to cultural history and to a field of learning about the video nasties and all that surrounds them.

However, if a number of facts and materials are amassed in this way on nasty websites (by plundering the creator's own private video collection and placing the materials therein for public display as a contribution to a cultural history which can benefit and enrich the sites' visitors), it is arguable that this activity also gives the website constructor a sense of self-worth, in the sense that this is *their* contribution, of *their* facts and materials, on *their* website. However, while this sense of self-worth is convincingly achieved through the placing of materials online which belong to the site creator (in the sense that they originate from the creator's collection), this does not account for the fact that a number of other materials and facts placed online clearly derive not from the website creators themselves (or even, primarily, from niche horror publications), but from academic, official or governmental sources.

Indeed, it is notable that if nasty websites sometimes include pages of video covers and sometimes include lists of running times, cuts and distributor details, every single site that I visited always has one central and identical staple – the Director of Public Prosecutions' (DPP) list of video nasties (or, more specifically, the list of videos that, in the early 1980s, were deemed liable for prosecution under the 1959 Obscene Publications Act). While the contents of this list varies from site to site – something which is perhaps inevitable, considering that the DPP frequently removed and added titles to the list prior to the passing of the 1984 Video Recordings Act (VRA) – it is always included, and is often given the air of a being an 'official' list (in particular on the *Hysteria/Slasher/Nasties* site, where the list is introduced as 'the original, the infamous, the banned, the ... video-nasties' and on *Wayney's Movie World*, where it is described as 'the DPP's original list of "Video Nasties"').[16]

In terms of Hoxter's initial comment that such British horror sites present information as *their* facts, which *they* own and that *they* will teach, the constant inclusion of this list, and of other British Board of Film Classification (BBFC) press releases, problematises what has been argued thus far. To put it simply, how can websites present these facts as their information and as part of their archive when such facts derive from official documents produced

by governmental or state departments? Arguably, some indications can be obtained from a number of message-board discussions surrounding the nasties.

On a message-board thread, set up as part of the *Guardian Unlimited* website, a long debate on the video nasties (stretching to eighty-six messages) is initiated by a posting requesting views on the nasty titles and experiences of video nasty-watching. While the initial debate centres on experiences of renting nasties in the 1980s, and of the merits of particular titles, this debate soon becomes subsumed by a discussion of which websites to look at and which sources to use for further information and facts. Towards the end of the thread, the participants begin to discuss the intricacies of cuts to particular videos and why such cuts were made by the censors, and constant references are made to BBFC decisions, culminating in the recommendation that: 'if you want to keep track of the BBFC, check out www.melonfarmers.co.uk or visit their website at www.bbfc.co.uk. It has all their guidelines, press releases and other geek shit'.[17]

This comment, although made as a simple and friendly recommendation to other message-board users, is revealing in its labelling of such official documents as 'geek shit', and the use of this term suggests two related, but seemingly opposed, ideas. Firstly, there is the simple fact that these pieces of information, press releases and lists are not seen as 'BBFC shit' but 'geek shit', and that they therefore seem to function, for such nasty enthusiasts, as sources for fan information rather than as documents used and distributed by official bodies. What such an approach therefore suggests is not only that official information is frequently appropriated by fans, but also that, in some ways and because of their investment in the nasties, fans therefore see themselves as owning it – it is their property, to use as they so desire.

Secondly, however, if this suggests that such fans and website creators reclaim both the DPP list and other official sources as their collective property, it does not suggest how they use this information and why they use it. An interesting indication of at least one purpose such official information has for nasty fans and enthusiasts can again be found on a message-board thread. Here, as with the previous example, a thread discussion is initiated by a fan who requests recollections and experiences of watching slasher films in the early 1980s. While the vast majority of this discussion is

conducted by American fans, a separate debate (weaved through-
out the thread) begins to occur between two British message-board
users (one of whom, significantly, has his own nasty site,
Hysteria/Slasher/Nasties), who commence a discussion of the intri-
cacies of British censorship decisions. The *Hysteria* site creator,
Justin (responding to mentions of such titles as *Nightmares in a
Damaged Brain* and *Texas Chainsaw Massacre*), begins by
explaining the background to the video nasties and the video nasty
era to the message-board's American users, with a number of his
postings mirroring entries from his website, where the story of the
nasties is recounted in the form of a history lesson (beginning with
the phrase 'when the VRA came into being in the mid-80's').

However, his dominance over this discussion is suddenly broken
by another British participant (Tim) who, while confirming that
Justin is correct in his assumption that *Texas Chainsaw Massacre*
and *The Exorcist* never appeared on the DPP's nasty list, notes that
the former film was rejected by the BBFC in 1975 and had not been
given a cinema release until the late 1990s. If this questioning of
Justin's ability to hold mastery over official information does not
fully succeed in undermining his role as primary expert, Tim
continues his posting by pasting in a reproduction of the BBFC
press release issued when the film was finally given a theatrical
certificate, with Justin then, in turn, admitting defeat on this partic-
ular factual detail, but striking back with a lengthy quotation from
James Ferman, head of the BBFC at the time the certificate was
granted, culled from an academic book on censorship.[18]

While this message-board thread seems to have the friendly air of
users passing back and forth pieces of information and pooling
together knowledge for the benefit of all (and indeed, and as Henry
Jenkins has argued, this is clearly an important aspect of such
threads),[19] this discussion also appears to be firmly based around
the need for online nasty fans to maintain their identity as teacher
and guide, in the sense that such official sources and facts can be
used as 'weapons' to win the argument and emerge as the proven
expert. Further to this, it is interesting, in some senses, that Tim is
able to reproduce an entire official source by visiting another
website (in all likelihood, the BBFC site) and pasting it in to his
own text. Here, and again in line with Jenkins' arguments,[20] the
particular workings of the internet (where text from other sources
can be retrieved from other sites and reincorporated as part of the

fans' message-board text) appears as a particular advantage in such discussions, allowing for a literal reclaiming of such official text as the property of fans, for the purposes of authenticating and giving power to a particular fan's contribution to discussion and debate.

However, as this particular message-board discussion should suggest, this reclaiming of official material may appear a positive act, but it can also appear to be an implicitly defensive one. While the messages posted by Justin and Tim are constituted, at first, as a friendly discussion, they seem, over the course of such discussions, to mutate into a battle of wills, where one lecture on the intricacies of the nasties and censorship is counteracted by another, and where, at sticky and awkward moments, sources of information are utilised to back up particular points. Thus, in the sense that such fan debates continue to fall-back, and are dependent, on official and published sources to win arguments and retain their power to teach, it could be suggested that what underpins this approach is a defensiveness and an insecurity that such power will be taken away from them by a knowledgeable competitor, with a greater mastery over the facts concerned.

This particular notion of fans gathering together knowledge and facts as an insecure, defensive display of learning is identified, by both Kendall and Straw, as a traditional characteristic of the nerd, who can be seen as using a mastery over facts or, in Kendall's examples, technology as compensation for a lack of social and implicitly male power in the real (or off-line) world (and this is the second, and more obvious, connotation of the labelling of official sources as 'geek shit'). Thus, for Straw, while 'nerdish dispositions are marked by their ability to turn virtually any domain of expertise into a series of numbers on a checklist', this is countered by the fact that 'canonical forms of nerdishness take shape around domains of knowledge ... which may only in special circumstances emerge as heroic'.[21] However if, in the world at large, such dispositions and attempts to wield power and status through knowledge often fail to appear straightforwardly masculine and powerful, within the world of the fan website, and the world of a fan culture centrally based around issues of censorship, such actions can give a sense of autonomy to fans, where the reclaiming of facts and official sources precludes an attempt to contribute to, and become part of, the cultural history surrounding the nasties.

It is with this in mind that I return to the question of why such

official sources are utilised and reclaimed by such message-board contributors and nasty website creators. If, as has traditionally been argued, subcultures and fan formations, of the kind of which the nasties fan culture is a clear example, have operated as subversive forces in society[22] – existing in opposition to state-sanctioned or dominant bodies and organisations (of which the DPP, the BBFC and, to some extent, academia in general are clear examples) – then why are the press releases, lists, published works and documents of such bodies reclaimed in this way, and used as a resource by such fans?

For Hoxter, a major sense of insecurity for fans in general, when considering their relationship to their objects of fandom, is the fact that 'in normal circumstances, the fan can only ever aspire to becoming, at most, a post facto addition to the cultural meaning of … [a] film'.[23] In terms of a number of fan cultures that centre on films, it is generally the background information surrounding the film itself (star profiles, production information and critical reception) that come together to give the film its cultural meaning. However, in terms of the nasties, whose reputation and status is based more around the details of the press campaign against them and the subsequent state legislation which banned them, it is the activities of the government, the censors and the media (in the form of the British press and moral campaigners) which have assisted in giving them a Brit-specific cultural meaning and history.

In this sense, for fans to obtain a sense of closeness to the nasties, the history of these videos needs not only to be recounted and preserved by fans, but, through the snatching back of facts from official bodies, to be wrenched away from those who have traditionally been seen as the main contributors to the nasties' cultural meaning. Thus, while official sources are consistently utilised by these website creators, the bodies from whom such sources have been obtained are consistently set up as the enemy (in a way which correlates with Hollows' argument that male cult consumers aim to achieve an authentic and radical status). This theorised enemy or 'other' appears a hugely malleable entity on such sites. While some cite specific bodies or individuals whom they are directly opposing (for instance, *Hysteria/Slasher/Nasties* has a section entitled 'why I grew up to hate the *Daily Mail!*'),[24] other sites use more general terms to describe the perceived enemy, including such phrases as 'the intelligentsia', 'a certain vocal minority of so called do-

gooders', 'the self-righteous barmy army of censorious fools', the 'militant blue rinsed octogenarians', 'the media' and 'the righteous'.[25]

However, arguably, it is the fact that this enemy appears so vague and malleable that allows these website creators to so easily mock them, dismiss them and, in some instances, to parody them. For instance, in the *Dark Angel's Realm of Horror* message-board, mysterious postings from a 'Mary Whitehouse' (the name of the key moral campaigner against the nasties) argue for the banning of everything – from pigeons to gardening shears. As Mark Jancovich has pointed out about the politics of cult fan formations in general, 'cult movie audiences are less an internally coherent "taste culture" than a series of frequently ... contradictory reading strategies that are defined through a sense of their difference to an equally incoherently imagined "normality", a loose conglomeration of corporate power, lower middle class conformity and prudishness, academic elitism and political conspiracy'.[26]

If, as website sections on the nasties' censorship history often convey, it was this malleable enemy who not only removed the original pre-certificate nasties from these fans (by banning them), but also, in the process, dismissed those who coveted them as social inadequates, deviants and, in extreme cases, perverts, then a sense of autonomy can be achieved by reclaiming this right to educate, to teach and to wield facts about the nasties. To proclaim, in a total reversal of the logic of their enemies, that it is 'them' ('normal' or dominant spheres of society) that are culturally blind and 'us' (the fans) who are committed to an authentic, and factual, project of learning.

However, it should be remembered that while this seems a powerful act on the part of nasty fans, and an act which potentially redeems the problematic masculinity of their potential 'nerd' or 'geek' status, it still remains an act that has a fundamental dependency on those they so fervently oppose. If such fans want to consolidate a sense of themselves as authentic and original educators and historians, and to achieve dominance over other fans by knowing the most facts, figures and information, then this can only be achieved: 1) by propping themselves up with factual and 'bookish sources', which are wrenched away from their original contexts and reclaimed as their own; 2) by adopting an educational and journalistic tone, which replicates the tone and approaches

of those newspapers, magazines, and books that they wish to distinguish themselves from; and 3) by closeting themselves away in the safe and secure realm of the website, where they call the shots and where knowledge and power can be wielded without being challenged or questioned.

However, if this dependency on second-hand information is sometimes exposed in debates with other nasty fans (as in the message-board discussion between Justin and Tim), then, just as in the letter from Dave Green outlined in the previous chapter, the fan can always utilise a second resource to demonstrate the authenticity of their knowledge and validity of their right to teach – their ability to reminisce and recount nostalgic memories and experiences of renting the video nasties themselves. For if one prominent staple of the nasty site is to collate together facts and materials, as a means of educating others and constructing a history around the objects of their fandom, then another is the site section where creators go back in time to a nostalgic past – the 'golden age' of the video nasties.

The 'halcyon days of horror': nostalgia and the construction of a male rite of passage

In terms of what has been argued thus far, it can be seen that the activities of nasty website creators are frequently underpinned by a contradictory logic. While the creation of an archive and the wielding of facts is presented as a heroic and, implicitly, powerful activity within the confines of a nasty website, it could also, from an external point of view, be seen as an irrational and anti-social activity in the sense that such website creators are displaying an attachment to a series of lifeless objects, factual information and materials. Arguably, the inclusion of sections which recount nostalgic memories on such sites, in some ways, seems to add to this sense that website creators are not just hiding behind facts, sources and materials, but are also hiding away in a romanticised past.

This contradictory state of affairs is something that Fred Davis is quick to identify in his book-length study of nostalgia, *Yearning for Yesterday*. Here, in one of the few direct references to gender that I found in the book, Davis confirms that nostalgia appears (albeit only through the means of psychological testing) to be an activity

and a tool that, historically, has tended to be utilised more by men than by women, and that, in some respects, this stands in opposition to the idea that nostalgia is popularly considered to be an emotional, irrational and, thus, a particularly feminised activity. As he argues:

> early studies, including the many by American psychologists during the 1930–1960 heyday of the 'personality inventory' approach to behavioural phenomena, seemed to establish, though by no means conclusively, that men are the more nostalgic. This, of course, flies in the face of that familiar strain in popular thought which holds that women are the more sentimental, more romantic, more open to emotional influence, and in general more 'feelings-orientated' and hence, one would infer, more nostalgia-prone.[27]

However, in another part of the book (devoted to nostalgia and identity), Davis attempts to demonstrate how nostalgia can be used as a powerful biographical, as well as an emotional, tool, allowing a person to strengthen their sense of identity – by making them feel, through a use of past memories, that at one time in their life (in particular, in their adolescence or early adulthood) they were not only culturally active and dynamic, but also that they participated in radical, subversive and illicit activities. Taking these ideas into consideration, it could be argued that nostalgia, and its use on nasty websites, can act as an effective demonstration that such fans were there at the beginning of the nasties phenomenon – doing radical things, opposing the mainstream and the dominant, and taking part in what would later become a subcultural phenomenon. As Davis puts it, nostalgia 'likes to fasten on those periods in our past when we thought and felt ourselves different; when we espoused minority tastes in movies, music, comics, clothes, and ice cream flavors; when our secret sorrows and exclusion from the mainstream seemed somehow more enobling than the "vulgar enjoyments" of the crowd'.[28]

This discourse, stressing participation in alternative activities and involvement in the making of the history of the nasties (before it was even known about or widely documented), therefore succeeds in giving a unique autobiographical and 'human' quality to each site. However, arguably and in contrast to the idea that a nasty online archive is an anti-social realm, this discourse also seems to give such sites a quality of dynamism, through the recounting of experiences which mix together the distinct

romanticism of a past age, with the excitement, risk-taking and danger which are part and parcel of traditional ideas of what it's like to be young and male.

This pull (between romanticism and emotional attachment, and active participation and risk-taking) is something that comes across distinctly in the sections devoted to memories on a number of nasty sites. Notably, such stories operate through three distinct, but related, discourses. Firstly, subheadings or titles such as 'growing up during a moral panic' combine with stories of parents renting nasties and watching them in the family home, and of kids swapping stories about nasties in the schoolyard,[29] to give a sense of how the nasties impacted on a fan's life – how it permeated their upbringing and was, to all intents and purposes, part and parcel of *their* generation.

Secondly, website creators pinpoint their particular personal relationship to the nasties through accounts of the delights of the early 1980s British video shop (replete with descriptions of dusty or dirty local shops, with over-sized rounded video cases and gory posters on the wall, which stand in opposition to ideas of the streamlined, and implicitly mainstream, Blockbuster Video type outlets of the present day)[30] and their particular romantic attachment to such delights and the experiences that surrounded it. Thus, while one fan states that 'I fell in love with a Video NASTIE' and talks about the local video shop which has now been turned into an Indian takeaway, another notes, in his site's opening mission statement, that 'the early 80s in England were the halcyon days of horror films for me'.[31]

Thirdly, while these descriptions point to veteran nasty fans' distinct emotional attachment to such re-imagined times, places and objects from their past life, they also frequently highlight such fans' active participation in the video nasties phenomenon, by recounting the risky and illicit activities they took part in in order to obtain and watch these videos. As the *Hysteria/Slasher/Nasties* site notes, 'so, yes I did get to see quite a few horror movies – including some of those mythical nasties, on friends VCRs. Despite the virulent crackdown on all things dubious there were still a number of local shops that had the odd unsavoury item tucked away on a dusty shelf and would turn a blind eye to a trembling fourteen year old with his parents video card'.[32]

Here, this site creator not only demonstrates how the nasties

phenomenon provided the background to his generation, and outlines how he felt a sense of attachment to the nasties, but also, notably, how he got involved himself, responding positively to the nasties' connotations of danger, illicitness and scarcity, taking his parents' video card into the video shop, and watching nasties on friends' VCRs.

Arguably, it is these approaches (in combination) which allow nasty fans to demonstrate and describe how they were a part (and *are* a part) of a particular community of fans – of the same age, nationality and upbringing, and with the same cultural heritage. But also, at the same time, this discursive use of the past also allows such fans to reiterate their own particular authentic status as someone who grew up with the nasties, is intrinsically tied to them, and who has participated in activities surrounding them from an early age. As a result, this demonstration of a fan's link to the nasties (through nostalgic descriptions of renting them and experiencing the video nasty era) seems to act, for this particular generation and particular group of internet-users, as a standard, almost default way of demonstrating their status as authentic card-carrying 'veterans' of the nasties subculture, with a deeply ingrained and long-running investment in all that is illicit and subversive. In addition to this, the recounting of such experiences also seems to act as a useful means of solidifying a website creator's identity as active and masculine, with descriptions of participating in the nasty phenomenon frequently taking the narrative form of a male rite of passage (in the sense that such fans seem to ground discussions of watching and renting the nasties within discourses of growing-up, taking risks, and, implicitly, of becoming a man).[33]

However, to return to my initial observation, if this use of nostalgia appears to operate as a way of solidifying a powerful and authentic subcultural identity, this still does not account for the fact that such heroic activities exist in the past – that they are an element of the website creator's past identity, and not their present one. Indeed, it is noticeable that while nasty websites remember, in a positive fashion, the dynamic activities of their creator's past – where nasties were sought out and rented from the grubby local video shop and stories were swapped in the schoolyard – these sites also express (as the fan comment about the Indian takeaway should demonstrate) a sense of regret that the video shop, and the consumption activities surrounding it, have changed. As the

Hysteria/Slasher/Nasties site puts it, 'even the days where one or two "nasties" would cling to the shelves was in decline, gradually replaced by cut-to-shit *Friday the 13th* sequels, and soon there would [be] none left'.[34]

Nevertheless, if the earlier-cited mission statement from the creator of *Video Carnage* is taken into consideration, it is apparent that such memories, while operating on the one hand as a demonstration of the authenticity of the nasty website creator, also function as historical materials that will be preserved in the website – alongside the facts and sources reclaimed from official bodies and the materials from the website creator's collection – as part of a unique nasty archive. In this sense, these memories appear to operate like oral histories, offered up to the site as undiscovered and unique artefacts and slotted into the nasties' official cultural history (and thus, in some ways, allowing a fan to rewrite this history from their perspective). To employ the terms used by Stuart Tannock in his discussion of Bakhtin's nostalgic vision in *Rabelais and His World*, the use of fan memories as historical material on nasty websites can therefore function as a key means of 'opening up a space in the historical record, of recuperating a set of practices and discourses, within which we can now read formerly illegible activities and potentialities of resistance'.[35]

Furthermore, because nasty website creators can use memories to rewrite the history of the nasties, this approach can also further highlight the importance and uniqueness of their site and further reiterate their own important position within the ongoing nasties fan community. For the gathering together and constructing of an online archive of a website creator's own memories is a goal that can only be achieved by the website creator himself (for the purposes of preserving the memories of a generation), and this fact can therefore, in turn, justify the creator's sense of possession and control over the nasties, of the facts (official or unofficial) surrounding them, and his right to teach others about these facts.

However, while the use of nostalgia by nasty website creators can therefore again be seen as a highly positive act (allowing site creators to feel a sense of power for themselves, and a sense that they are also participating in a shared subcultural project of archiving the memories and heritage of a particular generation), it is still (in line with Hollows' arguments) based on the exclusion of others – whether they are those who are excluded from the particular

narrative that is constructed around the nasties and their history, or whether they are those who refuse to 'buy in to' and invest in the discourses through which this narrative is constructed.

With this in mind, it is notable that while such exclusions operate to solidify and secure the world of the nasty website (and the logic around which it operates), there is always the danger that such excluded parties will 'bite back' in more public fan arenas, exposing and challenging the discourses that underpin this approach. A discussion on the *Dark Angel's Realm of Horror* message-board appears to provide a particularly illuminating example of such inherent dangers, on an occasion where a specific nasty-orientated debate occurred between a number of male and female British horror fans.

The *Dark Angel* board, while constituted as a general forum for the discussion of horror films, appeared to concentrate, in the main and at least during the period of my research, on discussions of collecting and watching different video versions of nasty titles. While the board appeared to be dominated, on the whole, by male horror fans, at least during the course of my research (from July to September 2001), two female horror fans also used the board. During this time an argument was initiated by one of these female fans (Andrea) concerning the particular merits of *I Spit on Your Grave*, with Andrea arguing, in ways that correlate with some of Cherry's findings on female horror fans,[36] that this film (which for her was misogynist and 'tasteless') gave horror fans a bad name, was vastly inferior to the imaginative terror of such films as *The Blair Witch Project* and *The Haunting*, and, as she puts it, allowed for the 'painting [of] the picture that all horror fans' were 'into snuff pics'.[37] While previous message-board discussions with Andrea had been friendly (with experiences being shared with other fans of watching, enjoying and collecting horror videos, including a number of versions of nasty titles such as *The House by the Cemetery* and *Evil Speak*), this comment receives a particularly defensive response from the other message-board users, including the other female participant, who defends *I Spit* as a feminist work. In particular, one male participant (CJ) warns that 'you asked for it Andrea!!!', and then proceeds, in an argument which correlates with Hollows' observations, to dismiss mainstream 'Hollywood pap' and to defend *I Spit on Your Grave* and *Cannibal Holocaust* as 'honest' and groundbreaking (in opposition to this 'Hollywood

pap'). In addition, and crucially, he also argues, in an approach which appears to draw on a number of the discourses I've previously discussed, for an acknowledgment of his status as a 'qualified' horror fan who has been watching horror films for 'over twenty years', and references the 1980s video nasty era as evidence that 'to [the] masses we are equally disturbed'.[38]

However, if this argument appears to be a means of telling Andrea to show the other fans the respect CJ feels they deserve,[39] and to refrain from attacking the films they value, this is something that Andrea is clearly not willing to do. In a large spate of invective (running over several pages of message-board discussion), Andrea notes that 'the year is not 1984', that this reference to the 1980s is 'pointless', and, most markedly, that *I Spit on Your Grave* is a film that is valorised by 'young dumb drive in males or wannabe movie critics, helplessly repeating lines they have read in magazines or on the internet in a vein attempt to give validity to the kind of movies they watch'. Notably, she also defends *The Blair Witch Project* by arguing that 'even Allan Bryce from [the] *Dark Side* liked it, and many of you seem to like to have your options [sic] written for you'.[40]

While I do not wish to present this message-board discussion as an emblematic example of the differences between male and female British horror fans (indeed, as acknowledged, two female fans were on opposite sides of the argument in this particular discussion), it is particularly revealing for two reasons. Most obviously, some of the terms and ideas employed within the discussion correlate convincingly with Hollows' arguments, in terms of the frequent use of notions of the anti-commercial to defend and distinguish the tastes of nasty fans. However, more interestingly for my purposes, what this discussion also reveals is the extent to which facts and nostalgia can be used as a defence by nasty fans, but a defence which still, potentially, can be deflated by an excluded opponent. By exposing all that other nasty fans wish to sideline and avoid about their online world, Andrea is able to connect the nasty fans' imputed maleness to a clinging to the past ('the year is not 1984') and a dependence on the words or opinions of other more public sources and discourses. And, as a result, she is able to devalorise the power hierarchies that have been set up around this idea of the authentic nasty fan, allowing her to dismiss their logic as 'pointless' and unoriginal (insults which immediately deflate the wish of many

nasty fans to prove themselves to be authentic and original educators, and important cultural historians).

Conclusion: the ambiguities and insecurities of the 'popular archivist'

For Jim Collins, 'the emergence of new repositories of information such as the computer network ... exemplify the widespread reformulation of what constitutes an archive, and just as importantly what constitutes an archivist'.[41] As my analysis of nasty website discourse should suggest, this new democracy of archivisation (achieved through the emergence of the internet) has allowed many nasty fans to reclaim official facts and collate memories, giving them new uses and meanings within the realm of the personal website. For, through the meshing together of the objective (facts, sources and lists) and the subjective (memories and the use of items from fans' collections) on fan websites, such fans both mesh public and personal histories of the nasties and carve a niche for themselves between public bodies (fan magazines such as *The Dark Side*, but also wider, more legitimate bodies such as the BBFC and the DPP) and private consumers (the individual activities of nasty video collectors, who watch, store and catalogue such videos in the private spaces of their homes).

However, as Will Straw recognises, while such approaches seem to have a social and dynamic bent (with published and establishment sources being reclaimed, with ongoing archives being constructed, with colourful memories being recounted and preserved), they also have an anti-social and insecure flipside (a propping up with published sources, an emotional attachment to past objects and past times, a hiding away in the realm of the online archive). What the existence of such a flipside, arguably, reveals is that while the uses of video nasties on such sites can operate as a means of obtaining a feeling of autonomy, authenticity and activeness for the British horror fan, the ambiguities that exist behind these uses can always run the risk, on more free-flowing messageboard discussion, of being easily exposed and open to criticism. With, if the earlier cited message-board discussion is taken into consideration, this particularly being an approach open to female horror fans with differing attitudes to the appreciation or consumption of horror and/or cult cinema.

Notes

1 Lori Kendall, '"Oh no! I'm a nerd!" Hegemonic masculinity on an online forum', *Gender and Society*, 14:2 (2000), 259.

2 Most of this research was conducted during August and September 2001, using the www.google.co.uk search engine. I chose to disregard a number of sites that appeared amongst my search results (including the British Board of Film Classification site, a number of sites which dealt with the sale or exchange of video nasties, and the infamous *Melonfarmers Video Hits* website) on the basis that I wanted to look at a representative sample of explicitly personal and unofficial sites.

3 For instance, see Caroline Bassett, 'Virtually gendered: life in an on-line world', in Ken Gelder and Sarah Thornton (eds), *The Subcultures Reader* (London and New York: Routledge, 1997), pp. 537–50.

4 Indicated, in most cases, by either the site's url (which frequently featured the name of the site creator), from the site's title, from the biographies or mission statements on such sites, or, in one instance (*Hysteria/Slasher/Nasties*), from the fact that the website creator used a male name in message-board discussions.

5 As Hoxter acknowledges, 'my own investigation into Internet fan sites has concentrated, in as much as this is possible to ascertain given the structure of the object of enquiry, on young, male (mainly British), adolescent fans of *The Exorcist*.' Julian Hoxter, 'Taking possession: cult learning in *The Exorcist*', in Xavier Mendik and Graeme Harper (eds), *Unruly Pleasures: The Cult Film and its Critics* (Surrey: FAB Press, 2000), p. 174.

6 *Ibid.*, p. 175.

7 Xavier Mendik and Graeme Harper, cited in Joanne Hollows, 'The masculinity of cult', in Mark Jancovich, Antonio Lazaro Reboll, Julian Stringer and Andy Willis (eds), *Defining Cult Movies: The Cultural Politics of Oppositional Taste* (Manchester: Manchester University Press, 2003), p. 37.

8 Most explicitly, *Dark Angel's Realm of Horror* references *The Dark Side* and recommends Allan Bryce's book on the nasties, discussed in the last chapter. '*Dark Angels' Realm of Horror* presents … video nasties', *Dark Angel's Realm of Horror*, http://website.lineone .net/~darkangel5/nasties.htm (28 August 2001).

9 Nigel Wingrove and Marc Morris' limited edition book, *The Art of the Nasty*, which is referenced in a number of message-board discussions about the nasties, also appears to be a key influence on the structure of such sites. Nigel Wingrove and Marc Morris (eds), *The Art of the Nasty* (London: Salvation Films, 1998).

10 Brigid Cherry, 'Screaming for release: femininity and horror film fandom in Britain', in Steve Chibnall and Julian Petley (eds), *British*

Horror Cinema (London: Routledge, 2002), pp. 48–50.

11 Will Straw, 'Sizing up record collections: gender and connoisseurship in rock music culture', in Sheila Whiteley (ed.), *Sexing the Groove: Popular Music and Gender* (London and New York: Routledge, 1997), p. 4.

12 Jim Collins, *Architectures of Excess: Cultural Life in the Information Age* (New York and London: Routledge, 1995), pp. 25–8.

13 'Welcome to video carnage!', *Video Carnage*, www.videocarnage.co .uk/vccontents.html (29 August 2001).

14 Dark Angel, '... video nasties'; and 'A–Z of video-nasties', *Hysteria/Slasher/Nasties*, www.south-over.demon.co.uk/Hysteria /slasher_nasties_1.html (9 October 2000).

15 Collins, *Architectures*, p. 27.

16 'A–Z of video-nasties'; and 'Video nasties', *Wayney's Movie World*, www.wayney.pwp.blueyonder.co.uk/video%20nasties.htm (29 August 2001).

17 Kittt, online posting (19 May 2001), *Guardian Unlimited Talking Film*, http://filmtalk.guardian.co.uk/WebX?50@211.89sQfdXQmr6^0@.ee 6ec50 (4 September 2001).

18 Justin Kerswell, '*Texas Chain Saw* vs. the BBFC' (8 October 2000), www.mhvf.net/cgi-bin/anyboard.cg...z&aK=4810 &gV=0&kQz=&a0=1&iWz=0 (4 September 2001); Tim Rogers, '*Chainsaw* was rejected by the BBFC in 1975' (8 October 2000), www.mhvf.net/cgi-bin/anyboard.cg...z&aK =4810&gV=0&kQz=&a0=1&iWz=0 (4 September 2001); and Justin Kerswell, 'The pornography of terror' (8 October 2000), www.mhvf.net/cgi-bin/anyboard.cg...z&aK=4810 &gV=0&kQz=&a0=1&iWz=0 (4 September 2001). Incidentally, the book cited by Justin is Tom Dewe Matthews, *Censored: What They Didn't Allow You to See, and Why: The Story of Film Censorship in Britain* (London: Chatto and Windus Limited, 1994).

19 See Jenkins' discussion of internet communities' ability to pool fan knowledge online for the benefit of all in the community (a pool of knowledge which he terms, citing Pierre Levy, as 'collective intelligence'). Henry Jenkins, 'Interactive audiences?', in Dan Harries (ed.), *The New Media Book* (London: British Film Institute, 2002), rpt. in Virginia Nightingale and Karen Ross (eds), *Critical Readings: Media and Audiences* (Berkshire: Open University Press, 2003), pp. 279–95.

20 As Jenkins argues, 'new tools and technologies enable consumers to archive, annotate, appropriate, and recirculate media content'. Jenkins, 'Interactive', p. 280.

21 Straw, 'Sizing up', pp. 8 and 10. See also Lori Kendall's discussion of the problematic status of the nerd in terms of computer technology

where, for Kendall, an adeptness at computer technology, while seen
as ambivalently masculine by society at large, can also allow a person
to indulge in 'aggressive displays of technical self-confidence'. R.
Wright, cited in Kendall, 'Oh no!', p. 261. Another example of this
nerdish disposition, where 'any domain of expertise [is turned] into a
series of numbers on a checklist', can be found on the *Dark Angel's
Realm of Horror* message-board, where participants frequently
compare their personal lists of the top ten best banned videos. See, for
instance, Darkest Desires, 'All time top 10 uncut/banned collectors
list' (13 July 2001), *The Realm of Horror Discussion Forum*,
http://disc.server.com/discussion.cgi?id=126992&article=2500&dat
e_query=995257783 (5 September 2001).

22 I'm referring here to arguments made in such classic subcultural texts
as Dick Hebdige, *Subculture: The Meaning of Style* (London:
Methuen, 1979) and Stuart Hall and Tony Jefferson (eds), *Resistance
through Rituals: Youth Subcultures in Post-War Britain* (London:
Hutchinson, 1976).

23 Hoxter, 'Taking possession', p. 178.

24 'An overview (or – why I grew up to hate the *Daily Mail*!)',
Hysteria/Slasher/Nasties, www.south-over.demon.co.uk/Hysteria
/slasher_nasties_1.html (9 October 2000).

25 See, for instance, 'Fear, panic and censorship', *Dark Angel's Realm of
Horror*, http://website.lineone.net/~darkangel5/vnphenom.htm (28
August 2001); 'An overview'; and 'I saw the best video stores of
my generation destroyed by madness: growing up during a moral panic
...', *Hysteria/Slasher/Nasties*, www.south-over.demon.co.uk/Hysteria
/slasher_nasties_1.html (9 October 2000).

26 Mark Jancovich, 'Cult fictions: cult movies, subcultural capital and
the production of cultural distinctions', *Cultural Studies*, 16:2 (2002),
315.

27 Fred Davis, *Yearning for Yesterday: A Sociology of Nostalgia* (New
York: Free Press, 1979), p. 55.

28 *Ibid.*, p. 40.

29 See Yodasnoog, 'I fell in love with a video NASTIE ...', *Video Nasties
by Yodasnoog*, www.geocities.com/spuffjockey19/nastie.html (4
September 2001); and 'I saw the best'.

30 This idea of dusty, dirty, marginal video shops as an implicitly mascu-
line space is developed by Hollows. Replacing the local video shop
with the cult movie theatre (and noting its status as a smelly, run-
down space, on the outskirts of town), she argues, citing Will Straw,
that a sacrilisation of such spaces 'works to confirm the figure of the
cult fan as a ... "manly adventurer" who sets out into the urban
wilderness, a position less open to women'. Hollows, 'The masculini-
ty', p. 41.

31 See Yodasnoog 'I fell in love …'; and 'Video Nasties', *Wayney's*. Another website, *Videocream*, while being official and journalistic (rather than an unofficial fan-based site), is noteworthy here as it actually sets itself up as an electronic version of an 'old-fashioned video shop', asking visitors to the site to enter the realm of 'the TV Cream Video Rental Shop, where the shelves still heave under those slightly oversized video cases … you know, the ones with the rounded spine. You never see 'em any more'. 'Videodrome', *TV Cream*, http://tv.cream.org/videocream.htm (4 September 2001).

32 'I saw the best'.

33 This air of 'manliness' about the fan's nostalgically constructed era of the 1980s seems to come across again in a discussion on the *Dark Angel's Realm of Horror* message-board, where a male participant notes, about the superiority of the nasties and other low-budget slasher films over more recent examples of the horror genre, that 'my girlfriend would kill me for sayin it – but … The 80s were better because most were made on the tiniest budgets (you can tell), had LOADS more death scenes in, terrible storyline and dialogue and … loads of T/A'. Mutilator, 'Girls who just scream and die' (27 August 2001), *The Realm of Horror Discussion Forum*, http://disc.server .com/discussion.cgi?id=126992&article=3440 (28 August 2001).

34 'I saw the best'.

35 Stuart Tannock, 'Nostalgia critique', *Cultural Studies*, 9:3 (1995), 462.

36 See both Brigid Cherry, 'Refusing to refuse to look: female viewers of the horror film', in Melvyn Stokes and Richard Maltby (eds), *Identifying Hollywood's Audiences: Cultural Identity and the Movies* (London: British Film Institute, 1999); and Cherry, 'Screaming', pp. 44–57.

37 Andrea, 'How far is too far?' (24 August 2001), *The Realm of Horror Discussion Forum*, http://disc.server.com/discussion .cgi?id=126992&article=3320 (28 August 2001); Andrea, 'Please don't take this the wrong way but …' (24 August 2001), *The Realm of Horror Discussion Forum*, http://disc.server.com/discussion.cgi?id +126992&article+3326 (28 August 2001); and Andrea, 'Personal insults?' (25 August 2001), *The Realm of Horror Discussion Forum*, http://disc.server.com/discussion.cgi?id=126992&article=3370 (28 August 2001).

38 See Beatrice, 'What are you missing?' (24 August 2001), *The Realm of Horror Discussion Forum*, http://disc.server.com/discussion.cgi ?id=126992&article=3322 (28 August 2001); CJ, 'Re: Please don't take this the wrong way but…' (24 August 2001), *The Realm of Horror Discussion Forum*, http://disc.server.com/discussion.cgi?id =126992&article=3343 (28 August 2001); and CJ, 'Re: A classic? Oh

please!' (25 August 2001), *The Realm of Horror Discussion Forum*, http://disc.server.com/discussion.cgi?id=126992&article=3372 (28 August 2001). It is interesting, in some senses, that *The Blair Witch Project* and *Scream* are the films which are brought into this discussion and attacked by CJ and the other female participant, Beatrice. For Mark Jancovich, *Scream* has provoked 'struggles between horror audiences', with Jancovich arguing that the film's high-budget and success with teenage females has allowed other fans to claim that such films are 'not just inauthentic horror but ... are made for, and consumed by, inauthentic fans: young girls who cannot have the subcultural capital to define what is hip!' Mark Jancovich, '"A real shocker": authenticity, genre and the struggle for distinction', *Continuum: Journal of Media and Cultural Studies*, 14:1 (2000), 29–30.

39 Or, as CJ puts it: 'I would appreciate a little more civility and respect, as I have shown you'. CJ, 'Re: A classic'.

40 Andrea, 'A classic? Oh please!' (25 August 2001), *The Realm of Horror Discussion Forum*, http://disc.server.com/discussion.cgi?id =126992&article=3364 (28 August 2001), and Andrea, 'Personal insults?'.

41 Collins, *Architectures*, p. 25.

The celebration of a 'proper product': exploring video collecting through the video nasties

Video collecting as a consumption practice has only just begun to be explored by film and media academics, and mainly since the advent of laserdisc and other digital forms of home cinema. To date, the key work on video collecting has come from Barbara Klinger, whose 2001 essay on post-video collecting cultures remains a prominent intervention into the field. Here, Klinger not only attempted to explore film's transformation, through video, into a collectible object that can be aligned with books, records, comics or stamps and to explore some of the predilections that characterise film collecting as a specific practice, but, perhaps most crucially, she was also the first to consider, systematically, how film collecting theories can be informed by theories based on comparative collecting practices, including work on collecting from Walter Benjamin, James Clifford and Susan Stewart. In addition, she has also sought to build on this work (much of which portrays collecting 'as personal and idiosyncratic') by placing film collecting 'within a cultural frame'.[1] It is this focus on the relationship between collecting and culture which has allowed Klinger to address the way film's transformation, through video, into a mass-produced commodity *and* a possessable object has created 'an intense link between private and public spheres', allowing video collecting to 'emerge ... as a complex activity situated suggestively at the fluid intersection between public and private'.[2]

In order to explore the importance of cultural and external influences on film collecting, Klinger takes as her focus video collectors of contemporary home cinema formats (with particular emphasis placed on laserdisc) and, in the process, posits a number of observations about the key discourses and dispositions that characterise

contemporary video collecting. Crucially, she achieves this by focusing on how public discourses generated by marketing and 'the discourses of new media technologies' have not only 'stimulated the growth of film collecting'[3] but also constructed the concerns of the contemporary film collector.

As she argues at length, media industries and film distribution companies have sought to market contemporary collectibles, firstly, through the creation of discourses of scarcity or exclusivity (where videos or discs are marketed as limited collector's editions, collector's special editions or classic collectibles) and, secondly, through the inclusion on discs of an array of extras and other forms of background information on the production and post-production history of the film concerned. For Klinger, such discourses and forms of background information help to imbue contemporary video collectibles with an aura of authenticity, while, in the process, targeting collectors as 'insiders', who are able to gain a heightened sense of 'intimacy'[4] with a particular film and reinforce their status as discerning collectors and serious cinephiles.

However, if this is one way in which contemporary video collectors are addressed as discerning cinephiles, then, for Klinger, the other, and perhaps defining, way in which this is achieved is through the creation of a key criterion of quality and value for such collectibles – namely, the extent to which the video version of a particular film reproduces the original theatrical conditions under which a film was viewed (achieved through the reconstitution of original theatrical aspect ratios and high-quality sound and image transfers). For Klinger, the ultimate consequence of this 'preoccupation with sound and image' is that home cinema collectors are beginning to valorise filmic elements that emphasise a video version's technical quality (for instance, sound and cinematography) over the quality of other elements (its social and cultural themes, its narrative and so on) – a process which, for her, gradually aligns 'a passion for cinema' with 'a passion for hardware' and, ultimately, associates 'cinephilia with technophilia'.[5]

Through an exploration of some of the key concerns of contemporary video collecting, then, Klinger is able to construct a persuasive 'top-down' model, focusing on the discursive practices of media industries and hardware manufacturers (who label and construct serious collectors and generate the key forms of knowledge and value that they bring to their collecting habits) and,

through this, highlighting the extent to which public discourses shape supposedly private collecting identities. However, while such arguments make Klinger's intervention groundbreaking and important, it is also an account which, at points, posits some generalisations about the nature and character of contemporary video collecting practices.

Most prominently, while Klinger is specific, throughout the course of much of her essay, about the type of contemporary video collector that she is choosing to focus on (the 'high-end' collector who has both a 'passion for the cinema' and an engagement 'with technological developments that mimic the conditions of the movie theatre within the home'),[6] she frequently allows her observations on this type of collecting practice to speak for contemporary video collecting practices as a whole. This is most markedly the case when she begins to align herself with the arguments of Charles Tashiro, a laserdisc enthusiast who had previously published an account of his own personal collecting habits in a 1998 edition of Film Quarterly. Like Klinger, Tashiro focuses on the degree to which technical criteria reigns supreme in his collecting habits, subsuming the importance of plot and characterisation to sound and image qualities of particular film texts. However, such subjective observations on his collecting dispositions allows Tashiro to make much grander claims about the characteristics of video collecting in general. For him, as for Klinger, because technically-orientated collecting practices are so focused on the contemporary standards of digital technologies (on notions of constant improvement, progress and an obsession with the technically 'perfect copy' of a particular film title),[7] technological value is always seen to negate any sense of historical value in the contemporary video collection.

In order to demonstrate the extent of this negation, Tashiro chooses to compare video collecting with Walter Benjamin's account of his own book collecting habits, where historical value (the appreciation 'of a book's individual history as an object') serves as Benjamin's key collecting criterion.[8] On the basis of this direct comparison, Tashiro is able to argue that 'if there is a consequence to the "historical pleasure" of book collecting, and the absence of that pleasure from *video collecting*, it lies in the shape and feel of the books as objects' (my emphasis), and that while a book may therefore be valued for its physical and material ability

to 'announce its history, its simultaneous existence in space and time', 'physical markers of history ... are present on the surface of a disc only to its detriment'.[9] By harnessing this claim in her own account, Klinger is also able to make sweeping claims about contemporary video collecting, arguing that the centrality of the precious, scarce and historically authentic 'dusty, dog-eared volume' or 'elusive first edition' is something that is 'sorely lacking in this context'.[10]

What therefore characterises both accounts is the sense that forms of 'historical pleasure' have been completely replaced in the contemporary video collecting world by an all-encompassing technophilia and, consequently, that there is always a distinct hierarchy amongst video collecting formats: where laserdiscs and DVDs are seen as the most important and valuable form of collectible, while VHS videotapes, which degrade and possess more potential to show their age, remain video collecting culture's 'second-class citizens'.[11] In this respect, Klinger and Tashiro can be seen to make grand claims about video collecting in general, painting a picture of a contemporary video collecting world where any sense that VHS videos can have their own, format-specific sense of authenticity is entirely negated, and without the acknowledgement that an appreciation of any collected object may vary according to the nature of the object *and* the reasons for its appreciation, its value and its organisation within the confines of the collection. As Susan Stewart has argued, 'to ask which principles of organization are used in articulating the collection is to begin to discern what the collection is about'[12] and it is the reasons and motivations that underpin a particular collection's organising sensibility that can therefore frequently determine, hierarchically, whether old or new objects, versions or formats are most highly valued and which key external discourses (whether historical or technological) come to inform a collection's structure of value.

As should be apparent from discussions in previous chapters, the distribution, marketing and censorship history of the video nasties in Britain, and its subsequent impact on the consumption practices of post-Video Recordings Act (VRA) banned video collectors, can clearly be delineated as an alternative cultural determinant to the contemporary marketing discourses discussed by Klinger. It exists as a marked example of how *past* nationally-specific commercial and political circumstances can inform and, in many respects,

determine the personal forms of meaning at work within particular, present day video collections, and the hierarchies of selection, value and categorisation through which such collections are constructed. Perhaps most crucially, the VRA had clearly given present day nasty collectors a clear 'principle of organization'[13] and a key criterion of value for their collections. For not only did the original Director of Public Prosecutions' video nasties list act as a 'shopping guide'[14] for collectors who wanted to obtain a full set of nasties, but it also established the primacy and importance of obtaining original, pre-recorded versions of particular pre-certificate titles.

As Kerekes and Slater demonstrate, this initial concern with original versions in the early years of video nasty collecting was largely based around the need to obtain the best quality and most politically authentic version of a banned title. However, what findings from the last two chapters seem to point to is the sense that, as newer, more uncut versions of the nasty titles have begun to proliferate, video nasty collecting concerns, for some, have mutated towards a focus on the historically authentic value of such videos, on both a cultural and more personal level.

On a collective, more community-wide level, British fan-orientated publications and fan-produced websites, from around 1998 onwards, have appeared consistently to foreground the artefact status of the original nasty videos, by focusing on their historically distinctive cover art and the minute historical details of their original distribution and censorship histories in the pre-VRA era.[15] What therefore, arguably, has come to be emphasised (at least within some of the most public sectors of the video nasty fan community) is not only the continued centrality of forms of specialist knowledge about pre-VRA covers, distributors and labels, but also the now marked importance of the original nasty videos' cultural history and their re-constituted status as 'origin objects' within British horror video collecting culture.[16]

On a more personal level, however, original video nasties have (at least for video nasty era-induced collectors like Dave Green and Justin) come to be valued not just as collective cultural artefacts, but also as personally meaningful reminders of a key moment in a collector's individual consumption history. It is this dual focus on the historically authentic value of such videos, then, which has, arguably, not only reconstituted original video nasties as residual

reminders of an authentic and meaningful golden age of video, but has also (through a concurrent focus on the status and currency of collectors' pre-VRA memories) enabled the 'ardent' veteran video nasty collector to emerge as a distinct type in the contemporary British horror video collecting world.[17]

In order to explore further both the status and dispositions of this particular type of veteran collector, I want to focus, for the rest of this chapter, on the collecting practices of John,[18] a self-proclaimed video nasty collector whom I met with on two occasions in 2001. From the accounts that John gave me of how he began to acquire his own nasty collection, it became clear that he was one of these veteran collectors. Firstly, he had experienced the era of video nasty hysteria first-hand. From the age of around ten or eleven years onwards, he had rented a large number of pre-certificate video nasties from video shops, watched them with friends and spent a large amount of time at school discussing titles like *The Evil Dead* and *I Spit on Your Grave*. Secondly, the commencement of his video nasty collecting activities in the early 1990s involved the employment of some of the traditional methods of video nasty acquisition outlined in chapter 4. Through a friend at work, John had learnt how to read advertisements in *The Dark Side* which discretely advertised 'rare horror collections', and to learn which video labels to look for and which markets and fairs to attend in order to acquire old versions of video nasty titles.

There are perhaps two distinct reasons why I'm proposing that focusing on a 'thick description'[19] of John's collecting history and habits might be productive within the realms of this chapter. Firstly, taking a 'bottom-up' approach to video collecting practices and focusing on a *specific veteran* video collector's acquisition and classification rituals can, arguably, allow for a tracing of the felt impact of an array of historical, and thus external, influences on the private collection (influences which frequently coalesce with some of the habits outlined in Benjamin's account of his book collecting practices). An exploration of how videos can accrue value over time can demonstrate how, just as with Benjamin's coveted book collectibles, residual layers of meaning (including 'the realization' of a video's 'individual history as an object' and the realisation of a specific 'collector's history of possession'[20] and consumption) can affect the value, and inform the video collector's appreciation, of their collected objects. In addition, a mapping of

the historical formation of an individual's collecting dispositions can highlight how forms of knowledge based around what Benjamin calls 'tactical instinct' and 'experience'[21] can slowly gain cultural currency in a collecting community and lead to the construction of 'insider' identities generated not by contemporary marketing discourses, but in relation to the changing context of a secondary market and to format-specific video distribution histories.

Secondly, however, it is also important to note that while John's video nasty collecting and consumption history allows him to be 'typed' as a veteran video nasty collector, it is also the case that he possesses particular collecting dispositions and practices which appear entirely peculiar to him. Not only is he resolutely anti-digital (refusing, unlike many other veterans,[22] to include digital versions of nasty titles in his collection or succumb to any modern forms of video acquisition, via the internet), but he also engages in a number of seemingly idiosyncratic categorisation and modification rituals (the creation of pre-VRA label archives and the restoration of certain videos) which, at least on the basis of my own research into video nasty collecting dispositions and discourses, do not appear to be widespread within the video nasty fan community. In this respect, John can also be perceived as a particularly committed example of a veteran nasty collector, in terms of his consistent attempt to move away from more central practices, construct entirely personally constituted rituals and thus underscore his role as creator of particular, personal systems of meaning and value within the collection.

While this may appear a methodological shortcoming, this focus on a partially divergent video nasty collector does allow for a deeper exploration of something glossed over in Klinger's account. For while Klinger does acknowledge, early in her essay, that the 'zealotry' of the video collector is 'undoubtedly characterised by the whims and obsessions of the individual',[23] her fervent attempt to highlight the primacy of public discourses in collecting cultures means that she relies, throughout the majority of her account, on industry discourse and marketing materials at the expense of a more detailed, empirically-based exploration of what the individual collector brings to their collecting practices. By therefore focusing in depth on a collector who, while shaped by community-wide dispositions and economies of value, also strives to create his

own personally meaningful rituals within the collection, the chapter will attempt to explore and illustrate how complexly interweaved personal meaning and culturally-determined meaning can *be* in each collection and how, paradoxically, personally-constituted collecting practices can succeed in even more forcibly highlighting the impact of commercial and cultural meanings, categories and discourses on individual collections.

In what follows, two key areas that characterise John's video nasty collecting practices will be touched upon. Firstly, in order to establish the reasons why certain videos are acquired and have value, the chapter will look at the importance of video labels, different video versions and original or rare videos to the veteran video nasty collector. Secondly, in order to explore further the variety of complex intersections between public and private in a particular contemporary video nasty collection, it will also look at the particular secondary consumption spaces through which John has acquired his videos (including the car boot fairs discussed in chapter 4), and at how these videos have then been renovated and categorised in order to become part of his collection. In order to explore the extent to which John's collecting habits converge with wider dispositions and practices amongst veterans and other collectors in the video nasty fan community, my account will also be informed by wider discussion of British nasty collecting from *The Dark Side* and from the British-based internet message-board *Dark Angel's Realm of Horror*. While it should be noted that the majority of this research was conducted during 2001, and that the dynamics of the video nasty collecting community may have changed since this time, the account given below is offered as a historical snapshot of the video nasty community (and of a specific video nasty collector's practices) at a key historical juncture, as DVD and the internet were beginning to usurp traditional forms of uncertified or illicit video acquisition, and at a time parallel to the publication of Klinger's crucial 2001 essay on video collecting.

Discussions with a nasty collector: issues of value, consumption and exchange

Since the banning of the original video nasties in 1984, an array of different video versions of particular nasty titles (some which are cut and others which are uncut) have been released in Britain and

overseas.[24] Over the course of my conversations with John, it became apparent that there were a variety of 'insider' ways to identify these different video versions, which could be picked up via horror magazines like *The Dark Side* and through accumulated knowledge and experience, word of mouth or particular contacts. In some cases, this would simply be based around identifying particular scenes which would only appear in an uncut version of a particular nasty title. For instance, John gained an uncut copy of *The Burning* when, on borrowing a friend's copy, he realised the previously removed 'shears scene' was intact, while, on a 2001 *Dark Angel* message-board posting, advice is given on how to find a particular scene in *I Spit on Your Grave*, which would identify whether a particular version of the film was uncut.[25] In other cases, tell-tale signs for collectors include serial numbers, dates or (if a letter from *The Dark Side* is taken into consideration) particular artwork used on the video sleeve or on the video itself.[26]

However, perhaps the most effective way to identify particular versions of nasty titles (or at least the way that appears to have been used most frequently by John, *Dark Side* readers and *Dark Angel* participants) is to have extensive knowledge about video labels and video distributors. As John explained, 'you can identify which video labels are cut films. You know which label to look for'.[27] However, while the key use of this label literacy is therefore to identify and find uncut video versions, it also appears to have encouraged many nasty collectors to use knowledge of labels and versions as a valuable research tool. Indeed, an illuminating example of this relationship between collectors and video companies occurs in a 2001 discussion of different versions of the nasty title *The Beyond* on the *Dark Angel* message-board. Here, when one Finnish horror video collector realised, to his dismay, that his Cosa Nostra copy of *The Beyond* was cut, other British participants managed, through a comparison of copies of *The Beyond* from their own private collections, to not only provide background information on the video distributor but also to expose them as producing cut bootleg videos and even to identify which video distributor's version of the film these bootlegs had been copied from.[28]

What emerges from such an example is an idea of the 'insider' which concurs with Klinger's definition (someone who has 'obtained apparently special knowledge, possessed by relatively

few others'),[29] but which manifests itself in a different way. Not through searching for the best transfer with the most deleted scenes and most 'behind the scenes' extras (all supplied legitimately by a contemporary video, laserdisc or DVD distributor), but through constructing a more active and interrogative relationship to distributors, both old and new. For, in order to identify the value and status of a version of a particular nasty title, collectors have to build up knowledge not only about the history of particular video distribution companies, but also their historical and commercial relationship to each other and to versions of particular nasty titles. As with Benjamin's book collecting practices, what this therefore seems to demonstrate is how a focus on a film title's history (its history of international distribution and the litany of video versions this history has generated) creates the potential for an array of different video versions to be sought out, and a rich, vast field of collecting knowledge and learning to be constructed around such versions. As Benjamin notes and as the last chapter demonstrated, what this allows is for 'the whole background' of each collected video ('the period, the region ... the former ownership') to turn the collection into 'a magic encyclopaedia' of information and history about the video distribution of particular film titles.[30]

While video nasty collecting therefore appears to be characterised, on the one hand, by the insatiable search for the most complete or uncut version of a film in existence, it is also characterised by another interest which is clearly informed by this conception of the collection as a historical information source – namely, to own every video version of a particular film title in existence. This tendency was identified by John as being central to his collecting habits on a number of occasions, including in terms of a discussion of video nasties, but perhaps the motivations that lay behind this tendency came across most clearly when he began to discuss the seven different versions of George Romero's *Dawn of the Dead* which exist in his collection. As he explained:

> The reason I've got so many [copies of] *Dawn of the Dead* ... is because different versions pop up all the time, and I thought 'I wonder what's in that one ... why's that one trimmed?' Different versions have been on TV and I got the 124 minute print off a mate. The one of the *Dawn of the Dead* I watch is the last video release. [The] retail release, which is one of the best quality copies I've got and

it's pretty much complete. I've got rental ones from years ago. There's chunks of film missing out of them ... so they're just now part of the collection, more than anything ... It's because it's my collection and it would seem now, if I removed any part of it, that it would be incomplete. I've got to keep it all.[31]

What John clearly conveys in this comment is the extent to which nasty collecting habits are frequently informed by two distinct notions of completeness: the need to possess the most complete, uncut video version of a film (the 'retail release' which is 'pretty much complete') *and* the need to make *the collection* complete via the acquisition of all the different available video versions of a particular film title (which, if removed, would make the collection 'incomplete'). Crucially, what this distinction highlights is the nasty collection's ability not only to function as a useable historical library or archive (where different video versions are compared in order to establish the identity of the most complete version), but also as a historical monument, where older, less complete items serve to strengthen and extend the historical worth of the collection as a whole.

This dual valuation and use of older, more incomplete video versions of nasty titles is also identified by horror video collectors in a number of *Dark Angel* postings where, in 2001, discussions about the exchange and acquisition of particular horror videos frequently occurred. In one *Dark Angel* posting, for instance, a collector justified his efforts to try to obtain an ex-rental, pre-VRA copy of *Cannibal Holocaust*, when uncut copies of the film were quite readily obtainable from abroad, by arguing that 'I know it was pre cut by GO VIDEO, but I want the pre cert to compare it with modern versions, and besides, cut or uncut it is a collectors item'.[32]

In this respect, the valorisation, by these nasty collectors, of older, pre-VRA videos can be seen to revolve, on the one hand, around their use as comparative objects in the collection (which can be compared with 'modern versions'), while, on the other, they also operate as 'collectors items' which function as necessary building blocks or components that extend both the quantitative mass and historical value of particular parts of the collection – something which, once again, appears to align these video nasty collectors with Benjamin and his fellow book collectors who, as Tashiro notes, could 'only add to a collection' and 'never' replace or 'part with parts'.[33]

However, while this is one justification for why video nasty collectors have 'got to keep it all' and allow an uncut video version to coexist alongside versions which have 'chunks missing', then it is also the case that original, pre-VRA versions of the nasty titles (whether cut or uncut) can also be appreciated, in their own right, as meaningful and valuable 'prize pieces' of the collection. What is suggested by the importance of these 'prize pieces' is that videos in the collection are frequently valorised not in relation to standard, public forms of monetary value but to more personalised forms of value, and, based on John's discussions, it can be argued that two types of personalised value relate to these older, defunct videos – aesthetic/historical value and the value of the rare or singular.

As Susan Stewart notes, for Jean Baudrillard 'a "formal" interest always replaces a "real" interest in collected objects' and, as she argues, 'this replacement holds to the extent that aesthetic value' can frequently 'replace … use value' within the confines of the collection.[34] If the predominant 'use value' of a video is to be watched, and certainly John seems to watch some of his videos, then it is also the case that particular videos in his collection also seem to be appreciated on this purely 'formal' or aesthetic level. When quizzed about why he continues to valorise VHS over DVD versions, when his VHS copies are often of bad quality and cut, John made the following comment: 'I like the big boxes … I like the fact you feel as if you've got a proper product – a bulky big tape, especially with the old ones. You know how much a proper video nasty tape weighs. It's like a brick … That's how all videos used to be'.[35] In addition to this, John also waxed lyrical, throughout our discussions, about an old pre-VRA *Dirty Harry* video that he'd seen at a car boot fair on an old Warner Brothers label, noting that 'I got excited about that *Dirty Harry* on the Warner Video … [with] all similar sleeve and spine designs, [a] picture, black border and Warner Brothers logo'.[36] In addition, and as John later revealed, his old Warner Brothers tapes and his tapes from a defunct video nasty era video company, VTC, had not only been purchased on the basis of their distinctive box, spine and sleeve, but also had been categorised together in, as he put it, 'a little collection on its own'.[37]

What these comments seem to emphasise is the frequency with which the value of particular videos in John's collection are delineated in relation to their status as outmoded objects which, to him,

represent the way 'all videos used to be'. For, in these examples, pre-VRA, ex-rental videos appear to be appreciated not for their actual content or use value (i.e. the actual aesthetic, generic or cultural quality of the film *or* how complete and uncut it is), but for the meaningful historical value of their material form (the bulky brick-like tapes, the big, battered old boxes and the distinctive spines, logos and designs on the video sleeve).[38]

This personally constituted link between aesthetic and historical value perhaps relates most clearly to the Benjamin-inspired idea that collecting 'becomes a form of personal reverie, a means to re-experience the past though an event of acquisition', and indeed that a collected object, through its aesthetic form, can also 'conjure ... memories of its own past'.[39] This idea, that the aesthetic form of a particular video can bring pleasure to the collector by conjuring up its past and, notably (and also in line with Benjamin's arguments), the collector's own past, is also clearly conveyed in two other accounts of video nasty collecting. In a *Dark Side* article on 'The death of the video nasty', journalist and video nasty collector Jay Slater notes that 'seeing those large video boxes with fabulous artwork (remember VTC's vacuum-sealed monstrosities!) takes you back to a bygone age',[40] while, for a veteran video nasty collec-tor cited in Kerekes and Slater's book, it is the smell of pre-VRA video nasties, as well as their aesthetic form, that allows for this 'personal reverie'. As the collector explains, 'There was a musty smell to the videos, too. Not an unpleasant odour – just what became an associative "video nasty aroma"... The smell lingers vaguely and a quick sniff transports me back to the halcyon days of seeking out banned movies'.[41]

As touched on in previous chapters, what these accounts suggest is that, for veteran nasty collectors, the appreciation of original video nasty versions often has a clear relationship to nostalgia and to 'personal autobiography',[42] and that these collectors therefore frequently value these videos because of their relationship, through video artwork, labels and shapes of boxes, to their adolescent past and prior consumption of these titles in the era of nasty hysteria. Indeed, the fact that consistent reference is made, in *Dark Side* clas-sified advertisements, to the fact that items for sale are 'pre-1984 originals', 'originally boxed films' or 'pre-certificated originals'[43] indicates how frequently the value of original nasties is articulated in relation to their status as emblems of a prior consumption era

which has key personal meanings to the veteran nasty collector.

In many respects, then, the nostalgic value of these old, ex-rental videos emphasises the extent to which, in Stewart and Baudrillard's terms, collecting can be an entirely personal and 'transcendent' domain, where the collector is able to 'marshal' their 'own discourse' which is always controlled and determined by the collector's own forms of value rather than those of the outside world.[44] Conversely, however, it is also the case that the determining influence of the cultural and external can still clearly be detected beneath the surface of John's appreciation and acquisition of these original, pre-VRA videos.

For, as should be apparent, these articulations of the authenticity of the original nasties relate not just to memories of their prior consumption in the pre-VRA age, but also to their distinctive material appearance (the materiality of their box and sleeve) and, as John's references to 'proper products' and 'similar sleeves and spine designs' seem to indicate, to past markets and past forms of marketing. In addition, while John justifies his acquisition of old pre-VRA versions from defunct video companies by explaining that these labels don't 'exist anymore, so they're not going to be doing any more stuff', he also freely admits that, for him, one of his VTC tapes, *Hitchhike*, is a terrible film and that it has largely been acquired because of the need to include it in his VTC collection.[45]

Indeed, the fact that *Dirty Harry* and *Hitchhike* weren't on the original video nasties list but are connected to the video nasties era purely via their distribution companies and their material form highlights the potential for John to be perceived as the creator of his own personal discourse, but a discourse which is still dependent on externally-controlled forms of meaning and categorisation. For here, in these particular cases, John appears to be purchasing certain videos not necessarily because he watched them in the pre-VRA era, but because of the need to complete a certain set of videos in his collection and acquire all the products from a defunct video company which doesn't 'exist anymore'. In cases like this, as Baudrillard argues, collectors can 'get so carried away that they continue to acquire titles which hold no interest for them', allowing 'the pure imperative of [their] association' to particular defunct video companies and their 'distinctive position within the series' or archive of similar objects to be the only reasons needed for acquiring them.[46]

John's attempt to create a personal discourse for his old, collected videos (and only acquire outmoded videos which have nostalgic value or meaning for him) is therefore complicated by the parallel need to imbue parts of the collection with wider cultural significance (in the sense that, through acquiring these videos, they can come to function as a complete archive of a defunct video company rather than just being a set of videos that only have a relationship to *his* past video consumption experiences). However, if the need for John to classify his personal investment into meaningful cultural categories can sometimes lead to a tension between personal and wider cultural justifications for acquiring videos, John is still frequently able to imbue his collection with more personal and unique meanings via the acquisition of more singular (and thus uncategorisable) videos, which, through the process of their singularisation, can be reconstituted as personally prized rarities in the collection.

Indeed, if the seeking out of the uncut is one means by which video collecting gains its sense of 'bravado',[47] then, as Tashiro argues, another revolves around the seeking out and acquiring of a rare or unique title. Aside from the aforementioned *Hitchhike*, the most valuable video in John's collection is a pre-VRA copy of the 1960s exploitation title *Mark of the Devil*. While he will not lend out his original version of *Hitchhike* (only agreeing to make copies for others to borrow), the sacredness with which he treats his version of *Mark of the Devil* reaches new heights – to the extent that he has never watched it, will never watch it, but would never part with it. As he explained, 'I've got one that's in a slipcase that did actually go to rental, but it was a promo copy – *Mark of the Devil*. The tape's slightly damaged, so I've never watched it ... It's probably worth 75, 80 [pounds] ... something like that. Dead rare. I think it came out on Redemption [a horror sell-through label], but it was heavily cut. Because I've got a promo copy, it's all there, the whole film'.[48]

While the value of this particular video is partly explained through its status as a complete, uncut film, the fact that John can never truly appreciate this (i.e. that he can never watch it) suggests that it's value is based more markedly on its rare status, with the irony of its extreme rarity being that, while the video is seen as an heirloom, it is, in a practical sense, damaged and, in some ways, useless. The fact that the video is a promotional copy clearly has

some bearing on this, as acquiring a promotional copy is, arguably, a further indication of John's status as an 'insider' (in the sense that a promotional copy of this video was never, strictly, supposed to be available for mass public consumption) and, indeed, a number of other videos in John's collection (including his aforementioned copy of *The Burning*) were also promotional videos.

What seems significant about these promotional ex-rental videos is that, largely due to their status as videos that weren't originally intended for sale *or* for mass market consumption of any kind, they seem to negate the basic idea of a commodity (as one of many copies which can be purchased and owned easily), and this can, potentially, succeed in giving the collector a sense of personal ownership over an object that seems to exist completely outside of the confines of consumer culture. Indeed, as Susan Stewart argues, 'the [unique] ... object has acquired a particular poignancy since the onset of mechanical reproduction; the aberrant or unique object signifies the flaw in the machine just as the machine once signified the flaws of handmade production'.[49]

In this respect, then, the commercially 'aberrant' and thus rare promotional video acts as proof that some objects can negate mass production and escape commodity status, something which allows collectors like John to reconstitute them as seemingly unique objects, whose 'absolute singularity', as Baudrillard notes, then 'depends entirely upon the fact that it is *I* [the collector] who possess[es]' them.[50] Indeed, John's ability to cut off his treasured copies of *Hitchhike* and *Mark of the Devil* from certain primary market-influenced forms of value is not only clear through the way that he freezes these videos in his collection (turning them into emblematic ornaments that can't be used, removed or borrowed), but also the way that he reiterated, throughout the course of our discussions, their entirely personal and thus independent value by noting that 'they're worth far more to me than they are to anybody else' and that he would only be able to sell his copy of *Hitchhike* at its true price, and thus value, 'if I met another person like me'.[51]

However, paradoxically, and as John's comment that his *Mark of the Devil* copy is 'probably worth 75, 80' pounds indicates, collectors like John still need to reference these videos' specific secondary market value in order to articulate and underline their status as singular rarities. Indeed, throughout the course of our conversations, *Mark of the Devil* and *Hitchhike* were the only

videos that John valued via the naming of specific secondary market prices, and moments where these videos were discussed represented the only points in our conversations where John admitted that particular pre-VRA labels have an effect on the economic (rather than just historical) value of defunct videos in the contemporary secondary video market place (something which, in the process, reinforces the sense that the valuation of such videos is frequently based on shared, community-wide valuations).

Once again, what this seems to demonstrate is the contradictory relationship collectors like John have to both commercial culture and to past and present market economies. For while the process of reconstituting a video as unique (rather than just promotional or 'aberrant') may allow a collector to disentangle themself from a complex web of prior commercial uses and meanings, a fervent reiteration of a video's personal value as a rarity still frequently needs to be related back to shared systems of value in order for a particular video's worth to be articulated. As Igor Kopytoff notes, what this means is that collectors like John are frequently 'caught' in an economic 'paradox', where 'as one makes ... [objects] more singular and worthy of being collected, one makes them valuable; and if they are valuable, they acquire a price ... and their singularity is to that extent undermined'.[52]

In many respects, then, such contradictions can, potentially, restrict collectors of defunct and second-hand videos, blunting their ability to entirely escape the culturally-constituted meanings and changing forms of secondary market value that impact on particular second-hand objects. However, in situations where they have harnessed their knowledge of these changing forms of value within the networks and spaces that they use to acquire their collected objects, collectors like John can be seen to regain some personal control over their collection, and, in the process, reinforce their status as all-powerful insiders.

For over the course of the two interviews it became clear that, in order to acquire his videos, John had constructed networks based around particular contacts and particular consumption spaces, and that his relationship with these spaces and contacts appeared to be based around issues of autonomy and power (swinging both ways, between John and the spaces that he frequented). The main sources that John uses, or has used, to obtain second-hand videos include a film fair, a car boot sale and a weekly market, all based in the

Nottingham area in the UK. What was particularly significant about his accounts of these places was that contacts and networks had to be built up over a long period of time, and required skill and effort on John's part. Indeed, it was notable that many of John's descriptions of exchange practices at these markets and fairs tended to begin with the phrase 'once you got to know them'. However, as he also related, once this obstacle of getting 'to know them' had been bypassed, John's efforts could be rewarded in kind, with perks and gifts which only added to his status as a particular type of secondary market 'insider'. As John explained (about his primary Nottingham car boot contact):

> you have to get to know him first, you have to be interested in what he is and then he'll slowly show you. He's got certain videos laid out, but the majority is crap which you wouldn't even consider. But you'll start talking to him, and he'll go in his car and get an NTSC copy of *The Evil Dead* out, [and he'll say] 'interested in this for £10?' He knew I wasn't going to run off to the police. He showed me his files, so [I've] got [a] lot of stuff from him and cheap prices as well. And covers, if he'd got them.[53]

What is clear from this account is that if uncertified video versions, whose initial value lies in their transgressive status as objects forbidden by British video classification laws, are to be acquired, then skill, patience and knowledge need to be carefully utilised by video nasty collectors. However, while on the one hand this requires nasty collectors like John to win over traders who possess equivalent levels of knowledge about the value of particular videos, collectors can also use acquired skill and knowledge to gain control over the space of the boot fair and the means by which a desired video is acquired. For John, a primary part of gaining this control was to build up information about a particular trader, to detect flaws in their knowledge of video nasty versions and to then exploit these flaws for his own purposes. For instance, when discussing the Nottingham film fair that he used to frequent, John noted that 'you'd get collectors there. Although it was nice to see it, ... collectors knew the price of things, they knew the value of things ... They'd charge 25, 30 [pounds] ... a film'.[54]

While, for John, these potentially more challenging traders could be managed through slowly 'getting to know them' (as was the case with the car boot contact mentioned above, and his primary

contact at the film fair, whom he often telephoned in advance in order to secure particular videos), other traders were often easier to manage if, unlike these veteran collectors and traders, their knowledge was lacking.[55] As John explained, sometimes 'it was just walking round and seeing what you could find. Sometimes you'd find somebody who didn't realise what they'd got, and they'd have a table of videos and sometimes you'd find one rarity there. And it would only be three [pounds] . . . so you'd grab it and think "I'll sell that for 25"'.[56]

What these examples once again reinforce is the extent to which prior cultural circumstances can affect the active and interrogative nature of exchange practices in these second-hand consumption spaces. For, in order for John to acquire these videos that he desires at the most reasonable prices (and considering that particular pre-VRA videos or other video versions of the nasties are often illegal, outmoded or second-hand), he is forced to interact with unpredictable, local and temporary consumption spaces (where goods change from week to week and where traders possess varying degrees of knowledge about the items they sell). As a result, John has to hone the necessary skills needed to operate effectively within these spaces by acquiring, as he puts, it 'knowledge [that] you pick up along the way'[57] about the value of particular video versions and the depth of collecting interest and knowledge that characterise those who sell them.

Nicky Gregson and Louise Crewe have written a number of articles which attempt to consider and explore the car boot sale as a newly marked type of consumption space from the 1990s and onwards, existing in clear opposition to the more predictable and rigid commercial spaces of the shopping centre or mall. Although their work tends, on the whole, to concentrate on more traditional types of second-hand goods (e.g. bric-a-brac, books and so on), a number of their observations appear to correlate closely with some of John's video acquisition practices.

For Gregson and Crewe, while the mall is more controlled and mass market-based, the alternative consumption space of the car boot sale is temporary, unpredictable and thus, for the people who frequent it, can be empowering and challenging. As they argue:

> here, clearly, is a form of exchange which recreates earlier – in this case pre-capitalist – forms of exchange. Here is a form of exchange which ... is dominated by cash, which looks back to an epoch

without credit cards, store cards and cheque books. This is a consumption space in which we can be, at one and the same time, vendors and purchasers ... where every price is negotiable, presenting the opportunity for haggling and, on occasion, barter.[58]

It is therefore this potential for the vendor and purchaser to be interchangeable at the boot fair that seems to give such spaces, in Gregson and Crewe's terms, their alternative and 'pre-capitalist' slant, in the sense that this view of the shopper seems in marked contrast to the idea of a restricted consumer at the mall or shopping centre. Indeed, if this argument seems to correlate with John's video-acquiring activities, then the ideas that Gregson and Crewe go on to discuss – ideas of the 'skilled shopper' (who knows how to get bargains) and the 'small-time entrepreneur' (who acquires bargains to sell on to others) – are also terms that can be applied to the roles that John has adopted in the boot fairs and markets he has attended.[59] Further to this, the adoption of malleable commercial identities also demonstrates how the public removal of the video nasties and other pre-VRA videos has enabled video nasty collectors like John not only to operate as archivists who collect, research and preserve distributor output and the video distribution histories of particular nasty titles, but also to ape these video distributors by reconstructing themselves as commercially-minded entrepreneurs within the context of a secondary market place.

The ability to flex forms of acquired knowledge and experience, to control price in relation to value and to adopt a variety of primary market roles are therefore all factors that help to construct this idea of the active and empowered veteran video nasty collector. However, for John, it is the subsequent modification of some of his collected videos that enables him to yet further extend this malleable collecting identity. For Crewe and Gregson, 'what is important about purchases made at car boot sales, particularly when these are second-hand goods, is that people are often not buying the commodity we see but a particular attribute of it which will be realized only when they return home and either renovate, alter, transform or display it. Possession rituals are particularly important in the case of items which are unique, old, second-hand or rare'.[60]

This focus on the value of an 'attribute' can clearly be seen in John and other nasty collectors' acquisition of particular labelled or boxed pre-VRA videos, which are bought for the historical value

of the video label and packaging rather than for the video's content. However, another, perhaps more idiosyncratic,[61] example of this approach is John's occasional renovation of his acquired pre-VRA videos. As he explained, due to the fact that a large number of pre-VRA tapes had been destroyed after their public removal, and that ex-rental boxes and sleeves had been lost or damaged, videos acquired at fairs and boot sales would often be incomplete objects – with tapes frequently being copied, rather than original pre-recorded videos, covered only with cardboard slipcases or plain video boxes.

As a result, John's acquisition of some of his pre-VRA videos would, sometimes, only be part of the process of possessing them and collecting them and, on a number of occasions, further work needed to be carried out on these videos before they truly became part of his collection. While some sleeves could be acquired via the internet (particularly in the case of some of the central video nasty titles), John frequently acquired others via local video shops, where old ex-rental sleeves could be purchased for twenty pence.

As John openly acknowledged, the consequence of this process is that a certain proportion of his video collection is made up of videos with 'original rental boxes and sleeves, and copied tapes'.[62] While, in some respects, this could appear as a disadvantage (in the sense that certain pre-VRA videos in his collection are only partly historically authentic), it does demonstrate the extent to which 'possession rituals' play a large part in placing a personal stamp on particular second-hand video collections, and how such rituals can, potentially, enable John to act as not only a collector of these videos, but also as a restorer and reproducer of their original commercial status and value as original pre-VRA videos.

In turn, what this once again emphasises is the extent to which personally constituted rituals and the historical and commercial frameworks that inform the value of his collected videos frequently collide and mesh in John's collection. On the one hand, these forms of renovation can be seen to allow John to act as a shadow or echo of the original manufacturers of pre-VRA videos, allowing him, in the words of Benjamin, to take on 'the attitude of an heir' to these videos and demonstrate 'an owner's feeling of responsibility toward his property'[63] by restoring them to their original pre-VRA material standards. On the other hand, and in a more personal sense, the ability to change and alter the meanings of these videos

also allows John to take even more active control of all aspects of a particular video's re-circulation around a secondary market economy and, in the process, to reinforce the Benjamin-inspired idea that 'the most important fate of a copy is [always] its encounter with him' and 'his own collection'.[64]

When placed in context, this conception of John as a restorer and manufacturer lines up convincingly with the more widely-shared community roles of archivist, researcher, skilled shopper and entrepreneur to present a powerful picture of a collector as the creator of his own alternative economic and cultural sphere. And, arguably, these collecting roles and dispositions are alternative because they are not primarily generated or shaped by the discourses of contemporary marketing and media industries, and specialist because they, instead, hinge so fervently around both situated and context-specific historical and cultural meanings, and the intimate knowledge and personal consumption and collecting history of the veteran video nasty collector.

If, as Klinger argues, 'the phenomenon of collecting' can therefore help 'us to explore ... cinema's fate as private property',[65] then perhaps what the collecting practices outlined above suggest is that it is the residual and second-hand end of the video collecting spectrum where video collecting identities not only have the potential to be at their most complex and malleable, but where videos remain at their most open to privatisation. Often circulating outside the restrictions of contemporary commercial constraints and national regulation, and often existing as discarded or battered objects (almost like traces of videos that were previously buried by censorship or damaged by the ravages of time), the original, ex-rental pre-VRA video seems to cry out to be preserved and reconfigured within the confines of the British horror video collection.

Conclusion: the death of the nasty and the threat of new technologies

In a 2001 *Dark Side* article, Jay Slater heralded 'the death' of the ex-rental video nasty, arguing that the 'Video Nasty generation' had 'grown up and moved on' and that the type of residual collecting enacted by John and other veterans was becoming distinctly outmoded.[66] For Slater, while the original video versions of the

nasty titles were damaged goods, the new uncut Region One DVD versions of such titles as *I Spit on Your Grave*, freely available to order and import from the US or Japan via the internet, were the way forward for contemporary British horror video collectors. In a form of logic which mirrors Tashiro's comparison of the shiny, perfect laserdisc and the impermanent shoddy video, Slater notes that 'why should a film fan pay over-the-top costs for an inferior quality video with possible tape damage and a cassette encrusted with chocolate, booze and engine oil that is often pan-and-scanned when they can buy a new and digitally improved 16.9 anamorphic widescreen print with plenty of mouth-watering extras such as audio commentary and additional scenes?'[67]

While it is clearly the case that the internet and the concurrent availability of imported DVDs has revolutionised nasty collecting (something which post-1998 letters and articles in *The Dark Side* and 2001 discussions on *Dark Angel* clearly connote), what is, arguably, missing from Slater's account is an acknowledgement of the pleasures and intricacies of VHS-centred video collecting and its relationship to issues of authenticity, exclusivity and the material life histories of objects. Indeed, if Slater's arguments are considered in light of the issues I've discussed in this chapter, it could be argued that the availability of import DVDs and the accessibility of the internet may not necessarily cause the 'death' of the pre-VRA video nasty version. If the import DVD version of a nasty title is the most complete and uncut, will it not extend and become the most complete copy in the video version archives of many nasty collectors? If the DVD is smaller and differently packaged and shaped, does this suggest that it will be valued, by some, as an entirely different aesthetic object and hence form the basis of an entirely new collection, rather than replacing a VHS one?

Perhaps most significantly, as DVDs become more accessible, and forms of acquisition via the internet become quicker and less risky, will the original video nasty versions become even rarer and more historically authentic video objects – the new vinyl to the DVD's compact disc, obtained in ever more intricate, time-consuming and thus appealing and attractive ways? However the relationship between VHS and DVD develops over time, perhaps, in some ways, the issues outlined above suggest that there is a need not only to consider video collections where new modern collectibles replace old, but also to consider the ways in which a

proliferation of different forms of the video collectible extend the implications, and enrich the possibilities, of ascribing meanings to a film within the confines of the home.

Notes

1 Barbara Klinger, 'The contemporary cinephile: film collecting in the post-video era', in Melvyn Stokes and Richard Maltby (eds), *Hollywood Spectatorship: Changing Perceptions of Cinema Audiences* (London: British Film Institute, 2001), p. 133.
2 *Ibid.*, p. 147.
3 *Ibid.*, pp. 139 and 134.
4 *Ibid.*, p. 147.
5 *Ibid.*, p. 136.
6 *Ibid.*, p. 136.
7 Charles Tashiro, 'The contradictions of video collecting', *Film Quarterly*, 50:2 (1996–97), 16.
8 *Ibid.*, p. 15.
9 *Ibid.*, p. 15.
10 Klinger, 'The contemporary cinephile', pp. 144 and 138.
11 Tashiro, 'The contradictions of video collecting', p. 12.
12 Susan Stewart, *On Longing: Narratives of the Miniature, the Gigantic, the Souvenir, the Collection* (Baltimore: Johns Hopkins University Press, 1984), p. 154.
13 *Ibid.*, p. 155.
14 As chapter 4 acknowledged, the portrayal of the nasty list as a 'shopping guide' occurred frequently in *The Dark Side* during the course of the 1990s. See, for instance, the advertisement for the *Dark Side* book on the video nasties. Advertisement for *Video Nasties, The Dark Side: The Magazine of the Macabre and Fantastic* (June–July 1998), pp. 48–9.
15 For examples of fan-orientated publications which employ this focus, see, in particular, John Martin, 'The official "video nasties" and how they got that way ...', *The Dark Side: The Magazine of the Macabre and Fantastic* (July 1996), pp. 48–62; Nigel Wingrove and Marc Morris (eds), *The Art of the Nasty* (London: Salvation Films, 1998); Allan Bryce (ed.), *Video Nasties!* (Cornwall: Stray Cat Publishing, 1998); and Francis Brewster, Harvey Fenton and Marc Morris (eds), *Shock! Horror! Astounding Artwork from the Video Nasty Era* (Surrey: FAB Press, 2005).
16 This continued focus on covers and labels, in order to delineate the historical value of the original video nasties and other pre-certificate videos, can clearly be seen in the codes that continued to be used by

collectors in classified advertisements in *The Dark Side*. With, for instance, a June/July 2000 advertisement noting that 'original horror films' were available, including 'many rare films' from such pre-VRA era labels as Go and Vampix, and a June/July 2001 classified including an 'original Intervision release of *Dawn of the Dead*, boxed with sleeve' amongst its list of 'wants'. 'Little shop of horrors', *The Dark Side: The Magazine of the Macabre and Fantastic* (June–July 2000), p. 55; and 'Little shop of horrors', *The Dark Side: The Magazine of the Macabre and Fantastic* (June–July 2001), p. 23.

17 Kerekes and Slater define the 'ardent' video nasty collector as someone who was still 'prepared to pay the sometimes exorbitant price for original pre-certificated films' despite the fact that, from the late 1980s, it was much easier and cheaper to get hold of copied 'bootleg' versions of particular banned titles. David Kerekes and David Slater, *See No Evil: Banned Films and Video Controversy* (Manchester: Headpress, 2000), p. 293.

18 The name of the collector has been changed.

19 Clifford Geertz, *The Interpretation of Cultures* (London: Fontana, 1993), pp. 3–30. Here, Geertz employed the term 'thick description' to describe the key task of ethnography, which he saw as being the need to get to grips with the complexities and the specificities of lived cultures on a small, and in-depth, scale.

20 Tashiro, 'The contradictions of video collecting', 15.

21 Walter Benjamin, 'Unpacking my library: a talk about book collecting', in Hannah Arendt (ed.), *Illuminations*, trans. Harry Zohn (London: Fontana, 1992), p. 64.

22 Not only did the earlier-cited Dave Green (see chapter 4) state, in his letter to *The Dark Side*, that he has collected laserdisc versions of video nasty titles, but a concurrent collecting of DVD versions of nasty titles was also common amongst evident nasty veterans on *The Dark Angel* message-board, and has also been championed by the most public nasty veteran, Allan Bryce, editor of *The Dark Side*.

23 Klinger, 'The contemporary cinephile', p. 137.

24 The re-release of cut sell-through versions of nasty titles in Britain began to occur in 1992, when distributors like Vipco, Redemption, Apex and Elephant took a lead from Palace Pictures' success at getting a cut version of *The Evil Dead* through the British Board of Film Classification. See chapter 7 for further details.

25 *Dark Angel*, 'I spit …' (28 June 2001), *The Realm of Horror Discussion Forum*, http://disc.server.com/discussion.cgi?id=126992 &article=2365&date_query=994004884 (5 September 2001).

26 This letter actually refers to the British release of Dario Argento's *The Stendhal Syndrome*. As the letter explains, while the distributor,

Marquee Pictures, had withdrawn the uncut version of the film and replaced it with the BBFC-approved one, the uncut version could still be sought out and identified via the black and white design on the video itself. Gary Rogers, letter, *The Dark Side: The Magazine of the Macabre and Fantastic* (June–July 2000), p. 12.

27 Nasty collector, personal interview, 27 September 2001.

28 *Dark Angel*, 'A twist to the tail' (29 June 2001), *The Realm of Horror Discussion Forum*, http://disc.server.com/discussion.cgi?id=126992 &article=2367&date_query=994004884 (5 September 2001).

29 Klinger, 'The contemporary cinephile', p. 139.

30 Benjamin, 'Unpacking my library', p. 62.

31 Nasty collector, 27 September 2001.

32 Adey, 'Re: bloodymoon' (28 June 2001), *The Realm of Horror Discussion Forum*, http://disc.server.com/discussion.cgi?id =126992 &article=2361&date_query=994004884 (5 September 2001).

33 Tashiro, 'The contradictions of video collecting', 16.

34 Stewart, *On Longing*, p. 154.

35 Nasty collector, 27 September 2001.

36 *Ibid.*

37 *Ibid.*

38 This tendency to centralise historical markers which authenticate videos, and also act as key nostalgic reminders, is also pinpointed in Kim Bjarkman's recent article on collectors of television recordings (published since this chapter was first drafted). In Bjarkman's account, television recording collectors are seen to valorise such elements as the era-specific television advertisements recorded on each tape, something which highlights, once again, how collecting cultures centred around historical valuations tend to focus on the most appropriate element to contextualise and effectively 'date' the object (whether textual or material). Kim Bjarkman, 'To have and to hold: the video collector's relationship with an ethereal medium', *Television and New Media*, 5:3 (2004), 217–46.

39 Klinger, discussing Walter Benjamin's work, 'The contemporary cinephile', p. 137.

40 Jay Slater, 'The death of the video nasty', *The Dark Side: The Magazine of the Macabre and Fantastic* (April–May 2001), pp. 50–1.

41 Cited in Kerekes and Slater, *See No Evil*, p. 288.

42 Klinger, again discussing Benjamin, 'The contemporary cinephile', p. 137.

43 For examples of the use of such terms in classified advertisements, see 'Fear Classified', *Fear* (May 1990), p. 66; 'The Dark Side Classified', *The Dark Side: The Magazine of the Macabre and Fantastic* (May 1992), p. 66; and 'Little shop of horrors', *The Dark Side: The Magazine of the Macabre and Fantastic* (July 1995), p. 61.

44 Stewart, *On Longing*, p. 165; and Jean Baudrillard, 'The system of collecting', trans. Roger Cardinal, in John Elsner and Roger Cardinal (eds), *The Cultures of Collecting* (London: Reaktion Books, 1994), p. 16.

45 Nasty collector, 27 September 2001.

46 Jean Baudrillard, 'The system of collecting', p. 23. Indeed, it is notable that, while both Stewart and Baudrillard generally construct collecting as an entirely personal and 'transcendent' domain, the determining influence of the cultural and external comes sharply into focus, for both, when they discuss the importance of categorisation and classification to collectors (and particularly to book collectors).

47 Tashiro, 'The contradictions of video collecting', p. 15.

48 Nasty collector, 27 September 2001.

49 Stewart, *On Longing*, p. 160.

50 Baudrillard, 'The system of collecting', p. 12.

51 Nasty collector, 27 September 2001; and Nasty collector, personal interview, 14 June 2001.

52 Igor Kopytoff, 'The cultural biography of things: commoditization as process', in Arjun Appadurai (ed.), *The Social Life of Things: Commodities in Cultural Perspective* (Cambridge: Cambridge University Press, 1986), p. 81.

53 Nasty collector, 27 September 2001.

54 *Ibid.*

55 Kerekes and Slater also acknowledge the existence of these two types of trader in the video nasty collecting world. As they note, while 'many [market] traders unwittingly threw these tapes in together with legitimate releases, others understood their black market value and potential risks involved, only offering them to select clients'. Kerekes and Slater, *See No Evil*, p. 289.

56 Nasty collector, 27 September 2001.

57 *Ibid.*

58 Nicky Gregson and Louise Crewe, 'Beyond the high street and the mall: car boot fairs and the new geographies of consumption in the 1990s', *Area*, 26:3 (1994), 262. For further discussion of the cultural implications of such second-hand spaces, see Nicky Gregson and Louise Crewe, *Second-hand Cultures* (Oxford: Berg, 2003).

59 Gregson and Crewe, 'Beyond the high street', p. 262–3.

60 Louise Crewe and Nicky Gregson, 'Tales of the unexpected: exploring car boot sales as marginal spaces of contemporary consumption', *Institute of British Geographers Transactions*, 23 (1998), 48.

61 The only two pieces of evidence I've uncovered which may suggest that others indulge in such practices are: a September 1995 *Dark Side* classified advertisement selling individual British video covers; and a

2001 discussion on the *Dark Angel* message-board, where a partici-
pant suggests, rather mysteriously and elliptically, that a particular
internet covers site might be useful for those who 'need covers for
some of your vids, due to obviously misplacing ... them'. 'Little shop
of Horrors', *The Dark Side: The Magazine of the Macabre and
Fantastic* (September 1995), p. 44; and Bubblezzz, 'Video coverzzz' (7
August 2001), *The Dark Angel's Realm of Horror Discussion Forum*,
http://disc.server.com/discussion.cgi?id=126992&article=2881&dat
e_query+997540380 (28 August 2001).

62 Nasty collector, 27 September 2001.
63 Benjamin, 'Unpacking my library', p. 68.
64 *Ibid.*, p. 63.
65 Klinger, 'The contemporary cinephile', p. 133.
66 Slater, 'The death', p. 49.
67 *Ibid.*, p. 48.

Part III

Re-releases and re-evaluations

Previously banned: remarketing the nasties as retro products

In a section on taste in *Destination Culture*, Barbara Kirshenblatt-Gimblett discusses the changing social and cultural meanings that are attached to objects, during their journeys in and out of the commodity sphere. For Kirshenblatt-Gimblett, some objects (the 'made-real') are so everyday, classic and enduring that they are 'just there',[1] with their acceptance as everyday and 'real' objects, in some senses, obscuring the notion that that they were actually invented, produced and manufactured by a named person or company at a specific point in time. However, for her, some objects can be legitimised (in specific commercial and cultural contexts) through reference to their historical status as objects that *were* once made (or 'made-up') in the past. As Gimblett argues, when discussing a specific catalogue of such objects called *The Encyclopaedia of Bad Taste*:

> historical snapshots expose such commodities as the inventions of named persons by attaching signatures to things that normally have none. The moment a historical portrait makes its human inventor 'real', an object previously experienced as 'made-real' and inevitable is apprehended as 'made-up' [...] Without their pedigrees such objects bear only the general signature of human manufacture ... [But] by affixing specific signatures to them ... [such snapshots] intensify their 'unreal' nature, their made-up-ness, and help to transform them from tools to artifacts.[2]

Arguably, Kirshenblatt-Gimblett's observations provide a useful theoretical framework for considering the now enduring connections between the video nasty titles and the video companies that marketed and distributed them in the early 1980s (companies who can thus be seen, in some respects, as the true 'human inventors' of

particular nasty titles, at least within a British context). In particular, this connection seems to be one that has been reinforced with the explosion of re-released nasty titles on to the British video and DVD market from the late 1990s and onwards, where extra-textual materials (ranging from publicity materials to DVD extras) have appeared to serve as 'historical portraits' which frame the nasties as video titles with a history and, to use Gimblett's term, a 'pedigree' which is largely framed by the histories of the British distribution companies that originally 'made' them. Two original nasty distributors, in particular, have appeared to play a particularly significant part in this process – Palace Pictures (the original British distributor of *The Evil Dead*) and Vipco (the original British distributor of a whole glut of nasty titles, including *The Driller Killer*, *The Slayer*, *The Bogeyman*, *Death Trap* and *Zombie Flesh Eaters*).

While the history and status of these two companies has differed considerably since the passing of the Video Recordings Act (VRA), they both stand out from the other original nasty distribution companies because of their continued presence and activity in the post-VRA British video industry, and their continued commercial links with particular nasty titles. Palace Pictures was the only original nasty distribution company to survive the initial onslaught of video nasty hysteria, to avoid bankruptcy and continue to trade. While, in the post-VRA marketplace, Palace switched its emphasis on to its roster of art-house fare (including its distribution of films by Rainer Werner Fassbinder, Werner Herzog, John Waters, Neil Jordan and the Coen Brothers) combined with a smattering of slightly more respectable horror titles (including key work from Dario Argento and Wes Craven), Palace were still around in the early 1990s to oversee the first video re-release of *The Evil Dead* (in a cut form) on to the British video market, before falling victim to the British economic recession of the early 1990s and going into liquidation.[3]

Vipco, on the other hand, was an initial victim of the VRA, going into bankruptcy as a result of continued prosecutions against its prime titles – in particular *The Driller Killer*, which as a result of its infamous video sleeve and marketing campaign was one of the first of the video nasty titles to be prosecuted under the Obscene Publications Act (OPA). However, in 1992, Vipco's director, Mike Lee, took a lead from Palace's success at obtaining a British Board

of Film Classification (BBFC) certificate for *The Evil Dead*, and submitted a number of nasty titles from its back catalogue for certification, with Vipco then, as a result of this success, re-emerging on the British video market as a horror video sell-through label.[4] Surviving into the late 1990s and up to the present day, Vipco has now diversified into rental as well as sell-through, is distributing nasty titles on DVD as well as VHS, and has, over time, managed to acquire a range of other nasty titles in addition to the ones languishing in the Vipco back-catalogue (including *Cannibal Holocaust* and a trail of other nasty-related zombie and cannibal titles, as well as slasher nasty titles such as *Pranks* and *The Burning*). Indeed, in 2002, video re-releases of nasty titles on the Vipco label appeared to have reached its peak, with *Cannibal Holocaust*, *House on the Edge of the Park* and *Island of Death* being submitted to the BBFC in quick succession, and with Vipco's distinctive video boxes and advertisements cropping up with noticeable frequency in video stores and in the pages of British film magazines.

The history and legacy of Palace and Vipco can therefore be seen to have shaped the nasty titles' commercial history in the British video market from the early 1980s right up to the present day, acting as the primary correlative link between these titles' original existence in the early pre-VRA British video market, and the ever-expanding proliferation of video re-releases of these titles in the post-VRA market. Indeed, in the context of the recent explosion of re-released nasty titles in Britain, the reinforcement of this correlative link has appeared to permanently mesh together particular nasty titles and their original British distributors. To give the impression that not only can the historical significance of a particular nasty title only be understood through its relationship to a particular video distribution company, but that the historical significance of particular distribution companies can only be understood in terms of their intrinsic relationship with particular nasty titles.

A particularly salient example of this discursive strategy is Anchor Bay UK's repackaging and reframing of *The Evil Dead* for its 2002 uncut special edition DVD re-release of the film. While Anchor Bay UK, as an off-shoot of an American specialist DVD company, packaged their *Evil Dead* box-set with materials that had a distinct overall lack of reference to the film's status and repu-

tation in the British video market (employing sleeve images and taglines culled from the film's original theatrical and video releases in the US, enclosing a collector's booklet which documented different US video and laserdisc versions of the film, and peppering the disc with versions of American theatrical trailers and original advertising spots from US television), it also featured a unique extra for the British market – a fifteen-minute documentary entitled 'Discovering *The Evil Dead*', which charted the history of Palace Pictures' relationship with *The Evil Dead* in Britain. What is significant about the narrative arc of this documentary is that it begins with a discussion of the origins of Palace itself – how its directors, Stephen Woolley and Nik Powell, teamed up in 1982 to distribute a variety of 'strange movies' or art-house titles acquired via Woolley's links with the Scala, a now famous repertory cinema in King's Cross; how it then came to a realisation that British video audiences in the 1980s were 'not particularly sophisticated' and craved 'under-the-counter' horror titles; and how then (as a result of the company's need to tap into this video horror market for economic reasons) Woolley acquired rights, via the American market, to *The Evil Dead*. Interviews with Woolley and Powell then dominate the rest of the documentary, as they guide the viewer through the film's initial British video marketing campaign and distribution, the film's demonisation in the British press and the seizure of video copies from British video shops, the video title's prosecution under the OPA (replete with tales of various court appearances where Powell was, on one occasion, in attendance), its eventual banning under the VRA and the film's subsequent British video re-release (again by Palace) in the early 1990s.

What emerges from this account is a clear framing of the history of *The Evil Dead* through the actions of its original British video distribution company, where Palace's directors, Woolley and Powell, emerge as the ultimate prime movers behind, and human inventors of, *The Evil Dead*'s British reputation. As a consequence, the story of *The Evil Dead* clearly becomes embedded within the context, origins and motivations of the early 1980s British video distribution company, who then lead the viewer through *their* accounts and experiences of *The Evil Dead*'s impact on the British video market, allowing the documentary to give the impression that *The Evil Dead*'s history can only be understood and fully appreciated when it is informed by these contexts and experiences

(i.e. that the only legitimate gateway to a particular nasty title's British past – specifically, the period of the early 1980s – is through these distribution companies).

However, to return to my earlier point, what is also key about this documentary is the way that a *reciprocal* historical relationship between a particular nasty title and its original distribution company is also set up: where it is also apparent that the historical worth and significance of a particular distribution company can only be fully understood through its relationship with particular nasty titles. As Woolley notes, after a discussion of the creation of Palace's distinctive marketing images for *The Evil Dead*, 'that was the kind of decision we were making on *The Evil Dead*. It wasn't just the film itself. It wasn't us cashing in on a movie that we could do a few videos on. It actually established what Palace became'.[5]

Even more distinctive discursive connections between particular nasty titles and their original British distribution company can be observed in contemporary publicity materials generated by the still buoyant Vipco. In a 2002 interview with Mike Lee in *The Dark Side* magazine, for instance, Jay Slater establishes Vipco's importance to the British public image of particular nasty titles by noting that 'think *Shogun Assassin* and *Zombie Flesh-Eaters* and VIPCO springs to mind', and then takes this further by noting that the word Vipco 'encapsulates early video horror'[6] (something which, once again, emphasises that it is only through the original video distribution company that a nasty title's past can be fully 'encapsulated').

This discursive approach (where the image and legacy of Vipco frames and informs a particular nasty title's historical legitimacy) is also apparent in a vast array of other contemporary publicity materials generated by Vipco. For instance, whereas, in the company's original pre-VRA advertisements and video sleeves, a tiny Vipco logo can be just about detected at the bottom of a sleeve or advertising image,[7] its post-VRA publicity materials are often framed by a dramatic logo at the top of the image (decorated with a row of blood-splattered skulls) which declares that 'Vipco's Vaults of Horror proudly presents' a particular nasty title.[8] In addition to this, a number of recent Vipco advertisements for zombie and cannibal films are framed, at the bottom of the image, by a 'coming soon' banner, which advertises an array of future Vipco-distrib-

uted nasty or nasty era-related zombie and cannibal titles.[9] What is therefore apparent, in the vast majority of post-VRA Vipco sleeves and advertisements, is that while such images and sleeves are primarily concerned with advertising the historical significance of particular nasty titles, they are also concerned with embedding this advertising within a wider promotion of the historical significance of the Vipco video company (a company whose name alone 'encapsulates early video horror'), and of branding all its video nasty titles with the rubber stamp or 'signature' of Vipco's past and continued ownership.

This strategy of promoting Vipco's historical status and ownership is also clearly at work on the company's promotional website (which also serves as an online service, where Vipco products can be ordered and dispatched to customers). On accessing this site, an initial homepage brings forth a Vipco logo which drips blood[10] – an approach which illustrates the usefulness of such video company sites, where distributors can place their stamp on particular nasty titles by promoting themselves as equally as they promote their products, and where, in a literal and visual form, Vipco can present itself as the only available gateway through which particular nasty titles can be accessed. However, what is also apparent when clicking on the welcome page to the site is that, while the promotion of particular nasty titles as historically legitimate appears dependent on the legacy of Vipco, Vipco appears equally reliant on the legacy of the nasty titles, in order to articulate and promote its historical legitimacy. At the right-hand corner of the Vipco welcome page, for instance, a legend declares that Vipco are the 'Pioneers of the Video Nasty!! Est. 1979. We'll never die!! The Oldest and Greatest Horror Video Label in the world!!'[11]

What is apparent here (as with Woolley's comment that *The Evil Dead* 'established what Palace became') is the mutual dependence of nasty title and distribution company. That while an appending of the Vipco signature to an advertisement for a nasty title allows for an immediate gateway into the title's British past, allowing it to be promoted as a historically meaningful artefact, Vipco also clearly need to harness the legacy of the nasties in order to consolidate their historical image and status within the British video market. Thus, Vipco achieves its historical legitimacy not through being a pioneer of horror videos in general, but through being a pioneer of the video nasty – an achievement which gives requisite

weight to their claim that they are the 'oldest and greatest horror video label in the world'.

By associating itself with the public image, status and history of the nasties, then, Vipco is able to underscore the historical distinctiveness of all the video distribution companies that originally distributed the nasty titles and, as a consequence, such processes seem to rewrite these companies back into the historical and commercial script of the story of the nasties, with them being identified as the major players, personalities and 'pioneers' of the video nasty era and the human face of the nasty phenomenon. In this respect if, as Richard Falcon argues, the reclassification and re-release of a film on video or DVD allows for 'an opportunity to reappraise a film',[12] it also, in the case of the re-releases of the nasties, appears to act as a clear opportunity to reappraise a video title's original distributors and their historical and commercial significance.[13]

However, what should be noted here is the unique position in which this places post-VRA Vipco as the only original nasty distribution company still re-releasing nasty titles in the contemporary British video and DVD market. For while other original nasty distributors, such as Palace, can be reappraised as historically and culturally significant through the reattaching of their 'signature' to the contemporary re-release of *The Evil Dead*, this, quite simply, does not have any commercial gain for a now defunct company – a company that remains resolutely located in the past. Vipco, on the other hand, can use this reappraisal of their historical significance (achieved through embedding their company's image within the legacy of the nasties) to carve a contemporary commercial legitimacy for themselves as a specialist, niche purveyor of old, culturally meaningful horror titles.

The means by which this concurrent marketing of a niche product (a nasty title) and a niche company (post-VRA Vipco) is achieved has a clear relation to Kirshenblatt-Gimblett's theories of old commercial objects and the process of their transformation into historical artefacts. As she argues, such objects 'need only be experienced as out of joint with the moment ... to recover their quality of madeness'.[14] This notion of an object recovering its historical value (its 'madeness' or 'made-up-ness') by presenting itself as 'out of joint with the moment' has a clear link to the contemporary marketing of old products through discourses of retro and 'stylised

nostalgia' (as discussed, in particular, by Paul Grainge and Raphael Samuel, as well as Kirshenblatt-Gimblett), where products are presented in a style which makes them appear anachronistic or imbued with, as Grainge puts it, 'some essential quality of pastness'.[15] However, while for Kirshenblatt-Gimblett this status of 'unreal' artefact from another time is achieved only by the product itself (through the reattaching of the signature of its original maker or inventor), it also, in the case of post-VRA Vipco, permits the original maker (or distributor) to acquire this status as well, by allowing Vipco, in its contemporary manifestation, to appear to be as anachronistic and 'out of joint with the moment' as the old products it markets.

What the reciprocal discursive connections between Vipco and the nasty titles seem to illustrate, then, is the commercial benefits, for both company and product, of carving out a niche commercial image based around notions of the anachronistic, the retro or 'stylised nostalgia'. What is key to this is the argument that discourses of retro and 'stylised nostalgia' are grounded less in real cultural yearning for past times and eras (which informed, for instance, the collecting of original nasty video versions discussed in the previous chapter) but are based, instead, around constructed ideas about nostalgia and the past which are informed by purely commercial motivations. As Grainge argues, in his discussion of the American niche cable channel The Nostalgia Network:

> significant … is … the connotative drift experienced by the very word and concept of 'nostalgia'. In commercial terms, it need not depend on a specific idea of the past; it can designate anything that has been culturally recycled and/or appeals to a market where pastness is a value. It is not, in other words, symptomatic of cultural or consumer longing, but is an index of commodities, media products, and programming orientations that draw upon notions of tradition, or use an idea of the past to position themselves within particular niche markets.[16]

What I aim to do in the rest of this chapter, then, is to home in on these 'notions of tradition' and 'ideas of the past' in more detail by looking at a broad array of publicity material which accompanied the re-release of the nasty titles onto the British video market (from Vipco and other contemporary British video companies). The aim will be to explore how the attaching of a variety of historical signatures to the nasty titles (signatures which demonstrate where the

title came from and who made it)[17] can allow for a variety of 'ideas of the past' to be constructed, ideas which have commercial benefits for both re-released versions of the nasty titles *and* for Vipco in its post-VRA manifestation. In the analysis that follows, then, I'll attempt to assess the extent to which such re-release publicity material scripts the nasties into a variety of ideas about the early 1980s British video market, ideas which then help to construct and distinguish post-VRA Vipco as a bygone niche company with a unique role to play in the contemporary British video market.

'Banned since 1982!!': the use of dates and the construction of an authentic, dangerous and primitive past

When surveying a vast array of nasty re-release publicity materials (materials which stretch from the 1990s and onwards), what is most apparent is the continued emphasis placed on time, which appears to act as the key discursive strategy through which the nasty titles' historical significance is emphasised. There are, perhaps, three distinct ways in which this strategy appears to operate in re-release publicity. Firstly, an emphasis is placed on how long a nasty title has been banned and removed from the public eye. Thus, *The Driller Killer* is presented as having been 'outlawed for 15 years' or (in a HMV advertisement) 'banned in this country for over ten years', *Sight and Sound* begin their video re-release review of *Tenebrae* by noting that it was 'appearing on video some 16 years after its banning in the UK', and *The Slayer* (in another HMV advertisement) is heralded as 'being seen on the small screen for the first time in eight years'.[18] Secondly, a film's historical significance is marked out by emphasising its status as *the* original nasty, of being 'the first' or of being the most historically important of the nasty titles. Thus, the original Vipco re-release of *Zombie Flesh Eaters* is proclaimed, in an HMV advertisement, as being 'the first major film on the British Board of Film Classification's "video nasty" list to be officially certified since *The Evil Dead*', and *The Driller Killer* is presented, in a re-release advertisement, as being 'the original video nasty' or, on the back of its re-release video box (and in a number of re-release reviews), as being the film that 'almost single-handedly spawned the media "video nasty" hysteria of 1984 and the introduction of the video recordings act'.[19]

However, the third, and perhaps most distinctive, way in which the historical significance of the nasty titles is conveyed is through the use of dates (which are attached, like signatures, to video boxes and advertisements). While this discursive approach appears to have been used by a wide variety of British video distributors (for instance, by CBS/Fox, who note, in a re-release advertisement, that *Inferno* was 'made in 1982 yet hidden since then from the sight of British movie audiences'),[20] it has clearly been most consistently used by Vipco. Thus, on Vipco re-release covers, large disclaimers (at the top of the front of the video sleeve or in underlined text on the back) note that *The Toolbox Murders* has been 'banned since 1982!!', that *The Bogeyman* has been 'banned since 1982 as a "nasty" [but] is at last presented uncut!!', and that *Cannibal Ferox* has been 'banned since 1982 in the UK as a nasty!'.[21]

These varying approaches to the use of dates are revealing, in a number of ways. Firstly, they seem to indicate that the marketing of the historical legitimacy of particular nasty titles is a hugely competitive project – where British video companies fight it out to proclaim that their re-released nasty title has been banned the longest, or is the first, the original, or the most important video nasty (the one that truly 'spawned the "video nasty" hysteria'). Secondly, they also illustrate the extent to which a promotional use of dates can work to market a re-released nasty as both the ultimate extreme horror title *and* the ultimate historically significant horror title. In the HMV advertisement for the re-released version of *The Slayer*, for instance, the advertising copy notes that 'the [film's] menace builds from spooky beginnings to a middle and end of such horripilation that, in their infinite wisdom, the powers-that-be banned "The Slayer" on video in 1984'.[22] Thus, what this use of dates underscores here is both the fact that *The Slayer* was banned in 1984 because it was the ultimate in extreme horror *and* that, because it was banned in 1984, it is not just a standard horror film, but a horror film with an interesting history. Indeed, this discursive strategy of marketing a nasty title as the ultimate in extreme horror films and the ultimate in historically significant horror films is also mirrored in Vipco's contemporary use of the moniker 'Vipco's Vaults of Horror' (which has both distinct horror connotations and also relates to notions of the archive and of artefacts).

However, perhaps most crucially, the use of dates on the front of video sleeves also seems to relate to the commercial strategies of

stylised pastness discussed by Grainge. Crucial to this is the fact that Vipco seem to have adopted this approach (of including references to dates on the front and back of video sleeves) on their more recent DVD re-releases of nasty titles, as well as including a symbol (usually on the front, back and spine of the video box) which notes that these titles were 'previously banned'.[23] Indeed, what is also noteworthy is that these 'previously banned' logos (which look like hazard symbols, with bold text flanking a bright red 'x' symbol) are often placed by Vipco (on back, spine and front) alongside a variety of official symbols – including the Video Packaging Review Committee (VPRC) symbol and the BBFC certification logo, as well as the DVD brand symbol. As a result of this strategy, the 'previously banned' logo appears to be visually and spatially equated with these symbols on video sleeves. Further to this, if the VPRC symbol is a 'mark [which] ... is an indication of testing and approval by an authorised body',[24] then the apparent consequence of this strategy is that the 'previously banned' symbol can also, potentially and by association, be perceived as a mark of authenticity, indicating to the public that while this is a new product (a DVD, authorised and approved by both the BBFC and the VPRC), it also has a history, a legacy and a distinct sense of pastness attached to it.

What the promotional use of dates and 'previously banned' logos seem to do, then, is to present these products (however new they appear to be) as, to use Kirshenblatt-Gimblett's term 'commodity oxymorons – old stuff that is brand-new'.[25] While there are a vast array of symbols on these DVDs, indicating that they are legitimate and have been approved by a number of official bodies, the 'previously banned' symbol appears to problematise this by suggesting that while these titles are now officially approved, they *were* illegitimate and uncertified in the past. Equally, while the DVD brand symbol indicates that these videos are brand new mass-produced products, the 'previously banned' symbol also appears to complicate this format-specific branding by demonstrating that this video title *does* have a history – that it is old and historical, and that its value is truly located in the past.

While primarily utilised by Vipco, this 'previously banned' marketing strategy has also been adopted by a range of other contemporary British video companies. Indeed, while a number of other video companies do not state explicitly on their video sleeves

that a particular re-released title is a nasty (unlike Vipco who, as the above examples demonstrate, frequently make this explicit), a number of re-released nasty distributors have still adopted a version of the 'previously banned' logo. Thus, while Tartan's 2001 re-release version of *Blood Feast* contains no reference whatsoever to the nasties or even to specific dates from the 1980s in its extras or on its packaging, a white sticker is still affixed to the video box, noting that the film is 'previously banned' (with similar approaches also being adopted on the packaging of Screen Entertainment's 2002 re-releases of *I Spit on Your Grave* and *Nightmares in a Damaged Brain*).[26]

Paul Grainge has noted that, with record companies increasingly reselling their old back catalogues of recordings as 'classics', 'nostalgia has become a musical category in its own right'.[27] Arguably, the wide-ranging adoption of dates and 'previously banned' logos on new re-release DVD versions of nasty titles (and other contentious old horror titles) seems to suggest something similar – that the 'previously banned' film (imbued with notions of nostalgia and pastness) has become a generic or subgeneric category in its own right, a category that has been retrospectively constructed within the context of the DVD re-release.

Within this 'previously banned' genre, then, the 'previously banned' logo and the use of dates appear to act as a type of genre-based marketing shorthand. In a climate where knowledge of the nasties, and of other 'previously banned' film titles, has reached its peak among a generation of British fans, the use of these promotional strategies appears to be all that's needed to connote nasty, and thus to also connote a specific era in the past. In a 2002 retrospective newspaper article on the nasties, Andrew Holmes argues that, for a large number of contemporary British horror fans, the era of nasty hysteria 'was their first experience not only of censorship but of the media's potential to distort the truth'.[28] Arguably, the term '1982' or the 'previously banned' logo can work to connote this era, and consolidate the sense that it was the origin of modern British experiences of film censorship, moral panic and media frenzy, in a way that is economical and allows for maximum impact.[29]

Indeed, this notion that re-released nasty titles can be marketed via their links to particular experiences located in the past also appears to be highlighted on *The Driller Killer* re-release DVD,

where an 'introductory commentary' extra by Xavier Mendik is noted as being filmed at the now defunct Scala cinema – a cinema that not only had key links to Palace Pictures, but which played a major part in the early 1980s nasties scene.[30] It was the Scala, after all, that was one of the few places in Britain where early video horror fans could view *The Driller Killer* after its initial prosecution under the OPA, and which subsequently held a 'Revenge of the Bright Bill' twenty-four-hour event in 1984, where fans were able to view nasty titles recently prohibited on video back-to-back in a marathon session. The DVD commentary makes no mention of the historical significance of this location and the past nasty-related experiences that it could conjure up, but the use of the Scala here could still be seen to work (like the use of dates and 'previously banned' logos) as a reference point to the era of the nasties and the experiences that characterised it (experiences of prohibition, media hysteria, danger and transgression).[31]

However, while the reference points embedded in these marketing strategies represent one way in which Vipco and their ilk can place a stamp of pastness on new commodities, the techniques themselves (the use of logos which are hyperbolic, and exclamation-filled or which, in the case of the 'previously banned' logo, appear to act as mock-official symbols) are also loaded with other historical meanings, meanings which further enable these companies to present their products as 'out of joint with the moment'. Such techniques, after all, have a link not only to the original video marketing of the nasties in the early 1980s, but also the key marketing techniques of classic exploitation cinema, which are identified and discussed at length by Eric Schaefer in his book, *Bold! Daring! Shocking! True!* As Schaefer notes, the use of mock-official warnings, combined with bombastic, exclamation-filled claims about a film's shocking, transgressive nature, were cornerstones of classic exploitation marketing, acting as a means of creating controversy, which could then act as useful publicity for a film and ignite the curiosity of potential audiences.[32] As argued in chapter 2, the original marketing campaigns for the nasties also appeared to adopt these approaches and, as a result, assisted in generating a large amount of the subsequent British press hysteria which eventually led to the prohibition of the titles concerned.

In this respect, the contemporary use of such exclamation-filled legends as 'banned since 1982 in the UK as a nasty!', 'the most

violent film ever made!',[33] or, in the case of Vipco's re-release of
Cannibal Holocaust, 'the film they did not want you to see!'[34]
could be expected to generate the same type of media hysteria
which characterised the nasty titles' first British appearance in the
early 1980s. However, as well-documented by contemporary
British journalists and commentators, this hasn't been the case. In a
climate which has seen the liberalisation of the BBFC (in terms of
their increasing accountability to the public, and the publication
and deconstruction of their decisions on particular films) and
where, as Brian Pendreigh notes, the recertification of previously
banned or withheld titles on video has 'elicited more letters of
support than complaint',[35] the re-release of the majority of the
nasty titles has appeared to provoke little in the way of public
outrage.

As a result of this, the use of such disclaimers on re-release video
boxes appears particularly anachronistic, allowing video sleeves
and publicity materials to appear completely detached from
contemporary Britain, and completely tied up with, and making
reference to, a past Britain that doesn't exist any more – an archaic
world of restrictive censorship regimes and early video horror.
Indeed, the use of these hyperbolic approaches (combined with the
equally exploitation-inspired use of bold, sketchily drawn images
and text) seems to imbue these publicity materials with a distinct
archaic and primitive quality, a quality which, arguably, further
consolidates the idea that the re-released nasties are 'out of joint
with the moment'.

Indeed, Eric Schaefer notes that a large amount of the retrospec-
tive appeal of exploitation films lies in 'their bombastic promises
about shocking truths and fearless frankness', which, for him, 'can
seem like a tonic when compared with the jaded marketing and
merchandising efforts that pass as films today'.[36] In a British
context, where knowledge of American and European exploitation
cinema and its marketing techniques was muted prior to the advent
of the nasties, this bombast and frankness is something that,
arguably, is more associated, for many, with early video than with
grindhouse or drive-in exploitation cinema and, as a result, this
could potentially allow these re-release marketing images to appear
markedly primitive in the context of the contemporary British
video market.

Indeed, the apparent primitiveness of a large amount of nasty re-

release advertising seems particularly evident in a 2002 'HMV recommends' advertisement, where the re-release video sleeve for *I Spit on Your Grave* (complete with mock-official symbols, previously banned logos and the film's original video nasty era sleeve image) is placed next to the sleeve image for a collectors' edition DVD of *The Matrix*, with its designer, minimalist cover art.[37] In a commercial climate characterised by minimalist, high-concept advertising, it is the *I Spit* image which here appears anachronistic and out-of-place and, arguably, it is this kind of contrast which makes re-release nasty sleeves seem particularly eye-catching and distinctive in a contemporary film magazine or on a shelf in Blockbuster Video, where the 'jaded' marketing images that Schaefer refers to are the industry norm. As well as acting as stamps of authenticity and as shorthand for a past era, these exploitation-inspired techniques therefore appear to imbue this marketing material with a striking quality of retro-primitiveness, which appears to draw on a sense of, in Raphael Samuel's terms, 'nostalgia for a simpler life'.[38]

Further, this quality of primitiveness is something that also seems to characterise post-VRA Vipco and the way the company and, in particular, its director present and publicise themselves. In the aforementioned *Dark Side* interview and in an interview for the 2001 BBC documentary *Taboo*, Mike Lee seems to present himself a self-styled huckster, recounting anecdotes about the British video industry and (on the *Taboo* documentary) referring to *Cannibal Holocaust* as 'one of my horror films', while clad in a T-shirt emblazoned with the film's Vipco re-release advertising image.[39]

Just like the products he markets, Lee therefore seems to present himself as a distinct anachronism, evoking not only the kind of classic exploitation ballyhoo merchant discussed in chapter 2, but also the Thatcherite entrepreneur of the early British video horror era. In the *Dark Side* interview, for instance, Lee also discusses the early days of Vipco during this era, where, as he explains, he used all his savings to enable *Zombie Flesh Eaters* (and a number of other video titles) to be released and marketed, and then sold videos door-to-door in the day and duplicated copies of videos from master tapes at night.[40] What clearly emerges from this account, then, is an image of Lee as an exemplar of the Thatcherite entrepreneur, and a concurrent image of Vipco as a small, artisan company based around the enterprise and effort of one person who

works day and night and oversees all aspects of the distribution process (from duplicating videos to designing marketing campaigns and video sleeves) in order to succeed and make money.[41]

In the sense that Lee still appears as Vipco's driving force ('owning' films, rather than just distributing them, and designing and modifying all re-release advertising images), post-VRA Vipco's presentation of itself as an anachronistic company appears to be clearly related here to Vipco's pre-VRA status as a small company based around the ambitions of one 'canny entrepreneur'.[42] And, as a consequence of this strategy, this allows Vipco to be heavily marketed through notions of retro, where Lee's (and, by default, Vipco's) past is, as Samuel argues, 'there to humanize the present, and [to] substitute a personal for a corporate image'.[43]

However, to return to an earlier observation, this 'human' version of early video that Lee constructs is not seen as peaceful or serene, but (as Lee's status as an anachronistic ballyhoo merchant should suggest) as vital and dangerous, as a better, more exciting, more authentic time for horror video. Indeed, it is telling that retrospective British newspaper and magazine articles on the nasties are often peppered with references to punk, with, for instance, Holmes' article arguing that Sam Raimi was 'the Johnny Rotten of the video nasty era' and Slater's *Dark Side* article noting that Vipco's original pre-VRA video releases were 'outrageous splatter films of dubious merit that put two fingers up to the BBFC during the early 1980s'.[44] Such discursive approaches appear to eulogise the nasty era as a brash, vital time where 'human' inventors and entrepreneurs (or, as Vipco puts it, 'pioneers') could shake up the British commercial landscape, armed with and influenced by the youthful exuberance, vitality and transgression of punk and rock 'n' roll. Indeed, this conception of the early video era is also evident in a 1996 issue of *Sight and Sound*, where the aforementioned Nik Powell, in a review of Angus Finney's book on Palace Pictures, notes that 'as outsiders, we brought some of the ethos of the rock 'n' roll business into what could be described as a rather staid and clannish distribution marketplace. This encompassed many strategies and gimmicks ... Among these innovations were "guerrilla" marketing, flyposting ... "hit and run" promotions, stylised posters, the stimulation of tabloid fury'.[45]

What these comments suggest, then, is that the retro referencing

of both the techniques of exploitation cinema and of early 1980s
'guerrilla marketing' in the contemporary promotion of re-released
nasties and of Vipco seem frequently related to a discursive recon-
struction of a British past characterised by the excitement, the
danger and the authenticity of punk and rock 'n' roll.[46] However
(in a further take on the idea that these retro strategies draw on 'the
nostalgia for a simpler life'), the authentic appeal of both Vipco
and the re-released nasties also appears indebted to the idea that
the era of early British video was not only more dangerous, but was
also less politically-correct, pretentious and sophisticated.[47]

In order to explore this at further length, it is useful to compare
the promotional strategies of post-VRA Vipco with those of their
most significant British niche video horror competitor, Salvation
Films. On the basis of their website and other publicity materials, it
appears that Salvation have adopted marketing techniques similar
to those employed by paracinema video mail-order catalogues in
the US (which are discussed at length by Joan Hawkins in her book
Cutting Edge). Like these mail-order catalogues, Salvation
promote themselves, in a 1993 advertisement for their off-shoot
label Redemption, as purveyors of 'a cocktail of horror, passion
and extreme decadence on video', remarketing old horror titles
(including a number of nasty titles) as works by classic cult auteurs,
and repackaging such videos in, to use Tom Dewe Matthews'
phrase, 'arty, po-mo black-and-white photo-sleeves'.[48] Through
this foregrounding of their art/horror crossover status in publicity
materials, Salvation product appears to be reframed and promoted
as both gory horror and sophisticated art-house product, an
approach which allows the company to tap into a lucrative niche
demand for 'something different' from Hollywood by promoting
particular titles as having, in Joan Hawkins' terms, 'high produc-
tion values, European art film cachet, and enough sex and violence
to thrill all but the most jaded horror fan'.[49]

However, in contrast to this, Vipco appear to have completely
jettisoned any attempt to imbue the contemporary marketing of
horror titles with an arty authenticity or sense of quality. When
asked about his opinions on Redemption/Salvation in *The Dark
Side* interview, for instance, Mike Lee notes that the company:

> don't get to the point when compared to VIPCO titles, which really
> deliver. Take one of their leading titles, *Salon Kitty*, for example – a
> nice little movie but it doesn't really get there, does it? It's boring, a

bit pedestrian ... I wouldn't have it on my label. You can fall to sleep watching that movie, but with *Zombie Flesh Eaters* and *Shogun Assassin*, you know what you're getting ... Gor, blimey, come on! The blood flows, there it is! It gushes all over the screen. With *Salon Kitty*, you have to wait two days until you see a bird get her kit off. I mean, what is this?[50]

This unapologetic promotion of Vipco as being all about straightforward, old-fashioned, non-PC gore (which 'delivers' rather than being in any way artistic) is also mirrored in re-release publicity for their nasty titles. Thus, while *The Driller Killer* is presented, in its re-release advertisement, as containing 'scenes previously unseen in the UK', the sleeve for Vipco's re-release of *Zombie Flesh Eaters* is stamped with a huge red label which notes that the video has 'more gore than allowed before!!'. This bombastic approach seems to clearly denote Vipco's dismissal of contemporary horror video marketing trends, where DVDs are frequently (as appears to be the case with *The Driller Killer* advertisement) marketed as authentic by virtue of their status as 'director's cuts' with more footage, rather than as unexpurgated versions with 'more gore'.[51] Indeed, if this dismissal of the discourses of the artistic and sophisticated on the *Zombie Flesh Eaters* cover isn't marked enough, then Vipco's complete failure to market *Cannibal Holocaust* as the film 'on which *Blair Witch* was modelled'[52] or to promote the increased journalistic interest in Italian zombie films on the re-release covers of their vast range of zombie titles also appears to indicate that, in a niche horror video market characterised by notions of art/horror authenticity, post-VRA Vipco can distinguish themselves as a retro horror distributor by cheerfully sticking with low cultural appeal and notions of 'gore'.

As a result, this approach, just like the promotion of Lee as an exploitation huckster and guerrilla marketeer, succeeds in further presenting post-VRA Vipco as an anachronism. However, by presenting itself as a company that seems as if it should exist in another time, Vipco is clearly able to carve a distinct identity for itself in the contemporary British video marketplace, and to achieve a sense of historical legitimacy through references to a past which is not only constructed as dangerous and primitive, but, through a dismissal of new-fangled notions of art/horror, is also presented as unpretentious.

However, as Lee's 'gor blimey' comment and the previously cited references to punk and rock 'n' roll seem to indicate, this promotion of the nasties through notions of the unpretentiously gory is not only informed by notions of a more human and authentic past, but also, arguably, through a parallel idea of the past as 'fun', frivolous and, in both senses of the word, as 'the bad old days' of video horror.[53] While Samuel may note that a key contemporary use of retro is to allow the past 'to humanize the present', the final section of this chapter will explore how, as he also argues, it can also be 'used for comic, or serio-comic effect'.[54]

'Signs of the times': styles, icons and puns and the construction of a bad, tacky and infamous past

In the 'introductory commentary' extra on *The Driller Killer* re-release DVD, Xavier Mendik discusses the original *Driller Killer* video marketing campaign and argues that the original British *Driller Killer* video sleeve has 'become a symbol of the extremes of violence and exploitation occurring in an unregulated video market'.[55] What this comment underscores is, firstly, the extent to which some of the original video nasty marketing images have become both familiar and iconic amongst British horror fans[56] and, secondly, the potential for these iconic images to connote, and immediately conjure up, the danger and the extremity of the 'bad old days' of early video horror.

Indeed, while the original *Driller Killer* marketing image is perhaps the most prominent of these early video icons, there are a plethora of other original nasty marketing images which have, arguably, become equally iconic in the British context – the comic-book covers of *The Evil Dead* and *Zombie Flesh Eaters*, for instance, or the provocative original video sleeves for *I Spit on Your Grave*, *SS Experiment Camp* or *Death Trap*. As Andrew Holmes puts it, 'the cover of *SS Experiment Camp*, with its infamous image of a topless woman hanging in upside-down crucifixion; *The Driller Killer*, with a close-up of a bit boring into the skull of its bearded, screaming victim; the gut-guzzling cannibal on the cover of *Cannibal Holocaust* – these were signs of the times'.[57]

What these comments suggest is that these original nasty era marketing images (images which are 'signs of the times') hold the

potential to work, like the 'previously banned' logo or the use of dates, as effective retro signatures in the contemporary British video marketplace. Firstly, these images connote, in an economical and dramatic way, an immediate sense of the past. Indeed, this is something which clearly informs the frequent use of original nasty marketing images in retrospective articles on the nasties (including the Holmes' piece) and in documentaries on the nasties and censorship – in particular, in the 'Discovering *Evil Dead*' documentary and the BBC documentary *Taboo*, where a sense of the drama of the nasty era is primarily conveyed through a montage of such images. The *Taboo* sequence is particularly striking in this respect, allowing a camera to pan in and out on video cover images and to focus in on the sleeves' frequent use of bold, red text and words such as 'blood', 'evil', 'death' and 'massacre', to the accompaniment of suitably dramatic music. While this is an approach which appears contrived, it still, arguably, has an effective impact, illustrating convincingly that a sense of the past can be successfully and dramatically conjured up through the utilisation of meaningful and iconic visual images.[58]

Secondly, however, the original nasty marketing images can also work effectively as retro signatures because they are, as Raphael Samuel terms it, 'yesterday's advertisements'[59] – defunct commercial images which, while appearing to be devoid of commercial use value in the contemporary marketplace, can be utilised, in certain contexts, for their ability to conjure up an immediate sense of the past and to appear as both vintage *and* as backward and quaint. Indeed, it is this second notion (of the backward and quaint) which appears to inform the use of original marketing images in nasty re-release publicity materials, where, in line with the notion that much of what is distinctive about retro marketing is derived from its theatricality and irreverence, such images are frequently played with and deconstructed.

One way in which this is achieved is through the discussion and deconstruction of nasty marketing images on DVD extras. As well as Mendik's *Driller Killer* DVD introduction (which discusses *The Driller Killer* sleeve at length), the Anchor Bay UK extra 'Discovering *Evil Dead*' includes a number of stills of the extremely distinctive original Palace marketing sleeves and posters for the film, as well as footage of Stephen Woolley discussing the sleeve artwork at length (explaining that a young artist was brought in to

produce a sleeve design for the film, which was based largely around old horror movie posters 'done in a particular style').[60] Arguably, this discursive approach is suggestive of a number of things. Firstly, it indicates the extent of *The Evil Dead*'s association with these marketing images in the British reception context. Indeed, it is notable that, while Anchor Bay UK dramatically repackaged the video sleeve for their 2002 *Evil Dead* re-release (using old US marketing materials, thus divorcing the film from its association with the old Palace images), a number of British film magazines still illustrated their reviews of the DVD re-release with pictures of these original British video images, highlighting the extent to which these images have, over time, become part of the film's iconography in the British market.[61] Secondly, however, while this discussion and analysis of *The Evil Dead* and *The Driller Killer* images suggests the extent to which they have become iconic images of early British video, the deconstruction of these images by Woolley and Mendik (taking them apart, looking at them, trying to encapsulate their significance) also seems to suggest that they have not only become meaningful icons, but also malleable icons – icons which, visually, can be played around with, meshed together and split apart.

Indeed, this playful approach to some of the original nasty images is clearly at work in a number of recent re-release advertisements and sleeves. Visual Film's *The Driller Killer* re-release sleeve, for instance (see figure 7), while dispensing with the tramp and the violence of the original British sleeve, still utilises an image of a drill swathed in clean, bold splashes of red, and still uses the original *The Driller Killer* title image (the words '*The Driller Killer*' sliced through with an illustrated drill bit). While the drill is clearly different from the one used on the original British sleeve, and the blood resembles a splash of red paint, the juxtaposition of drill and blood (key visual elements of the original British sleeve image) are enough to point to and conjure up the original *The Driller Killer* video cover in a rather knowing and self-conscious way (indeed, it is notable that these same motifs are also employed on all the DVD's interactive menus).[62]

Inevitably, perhaps, an even more striking example of this self-conscious visual 'play' with, and fragmentation of, original nasty video covers can be found in a series of 2002 Vipco advertisements for a range of their nasty and nasty-related zombie titles. In adver-

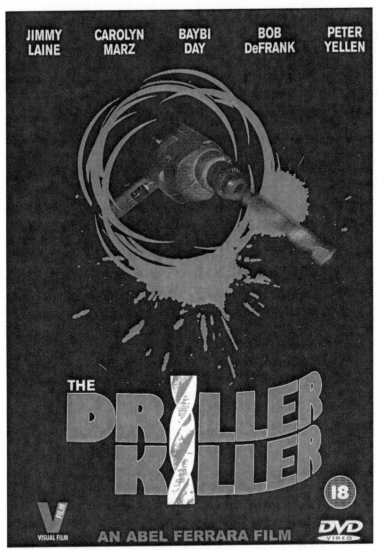

7 Referring back to an iconic video cover: the re-release Visual Film British DVD cover for *The Driller Killer*

tisements for *Zombie Creeping Flesh* and *Zombie Flesh Eaters 2* (see figure 8), DVD and VHS copies of the film are pictured in front of an illustrated New York skyline, an orange sun, a graveyard and a row of shadowy zombie silhouettes, all of which have been borrowed from Vipco's original British video sleeve for *Zombie Flesh Eaters*. However, if this is not marked or knowing enough, the DVD or VHS copy of the particular title in question is also presented, in these advertisements, as being held aloft by a large green, illustrated zombie hand bursting out from a grave – something which has also been borrowed directly from, and which is the central and most distinctive element of, the original Vipco *Zombie Flesh Eaters* sleeve (see figure 9).[63] The result of this play with, and mixing and meshing of, old nasty era video images in these re-release advertisements is the creation of a knowing and self-conscious advertising image, a clear example of how, as Samuel puts it, retro marketing can be 'playful and theatrical in the way it appropriates artefacts and uses them as icons and emblems'.[64]

Arguably, there are two motivations lying behind Vipco and other re-release companies' utilisation of this fragmented, playful and knowing approach to advertising. Firstly, and particularly in the case of the Vipco zombie film advertisements, issues of ownership appear clearly to be at work here. If, as I argued earlier, Vipco has become strongly associated, in the British context, with particular nasty titles (that when you 'think … *Zombie Flesh Eaters*, Vipco springs to mind'), then the visual framing of other Vipco re-releases within the *Flesh Eaters* iconography is another way in which Vipco can place its rubber stamp of ownership on particular nasty titles *and* original nasty marketing images. In other words, the visual implication is that the original *Flesh Eaters* marketing image is part of the historical iconography of Vipco, and that any Vipco re-release is therefore framed within, and informed by, the historical legacy of the *Flesh Eaters* image *and* Vipco's past and continued ownership of it.

In addition to this, Vipco's consistent aim to convey ownership of particular nasty marketing images also appears to inform a comment made in Mike Lee's *Dark Side* interview, where Lee expresses his annoyance that Nigel Wingrove (director of rival video distributor Salvation Films) had used the original *Driller Killer* sleeve in a book on the nasties without obtaining his permis-

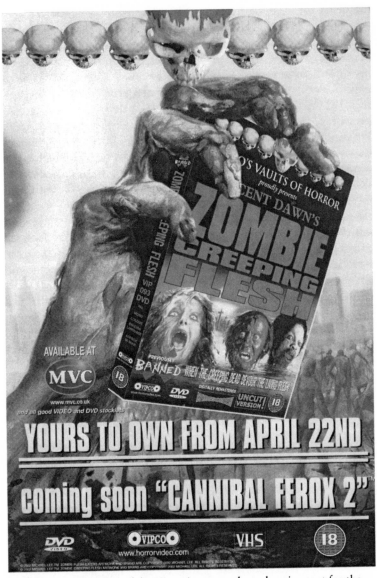

8 A self-conscious use of the Vipco iconography: advertisement for the
 Vipco British DVD re-release of *Zombie Creeping Flesh*, *Empire* (May
 2002), p. 149

sion first.[65] In the sense that the book in question, *The Art of the Nasty*, was a book which clearly sought to present the original nasty sleeves as fan artefacts, Lee's *Dark Side* comment seems to point to Lee's need to reinstate the *Zombie Flesh Eaters* image and their ilk as commercial symbols (rather than as revered fan 'art') which *he* owns (something which is also suggested by his frequent copyrighting of marketing artwork at the bottom of Vipco advertisements). And, as a consequence, this reinstated commercial ownership of nasty marketing images then appears to sanction Vipco's strategy of fragmentation and play with these images in their re-release publicity material.

However, without question, the second factor informing this marketing strategy relates to the changing nature of advertising legislation in Britain and, more specifically, the activities of the VPRC in the post-VRA context. As Julian Petley explains, in a 1989 article on the post-VRA British video industry, the VPRC has, since its constitution in 1987, had a considerable impact on the kinds of images that are considered to be permissible on contemporary British video sleeves and packaging, relating, in particular, to standards of taste and decency and representations of violence and sexual violence. In this respect, the use of fragments of original nasty marketing images on, for instance, *The Driller Killer* re-release video sleeve and advertisement can, potentially, serve as a means of bypassing these restrictions. While the original British *Driller Killer* marketing sleeve, a sleeve which Wingrove and Morris argue is 'the most over-the-top video cover ever seen in the UK',[66] would be unlikely to be approved by a body like the VPRC, fragments of this image (which are divorced from their original context, but which still denote and refer to this context) can act as useful marketing shorthand, conveying, economically, the film's relationship to the nasty era while also effectively bypassing current British video packaging restrictions.

However, from an alternative perspective, while the VPRC guidelines on truthfulness state that 'claims made on packaging must be accurate and unambiguous', an interesting disclaimer is also included which notes that 'certain licence is extended to copy where it is clear that the facts are being intentionally distorted by humour and exaggeration'.[67] This disclaimer, clearly, seems to link up to the idea (discussed earlier in the chapter) that the ballyhoo and hyperbolic taglines of the original nasty marketing campaigns

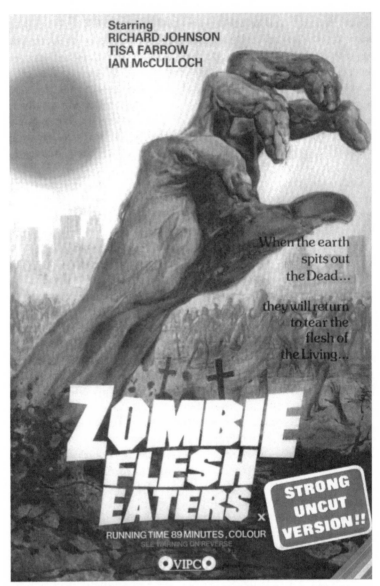

9 The original image drawn on by Vipco: the 1981 Vipco British video
cover for *Zombie Flesh Eaters*

are now rather blunt instruments, which, rather than being seen as a moral outrage or threat by the BBFC, the VPRC or the media, may now, in a contemporary British context, seem nothing more than harmless 'exaggeration' or 'humour'.

In this respect, the nasty marketing images (once considered to represent 'the extremes of violence and exploitation' in the British video market) could also appear, from the point of view of the VPRC or the BBFC, as past artefacts which, like the films themselves, have lost their power to shock or inspire letters of complaint and instead can be used for the benefit of perfectly acceptable retro 'humour'. Because of the liberalisation of censorship regimes in Britain and the diminishing nature of public complaints about the re-release of previously contentious titles, the theatrical play with nasty marketing images on re-release covers therefore suggests that such covers hold the potential to amuse rather than shock: a kind of discursive approach which Vipco, at the very least, seems particularly aware of.[68]

However, if the fracturing of, and play with, old nasty marketing images is one way in which the 'tongue-in-cheek' quality of the retro can be productively tapped into, another is the adoption of marketing materials which weren't used in the original nasty marketing campaigns, but which seem to convey an essence of the nasty era perhaps more dramatically and effectively than the original marketing materials themselves. Again, Vipco is the most consistent user of this approach, an approach which is evident not only on their video sleeves and advertisements, but also through the use of 'original trailer' extras on the vast majority of their nasty re-release DVDs. These trailers, on the whole, do not appear to have been produced for the films' 1980s British video incarnations but instead have predominantly been derived from their original theatrical exhibition contexts (with this, in some cases, being Britain, but, no doubt, more frequently being US drive-in and grindhouse circuits). The trailers themselves have a quite evident retro appeal, being both anachronistic (they're long, they tend to reveal the entire plot of a film, and often don't have voiceovers) and, from a contemporary perspective, are technically unsophisticated (they're badly edited and are frequently accompanied by a dated synthesiser soundtrack).[69] As a result, while they are clearly not a product of the days of early British video horror, these original theatrical trailers seem to possess an intrinsically dated and

primitive quality which seems to immediately conjure up connotations of the video nasty era.

However, crucially, these trailers also reveal their own status as influence for a number of Vipco's re-release nasty sleeves and advertisements, something which is most markedly the case with those nasty titles that Vipco didn't own originally, but have acquired since the passing of the VRA. While, on the basis of the nasty covers in Wingrove and Morris' book, it is clear that a number of the original nasty distributors chose not to adopt the sketched, wavy titles, text, images and hyperbole of exploitation marketing and, instead, used rather slick designer covers, Vipco have repackaged these covers in a way which makes them appear, to put it simply, more nasty or more exploitation-inspired than before. For instance, while the original *Cannibal Holocaust* video sleeve, produced in 1982 by Go Video, had a plain white '*Cannibal Holocaust*' title (see figure 10), the Vipco re-release advertisement and sleeve sport a huge, dramatic, wavy, red and white title image (see figure 11), which is featured heavily in, and appears to derive from, the film's original theatrical trailer. In addition, the re-release sleeve also appears to have adopted a number of taglines (not featured on the original Go packaging) from this trailer, including the legend 'better to be in the warm body of a friend than in a cold hole in the ground . . .'.[70]

This approach (of using old theatrical trailers, taglines and advertising styles from other eras and contexts to connote, and to encapsulate, the essence of an entirely different era and context) is again something which, through its play with images of the past, has a clear link to discourses of retro. Indeed, as Raphael Samuel argues:

> [retro] is not concerned with restoring original detail, like the conservationist, but rather with decorative effect – choosing objects because they are aesthetically surprising, or 'amusing', rather than because they are authentic survivals of the past. Indeed, retrochic seems often to prefer remakes to originals, cheerfully engaging in the manufacture of replicaware without any attempt to disguise the modernity of its provenance.[71]

In this respect, the *Cannibal Holocaust* sleeve, and other Vipco re-release sleeves, can clearly be approached and understood as 'remakes' of original video nasty sleeves, but 'remakes' which are visually enhanced by Vipco (through the use of a historically-

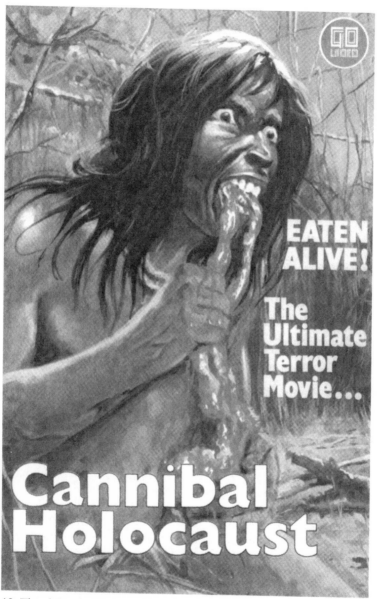

10 The plain white lettering of the original *Holocaust* sleeve: the 1982
Go British video cover for *Cannibal Holocaust*

vague, exploitation-informed advertising style) in order to appear even more evocatively 'nasty' than some of the original nasty covers. Indeed, what Vipco appear to be doing here is adopting a 'particular style' (an exploitation or old horror movie-inspired style of sketchy, bold lettering and bombastic taglines) which replaces the actual detail of the original nasty marketing images with a more 'decorative' essence, which, for Vipco, appears to capture the nature and appeal of the nasty era more persuasively, and which also appears, to use Paul Grainge's term, to have a greater 'feeling of pastness' about it.[72]

Indeed, this idea of a 'feeling of pastness', in relation to the nasty era and the nasty titles, is something that is also conveyed in contemporary reviews of nasty re-releases, where, for instance, *Driller Killer* is described as a 'rough-edged production' and as a film which 'was to usher in the tacky look of the early eighties', or where it is noted that *The Evil Dead* re-release still has 'a hint of the grungy edge that condemned the film to the infamous Video Nasties list in the mid-'80s'.[73] While these comments are made in reference to the films themselves (the 'look' of particular film texts), it is notable that the adjectives used ('rough-edged', 'tacky', 'grungy') appear to relate to the predominant contemporary image of the early 1980s British video era itself, and, perhaps implicitly, these reviewers' memories of the early video marketing sleeves that have become such an integral part of these films' reputation and historical status in Britain.

What this seems to suggest is that this constructed essence or 'feeling' of an era is something that seems to inform contemporary perceptions of both the nasty film text and the nasty marketing icon, and which therefore also appears to inform Vipco's marketing strategy of amplifying the rough edges, the grunge and the tackiness of a re-released nasty title when it is deemed necessary to do so (i.e. when original nasty marketing materials are not deemed to be nasty or dated enough). However, crucially, while this decorative application of tackiness and grunge is something that appears to assist in the process of distinguishing Vipco's products as old and historical, it once again also appears to assist in the process of allowing post-VRA Vipco to distinguish *itself* as old and historical. As Joan Hawkins notes, the production of tacky, grungy videos or DVDs (badly produced and cheaply and tackily packaged) can be a source of pride for specialist video companies like

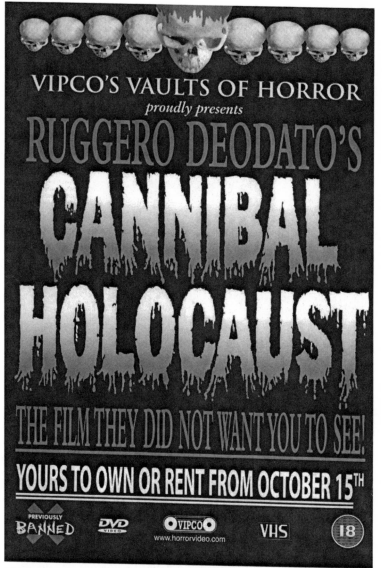

11 The more 'exploitation-inspired' lettering of the re-release sleeve: advertisement for the Vipco British DVD re-release of *Cannibal Holocaust, Empire* (November 2001), p. 114

Vipco, who can use this quality of tack or grunge as 'a signifier of ... [a] tape's outlaw status and a guarantor of its authenticity', while also allowing the company to emphasise *their* 'outlaw status' as well.[74]

Indeed, if Vipco's marketing materials can be considered as decoratively tacky and cheap, then the same could, quite easily, be argued of the Vipco company itself. As its use of old theatrical trailers should suggest, Vipco is frequently denigrated for its 'penny-pinching' ways, its 'substandard' discs, its frequent failure to release titles in an uncut form, and its general failure to live up to the standards and expectations of contemporary DVD-buying horror film collectors (who, at least when it comes to new versions of the nasty titles on DVD, crave superior picture and sound quality and substantial extras and bonus features from their discs).[75] As a result, the criticisms of Vipco and its products as duds and letdowns has become a key part of nasty fan debates and discourses, both in the pages of film and horror magazines (for instance, in a 2002 letter to *Sight and Sound*, where Neil Jackson wonders 'whether it's worth releasing ... [Vipco] titles at all')[76] and in the confines of horror fan message-boards (where, at least on the *Dark Angel's Realm of Horror* board in 2001 and 2002, 'Vipco Bashers' were debating the laughable inadequacies of 'SHITCO' and 'VIPCO shite').[77]

Indeed, what also comes across quite clearly in *The Dark Side* interview with Mike Lee is the limits of both his (and thus Vipco's) knowledge regarding the cultural circulation and reception of the films he markets. During the course of the interview, Lee demonstrates that he has limited knowledge about censorship issues or of the collecting culture that has built up around the nasties since they were banned in the early 1980s, and, unlike Salvation who market titles around cult directors, that he has a limited awareness of contemporary film culture in general (something which is apparent in Lee's frequent tendency to name-drop hack directors and to treat them as if they are already recognised as established horror auteurs). In addition to this, while it appears to be the norm for other specialist DVD companies, including Anchor Bay UK and Salvation, to include customer message-boards and forums on their company websites, the Vipco website (which, inevitably, appears to have been cheaply produced and constructed) makes no such concessions to its customers and to the notion of consumer care in

general. Yet again, then, such 'no frills' approaches seem to further consolidate the sense that post-VRA Vipco is as shoddy and cheap as its earlier pre-VRA incarnation, seeming more concerned with bolstering its roster of titles than obtaining quality prints and extras and developing its customer service.

However, arguably, this cheap, shoddy company image, in some respects, appears to remain truer to the general contemporary perceptions of the nasties and the dominant associations that are attached to them. For instance, in the *Taboo* documentary, Joan Bakewell notes that the nasties 'achieved cult status with their low-budget look, dated special effects and tongue-in-cheek-humour', while Steve Rose, in a *Guardian* article on the nasties and censorship, argues that 'in the sober light of the 21st century, the majority of these low-budget splatterdramas are more hilarious than disgusting'.[78] Indeed, with this in mind, what is also notable is that while *Dark Side* reviews and *Dark Angel* message-board postings frequently attack Vipco for their cheesiness and general 'badness', they quite clearly, in the case of at least some of the nasty titles, revel in the tongue-in-cheek, low-budget and dated nature of the films themselves (with, for instance, *The Dark Side*'s Allan Bryce filling up most of a 2002 review of a *Zombie Creeping Flesh* re-release with a discussion of the film's unintentionally comic, rather than its gore-related, highlights).[79]

What this general discursive celebration of 'badness' seems to point to is the, possibly unintentional, salience of Vipco's marketing approach. That, by refusing to give low-budget nasty titles a 'digital makeover' (makeovers, which in a number of cases, would only draw attention to the general bad quality of the film's original sound and image), Vipco, in some respects, can be seen to remain true to the cheap aesthetics of the films themselves.[80] In addition, by refusing, as Allan Bryce puts it, to 'polish a turd' and throw money into the, possibly futile, restoration of cheaply made horror films, post-VRA Vipco can also imbue itself with a truer, cheaper, grungier nasty-era-related image, an image which can allow the company to distinguish itself through its status as an 'outlaw' company, via a notion of infamy (displayed in Bryce's or the *Dark Angel* message-board users' certainty that any Vipco re-release is always going to be 'VIPCO shite').[81] Indeed, while magazine critics frequently attack Vipco for their inherent 'badness', they also seem to take a perverse pleasure in Vipco's infamous status, often

making jokey and rather fond references to the company's depend-
able, and thus rather loveable, cheapness.[82] Thus, for *The Dark
Side*, Vipco is 'everyone's favourite video nasty label', while, in
SFX, the re-release of Lucio Fulci's *City of the Living Dead* is
heralded as 'another cheerful flick from Vipco's Vaults of Horror
label'.[83]

Conclusion: the 'badness' of early British video horror

The portrayal of Vipco as an infamous and dependably 'bad'
company is another way, then, in which the company can present
itself as anachronistic and 'out of joint with the moment'.
However, when surveying the range of predominant discourses
that underpin Vipco's contemporary marketing strategies, what is
also apparent is the way in which these strategies also function as
an illumination of the wider historical trajectory of the British
video industry, from its origins up to the present.

Julian Petley's article on the late 1980s British video market
discusses the consolidation that occurred after the passing of the
VRA, where, as major video companies wrested control of the
British video industry and legislative and other regulatory frame-
works were put in place (including the VRA, the VPRC and the
Federation Against Copyright Theft), the industry could be seen,
slowly, to become more centralised, more family-orientated and
thus more respectable. As a result, and as a BBFC report quoted in
the article notes, the post-VRA video industry (from the late 1980s
onwards) could be seen to have been marked by 'the increasing
professionalism' with which video releases were 'presented to the
public'.[84] With this in mind, the 'badness', cheapness and tongue-
in-cheek marketing strategies of post-VRA Vipco could be seen to
be informed by a nostalgic *unprofessionalism*, an unprofessional-
ism which appears, in the context of an established and centralised
contemporary British video industry, as an anachronistic throw-
back to the fly-by-night distributors of the pre-VRA world.

However, what is also significant is Vipco's relationship to the
history of the British video industry, which has moved from an
early, unregulated era (where Vipco flourished), to a centralised
era (where Vipco was banished and blocked), to an era marked by
the proliferation of new technologies and the liberalisation of the
BBFC (where Vipco re-emerged once again). Arguably, this history

of Vipco's appearances and disappearances from the British video market has allowed post-VRA Vipco to adopt an even more self-conscious identity. As Raphael Samuel argues, retrochic originally won 'a cult following by allowing for a return of the repressed'.[85] In this respect, Vipco can be seen, via a series of self-conscious marketing puns, as the video industry equivalent of the rampaging, ever-returning repressed horror film monster, frequently peppering its advertisements with phrases like '*Zombie Flesh Eaters* is back!' or its website with warnings that 'we'll never die!!'.[86] Indeed, the use of such horror-related puns, when marketing or discussing both the re-released nasties and Vipco, has also been adopted more widely, to the point where, for instance, *The Driller Killer* is presented, in its re-release advertisement, as having been 'unleashed', where it is noted, in *The Dark Side*, that the Vipco label has been 'resurrected' or, in Kerekes and Slater's book, that the Vipco label earned their reputation by 'exhuming former nasties'.[87]

In his book on classic exploitation cinema, Eric Schaefer argues that 'the organized film industry denigrated exploitation films, creating barriers to their distribution and exhibition, as a way of elevating the stature of its own product'. However, he also notes that 'the mainstream industry also depended on the contrast of exploitation to construct its own image as a responsible business', something which suggests that exploitation cinema can often frequently be understood as the 'other' of Hollywood.[88] In a similar fashion, Vipco, the repressed 'other' of the responsible, centralised post-VRA video industry, has been able, in the context of an increasingly globalised and ever-evolving contemporary video market, to create a commercial niche for itself as a historically authentic and nationally-specific outlaw company, returning from the video distribution graveyard with its tongue firmly in its cheek and with a 'rogues gallery of video greats'[89] tucked under its arm.

Notes

1 Barbara Kirshenblatt-Gimblett, *Destination Culture: Tourism, Museums, and Heritage* (Berkley and Los Angeles: University of California Press, 1998), pp. 271–2.
2 *Ibid.*, p. 272.

3 For further background information on Palace Pictures, see Angus Finney, *The Egos Have Landed: The Rise and Fall of Palace Pictures* (London: Heinemann, 1996); and Nik Powell, 'The company among the wolves', *Sight and Sound*, 6:5 (1996), 40–1.

4 Richard Marshall, 'Return of the video nasties!', *The Dark Side: The Magazine of the Macabre and Fantastic* (March 1992), p. 38.

5 'Discovering *Evil Dead*: The Palace boys meet *The Evil Dead*', *The Evil Dead* Full Uncut Special Edition DVD, Anchor Bay Entertainment, 2002.

6 Jay Slater, 'Flesh eating mother', *The Dark Side: The Magazine of the Macabre and Fantastic* (August–September 2002), p. 6.

7 See Vipco original video sleeves for *The Driller Killer, Zombie Flesh Eaters, The Bogey Man, Death Trap, The Slayer, Shogun Assassin* and *The Deadly Spawn* in Nigel Wingrove and Marc Morris (eds), *The Art of the Nasty* (London: Salvation Films, 1998) pp. 20, 27, 31, 32, 39 and 104. It should be noted here that while Vipco have adopted this new, more prominent brand symbol on its post-VRA DVD sleeves and advertisements, it frequently uses the original, small pre-VRA brand symbol as well, a symbol which appears to work as what Raphael Samuel would call a retro 'vintage logo'. See Raphael Samuel, *Theatres of Memory Volume 1: Past and Present in Contemporary Culture* (London and New York: Verso, 1994), p. 92.

8 See, for instance, advertisement for *Cannibal Holocaust*, *Empire* (November 2001), p. 114.

9 See, for instance, advertisement for *Zombie Creeping Flesh*, *Empire* (May 2002), p. 149; and advertisement for *Zombie Flesh Eaters 2*, *Empire* (April 2002), p. 88.

10 See the Vipco website homepage, *Vipco's Vaults of Horror*, www.horrorvideo.com (30 July 2002).

11 'About Vipco', *Vipco's Vaults of Horror*, www.horrorvideo.com /index2.htm (30 July 2002).

12 Richard Falcon, 'The adjuster', *Sight and Sound*, 6:2 (1996), 62.

13 For another example of a re-release inspiring a reappraisal of an original nasty company and its importance to the historical significance of particular nasty titles, see the discussions of *Nightmares in a Damaged Brain*'s original distributors, World of Video 2000 (their court appearances, prosecution and imprisonment under the OPA) on *Nightmare in a Damaged Brain, Screen Entertainment*, www.nightmareinadamagedbrain.co.uk (30 July 2002).

14 Kirshenblatt-Gimblett, *Destination Culture*, p. 272.

15 Paul Grainge, *Monochrome Memories: Nostalgia and Style in Retro America* (Westport and London: Praeger, 2002), p. 54.

16 *Ibid.*, p. 49.

17 This notion of 'where does the thing come from and who made it' is borrowed from Igor Kopytoff, who argues that this is one of the questions that could be posed when researching a biography of an object or a thing. Indeed, one of his other suggested research questions – 'what, sociologically, are the biographical possibilities inherent in … [an object's] "status" and in the period and culture, and how are these possibilities realized?' – also relates to the concerns of this chapter. See Igor Kopytoff, 'The cultural biography of things: commoditization as process', in Arjun Appadurai (ed.), *The Social Life of Things: Commodities in Cultural Perspective* (Cambridge: Cambridge University Press, 1986), p. 66.

18 Advertisement for *The Driller Killer*, *Empire* (November 1999), p. 69; advertisement for HMV recommends … *The Driller Killer*, *Empire* (November 1999), p. 45; Danny Leigh, review of *Tenebrae*, *Sight and Sound*, 9:10 (1999), 60–1; and advertisement for HMV recommends … *The Slayer*, *Empire* (August 1992), p. 36.

19 Advertisement for HMV: *Zombie Flesh Eaters*, reproduced in John Martin, *The Seduction of the Gullible: The Curious History of the British 'Video Nasty' Phenomenon* (Nottingham: Procrustes Press, 1993), p. 177; advertisement for *The Driller Killer*, p. 69; DVD sleeve for *The Driller Killer*, DVD, Visual Film, 1999.

20 Advertisement for HMV Recommends … *Inferno*, *Empire* (June 1993), p. 78.

21 Video sleeves all accessed from the *Vipco's Vault of Horror* website.

22 Advertisement for HMV recommends … *The Slayer*, p. 36.

23 Indeed, the increasing importance of these 'previously banned' logos, as a key marketing tool for Vipco DVDs, is further highlighted by the fact that, at the time of writing, their most recent nasty re-release, *Island of Death*, has a plain black sleeve with an enlarged version of this 'previously banned' logo on the sleeve front. See video sleeve for *Island of Death*, *Vipco's Vault of Horror* website.

24 This, according to Julian Petley, is how Trading Standards Officers ruled the VPRC mark, under the auspices of the 1968 Trade Descriptions Act. See Julian Petley, 'The video image', *Sight and Sound*, 59:1 (1989), 25.

25 Kirshenblatt-Gimblett, *Destination Culture*, p. 273.

26 DVD sleeve for *Blood Feast*, DVD, Tartan Video, 2001; Video sleeves for *I Spit on Your Grave* and *Nightmare in a Damaged Brain*, *I Spit on Your Grave*, Screen Entertainment, www.ispitonyourgrave.co.uk (20 July 2002) and *Nightmare* website. What is particularly interesting about Tartan's use of this symbol is that Tartan has a very different image to Vipco, having built up a reputation, through the course of the 1990s, as a quality, independent art-house distributor. Tartan's use of the 'previously banned' symbol therefore seems to

suggest that Vipco's tactics have had a wide-ranging impact on specialist companies, including those which, in other respects, have a very different image and status to Vipco.

27 Grainge, *Monochrome*, p. 52.

28 Andrew Holmes, 'Let there be blood', *Guardian Friday Review* (5 July 2002), p. 12.

29 Interestingly, the use of a generation's experience of a key era as a retrospective marketing tool is something that, according to Joan Hawkins, is also prevalent in American paracinema circles, where art/exploitation crossover catalogues 'celebrate the two extreme tastes of the postwar youthful filmgoing public'. Joan Hawkins, *Cutting Edge: Art-horror and the Horrific Avant-garde* (Minneapolis: University of Minnesota Press, 2000), p. 22.

30 Xavier Mendik, 'Introductory commentary by Xavier Mendik filmed at The Scala, London', *The Driller Killer*, DVD, Visual Film, 1999.

31 For further background on the Scala, and its links to the video nasty era and to particular nasty titles, see Jane Giles, 'Scala!!!! Autopsy of a cinema', in Stefan Jaworzyn (ed.), *Shock Xpress 2: The Essential Guide to Exploitation Cinema* (London: Titan Books, 1994), pp. 30–5. The Scala's importance to the British horror scene in the late 1970s and early 1980s is also touched on in Mark Kermode's eulogy to horror films and horror fans, Mark Kermode, 'I was a teenage horror fan: or, "How I learned to stop worrying and love Linda Blair"', in Martin Barker and Julian Petley (eds), *Ill effects: The Media/Violence Debate* (London: Routledge, 2nd edn, 2001), pp. 126–34.

32 For instance, see Schaefer's discussions of the use of timeliness, veracity and 'pinking' in classic exploitation cinema marketing and advertising. Eric Schaefer, *'Bold! Daring! Shocking! True!' A History of Exploitation Films, 1919–1959* (Durham and London: Duke University Press, 1999), pp. 109 and 124.

33 Video sleeve for *Cannibal Ferox*, Vipco's *Vault of Horror* website.

34 Advertisement for *Cannibal Holocaust*, p. 114.

35 Brian Pendreigh, 'So where is the clampdown?', *Guardian Unlimited* (30 April 1999), www.guardian.co.uk/Archive/Article/0,4273, 3859769,00.html (20 May 2002).

36 Schaefer, *'Bold! Daring! Shocking! True!'*, p. 3.

37 Advertisement for HMV recommends ... *I Spit on Your Grave*, p. 79.

38 Samuel, *Theatres of Memory*, p. 92. Indeed, the *I Spit* distributors (Screen Entertainment) can be seen to have further emphasised this notion that their title was primitive and anachronistic by packaging it in an old-style big rental box. See 'Notorious "nasty" to get BBFC go-ahead', *Home Entertainment Week* (12 November 2001), *I Spit on*

Your Grave, Screen Entertainment, www.thezone.co.uk/otherwebs /ispit/HEW.htm (30 July 2002).

39 Joan Bakewell, 'Looks that kill', *Taboo: 50 Years of Censorship*, BBC2, 5 December 2001.

40 As Lee explains, 'I used to approach shops singly trying to sell them. I was selling them during the day and duplicated copies in the evening with a master machine and six rented VCRs. That was what I did in the early days of VIPCO, and I can tell you, I used to be knackered!' Slater, 'Flesh eating mother', p. 7.

41 A similar picture of Palace as one of Thatcher's heroic, hard-working entrepreneurial companies is given in Angus Finney's book, *The Egos Have Landed*, where it is noted that Woolley (and a small group of staff) sold videos from the foyer of the Scala, and carried piles of Palace videos up the stairs on a regular basis and crammed them into a cramped office above the cinema. See Finney, *The Egos*, p. 51.

42 As Jay Slater notes in his interview with the Vipco director, 'So what is VIPCO? Who is VIPCO? might be a better question. Vipco is Mike Lee, a canny entrepreneur'. Slater, 'Flesh eating mother', p. 6.

43 Samuel, *Theatres of memory*, p. 93.

44 Holmes, 'Let there be blood', pp. 12–13; and Slater, 'Flesh eating mother', p. 6.

45 Nik Powell, 'The company among the wolves', *Sight and Sound*, 6:5 (1996), 40. In the same article, Powell argues that Palace's direct American counterparts were Miramax's Weinstein Brothers (who, like Powell, also had a background in rock 'n' roll). In addition, Powell also helps to construct Miramax (and, by implication, Palace) as anachronistic by arguing that 'the brothers had the energy, the instinct for promotion and the savvy of the old Hollywood moguls'.

46 This contemporary eulogisation of the rock 'n' roll 1980s is also conveyed in a *Sight and Sound* editorial which calls for a revival of Palace's 'intrepid spirit' in the contemporary British film industry, a spirit which, for them, seemed to characterise the 1980s. See 'Gentlemen and players', *Sight and Sound*, 6:5 (1996), 3.

47 There are two particularly useful comparative examples of this tendency to see the past as less pretentious and less politically correct. The first is the retrospective appreciation of film noir for its 'moral ambiguity' and 'lack of bourgeois sentimentality or "high-minded-ness"'. See James Naremore, *More Than Night: Film Noir in Its Contexts* (California: California University Press, 1998), p. 163. The second is the British retro-inspired phenomena that is *School Disco.com*, a hugely successful contemporary club night set up as a 'fun' alternative to the stylish superclubs (Cream, Ministry of Sound, etc.) that have been the norm in Britain since the late 1990s. As a 2002 *Guardian* article explains, *School Disco.com* revels unashamedly in

1980s pop hits and is marked by its refusal to 'educate the crowd' and to buy in to the chic, drug-inspired asexuality of the superclub. Instead, as the article notes, *School Disco.com* 'plays *Careless Whisper* and encourages people to snog'. See Alexis Petridis, 'Boys and girls come out to play', *Guardian Unlimited* (5 July 2002), www.guardian.co.uk/Friday_review/story/0,3605,749046,00.html (19 August 2002).

48 Advertisement for Redemption, *Empire* (April 1993), p. 105; and Tom Dewe Matthews, 'And I'd also like to thank the censors', *Independent Review* (14 April 2000), p. 12. Also see *Salvation Films: Cult DVD and Video*, www.salvation-films.com (30 July 2002); and *Anchor Bay Entertainment UK*, www.anchorbay.co.uk (30 July 2002). Salvation distribute titles by cult horror directors such as Pete Walker, Jean Rollin, Roman Polanski and David Cronenberg, as well as nasty titles such as *Bloodbath, Killer Nun* and *Night of the Bloody Apes.* As well as the factors listed above, Salvation differ from Vipco in their more overt political stance (their website has a banner which reads 'smash censorship') and their international scope (they have subsidiary distribution labels set up in the USA, Australia and in mainland Europe). See advertisement for Redemption, *Sight and Sound*, 5:4 (1995), 65.

49 Hawkins, *Cutting Edge*, p. 22–3.

50 Slater, 'Flesh eating mother', p. 9.

51 Advertisement for *The Driller Killer*, p. 69; and video sleeve for *Zombie Flesh Eaters, Vipco's Vault of Horror* website.

52 By contrast, the *Guardian* highlighted this association in its short review of Vipco's re-release version of the title, where it notes that *Cannibal Holocaust* is a 'notoriously gruesome but not brainless horror – on which *Blair Witch* was modelled'. Review of *Cannibal Holocaust, Guardian: The Guide* (27 October 2001), p. 21.

53 Taken from a quote from Derek Mann of the Video Trade Association from Julian Petley's article on the post-VRA video industry. Here, Mann is arguing that 'the image of some shops hasn't changed one iota since the bad old days'. Petley, 'The video', 25.

54 Samuel, *Theatres of Memory*, p. 93. This notion that retro or 'stylised nostalgia' can either construct the past as authentic or can play with the past for 'comic effect' is also asserted by Paul Grainge. As he argues, 'nostalgia has been taken up within different kinds of taste regime; it has become a style value in representations of the past that are hybrid, ironic and playful, and that, alternatively, summon and stage a particular idea of the authentic'. Grainge, *Monochrome*, p. 57. As he goes on to note, both approaches 'have evolved within, and are in some sense a response to, the cultural exigencies of postmod-

ernism'. As noted in chapter 5, this is something which is particularly marked in the case of the nasties, which are often compared favourably, by fans, to post-modern horror films such as *Scream* and *Urban Legend*.

55 Mendik, 'Introductory commentary'. Notably, after discussing the historical significance of the marketing campaign and the film's status as a nasty, Mendik then chooses to distance the film from its connections with the video nasty era (distinguishing it from other nasty titles by virtue of its artistry and its status as a 'disturbing study of urban psychosis'). What this suggests is how polarised contemporary perceptions of nasty titles have become – while distributors emphasise a title's connections to the era for commercial benefit, academics establish this connection only in order to then negate and sever it, so that a particular title can be artistically reappraised.

56 This notion of the nasty marketing image as familiar is in marked contrast to their status in the pre-VRA market, where, as noted in chapter 2, due to the fact that access to particular exploitation traditions had been blocked in Britain prior to this time, much of the impact of the nasty sleeves was due to the fact that they appeared unfamiliar, new and exotic.

57 Holmes, 'Let there be blood', p. 12.

58 Bakewell, *Taboo*.

59 Samuel, *Theatres of Memory*, p. 92.

60 'Discovering *Evil Dead*'.

61 See, for instance, Chris Hewitt, review of *The Evil Dead*, *Empire* (October 2001), p. 131; and Ben Walters, review of *The Evil Dead*, *Sight and Sound*, 12:5 (2002), 59.

62 Video sleeve and interactive menus for *The Driller Killer*, DVD.

63 See advertisement for *Zombie Creeping Flesh*; and advertisement for *Zombie Flesh Eaters 2*.

64 Samuel, *Theatres of Memory*, p. 95.

65 See Slater, 'Flesh eating mother', p. 9.

66 Wingrove and Morris (eds), *The Art*, p. 20.

67 'Process for packaging – VPRC', *British Board of Film Classification*, www.bbfc.co.uk/website/Customers...ation/ProcessPackagingVPRC ?OpenDocument (30 July 2002).

68 Indeed, within the context of the current 1980s nostalgia boom, the nasties now seem to be treated as if they are as cheesy, dated or kitsch as Duran Duran or *The A-Team*. For instance, the 2001 BBC nostalgia show *I Love 1984* devoted a five-minute spot to the nasties, where British celebrities reminisced about renting them from the local video shop. *I Love 1984*, BBC2, 17 February 2001. Such contemporary approaches to the nasty era seem to stand as firm evidence that, for some, the nasties have become, as Kerekes and Slater put it, 'the cine-

matic equivalent of disco'. David Kerekes and David Slater, *See No Evil: Banned Films and Video Controversy* (Manchester: Headpress, 2000), p. 365.

69 For instance, see advertisement for *Shogun Assassin*, *Cannibal Holocaust*, DVD, Vipco, 2001; and advertisement for *Mountain of the Cannibal God*, *Cannibal Holocaust*, DVD, Vipco, 2001.

70 See the Go cover in Wingrove and Morris (eds), *The Art*, p. 18. The Vipco *Cannibal Holocaust* video sleeve was accessed from *Vipco's Vault of Horror* website. The Vipco re-release sleeves also appear to have adopted another convention from such trailers, the recounting of the entire plot of a film (conveyed in the trailers in a visual form, and on the re-release sleeves in a verbal form) where large chunks of text describe the plot of a particular title and emphasise its most gory, violent or sexually explicit moments in a dramatic and bombastic way.

71 Samuel, *Theatres of Memory*, p. 95.

72 Grainge, *Monochrome*, p. 59. Grainge is here talking specifically about the contemporary use of black and white, which, for him, has become a 'a nostalgia mode where the (representational) content of the past ... [is] often less significant than ... [its] (nonrepresentational) feeling of pastness'. What am I trying to do here is to make similar claims about the use of a historically-vague exploitation style in nasty re-release marketing, a style which, like Grainge's black and white image, appears to be 'disposable' and 'one of many stylistic codes that appear and disappear in the commercial and cultural sphere'.

73 Kim Newman, review of *The Driller Killer*, *Empire* (July 1999), p. 119; Richard Callaghan, 'IMDb user comments for *The Driller Killer*' (14 April 2000), *Internet Movie Database*, http://us.imdb.com /CommentsShow?0079082 (9 August 2004); and Hewitt, review of *The Evil Dead*, p. 131.

74 Hawkins, *Cutting Edge*, p. 47.

75 The phrases 'penny-pinching' and 'substandard' are borrowed from the *Dark Side* re-release reviews of *Zombie Creeping Flesh* and *Zombie Flesh Eaters 2*, where the reviewer (*The Dark Side*'s editor, Allan Bryce) breaks into a rant about Vipco. Allan Bryce, 'DVD video library', *The Dark Side: The Magazine of the Macabre and Fantastic* (June–July 2002), p. 36.

76 Neil Jackson, 'Cutting for England', *Sight and Sound*, 12:5 (2002), 64.

77 Bubblezz, 'Re: I can understand but ...' (5 July 2002), *The Realm of Horror Discussion Forum*, http://disc.server.com/discussion.cgi?id =126992&article=7140&date_query=1025904533 (30 July 2002); CJ, 'Zombie creeping Bruno' (10 August 2001), *The Realm of Horror*

Discussion Forum, http://disc.server.com/discussion,cgi?id=126992 &article=2934&date_query997540380 (28 August 2001); and CJ, 'No offence guys but …' (11 August 2001), *The Realm of Horror Discussion Forum*, http://disc.server.com/discussion.cgi?id126992 &article=2959&date_query=997833238 (20 August 2001).

78 Bakewell, *Taboo*; and Steve Rose, 'In the realm of the censors', *Guardian: The Guide* (28 October 2000), p. 6. This 'cheapness' also relates back to notions of the anachronistic and authentic, in the sense that 'cheapness' could also suggest that a company is traditional, that it has a 'no frills' approach. See Samuel, *Theatres of Memory*, pp. 105–7, for a further discussion of retrochic's use of notions of the traditional.

79 Bryce, 'DVD video library', pp. 36–7.

80 An illustration of how other video companies override the cheap and cheerful production values of nasty titles by giving them a 'digital makeover' is provided by Michael Felsher in the Anchor Bay *Evil Dead* collector's booklet which accompanied its 2002 Special Edition re-release. After recounting the history of *The Evil Dead*'s re-master-ing on laserdisc and DVD, Felsher notes that 'it can't help but be a little ironic that more money has been spent on re-mastering and re-releasing this film for home video than was ever spent to make the damn movie in the first place'. Michael Felsher, 'Bringing the dead home for dinner: a history of *The Evil Dead* in your home', collector's booklet, *The Evil Dead*, Full Uncut Special Edition DVD, Anchor Bay Entertainment, 2002, p. 18.

81 The terms 'digital makeover' and 'polish a turd' are borrowed from Bryce, 'DVD video library', p. 36.

82 This awareness of Vipco's past and continued infamy is something that is apparent in both the DVD and the Film Four introductions to *Driller Killer*, where Xavier Mendik and Mark Kermode name-check Vipco as the mastermind behind the infamous original *Driller Killer* campaign. See Mendik, 'Introductory commentary'; and Mark Kermode, Introduction to *The Driller Killer*, Channel Four, 2 April 2000. In addition, the sense that particular parties seem to revel in Vipco's dependable 'badness' (a 'badness' which seems to give Vipco a distinct sense of personality) was frequently conveyed on the *Dark Angel's Realm of Horror* website, where fans and collectors often attempted to guess how bad and inadequate certain forthcoming Vipco releases would be.

83 Marshall, 'Return', p. 38; and review of *City of the Living Dead*, SFX (December 2001), p. 100.

84 1988 BBFC report, cited in Petley, 'The video', 25.

85 Samuel, *Theatres of Memory*, p. 91.

86 Advertisement for HMV: *Zombie Flesh Eaters*, reproduced in Martin,

The Seduction, p. 177; and 'About Vipco'. Interestingly, this pun is also used in the 2002 advertisement for the British re-release of *Straw Dogs*, where it is noted that the film has been 'banned for 18 years' but is 'now unleashed uncut!' Advertisement for *Straw Dogs*, *Sight and Sound*, 12:11 (2002), 27. The use of these puns seem to have replaced techniques employed for the initial re-releases of the nasty titles in the 1990s, where banners reading 'at last its legal' and 'not guilty!' were frequently used. See advertisement for *Contamination*, reproduced in Kerekes and Slater, *See No Evil*, p. 120; and advertisement for *The Evil Dead*, reproduced in Martin, *The Seduction*, p. 177.

87 Advertisement for *The Driller Killer*, p. 69; Marshall, 'Return', p. 38; and Kerekes and Slater, *See No Evil*, p. 406.

88 Schaefer, *'Bold! Daring! Shocking! True!'*, p. 14.

89 Legend taken from the Vipco website, which reads 'we present for your enjoyment the all-time rogues gallery of video greats'. 'About Vipco'.

Low or high? Film Four, film festivals and the nasties

In a 2001 *Sight and Sound* special issue on the limits of film censor-
ship in the new millennium, prolific British film critic Mark
Kermode chose to focus on the strange case of *The Last House on
the Left* – one of the few of the more infamous video nasty titles to,
at that point in time, still not have been recertified and re-released
in Britain, either at the cinema or on video. For him, while the
British Board of Film Classification (BBFC) may have trumpeted
their increasingly liberal attitude to censorship, their treatment of
Last House illustrated that an inherent prejudice towards art-
house and foreign language titles remained a hidden part of their
criteria for certifying films. Thus, while such foreign language (and
implicitly 'art-house') titles as *Salo, Baise-moi, Romance* and *Ai
No Corrida* had passed through the new more liberal post-1997
BBFC[1] either uncut or with a minimum of alterations, the British
distribution of Wes Craven's *The Last House on the Left* was still
blocked due to a BBFC demand for heavy cuts, despite the fact that
it dealt with 'similarly controversial themes' as *Baise-Moi* or
Romance. For Kermode, what this highlighted was the 'random-
ness' of BBFC decisions regarding 'graphic depictions of sexual
violence',[2] a randomness which *Last House*'s potential British
distributor – in a follow-up letter in *Sight and Sound* – termed a
clear sign of 'middle-class elitism'.[3]

 What Kermode clearly wanted to illustrate here was how little
had changed in British film censorship circles since the early 1980s,
in the sense that (as far as *Last House* was concerned) the valorisa-
tion of 'art' over 'entertainment' that had determined the fate of the
nasties still appeared to be in place, allowing the BBFC to police the
boundary between what was considered culturally acceptable and

unacceptable in contemporary Britain. Indeed, on the basis of this article, an attack on the BBFC's valorisation of 'art' over 'entertainment' appears to remain the most effective way for anti-censorship critics like Kermode to condemn the decisions of the British censors and argue against the rejection of versions of particular contentious films. However, if the continued existence of this legal bias towards 'art' has given Kermode and others a clear line of attack, through which they can argue against the decisions of censors on particular horror titles, the means by which these critics redeem or defend the titles in question appears to be a much more slippery issue. In the course of Kermode's article on *Last House*, for instance, the film is termed, in opposition to the arthouse fare that he cites, as an 'English-language film', a 'mainstream' film and 'a 70s slasher classic' (terms which therefore clearly associate the film with notions of the commercial and the mainstream).[4] Furthermore, in the follow-up letter in *Sight and Sound*, *Last House*'s potential distributor, David Flint of Exploited Films, underscores his claim that BBFC decisions are based around 'middle-class elitism' by arguing that 'the BBFC clearly believes that a film which might have a wide appeal to the great unwashed is more likely to "deprave and corrupt" than a foreign-language "arthouse" film which will be primarily seen by earnest middle-class intellectuals much like themselves'.[5]

However, if this suggests that a defence of *Last House* is being built around the idea that the film is a mainstream commercial title, with the potential to attract a mass audience (and therefore, in line with Richard Maltby's arguments,[6] that the BBFC is demonstrating their 'elitism' by militating against mainstream 'entertainment' titles aimed at a mass and, implicitly, working-class audience), then other factors complicate this considerably. Most predominantly, while Flint is claiming here that *Last House*'s potential theatrical redistribution would be targeted at a mass audience and promoted as a film with 'wide appeal', then this is contradicted by Kermode, who argues that the film needs to be released uncut as it would otherwise be 'virtually unmarketable to the completist horror aficionados who constitute its core audience'.[7]

What these different discursive framings of *Last House* suggest is that attempts to counter the BBFC's valorisation of 'art' over 'entertainment' are not as easy or straightforward as they might seem, and that, while films that need to be defended will often be

slotted into the category of oppressed mainstream entertainment (in order for pro-censorship battles and arguments about 'elitism' to be won), the objects under scrutiny will often then be shifted onto different cultural terrain in order to be redeemed and reappraised. Specifically, as the above examples suggest, such embattled films will often be reframed as titles which will primarily be appreciated by, and are explicitly aimed at, discerning or specialist audiences of, in Kermode's terms, 'aficionados' (a label which, arguably, assists in re-categorising these films as alternative titles with niche appeal).

Thus, in cases like this, where anti-censorship arguments need to be effective but vilified films also need to be culturally redeemed, anti-censorship critics are often forced to construct fluid and contradictory arguments: attacking the censors by claiming that they are biased towards low (or mass) culture, but, at the same time, attempting to reinscribe a particular film's cultural value by highlighting its specialist status and appeal to 'aficionados'.[8] However, in turn, what this also suggests is that, in order for these strategies to be effective, the vilified film itself must be considered culturally 'low' enough to be held up as an example of the censor's prejudice, but also hold the potential to be reappraised as having artistic and cultural worth.

This potential for culturally 'fluid' objects to be used to rhetorically counter the seemingly still prevalent British valorisation of 'art' over 'entertainment' (by being seen, in different contexts, as both 'low' or 'high', and thus unable to be straightforwardly categorised within this restrictive framework) will thus be the focus of this final chapter, and will be examined through the contemporary British exhibition, and concurrent re-evaluation, of a number of nasty titles. Firstly, the chapter will consider the extent to which some of the nasty titles (and previously banned films in general) can be seen as ripe for reconfiguration as fluid films in a later period of their existence, holding the potential to be constituted, in different circumstances, as 'low' or 'high' and thus defying clearcut cultural categorisation as 'art' or 'entertainment'. Secondly, however, it will then attempt to explore the ways in which this reconfiguration (constituted, at least in this case, within the realms of an anti-censorship argument) feeds into the remarketing of these previously banned titles to specialist audiences via specific niche exhibition venues (venues which target similar types of audiences

as those that read *Sight and Sound* and whose reputation and image are, in turn, affected by their association with these titles). Finally, this chapter will consider how this reframing of the nasties, in relation to both their prior censorship history and their contemporary exhibition in these venues, impacts on the ways in which they are discussed and reappraised, both within screening programme notes and related publicity materials and in the *Guardian*, the *Independent* and *Time Out* – three publications that, arguably, also target themselves at this same specialist audience.

The overall aim will be to explore the extent to which the accumulated cultural reputation of the nasties has contributed to the process through which a particular group of horror titles, previously constituted as commercial, mass objects in their prior existence on British video, have been reframed as films which, in Barbara Klinger's terms, are considered as 'part of enlightened culture, edifying for an urban cognoscente, rather than as simply entertainment for the average moviegoer'.[9]

The cultural permeability of the nasties and their reconstitution as fluid films

In a 2001 issue of the specialist film magazine *Total Film*, an article on films that had been (or continue to be) 'banned' in Britain runs through the now familiar pantheon of the key films in British censorship history.[10] When stepping back from this list, it is clear that the films can (broadly) be separated into two categories – the horror film (*Texas Chainsaw Massacre*, *The Driller Killer*, *The Exorcist*, *Peeping Tom*, *Freaks* and *Straw Dogs*) and the art film (*Battleship Potemkin*, *Salo*, *Crash*, *Ai No Corrida*, *The Devils* and *A Clockwork Orange*). However, on a second glance, some of these categories seem to blur: *The Devils* and *A Clockwork Orange* have both been categorised, by some commentators, as landmark British horror or sci-fi,[11] and both *Peeping Tom* and *Freaks* are films that, while initially promoted as exploitation or mainstream horror, are now more likely to be shown, in both the US and Britain, at a repertory film theatre, film festival or art-house cinema.

What this pantheon therefore seems to indicate, in terms of the titles listed and the different ways in which they can be categorised,

is that the history of British critical outlawing and banning of particular titles has caused a range of horror and art films to be, retrospectively, grouped together in a way that makes them seem almost interchangeable. This retrospective grouping of a range of contentious film titles into a new cultural category has a clear relation to arguments posited in Joan Hawkins' book *Cutting Edge*, and in particular to her analysis of the re-categorisation of film titles in specialist mail-order video catalogues in the US. For Hawkins, the listing of films in such catalogues, where (as in the *Total Film* pantheon) art-house titles and horror and exploitation films are grouped together, clearly demonstrates that 'the sacralization of performance culture (its division into high and low art) never completely took root among art and horror/sleaze/exploitation film fans'.[12]

One of the primary reasons Hawkins gives for this lack of 'division' is the hybrid nature of the texts themselves, as films that mix conventions of the horror/exploitation genre with art cinema devices and, notably, two of the films that she cites as sharing this hybrid textual quality are *Freaks* and *Peeping Tom*. However, it is also notable that her discussion of these two particular examples of hybrid art/horror titles also draws on issues relating to the films' critical reception (and the way in which they were, and have been, critically and commercially framed). In the case of *Freaks*, this is discussed in terms of the film's initial existence as a badly-received MGM horror film, which was then leased out to the exploitation circuit and then revived thirty years later as an art film, and in the case of *Peeping Tom*, in terms of the fact that it was a critically reviled film which was then 'shown in art houses as well as in horror venues', as well as being 'frequently taught ... in university courses treating the history of British cinema'.[13]

What this therefore seems to suggest is that while these films' hybrid qualities may have originated in the context of their production, they have been considerably enhanced during the course of the history of their critical reception and exhibition in different venues through time. Furthermore, as *Peeping Tom* and *Freaks*' reappearance in *Total Film*'s pantheon suggests, these hybrid associations are also undoubtedly informed by censorship and other regulatory activities which restrict the free circulation of particular films, a factor which Hawkins clearly alludes to when she argues that:

the routine cutting of European and Asian horror films to meet U.S. standards, the difficulty over copyright, and the decision not to make certain films available to a mass-market audience all have contributed to creating a consuming public whose tastes are not served by the 'pure' marketplace of mainstream video and film distribution companies. Video chain stores such as Blockbuster, which limit themselves to serving a mainstream audience, have necessitated the creation of ... an unsacrilized cultural space, a space where high art and low/fringe cultural products are grouped together.[14]

Thus it is often the rejection of a film (in terms of governmental or commercial regulatory policy) or its dismissal by mainstream markets (which, in Hawkins' argument, is represented by Blockbuster Video) that often serves as a primary reason why a film comes to circulate in an 'unsacrilized cultural space' populated by both 'high' art and 'low' horror. For it appears to be here (at the point where films are legally or commercially rejected) where a particular marginalised title is brought into the 'unsacrilized' realm, is reconstituted as a film of niche appeal and is retargeted at a 'consuming public whose tastes are not served by the "pure" marketplace' of mainstream video or film consumption. When taken as a whole, what these processes therefore illustrate is that films that have been banned or rejected are often ripe for reconstitution in different (or hybrid) generic categories, and also ripe to be given new cultural meanings.

However, if this demonstrates that the censorship history of a particular film can serve as a key criterion for propelling a film into a new specialist marketplace, it is also true that other historical factors can play influential roles in this process. In the case of some of the nasty titles, which, as earlier chapters have demonstrated, were films that were made in different national contexts and as part of different film-making traditions, particular initial production, reception and exhibition circumstances could also be seen to have assisted in determining whether, and how, they would later be reappraised. While I will go on to discuss this further later in the chapter, it is worth noting here that a number of the nasty titles *did* emerge in Britain on video with a range of cultural meanings already attached to them (some which had a relationship to art or specialist film cultures and some to trash and exploitation). On the one hand, three of the nasty titles (*The Evil Dead*, *Death Trap* and *Possession*) were originally premiered in Britain at the London

Film Festival, while *The Last House on the Left* was widely known to be a remake of Ingmar Bergman's *The Virgin Spring* and (despite its lack of theatrical certificate at the time) was shown in 1982 at a horror retrospective at the British Film Institute-affiliated National Film Theatre (NFT). However, on the other hand, a number of these films had been exhibited in both drive-in circuits and midnight movie screenings in repertory theatres in the US and, as nasty directors Wes Craven and Sam Raimi have acknowledged,[15] were made explicitly to be consumed as drive-in or exploitation fodder. What this range of cultural associations therefore suggests is that a number of these films may have, originally, possessed meanings (culled both from production circumstances and initial British forms of exhibition) which already placed them in a commercial and cultural grey area 'where high art and low/fringe cultural products are grouped together', and which therefore may, potentially, have already imbued these titles with an ambiguous and fluid cultural status prior to their identity as nasties.

Thus, in line with Hawkins' arguments, it is the fact that a number of the nasty titles had an ambiguous status as films that had been exhibited in both art cinemas and grindhouse theatres, coupled with their official rejection from the British cultural land-scape in the early 1980s as a particularly malevolent strain of mass, crass popular culture, that assisted in making them the fluid films that anti-censorship campaigners needed, to both criticise the prej-udices of the censors and, in turn, to defend and reappraise the films as marginal texts with art-house credentials that deserved respect. In turn, the inherent cultural fluidity of some of the nasty titles also made them ripe for re-categorisation and reappraisal in newspaper articles and via a number of specialist exhibition outlets, while also, crucially, assisting in solidifying the image of certain niche exhibitors and specific cinematic events as offering 'something different' for the discerning viewer.

Framing a film through a censorship filter: the importance of the nasties to the niche exhibitor

Outside of their re-release on DVD and video (discussed, at length, in the previous chapter), a number of original nasty titles have been publicly exhibited in Britain in two types of exhibition venue since their banning in the mid-1980s – in a number of urban art cinemas

and at film festivals (most notably *Last House on the Left*, which was toured by its would-be distributor, Exploited, around regional cinemas and film festivals throughout 2000), and on the terrestrial British television channel, Channel Four and its satellite off-shoot, Film Four (which, at the time of writing, has screened cut versions of *The Driller Killer* and *Tenebrae*, and uncut versions of *The Evil Dead* and *Blood Feast*). For Julian Stringer, the relationship between film festivals and the films they screen is clearly reciprocal, with the image and meaning of the festival and the screened film simultaneously affecting each other. As he argues:

> part of the job of a film festival is to provide participants and outside observers with frames of reference for the titles being exhibited. While these frames of reference generate interest in, knowledge about, and appreciation of this or that particular movie, they just as importantly work to promote the perceived uniqueness of an event's own festival image ... The way in which festival titles are selected, presented to a public, and talked about says as much about the status and purpose of a specific event as it does the individual films chosen to make up that event's screening schedule.[16]

While Stringer restricts this observation to a discussion of specific exhibition practices at film festivals, it can also, arguably, be applied to the way in which film titles are framed and brand images are solidified in art cinemas and on Channel Four and Film Four (most markedly, in the sense that these screenings are invariably accompanied, like in film festivals, by such framing devices as programme notes, pre-screening talks or promotional newspaper articles).

A focus on Channel Four and Film Four perhaps allows for the clearest illustration of how screening nasty or other previously banned titles can benefit a media brand image or the status of a type of exhibition venue (or at least compliment and strengthen a pre-existent image). Indeed, Channel Four had a number of clear cultural links to the nasties from the moment of its inception. Not only did the channel commence its broadcasting at the height of the video boom in Britain (and thus, in some ways, is as clearly tied up with memories of the cultural climate of early Thatcherite Britain as the nasties and video in general were), but it also screened a high-profile documentary on the nasties controversy in June 1983 (*A Gentleman's Agreement*, part of their provocative documentary series *Broadside*) which was postponed due to complaints from

moral campaigner Mary Whitehouse, who considered the showing of clips from particular nasty titles as being in breach of the Obscene Publications Act (OPA).

Indeed, if the nasties thrived (in their early British existence) on the commercial life-blood of controversy and moral panic, then Channel Four clearly adopted a less extreme, but related, commercial approach where, as *Sight and Sound* note, 'being in trouble with the regulatory authorities' was an initial 'badge of honour' for the channel.[17] In some respects, this early image of Channel Four as a contentious, and often highly political, alternative to the more mainstream British terrestrial channels (as well as its status as a mouthpiece for marginal groups and ethnic minorities)[18] has been maintained into the new century, but, as a 2000 *Sight and Sound* piece on the channel argues, its image has also begun to evolve in order to meet the need to adapt to, and distinguish itself from, the proliferation of media options available in Britain from the 1990s and onwards. As a result, as the *Sight and Sound* piece also acknowledges, Channel Four has, in the last fifteen years, begun to recognise that 'in the contemporary marketplace brand is everything', adapting to competition from competing media by solidifying its reputation, its target audience and thus its brand name, and becoming 'the choice and voice of a younger, urban, better-educated audience'.[19]

If this approach is clearly at work on Channel Four, then it is perhaps even more marked on the channel's satellite offshoot, Film Four, which, from its inception, was marketed as a televisual art cinema venue. Thus, in a promotional launch booklet published, tellingly, as a pull-out in the urban listings magazine *Time Out*, Nick Bradshaw argued for the necessity of the channel, in light of the fact that 'a skeleton network of regional arts cinemas are the only remaining provision against the monopoly of new Hollywood product'.[20] This clear acknowledgement that Film Four wanted to replicate (or even replace) the British regional art-house exhibition venue is also conveyed via a number of other promotional strategies (strategies which link the channel up to both art-house screenings of nasty titles that were occurring at the same time, and to the effect the nasties' reputation – and the cluster of meanings around them – had on both kinds of exhibition venue). Briefly, these strategies can be defined as follows (although they are all clearly inter-related and can serve to strengthen each other):

1. The aim to oppose, or work as an alternative to (as the above *Time Out* quote clearly conveys), the more prevalent exhibitors of multiplex film product or, as a Film Four advertisement terms it, 'Hollywood fluff'.[21]
2. The concurrent aim to thus offer 'something different'[22] to the 'younger, urban, better-educated' audience which they were targeting (a factor that is clearly apparent in Film Four's primary advertising slogan of the time, 'great films you know, great films you don't').
3. The aim to maintain and perpetuate (through this niche image) the parent channel's image as a political and controversial broadcaster, which took an interventionist approach to the screening of films and television programmes, by using such screenings to challenge regulatory policies relating to television and the cinema.
4. The aim to maintain an image of exclusivity, which was largely promoted through Film Four's insistence that, where possible, all films should be screened 'uncut, uninterrupted and broadcast in widescreen, as films should be'.[23]

Firstly, what these promotional strategies illustrate is the extent to which Film Four placed itself, from the outset, on the same cultural terrain as had traditionally been occupied, since the post-war era, by the art-house cinema venue. As Barbara Wilinsky argues, in her book-length study of the emergence of post-war art-house venues in the US, art-houses had traditionally used the marketing strategy of 'sensationalism' to attract an audience who, in Charles Teitel's words, 'wanted to see something unusual, something different'.[24] For Wilinsky, this audience had primarily been generated and constituted by such post-war social and cultural factors as 'the increasing number of people getting a higher level of education, the rising incomes and number of leisure hours of many workers, and the growing diversity of leisure options'[25] (thus making this audience appear, in some ways, to be an earlier, embryonic version of Film Four's media savvy, young, educated and urban target market).

While Wilinsky posits 'sensationalism' (usually in terms of sex) as being the key means used to attract this discerning audience (and to market screened films as exclusive), it is also clear that actual or potential censorship could also be highlighted in promotional

strategies in order to frame a screened film's status as exclusive, controversial and (to once again employ Klinger's terms) as something that was therefore part of 'enlightened culture' for an 'urban cognoscente'. Indeed, as Steve Neale points out in his article on the emergence of art cinema as an exhibition institution (and its relationship with such classic censorship *cause célèbres* as *Battleship Potemkin*):

> the development of film clubs and *cine-clubs* in the 1920s – the exhibition basis for the subsequent emergence of Art Cinema as a distinct sector within the cinematic institution – was due in large part to censorship restrictions on the showing of films from the Soviet Union. The Soviet films themselves became the models for notions of film as art and the fact that they were subject to political censorship meant that they could only be shown in private members' clubs ... [This, amongst other factors,] set the seal on the construction of Art Cinema as a cinematic space distinct from that of the mainstream cinema of entertainment.[26]

Thus, if Neale's argument is taken into account, it is often censorship or restriction that plays a key role in: 1) determining which films circulate in the alternative space of the niche exhibition venue (whether private cinema club, art-house cinema or niche film channel); 2) solidifying and emphasising the status of such venues as being 'distinct from that of the mainstream cinema of entertainment', and therefore further promoting the sense that a particular exhibition venue is alternative and exclusive; and 3) enabling this venue to target a particular audience demographic who are discerning and are looking for 'something different'. Following on from this, the nasty titles' potential to contribute to this idea of the art-house exhibition venue as 'adventurous', 'innovative' and 'a little bit different' should be evident[27] (considering that the nasties are modern equivalents of the Soviet films that Neale cites, in the sense that they have a cluster of meanings surrounding them which are associated with their censorship history).

Indeed, when looking at programme notes and promotional material produced to frame contemporary screenings of nasty titles, it is clear that such screenings are often promoted in this way in order to strengthen or solidify the niche appeal of a particular exhibitor. To return to my earlier list of promotional strategies, it is clear that in order to disassociate these exhibition sites from connotations of 'Hollywood fluff' and to thus attract the discerning

audience, three particular qualities of these screenings are frequently invoked: firstly, that the screening is tied up with a wider challenge to the British establishment (mainly to the government, BBFC and other regulatory authorities), secondly, that the screening is exclusive, and thirdly (and related to this), that it is often uncut.

In terms of challenging regulatory authorities, a number of contemporary showings of nasty titles in art cinemas and, as Klinger puts it, in 'institutions associated with public intellectual life'[28] clearly and carefully frame such showings with talks and debates on the wider implications of film censorship. For instance, in a November 2000 season at the Institute of Contemporary Arts (ICA) (which, interestingly, was co-organised with Film Four), screenings of uncut versions of The Evil Dead and The Last House on the Left were accompanied by a debate on film censorship, which allowed, in the ICA director Philip Dodd's words, Film Four to 'set the new agenda' on this issue and to, in turn, strengthen their 'branding strategy – which foregrounds ... an "Extreme Cinema" strand scheduling past censorship cause celebres'.[29] In addition, the 2001 Bradford Film Festival screening of The Last House on the Left (part of a season called 'Craven images: a debate on censorship in the 21st century') was accompanied by a public discussion with the BBFC director at the time, Robin Duval; while a five-day screening of The Last House on the Left at the Cube Cinema, Bristol in November 2000 was framed by a discussion set up to discuss the film's British classification problems (with the discussion panel including key British censorship critics Mark Kermode and Julian Petley, a BBFC representative and members of the distribution team from Exploited Films).

However, if these discussion panels helped to frame particular screenings of nasty titles, and thus served to strengthen the controversial and interventionist image of the exhibitor concerned, other even more direct approaches (where the exhibitor could be seen to become more directly, and thus politically, involved in issues surrounding the recertification of a particular title) further assisted in consolidating this image. For instance, when The Evil Dead premiered uncut on Film Four in November 2001, articles written by Mark Kermode, appearing prior to the screening in the Independent and on the Film Four website, framed the film clearly in terms of its British censorship history (its prosecutions under the

OPA, its later status as a nasty and so on), and then noted that *The Evil Dead*'s uncut premiere was 'thanks to the efforts of Film Four's unsung movie maestro and all-round screening room hero Adam Roberts, who has steered this once-banned masterpiece through a refreshingly open-minded encounter with the British Board of Film Classification'.[30]

Arguably, this declaration presents Film Four as not just a passive vehicle for the public screening of films, but also as a vital mediator figure between censors, distributors and the films themselves, working to protect a film for the benefit of their discerning film-loving viewers, British film culture and civil liberties in general and, through this, foregrounding the channel's uncompromising approach to the screening of films. If this way of framing *The Evil Dead*'s passage on to Film Four is one example of this, then an even more distinctive example of this discursive approach occurs in the promotional materials which accompanied Exploited films' theatrical tour of *The Last House on the Left* in 2000 and 2001 (which took in a number of British regional art cinemas, as well as the Bradford Film Festival, the Edinburgh Film Festival and the aforementioned ICA event). For, while the tour was clearly designed to increase *Last House*'s public profile, it was also framed within an ongoing campaign to get the film recertified and passed uncut by the BBFC – a campaign which, while of clear benefit to Exploited and the film itself, also held the potential to positively affect the image of the exhibition venue concerned.

Thus, while the information pack produced to compliment *Last House*'s screening at the Phoenix, Leicester includes a range of essays on the film's cultural and artistic importance (essays that I will return to later in the chapter), it also includes a piece on British film censorship in general, which notes in particular that 'courtesy of your local Council, Leicester adults can now watch *Last House on the Left*'.[31] Furthermore, this statement is also reiterated in an enclosed statement from the Phoenix's head of cinema, who notes that 'it is therefore commendable that the members of Leicester City Council's Licensing Committee agreed to pass the film for public viewing in May 2000 on the basis that it is not for the self-appointed "guardians" of public morality to pass judgement – it is a right that belongs to the people. It is *your* right'.[32] While the primary aim of these comments is, undoubtedly, to highlight the benefits of local film classification boards (and rightly celebrates

the potential for local councils to override BBFC decisions), such comments also, whether intentionally or otherwise, assist in further highlighting the exhibition venue's role as a vital mediator figure between distributor and audience, who works to get a contentious film on to British screens for the benefit of the venue's valued patrons.

In addition, and as established earlier, a focus on issues of film censorship also benefits the cultural image of an exhibition venue in another way, which relates to the perceived exclusivity of a particular screening of a nasty or other previously banned title. One example of this is Bradford Film Festival's decision to call their 2001 censorship season 'Craven images', an approach which foregrounds the fact that the screening of Craven's *Last House* is the main 'draw' of the event, which is also clearly conveyed by the highlighting of the film's previous status as a nasty in the programme notes to both the film and Robin Duval's accompanying talk.[33] However, perhaps a more explicit example of this approach occurs in Leicester Phoenix's aforementioned information pack, which, while providing information on *Last House* and *Texas Chainsaw Massacre*, again explicitly highlights the screening of *Last House* as the main 'draw' and the 'jewel in the crown' of the event. In addition, a still of *Last House* with a red 'banned' logo below it adorns the front of the pack, while inside the pack Head of Cinema, Alan Smith, emphasises the historic and exclusive nature of the screening by thanking his patrons for 'making history' and stressing that 'the movie has been viewed under club conditions and via imported video but don't be fooled by cheap imitations: our uncut 35mm version of Wes Craven's notorious 70s shocker has never before been shown to anyone in Britain who simply bought an ordinary cinema ticket, sat down and watched the film'.[34]

What is interesting here is not only the emphasis on the exclusive and historic nature of the screening, but also the special nature of the event (in the sense that no-one in Britain who has bought an 'ordinary cinema ticket' has had this experience or seen this version of the film before). Indeed, this idea of a film being viewed in special conditions (and therefore that the event's audience is, in some ways, privileged) is something which is also conveyed in The Cube Cinema's programme notes for their five-night run of screenings of *Last House*. As it notes, 'remember, the film is still banned

in the UK, both theatrically and on video. We can show the film only because we are a membership cinema. Watch *Last House on the Left* and decide for yourself whether the BBFC are right to protect us mere mortals'.[35]

While, clearly, this statement has been primarily designed as a legal disclaimer (in order to protect the cinema from any legal intervention), it also appears, at the same time, to emphasise the venue's uncompromising attitude to the screening of films and, crucially, the privileged and special nature of the event itself (in the sense that The Cube can only screen the film because it is a 'membership cinema'). However, as suggested by the above quotation from the Phoenix pack, a large part of this exclusivity and specialness can be conveyed not just through an emphasis on the exclusive conditions of the screening (its status as a 'one-off') but also via an emphasis on the fact that the screened film is uncut.

For, to allude again to Smith's aforementioned quote, these venues, quite rightly, never aim to screen 'cheap imitations' but carefully treated, complete original prints of the films concerned. Indeed, if Andrew Syder can argue, in a 2000 article on the nasties, that British horror fans and collectors have engaged in an ongoing cultural battle with the BBFC over '"scarred" texts' – either 'BBFC-approved cassettes [which] have been cut and censored' or 'poorer quality bootlegs, often featuring foreign language subtitles from a tape's country of origin'[36] – then the exclusivity of the showings of nasty titles held at the Phoenix, the Cube or the Bradford Film Festival can be seen to be heavily distinguished by the fact that they are publicly screening precious and completely 'unscarred' celluloid versions of these films, which, due to their lack of previous public circulation in Britain, have been protected from the ravages of censorship and re-circulation around unofficial video trading networks.

Indeed, as stated earlier, this emphasis on the importance of presenting films as they 'should be' seen is also key to the image of Film Four. For instance, in an introduction to a screening of *Texas Chainsaw Massacre* in November 2000 (broadcast simultaneously on Film Four and Channel Four), Mark Kermode notes that 'these intros are a taster of the kind of special treatment films get on the Film Four channel. Every effort is made to broadcast films as the director intended, correct ratio with original language, and, wherever possible, uncut'.[37] Here, as with the earlier quote, the

emphasis is on the 'special treatment' that films receive, which, in turn, allows the channel to present itself as a televisual archive, where complete, original theatrical versions of particular, mistreated films are preserved and then screened for the viewer who can then 'decide for themselves' (an idea that is emphasised not only in the above quoted Cube brochure, but in a whole range of promotional materials for Film Four screenings).

What all these discursive strategies therefore illustrate is the extent to which the nasty titles can assist in conveying this sense of specialness and exclusivity whenever they are screened in British exhibition sites. Indeed, the fact that the nasties were films whose legitimate circulation had been stymied in Britain (causing them to be reconstituted as 'something different' from those films circulated by 'mainstream video and film distribution companies') made them perhaps the perfect raw material through which to promote this sense of a special unique cinematic event, organised by an adventurous and uncompromising exhibitor.

However, if these exhibition venues primarily promoted these screenings as experiences where the opportunity to 'decide for yourself' was given to audience members, this was counteracted by other frames of reference which were constructed around the screening of the film itself. Arguably, and whether intentionally or otherwise, these frames encouraged audiences to view these films in a highly mediated way – a way which, in marked contrast to the unmediated viewing of a nasty title on video, emphasised how the film should be appreciated, and which therefore held the potential to impact on the cultural meaning of the film screened as equally as it impacted on the cultural image of the niche exhibitor. The final section of this chapter will go on to discuss these other frames of reference, and to assess the extent to which they contribute to the re-inscription of the meanings, attributes and appeal of these titles to a niche audience of well-educated urban viewers.

Picking them apart and putting them back together: the British reappraisal of the nasty titles

As Barbara Klinger argues in her analysis of the critical reappraisal of Douglas Sirk films in the late 1970s and 1980s, 'the growth of exhibition site as archive clearly aided the critical rewriting of past products of the film industry'.[38] As the last section of the chapter

illustrated, the niche exhibitor's need to distinguish itself as unique and exclusive was often tied up with promoting the 'special treatment' that they gave to particular films – films that could be promoted as precious and scarce through their status as uncut films that were no 'cheap imitations' but were pure, unscarred texts. In this respect, such niche exhibition venues as the Phoenix, Bradford Film Festival, The Cube and Film Four could also be seen to operate as 'archives' of old, lost versions of critically dismissed cultural products, functioning in the same way as MOMA or Carnegie Hall did during the 1970s American reappraisal of Sirk's films. However, as Klinger's analysis also suggests, if niche exhibition sites wanted to promote themselves in this way, then they also needed to justify the cultural and artistic worth of the films concerned, and thus the necessity of preserving them and giving them 'special treatment'.

In Alan Smith's aforementioned statement in the Leicester Phoenix information pack, this was simply because both *Texas Chainsaw Massacre* and *Last House on the Left* were 'indisputably' two works of 'art'.[39] However, when this defence of some of the nasty titles as works of art is elaborated upon in other discussions, a number of trends emerge which appear to relate to both the perceived British valorisation of 'art' over 'entertainment' and, more markedly, to the supposed cultural hybridity of the films concerned.

In terms of the first factor, a number of promotional introductions to nasty screenings have clearly attempted to culturally reframe a nasty title by highlighting its art-house influences or associations. For instance, Xavier Mendik (in his essay on *Last House* in the Phoenix pack) argues that 'although it would be convenient to locate *Last House on the Left* as beyond the boundaries of acceptable mainstream cinema of the era, it is important to note that the fictional basis for the film came from the respected art cinema template of Ingmar Bergman's *Virgin Spring*';[40] while Mark Kermode, in his introduction to the Film Four/Channel Four screening of *Driller Killer*, notes that the film 'owes more … to Warhol than it does to any slice and dice tradition' and that 'it's tough viewing, but hardly the stuff of the traditional nasty'.[41] In both these cases, then, a discursive process of cultural re-evaluation and re-categorisation is clearly at work. For while both films are initially presented as culturally notorious due to their censorship

history and status as nasty (a cultural association which enables the exhibition venue to present itself as interventionist and politically committed, as well as highlighting the exclusivity of the screening of such films), they are then often distinguished from the 'traditional nasty' (a nebulous 'other' of nasty titles which deserve the label) and, via this distinction, are then redeemed as important and artistic works.

Through this process of re-categorisation, then, a clear cultural hierarchy of nasty titles begins to be established, allowing certain nasty titles to still be associated with the video nasties phenomenon, but then moved to the top of the nasty pantheon by being distanced from this association and linked up to other cultural figures or meanings (whether Andy Warhol, Ingmar Bergman or other legitimate, highbrow cultural associations). Another, particularly illuminating, example of this revisionist approach to nasty titles occurs in a 1999 *Guardian* article by Kim Newman, which celebrated the video re-release of *The Driller Killer*. Beginning by, once again, contrasting the 'nebulous' body of nasty titles to the title that he wishes to redeem and reappraise, Newman argues that 'many video nasties were made by unknown Americans who got together to churn out *Mardi Gras Massacre* or *Don't Go in the Woods*, then disappeared for ever. *The Driller Killer*, however, was an early film from a man who has subsequently had a maverick but undeniably important career (he's even had an NFT season)'.[42]

Here, Newman clearly adopts this revisionist approach by allowing Abel Ferrara's subsequent career and critical success to act as primary justification for looking at this nasty title in a new light. In addition, and crucially, Newman uses a niche exhibition venue (the NFT) as a particularly effective cultural reference point, suggesting that it is Ferrara's association with this art-house venue that further justifies the cultural legitimisation of *Driller Killer*. Indeed, the implicit logic underlying Newman's comment is that if Ferrara has had 'a maverick but undeniably important career', then, by default, *Driller Killer* is a 'maverick but undeniably important' cultural artefact (and, indeed, it is noteworthy that *Driller Killer*'s screening on Film Four was also framed within a promotion for a whole season of Ferrara films).

Indeed, if the aim here is to redeem *Driller Killer* from its cultural association with the nasties, then it is clear that mobilising an auteurist argument is a particularly effective means of distinguish-

ing nasty titles from a nebulous body of related but lesser works (clearly confirming Klinger's argument that 'creating value for objects of mass culture in the public sector [relies] ... as much as academia [does] ... on establishing the aesthetic worth of their authors').[43] For such an approach allows titles like *Driller Killer* to be detached from one particular frame of reference (where it is judged and viewed in the light of being a banned and vilified film), and slotted into another (where the title could be appreciated as part of a body of work by a maverick auteur, thus allowing the film's artistic credentials to be recognised). Indeed, it is notable that the nasty titles which have been screened most consistently in niche exhibition venues are those which hold the most potential to be reframed in relation to the subsequent careers of their directors (in particular *Last House* and *The Evil Dead*, whose directors, Wes Craven and Sam Raimi, have continued to be prolific, and who are often perceived as key auteurs in the field of modern horror).

However, while references to a director's subsequent career, to specific niche exhibition venues, or to the art-house influences of the film concerned were all key strategies employed by critics in order to culturally redeem particular nasties, another, more multi-faceted strategy is also evident in some of these promotional and critical materials. In line with my earlier discussion of Hawkins' arguments, this distinct revisionist strategy appears to centre around a reattachment of nasty titles to their original non-British contexts of production and reception, with this, in turn, allowing particular titles to be reconstituted as hybrid works – elusive and unable to be straightforwardly categorised as either 'art' or 'entertainment'.

For instance, during the course of their reappraisals of, respectively, *Driller Killer* and *Last House*, Newman and Mendik both clearly attempt to disassociate the films from the context of the 1980s (where the films, in the British context, had been re-categorised as nasty), and to relocate them in the context of their original American production in the 1970s. Thus, for Newman, *Driller Killer* was, ultimately, 'an artifact of its time' which 'captures exactly a moment in [New York's] ... punk movement',[44] while for Mendik, *Last House* was a film of political, social and cultural worth, which made 'a serious comment on the insanity and unrestrained violence' of the 1970s, commenting on Vietnam and the Manson murders and hooking up with the domi-

nant thematic concerns of the 1970s American horror film (with Mendik using the work of Robin Wood to elaborate on this).[45]

The discursive strategy adopted by both critics here, then, appears designed emphatically to remove these films from their British categorisation as nasty, and to re-highlight, for a British audience, their cultural meaning and value as American films, which could primarily be understood and appreciated in relation to the predominant themes and changing modes of American horror and underground film production in the 1970s. However, this re-contextualisation of nasty titles by British critics also allows them to reactivate the 'hybrid' qualities of these films as works which mesh art film devices and exploitation/horror conventions. Thus, for Newman, Ferrara had made a career out of 'straddling art and exploitation', for Mendik, *Last House* 'transcends the otherwise exploitative label of "rape and revenge movie" to become a crucial index of the troubled American imagination of the era', and for Kermode, in a piece in *Time Out*, *Last House* could be seen to have a 'schizophrenic tone'.[46] In addition, in The Cube notes on *Last House*, emphasis is placed on 'Craven's cold, flat style of film-making', while also foregrounding the film's original exploitation-inspired marketing image and tagline 'to avoid fainting keep repeating, it's only a movie'.[47]

Indeed, the idea that these films are cold and flat in their aesthetic style or thematic tone (or, as Mendik argues, the idea that they are characterised by moral ambiguity) is perhaps the key means through which their status as hybrid texts can be re-realised. And, arguably, it is this hybrid quality which enables critics to demonstrate that these films can't be categorised straightforwardly as just 'art' or 'entertainment', and allows the portrayal of these films as *meshing* 'art' and 'entertainment' to present them, instead, as fluid and able to transcend (and break out of) the 'low' cultural category of the nasties (a category which, implicitly, they are seen to have been restricted by).

A slightly alternative take on this approach, which meshes 'art' and 'entertainment' in a different way, is to accept that a film is inherently trashy (and that it can, perhaps in the context of a new millennium, appear silly and dated),[48] but in a way that redeems this as part of the film's cultural appeal and which then enables the film and the film-maker in question to be reconstituted as culturally and artistically significant. In two retrospective articles

published in the *Guardian*, for instance, Herschell Gordon Lewis and Jesus Franco are presented as directors who have made key exploitation milestones, but, in the British context, whose work and renown has been blocked by British censorship restrictions. This cultural reframing of Lewis and Franco then allows both articles to argue that their films' initial status as notorious 'trash' has blocked a British cultural appreciation of the films' refreshing bad taste and ironic black humour, and to present both directors as undiscovered auteurs who have key highbrow cultural credentials (Lewis having written a number of academic books on marketing, and Franco being an upper-middle-class film-maker with a highbrow education, who had previously worked with Orson Welles).[49]

These discursive strategies seem to correlate, crucially, with Jeffrey Sconce's study of paracinematic audience cultures, where, as Sconce argues, an appreciation of trash films and directors is often informed by elite approaches to art cinema. Within such cultures, as in the *Guardian* articles discussed above, ironic reading strategies are employed in order to realise a particular trash title's cultural value, and directors are frequently reconstituted as eccentric maverick auteurs, with both approaches gradually allowing for a 'retrospective reconstruction of an avant garde through the ironic engagement of exploitation cinema's history'.[50] However, while this approach to trash cinema is, undoubtedly, something that should be applauded and celebrated (in the sense that it allows previously derided and dismissed films to be reappraised as fluid texts, which can be appreciated on a number of levels), it can also, arguably and conversely, reconstitute these films as exclusive, niche cultural artefacts, which, for Sconce, can then allow for 'a hierarchy of "skilled" and "unskilled" audiences' to become re-established[51] – loosely divided into those who can appreciate the 'trash' and ironic qualities of a particular film title and the eccentric characteristics of the films' directors, and those who can't. For, to return to Kermode's argument about 'horror aficionados', these revisionist discourses (in all their manifestations) appear heavily dependent on the idea of an exclusive niche audience who can appreciate a nasty title on a particular level (whether in terms of its horror conventions or its ironic qualities), defined against those who can't. For instance, as Kermode argues in his *Independent* piece on the screening of *The Evil Dead* on Film Four, 'it's a terrif-

ic film for horror aficionados who recognise in Raimi's feature debut a satirical homage to the traditions of *The Three Stooges*, with blood and guts standing in for custard pies. But for those less au fait with the conventions of the modern horror genre, *The Evil Dead* can seem an overwhelmingly unpleasant affair – hence the censorship problems'.[52]

What comments like these seem to illustrate, then, is that the process of redeeming and reconstituting nasty titles as fluid texts frequently, and inadvertently, becomes dependent on the idea that these films are an acquired taste, whose appeal can only be accessed and appreciated by a select few (the 'skilled' audience) who have the requisite cultural savvy required to decode the texts concerned. On one level, this savvy is based on whether an audience member is an ageing horror fan, *au fait* with the historical twists and turns of British exploitation exhibition culture (an argument which Newman also adopts by arguing that an appreciation of *Driller Killer* is often based around whether a viewer has frequented 'places that have gone with the 1980s', including the urban midnight movie venue, the Scala).[53] On another level, however (and in line with Sconce), the re-evaluation of some of the nasty titles as culturally significant is also, arguably, based around traditional discourses of elite art cinema, where audience members are required to have the necessary 'cultural capital' to enable them to appreciate a nasty title's irony, to have knowledge about the production processes of 1960s and 1970s exploitation filmmaking, or to be familiar with the filmic oeuvre of the exploitation director concerned.

Conclusion: the nasty as art-house product

Ultimately, then, the critical reappraisals of the nasty titles discussed above hold the potential to close off the British cultural appeal of these films as quickly as they pick it apart, open it up and make these films appear refreshingly fluid, multi-faceted and accessible. As James Naremore argues, in relation to film noir (another critically reconstituted and culturally fluid filmic category), 'media critics have always defended certain types of ostensibly disreputable, formulaic thrillers by appealing to their moral ambiguity and their lack of bourgeois sentimentality or "high-mindedness", and such a defense is valuable to the movie industry because it

enhances the films' crossover potential, allowing them to play at the higher end of the market'.[54]

What such discursive strategies therefore seem to suggest is that the nasty titles are continuing to be put to use for the purposes of cultural distinction in Britain, re-emerging in the theatrical public sector, but now as predominantly 'high' rather than 'low' cultural products. For while these films are carefully, and valuably, reframed by critics as pieces of maverick art, their reconstituted fluid qualities then enable them to be re-promoted as art-house product for groups of targeted (predominantly middle-class) niche audiences. If Bourdieu can argue that art objects (or objects imbued with connotations of art) can become financially valuable over longer periods of time,[55] then the continued British cultural significance of the nasty titles (like Tod Browning's *Freaks*, earlier in the twentieth century) now seems increasingly intertwined with their alternative, artistic and hybrid appeal, with a stress on these qualities allowing them to be reconstituted as films designed for urban audiences and art cinema venues.

Notes

1 From late 1997, the image of the BBFC changed considerably. A new president (Andreas Whittam-Smith) and new director (Robin Duval) were appointed and, subsequently, the board began to promote its new openness and accountability to the public, embarking on public roadshows around Britain and, in quick succession, recertifying and re-releasing such classic British censorship milestones as *The Exorcist* and *The Texas Chainsaw Massacre*. See Steve Rose, 'In the realm of the censors', *Guardian: The Guide* (28 October 2000), pp. 4–6; and Alan Travis, 'Going out with a bang', *Guardian Friday Review* (15 March 2002), p. 9.

2 Mark Kermode, 'Left on the shelf', *Sight and Sound*, 11:7 (2001), 26.

3 David Flint, 'Beyond exploitation', *Sight and Sound*, 11:8 (2001), 64.

4 Kermode, 'Left on the shelf', p. 26.

5 Flint, 'Beyond exploitation', p. 64.

6 See Richard Maltby, '"D" for disgusting: American culture and English criticism', in Geoffrey Nowell-Smith and Steven Ricci (eds), *Hollywood and Europe: Economics, Culture, National Identity: 1945–95* (London: British Film Institute, 1998), p. 106.

7 Kermode, 'Left on the shelf', p. 26.

8 Indeed, if a *Sight and Sound* piece on Ray Brady's *Boy Meets Girl* is taken into consideration, it can be seen that, in different circum-

stances, anti-censorship arguments involving the BBFC's attitude to 'art' and 'entertainment' are, on occasions, reversed. In this particular *Sight and Sound* piece, the BBFC is seen as treating big studio pictures, such as *Natural Born Killers*, with 'kid-gloves' while 'specialist fare', such as Brady's film, are blocked and refused certification. See 'The business', *Sight and Sound*, 4:12 (1994), 4.

9 Barbara Klinger, *Melodrama and Meaning: History, Culture, and the Films of Douglas Sirk* (Bloomington and Indianapolis: Indiana University Press, 1994), p. 84.

10 See Richard Luck, Mark Salisbury, Cam Winstanley and Jonathan Wright, '*Total Film* presents banned', *Total Film* (November 2001), pp. 49–64.

11 See, for instance, the entries for *A Clockwork Orange* and *The Devils* in Harvey Fenton and David Flint (eds), *Ten Years of Terror: British Horror Films of the 1970s* (Surrey: FAB Press, 2001), pp. 95–7 and pp. 118–20.

12 Joan Hawkins, *Cutting Edge: Art-horror and the Horrific Avant-garde* (Minneapolis: University of Minnesota Press, 2000), p. 12.

13 *Ibid.*, pp. 25–6.

14 *Ibid.*, p. 11.

15 See David A. Szulkin, *Wes Craven's Last House on the Left: The Making of a Cult Classic* (Surrey: FAB Press, 2nd edn, 2000); and '*The Evil Dead* film notes', *Filmfour.com*, www.filmfour.com /filmReview/filmReview_filmNotes.jsp?id=16784 (22 May 2002).

16 Julian Stringer, 'Regarding film festivals', PhD dissertation, Indiana University, 2003, pp. 136–7.

17 'The shock of the new', *Sight and Sound*, 9:4 (1999), 33.

18 For a further discussion of the cultural politics that underpinned Channel Four's inception, see Sylvia Harvey, 'Channel Four television: from Annan to Grade', in Edward Buscombe (ed.), *British Television: A Reader* (Oxford: Oxford University Press, 2000), pp. 92–117.

19 Ray Cathode, 'In praise of dirty washing', *Sight and Sound*, 10:11 (2000), 9.

20 Nick Bradshaw, 'Land of hope and glory?', *Time Out Guide to Film Four* (28 October–4 November 1998), p. 7.

21 Advertisement for Film Four, *Time Out Guide to Film Four* (28 October–4 November 1998), pp. 22–3.

22 Hawkins, *Cutting Edge*, p. 23.

23 Advertisement for Film Four, pp. 22–3.

24 Charles Teitel, cited in Barbara Wilinsky, *Sure Seaters: The Emergence of Art House Cinema* (Minnesota: University of Minnesota Press, 2001), p. 93.

25 *Ibid.*, p. 103.

26 Steve Neale, 'Art cinema as institution', *Screen*, 22:1 (1981), 30–1.

27 These are all terms that are used on the websites for two regional art cinemas that screened *The Last House on the Left* – Phoenix Arts, Leicester and The Prince Charles Cinema, London. See 'Hiring the cinema', *Prince Charles Cinema*, http://208.231.27.30:2600/html/hire.htm (14 May 2002); and 'Welcome to Phoenix Arts', *Phoenix Arts, Leicester City Centre Cinema*, www.phoenix.org.uk/main.asp (14 May 2002).

28 Klinger, *Melodrama*, p. 84.

29 Richard Falcon, 'How far can we go?', *Sight and Sound*, 11:1 (2001), 8.

30 Mark Kermode, 'The return of *The Evil Dead*', *Filmfour.com*, www.filmfour.com/banned/banned_update_evil_dead_old.jsp (14 May 2002).

31 Dave Godin, 'The problem with film censorship', *'Last Chainsaw on the Left': A 70s Horror Show at Phoenix Arts*, Screening information pack, Phoenix Arts, Leicester (25 June 2000), p. 1.

32 Alan Alderson Smith, 'Last chainsaw on the left', *'Last Chainsaw on the Left': A 70s Horror Show at Phoenix Arts*, Screening Information Pack, Phoenix Arts, Leicester (25 June 2000).

33 Bradford Film Festival 2001 programme, National Museum of Photography, Film and Television, Bradford, 1–17 March 2001, pp. 26 and 53.

34 Alderson Smith, 'Last chainsaw on the left'.

35 The Cube programme, The Cube Cinema, Bristol (October 2000).

36 Andrew Syder, 'Policing the home: "video nasties" and nasty videos', in Sarah Matheson (ed.), *Changing Channels: New Directions in Television Studies*, Special issue of *Spectator: The University of Southern California Journal of Film and Television*, 20:2 (2000), 96.

37 Mark Kermode, Introduction to *Texas Chainsaw Massacre*, Channel Four (28 October 2000). It is notable that, while *Texas Chainsaw Massacre* was broadcast simultaneously on both Film Four and Channel Four as a 'taster' of the 'special treatment' that the channel gives to film texts, an earlier 'taster' evening on both channels had included the British premiere of *The Driller Killer* in a cut form but with previously unseen footage restored, indicating quite clearly how the channel sought to associate itself with nasty and other banned titles.

38 Klinger, *Melodrama*, p. 84.

39 Alderson Smith, 'Last chainsaw on the left'.

40 Xavier Mendik, 'The politics of (family) violence in "*Last House on the Left*"', *'Last Chainsaw on the Left': A 70s Horror Show at Phoenix Arts*, Screening information pack, Phoenix Arts, Leicester

(25 June 2000), p. 2.

41 Kermode, Introduction to *Texas Chainsaw Massacre*.

42 Kim Newman, 'You know the drill', *Guardian Unlimited* (14 April 1999), http://film.guardian.co.uk/Feature_Story/Guardian/0,,42307,00.html (3 August 2004).

43 Klinger, *Melodrama*, p. 91.

44 Newman, 'You know the drill'.

45 Mendik, 'The politics of (family) violence', pp. 1–2.

46 Newman, 'You know the drill'; Mendik, 'The politics of (family) violence', p. 1; and Mark Kermode, review of *The Last House on the Left*, *Time Out* (7–14 June 2000), p. 83.

47 The Cube programme.

48 In particular, see the Film Four site's discussion of *The Evil Dead*, where it is argued that 'given that the film was made for a tiny budget and took three years to make, it was never going to be great cinema'. '*The Evil Dead* film notes'.

49 See Will Hodgkinson, 'Sympathy for the devil', *Guardian Unlimited* (29 June 2000), www.guardianunlimited.co.uk/Archive/Article/0,4273,4034783,00.html (11 July 2002); and Phelim O'Neill, 'Blood brother', *Guardian: The Guide* (28 July 2001), pp. 12–13.

50 Jeffrey Sconce, '"Trashing" the academy: taste, excess, and an emerging politics of cinematic style', *Screen*, 36:4 (1995), 392.

51 *Ibid.*, p. 392.

52 Mark Kermode, 'The end of the world as we know it?' *Independent Friday Review* (23 November 2001), p. 12.

53 Newman, 'You know the drill'.

54 James Naremore, *More Than Night: Film Noir in Its Contexts* (California: California University Press, 1998), p. 163.

55 Pierre Bourdieu, cited in Wilinsky, *Sure Seaters*, p. 87.

Conclusion: the nasties, British film culture and cross-cultural reception

In his chapter on 'The cultural biography of things', Igor Kopytoff notes that 'biographies of things can make salient what might otherwise remain obscure ... that what is significant about the adoption of alien objects – as of alien ideas – is not the fact that they are adopted, but the way they are culturally redefined and put to use'.[1] Britain, in the early 1980s, was a culture poised to react to the invasion of such an 'alien object' or 'alien idea' – the commencement of video (as a technology, a consumable and a consumption experience) and the concurrent consumer boom that accompanied it.

The official British response was to impose new regulatory frameworks and restrictions on this potentially burgeoning, global, and thus alien, consumer phenomenon, restrictions which, as chapter 3 argued, were clearly designed to reinforce the primacy of national and specific notions of culture over universal notions of the consumer and the ever-expanding range of products in the consumer market. The result, of course, was the coining of the term 'video nasty' and the introduction and implementation of the 1984 Video Recordings Act (VRA).

What this occurrence clearly illustrates is the tendency for any complex, modern society to continuously categorise and impose notions of order, hierarchy and restriction over ever-expanding occurrences of commodification in the modern world. For, as Kopytoff notes:

> new technological advances ... open previously closed areas to the possibilities of exchange and these areas tend to become quickly commoditized. The flattening of values that follows commoditization and the inability of the collective culture of a modern society to cope

with this flatness frustrate the individual on the one hand, and, on the other, leaves ample room for a multitude of classifications by individuals and ... groups.[2]

However, what should be remembered here is that while this initial British re-imposition of cultural order and regulation was achieved through a fundamental ejection of an alien cultural 'other', which was identified and named as the video nasties, this inevitably meant that, from the outset, the video nasties was established and constituted as a fundamentally British notion and term. For, as Andrew Higson argues, a concrete conception of national identity can only be achieved or maintained when 'a process of inclusion and exclusion is enacted, a process whereby one thing is centralised, at the same time necessarily marginalising another'.[3]

If this argument is taken into consideration, then the 'thing' that is named and suppressed is thus always, implicitly, a by-product, and an inherent part, of such attempts to concretise and define national identity. By naming the nasties and by making them a concrete and identifiable category, they were therefore always clearly attached to, and dependent on, the British culture that had rejected them, and were thus always, fundamentally, a British entity and a British idea. As Nigel Wingrove argues, in his introduction to *The Art of the Nasty*, by making the nasties 'a definable creature with the sole aim of creating and perpetuating evil', they became 'as far as the United Kingdom is concerned, part of our collective psyche'.[4] In this sense, exploring how an alien object like video is 'culturally redefined and put to use' can help to reveal the dominant political and cultural characteristics and preoccupations of a specific national culture at a particular point in time. It can also, however, help to chart how dominant notions of what constitutes a national culture can change *through time*.

Within the realms of this book, this has been tracked and analysed in two specific ways. Firstly, while the 'flattening' of cultural values caused by the initial explosion of video in Britain, and its rapid commodification, was then countered through a subsequent imposition of new forms of national regulation (through the implementation of the VRA), this restriction can be seen to have caused new forms of cultural 'flatness' which then led to further re-categorisations by cultural or commercially-orientated groups. Thus, in the second and third sections of this book, further forms of cultural re-categorisation were seen to have been

enacted in response to this new level of cultural 'flatness' – firstly by fans and collectors who created new distribution networks and new forms of subcultural value for the nasties, and then by British re-release distributors and exhibitors who created further cultural categories and forms of commercial value.

Secondly, what clearly underpins all of these subsequent re-evaluations of the nasties are a series of different, and increasingly more complex, methods of consumption and appreciation. Among nasty fans and collectors, a focus on the reconstitution of the value of the nasties as rare and valuable video collectibles and on the construction of new entrepreneurial distribution networks for the nasties were both clearly at work; amongst British re-release distributors and exhibitors, an emphasis was placed on the potential to reconstitute the nasties as niche specialist products through notions of history and exclusivity; and, amongst both fans and re-release distributors, a clear emphasis was placed on the formal appearance of the nasty videos and their original marketing and advertising images.

Crucially, all of these specific forms of redistribution, consumption and re-evaluation (constituted in reaction to cultural 'flatness' caused by the initial reorganisation of the video industry and the suppression of the nasties) can be seen to be emblematic of two cultural phenomena. On a wider level, such cultural practices and approaches can all be identified as characteristics of contemporary material culture and modern consumption in complex and heavily commodified societies. Indeed, many of the approaches named above mirror some of the key tendencies that Celia Lury identifies as characteristic of such societies, including 'the increasing visibility of different forms of shopping', the 'increase in sites for purchase and consumption', 'the increasing emphasis on the style, design and appearance of goods', 'the manipulation of time and space in the simulation of "elsewheres" and "elsewhens" to promote products', and 'the interest in the personal and collective collection, cataloguing and display of material goods'.[5]

What a charting of the changing British cultural and commercial approaches to the nasties has helped to illustrate and explore, then, is the tendency in specific, heavily commodified societies and cultures to react against the 'flatness' caused by cultural restriction *and* the subsequent further heavy commodification of other new technological areas (such as DVD, the internet and other digital

technologies), by continuously classifying and reclassifying more outmoded commodities with particular, seemingly more authentic and meaningful, uses and meanings. As Kopytoff argues, 'there is clearly a yearning for singularization in complex societies',[6] which the nasties' British re-inscription and re-categorisation through time seems to clearly illustrate.

However, on a more nationally specific level, all of the cultural responses to the nasties' initial banning named above appear to cohere with dominant cultural and commercial strategies and concepts widely championed during, and heavily attached to, the nasties' initial cultural moment of Thatcherite Britain in the early 1980s (from strategies of commercial entrepreneurship and niche marketing, to an emphasis on the material appearance and design of goods, and notions of commercial heritage and nostalgia).[7] In this sense, while the predominant cultural and commercial concerns of this period in British history clearly underpinned the official ejection of the nasties from British society, they also, paradoxically, assisted in generating a number of cultural concepts and strategies through which the nasties would later be re-categorised, re-evaluated and re-appropriated.

What all these cultural links seem to illustrate, then, is the extent to which a historical reception study of a particular cultural category not only illuminates the many struggles of the specific individuals, groups and institutions that use it, manage it and give it meaning, but also reveal the impact of past and changing commercial and cultural trends and practices prevalent in the culture and society within which the category's discursive history takes place. For, while all the specific commercial and cultural discourses formed around the nasties by specific groups and institutions can be seen to oppose and conflict against each other, they can all, arguably, be conceptualised as responses to an increasingly globalised and technological cultural landscape. Indeed, all the groups and institutions analysed in this book not only construct their own specific cultural discourses around the nasties, but also construct their own traditions and meaningful spaces, which can, potentially, counter the ever-expanding globalised, denationalised media marketplace.

For the press campaigners in part I of the book, the meaningful space of the parlour and the meaningful tradition of harmless childhood consumption and story-swapping are constructed,

protected and adhered to, while for the fans and collectors of part II, the early 1980s video shop is the totem-like space and the renting of original versions of video nasties is the romanticised legacy and tradition.

Many reactions to the nasties (whether negative or positive) can therefore be seen to be informed by the need to construct an authentic tradition which can act as a counterpoint to the complex and ever-evolving environment of the contemporary marketplace, where cultural traditions always have the potential to be lost or buried. By constructing worlds that exist in the past, or worlds that appear intimate, authentic, or culturally and historically-specific or unique, such groups are therefore constantly able to redefine and reclaim a culturally meaningful, authentic world which can act as a buttress against the ever-evolving world of the public and, implicitly, of the global.

In many instances in parts II and III of this book, this approach can be seen to have been constituted through challenges to a hegemonic national identity, where alternative British consumption practices and cultural traditions were constantly re-inscribed and where notions of the centre and the margins of the national were constantly switched around. In particular, a number of groups analysed in the book clearly use conceptions of the local (of local businesses, of local consumption spaces or of local art-house screenings and local councils) to challenge cultural regulation and other censorship restrictions, and thus to challenge dominant conceptions of national cultural identity and its traditions. It is in all of these respects, then, that this book has attempted to explore how the nasties (an 'alien object' and an 'alien idea') have been 'culturally redefined and put to use' in a specific national culture, through time.[8]

In a now classic 1989 article in the media journal *Screen*, Andrew Higson called for a new methodological and theoretical conception of national cinema and national film culture. He argued that 'to explore national cinemas ... means laying much greater stress on the point of consumption, and on the *use* of films ... than on the point of production ... an analysis of how actual audiences construct their cultural identity in relation to the various products of the national and international film and television industries, and the conditions under which this is achieved'.[9]

This book posits a commitment to this approach, and its under-

pinning assertion that a focus on a film's cross-cultural distribution, reception, censorship and consumption can allow historical struggles over national identity and their relation to changing conceptions of national film culture to be productively mapped and excavated. It is in this respect that this book has not only attempted to explore the reception history of the nasties, but, consequently, to also offer up this history as an illuminating case study of the nationally-specific discourses generated by cross-cultural film reception – discourses which, as the preceding chapters have indicated, are consistently informed by changing notions of what constitutes accepted British cultural traditions and experiences, and which a consistent focus on the historical materials generated by distribution, exhibition, reception and consumption can help to bring to light.

However, while this wide-ranging methodological focus has enabled the historical and 'cumulative'[10] impact of such nationally-influenced cultural discourses to be explored, it has also, in some respects and as Lury argues, 'constrain[ed]' a deeper analysis of, and a exclusive focus on, 'more short-term, specific and intimate trajectories'.[11]

Most prominently, and due to my findings being constrained by the limited amount of historical materials that I have been able to analyse within the confines of a much more historically wide-ranging piece of reception research, my exploration of the demographics of early British horror video renters and contemporary nasty collectors has remained small-scale and tentative (in terms of not only age and gender, but also, crucially, of class). For while such factors have begun to be sketched (through discussions of collated evidence which point to the prevalent age and gender demographics of veteran nasty fans and collectors), researching the *class* demographics of such renters remains a task which lies beyond the bounds of this book, but which would clearly be an extremely illuminating area to explore at further length, in the sense that issues of class quite clearly permeated the original video nasty governmental and press campaigns and, as argued in chapter 8, also seemed to implicitly inform the ways in which the nasties have recently been re-evaluated by British critics.

Indeed, considering that Martin Barker has argued that the targets of British moral panics around violent or controversial media tend to almost exclusively be 'young, working class

males',[12] it would be interesting to explore to what extent this holds true in the case of actual video nasty renters, collectors and fans (or, indeed, of fans of other previously banned materials), or whether, alternatively, such class assumptions derive, largely, from the perceptions and constructions of renters and fans generated by official, press and governmental discourse. This connection is something that could be explored fruitfully at further length (either through historical reception or audience research), allowing, potentially, a more 'intimate', 'specific', but still inherently nationally-informed, history of horror, film censorship and video culture to be filled in, extended and historically and socially developed.

Notes

1 Igor Kopytoff, 'The cultural biography of things: commoditization as process', in Arjun Appadurai (ed.), *The Social Life of Things: Commodities in Cultural Perspective* (Cambridge: Cambridge University Press, 1986), p. 67.
2 *Ibid.*, p. 88.
3 Andrew Higson, 'The concept of national cinema', *Screen*, 30:4 (1989), 44.
4 Nigel Wingrove, 'The nasties: a personal view', in Nigel Wingrove and Marc Morris (eds), *The Art of the Nasty* (London: Salvation Films, 1998), p. 10.
5 Celia Lury, *Consumer Culture* (Cambridge: Polity Press, 1996), pp. 29–36.
6 Kopytoff, 'The cultural biography of things', p. 80.
7 See, for instance, Don Slater, *Consumer Culture and Modernity* (Oxford: Polity Press, 1997), pp. 10–11; and John Corner and Sylvia Harvey, 'Mediating tradition and modernity: the heritage/enterprise couplet', in John Corner and Sylvia Harvey (eds), *Enterprise and Heritage: Crosscurrents of National Culture* (London: Routledge, 1991), pp. 45–75.
8 Kopytoff, 'The cultural biography', p. 67.
9 Higson, 'The concept of national cinema', pp. 45–6.
10 Charles J. Maland, cited in Robert E. Kapsis, *Hitchcock: The Making of a Reputation* (Chicago: University of Chicago Press, 1992), p. 9.
11 Lury, *Consumer Culture*, p. 19.
12 Martin Barker, 'Film audience research: making a virtue out of a necessity', *Iris*, 26 (1998), 138.

Select bibliography

Altman, Rick, *Film/Genre* (London: British Film Institute, 1999).

Andrews, Nigel, 'Nightmares and nasties', in Martin Barker (ed.), *The Video Nasties: Freedom and Censorship in the Media* (London: Pluto Press, 1984), pp. 39–47.

Appadurai, Arjun, 'Commodities and the politics of value', in Susan M. Pearce (ed.), *Interpreting Objects and Collections* (London: Routledge, 1994), pp. 76–91.

Austin, Thomas, *Hollywood, Hype and Audiences: Selling and Watching Popular Film in the 1990s* (Manchester: Manchester University Press, 2002).

Barker, Martin, 'Film audience research: making a virtue out of a necessity', *Iris*, 26 (1998), 131–47.

Barker, Martin, *A Haunt of Fears: The Strange History of the British Horror Comics Campaign* (London: Pluto Press, 1984).

Barker, Martin, 'Introduction', in Martin Barker (ed.), *The Video Nasties: Freedom and Censorship in the Media* (London: Pluto Press, 1984), pp. 1–6.

Barker, Martin, '"Nasties": a problem of identification', in Martin Barker (ed.), *The Video Nasties: Freedom and Censorship in the Media* (London: Pluto Press, 1984), pp. 104–18.

Barker, Martin, 'Nasty politics or video nasties?', in Martin Barker (ed.), *The Video Nasties: Freedom and Censorship in the Media* (London: Pluto Press, 1984), pp. 7–38.

Barr, Charles, '*Straw Dogs*, *A Clockwork Orange* and the Critics', *Screen*, 13:2 (1972), 17–31.

Bassett, Caroline, 'Virtually gendered: life in an on-line world', in Ken Gelder and Sarah Thornton (eds), *The Subcultures Reader* (London and New York: Routledge, 1997), pp. 537–50.

Baudrillard, Jean, 'The system of collecting', trans. Roger Cardinal, in John Elsner and Roger Cardinal (eds), *The Cultures of Collecting* (London: Reaktion Books, 1994), pp. 7–24.

Benjamin, Walter, 'Unpacking my library: a talk about book collecting', in Hannah Arendt (ed.), *Illuminations*, trans. Harry Zohn (London: Fontana Press, 1992), pp. 61–9.

Bennett, Tony and Janet Woollacott, *Bond and Beyond: The Political Career of a Popular Hero* (London: Macmillan, 1987).

Bjarkman, Kim, 'To have and to hold: the video collector's relationship with an ethereal medium', *Television and New Media*, 5:3 (2004), 217–46.

Bolin, Goran, 'Film swapping in the public sphere: youth audiences and alternative cultural publicities', *Javnost: The Public*, 7:2 (2000), 57–73.

Bourdieu, Pierre, *Distinction: A Social Critique of the Judgement of Taste*, trans. Richard Nice (London: Routledge, 1984).

Brewster, Francis, Harvey Fenton and Marc Morris (eds), *Shock! Horror! Astounding Artwork from the Video Nasty Era* (Surrey: FAB Press, 2005).

Brottman, Mikita, *Offensive Films: Toward an Anthropology of Cinema Vomitif* (Westport: Greenwood Press, 1997).

Bryce, Allan (ed.), *Video Nasties!* (Cornwall: Stray Cat Publishing, 1998).

Budd, Mike, 'The moments of *Caligari*', in Mike Budd (ed.), *The Cabinet of Dr. Caligari: Texts, Contexts, Histories* (New Brunswick and London: Rutgers University Press, 1990), pp. 7–119.

Cherry, Brigid, 'Refusing to refuse to look: female viewers of the horror film', in Melvyn Stokes and Richard Maltby (eds), *Identifying Hollywood's Audiences: Cultural Identity and the Movies* (London: British Film Institute, 1999), pp. 187–203.

Cherry, Brigid, 'Screaming for release: femininity and horror film fandom in Britain', in Steve Chibnall and Julian Petley (eds), *British Horror Cinema* (London: Routledge, 2002), pp. 44–57.

Chibnall, Steve, 'Double exposures: observations on *The Flesh and Blood Show*', in Deborah Cartmell, I. Q. Hunter, Heidi Kaye and Imelda Whelehan (eds), *Trash Aesthetics: Popular Culture and its Audience* (London: Pluto Press, 1997), pp. 84–102.

Collins, Jim, *Architectures of Excess: Cultural Life in the Information Age* (New York and London: Routledge, 1995).

Corner, John and Sylvia Harvey, 'Great Britain Limited', in John Corner and Sylvia Harvey (eds), *Enterprise and Heritage: Crosscurrents of National Culture* (London: Routledge, 1991), pp. 1–20.

Corner, John and Sylvia Harvey, 'Mediating tradition and modernity: the heritage/enterprise couplet', in John Corner and Sylvia Harvey (eds), *Enterprise and Heritage: Crosscurrents of National Culture* (London: Routledge, 1991), pp. 45–75.

Crewe, Louise and Nicky Gregson, 'Tales of the unexpected: exploring car boot sales as marginal spaces of contemporary consumption', *Institute of British Geographers Transactions*, 23 (1998), 39–53.

Davis, D. William, 'A tale of two movies: Charlie Chaplin, United Artists, and the red scare', *Cinema Journal*, 27:1 (1987), 47–62.

Davis, Fred, *Yearning for Yesterday: A Sociology of Nostalgia* (New York: Free Press, 1979).

Dewe Matthews, Tom, *Censored: What They Didn't Allow You to See, and Why: The Story of Film Censorship in Britain* (London: Chatto and Windus Limited, 1994).

Dika, Vera, 'The stalker film, 1978–81', in Gregory A. Waller (ed.), *American Horrors: Essays on the Modern American Horror Film* (Urbana and Chicago: University of Illinois Press, 1987), pp. 86–101.

Erb, Cynthia, *Tracking King Kong: A Hollywood Icon in World Culture* (Michigan: Wayne State University Press, 1998).

Fenton, Harvey and David Flint (eds), *Ten Years of Terror: British Horror Films of the 1970s* (Surrey: FAB Press, 2001).

Finney, Angus, *The Egos Have Landed: The Rise and Fall of Palace Pictures* (London: Heinemann, 1996).

Geertz, Clifford, *The Interpretation of Cultures* (London: Fontana, 1993).

Gelder, Ken, 'The field of horror', in Ken Gelder (ed.), *The Horror Reader* (London: Routledge, 2000), pp. 1–7.

Giles, Jane, 'Scala!!!! Autopsy of a cinema', in Stefan Jaworzyn (ed.), *Shock Xpress 2: The Essential Guide to Exploitation Cinema* (London: Titan Books, 1994), pp. 30–5.

Grainge, Paul, *Monochrome Memories: Nostalgia and Style in Retro America* (Westport and London: Praeger, 2002).

Gregson, Nicky and Louise Crewe, 'Beyond the high street and the mall: car boot fairs and the new geographies of consumption in the 1990s', *Area*, 26:3 (1994), 261–7.

Gregson, Nicky and Louise Crewe, *Second-hand Cultures* (Oxford: Berg, 2003).

Hall, Stuart and Tony Jefferson (eds), *Resistance through Rituals: Youth Subcultures in Post-war Britain* (London: Hutchinson, 1976).

Haralovich, Mary Beth, 'Mandates of good taste: the self-regulation of film advertising in the thirties', *Wide Angle*, 6:2 (1984), 50–7.

Harvey, Sylvia, 'Channel Four television: from Annan to Grade', in Edward Buscombe (ed.), *British Television: A Reader* (Oxford: Oxford University Press, 2000), pp. 92–117.

Hawkins, Joan, *Cutting Edge: Art-horror and the Horrific avant-garde* (Minneapolis: University of Minnesota Press, 2000).

Hebdige, Dick, *Subculture: The Meaning of Style* (London: Methuen, 1979).

Higson, Andrew, 'The concept of national cinema', *Screen*, 30:4 (1989), 36–46.

Hill, Annette, *Shocking Entertainment: Viewer Response to Violent Movies* (Luton: University of Luton Press, 1997).

Hollows, Joanne, 'The masculinity of cult', in Mark Jancovich, Antonio Lazaro Reboll, Julian Stringer and Andy Willis (eds), *Defining Cult Movies: The Cultural Politics of Oppositional Taste* (Manchester: Manchester University Press, 2003), pp. 35–53.

Hoxter, Julian, 'Taking possession: cult learning in *The Exorcist*', in Xavier Mendik and Graeme Harper (eds), *Unruly Pleasures: The Cult Film and its Critics* (Surrey: FAB Press, 2000), pp. 171–85.

Hunt, Leon, *British Low Culture: From Safari Suits to Sexploitation* (London: Routledge, 1998).

Hutchings, Peter, *Hammer and Beyond: The British Horror Film* (Manchester: Manchester University Press, 1993).

Jancovich, Mark, 'Cult fictions: cult movies, subcultural capital and the production of cultural distinctions', *Cultural Studies*, 16:2 (2002), 306–22.

Jancovich, Mark, '"A real shocker": authenticity, genre and the struggle for distinction', *Continuum: Journal of Media and Cultural Studies*, 14:1 (2000), 23–35.

Jenkins, Henry, 'Interactive audiences?', in Dan Harries (ed.), *The New Media Book* (London: British Film Institute, 2002), rpt. in Virginia Nightingale and Karen Ross (eds), *Critical Readings: Media and Audiences* (Berkshire: Open University Press, 2003), pp. 279–95.

Jenkins, Henry, '"Strangers no more, we sing": Filking and the social construction of the science fiction fan community', in Lisa A. Lewis (ed.), *The Adoring Audience: Fan Culture and Popular Media* (London: Routledge, 1992), pp. 208–36.

Jenkins, Henry, *Textual Poachers: Television Fans and Participatory Culture* (London: Routledge, 1992).

Kapsis, Robert E., *Hitchcock: The Making of a Reputation* (Chicago: University of Chicago Press, 1992).

Kendall, Lori, '"Oh no! I'm a nerd!" Hegemonic masculinity on an online forum', *Gender and Society*, 14:2 (2000), 256–74.

Kerekes, David and David Slater, *See No Evil: Banned Films and Video Controversy* (Manchester: Headpress, 2000).

Kermode, Mark, 'The British censors and horror cinema', in Steve Chibnall and Julian Petley (eds), *British Horror Cinema* (London: Routledge, 2002), pp. 10–22.

Kermode, Mark, 'I was a teenage horror fan: or, "How I learned to stop worrying and love Linda Blair"', in Martin Barker and Julian Petley (eds), *Ill Effects: The Media/Violence Debate* (London: Routledge, 2nd edn, 2001), pp. 126–34.

Kermode, Mark, 'Horror: on the edge of taste', in Ruth Petrie (ed.), *Film and Censorship: The Index Reader* (London: Cassell, 1997), pp. 155–60.

Kirshenblatt-Gimblett, Barbara, *Destination Culture: Tourism, Museums, and Heritage* (Berkley and Los Angeles: University of California Press, 1998).

Klinger, Barbara, 'The contemporary cinephile: film collecting in the post-video era', in Melvyn Stokes and Richard Maltby (eds), *Hollywood Spectatorship: Changing Perceptions of Cinema Audiences* (London: British Film Institute, 2001), pp. 132–51.

Klinger, Barbara, 'Film history terminable and interminable: recovering the past in reception studies', *Screen*, 38:2 (1997), 107–28.

Klinger, Barbara, *Melodrama and Meaning: History, Culture, and the Films of Douglas Sirk* (Bloomington and Indianapolis: Indiana University Press, 1994).

Kopytoff, Igor, 'The cultural biography of things: commoditization as process', in Arjun Appadurai (ed.), *The Social Life of Things: Commodities in cultural Perspective* (Cambridge: Cambridge University Press, 1986), pp. 64–91.

Kuhn, Annette, *Cinema, Censorship and Sexuality: 1909–1925* (London: Routledge, 1988).

Lury, Celia, *Consumer Culture* (Cambridge: Polity Press, 1996).

McArthur, Colin, 'British film reviewing: a complaint', *Screen*, 26:1 (1985), 79–84.

McCarty, John, *Splatter Movies: Breaking the Last Taboo of the Screen* (New York: St. Martin's Press, 1984).

McCracken, David Grant, *Culture and Consumption: New Approaches to the Symbolic Character of Consumer Goods and Activities* (Bloomington and Indianapolis: Indiana University Press, 1988).

McDonagh, Maitland, 'The house by the cemetery', *Film Comment*, 27:4 (1991), 43–4.

Maland, Charles J., *Chaplin and American Culture: The Evolution of a Star Image* (Princeton, New Jersey: Princeton University Press, 1989).

Maltby, Richard, '"D" for disgusting: American culture and English criticism', in Geoffrey Nowell-Smith and Steven Ricci (eds), *Hollywood and Europe: Economics, Culture, National Identity: 1945–95* (London: British Film Institute, 1998), pp. 104–15.

Martin, John, *The Seduction of the Gullible: The Curious History of the British 'Video Nasty' Phenomenon* (Nottingham: Procrustes Press, 1993).

Morley, David and Kevin Robins, *Spaces of Identity: Global Media, Electronic Landscapes, and Cultural Boundaries* (London: Routledge, 1995).

Naremore, James, *More Than Night: Film Noir in Its Contexts* (California: California University Press, 1998).

Neale, Steve, 'Art cinema as institution', *Screen*, 22:1 (1981), 11–39.

Neale, Steve, 'Questions of genre', *Screen*, 31:1 (1990), 45–66.

Newman, Kim, 'Journal of the plague years', in Karl French (ed.), *Screen Violence* (London: Bloomsbury, 1996), pp. 132–43.

Newman, Kim, 'Thirty years in another town: the history of Italian exploitation', *Monthly Film Bulletin* (January 1986), 20–4.

Petley, Julian, '"A crude sort of entertainment for a crude sort of audience": the British critics and horror cinema', in Steve Chibnall and Julian Petley (eds), *British Horror Cinema* (London: Routledge, 2002), pp. 23–41.

Petley, Julian, 'Us and them', in Martin Barker and Julian Petley (eds), *Ill Effects: The Media/Violence Debate* (London: Routledge, 2nd edn, 2001), pp. 170–85.

Petley, Julian, 'The video image', *Sight and Sound*, 59:1 (1989), 24–7.

Petley, Julian, 'A nasty story', *Screen*, 25:2 (1984), 68–74.

Petley, Julian, 'Two or three things I know about video nasties', *Monthly Film Bulletin*, 51:610 (1984), 350–2.

Samuel, Raphael, *Theatres of Memory Volume 1: Past and Present in Contemporary Culture* (London and New York: Verso, 1994).

Sanjek, David, 'Fans' Notes: the horror film fanzine', *Literature/Film Quarterly*, 18:3 (1990), rpt. in Ken Gelder (ed.), *The Horror Reader* (London: Routledge, 2000), pp. 314–23.

Sconce, Jeffrey, '"Trashing" the academy: taste, excess, and an emerging politics of cinematic style', *Screen*, 36:4 (1995), 371–93.

Slater, Don, *Consumer Culture and Modernity* (Oxford: Polity Press, 1997).

Stewart, Susan, *On Longing: Narratives of the Miniature, the Gigantic, the Souvenir, the Collection* (Baltimore: Johns Hopkins University Press, 1984).

Straw, Will, 'Sizing up record collections: gender and connoisseurship in rock music culture', in Sheila Whiteley (ed.), *Sexing the Groove: Popular Music and Gender* (London and New York: Routledge, 1997), pp. 3–16.

Street, Sarah, *British Cinema in Documents* (London: Routledge, 2000).

Strinati, Dominic, 'The taste of America: Americanization and popular culture in Britain', in Dominic Strinati and Stephen Wagg (eds), *Come on Down? Popular Media Culture in Post-war Britain* (London: Routledge, 1992), pp. 46–81.

Stringer, Julian, 'Regarding film festivals', PhD Dissertation, Indiana University, 2003.

Syder, Andrew, 'Policing the home: "video nasties" and nasty videos', in Sarah Matheson (ed.), *Changing Channels: New Directions in Television Studies*, special issue of *Spectator: The University of Southern California Journal of Film and Television*, 20:2 (2000), 90–100.

Szulkin, David A., *Wes Craven's Last House on the Left: The Making of a Cult Classic* (Surrey: FAB Press, 2nd edn, 2000).

Tannock, Stuart, 'Nostalgia critique', *Cultural Studies*, 9:3 (1995), 453–64.

Tashiro, Charles, 'The contradictions of video collecting', *Film Quarterly*, 50:2 (1996–97), 11–18.

Thornton, Sarah, *Club Cultures: Music, Media and Subcultural Capital* (Oxford: Blackwell, 1995).

Tunstall, Jeremy, *Newspaper Power: The New National Press in Britain* (Oxford: Oxford University Press, 1996).

Webster, Duncan, *Looka Yonder!: The Imaginary America of Populist Culture* (London: Routledge, 1988).

Wilinsky, Barbara, *Sure Seaters: The Emergence of Art House Cinema* (Minnesota: University of Minnesota Press, 2001).

Wingrove, Nigel, 'The nasties: a personal view', in Nigel Wingrove and Marc Morris (eds), *The Art of the Nasty* (London: Salvation Films, 1998), pp. 1–11.

Wingrove, Nigel and Marc Morris (eds), *The Art of the Nasty* (London: Salvation Films, 1998).

Index

CPSIA information can be obtained at www.ICGtesting.com
Printed in the USA
LVOW06s1527180714

394995LV00001B/270/P